Up on the Roof

For Eliza, Avery, Jeanne, Gaspar, and Simon

Up on the Roof

New York's Hidden Skyline Spaces

Alex MacLean

Introduction by
Robert Campbell

PRINCETON ARCHITECTURAL PRESS · NEW YORK

Liberty Island and Manhattan as seen from Staten Island

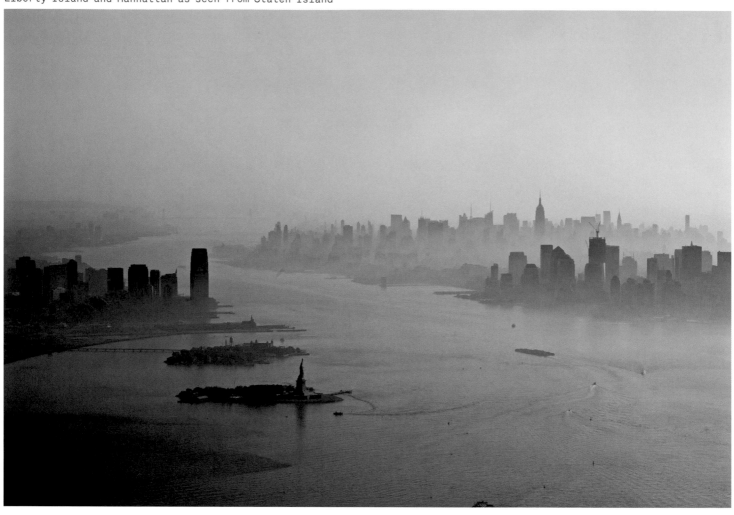

Queens and Brooklyn with Manhattan across the East River

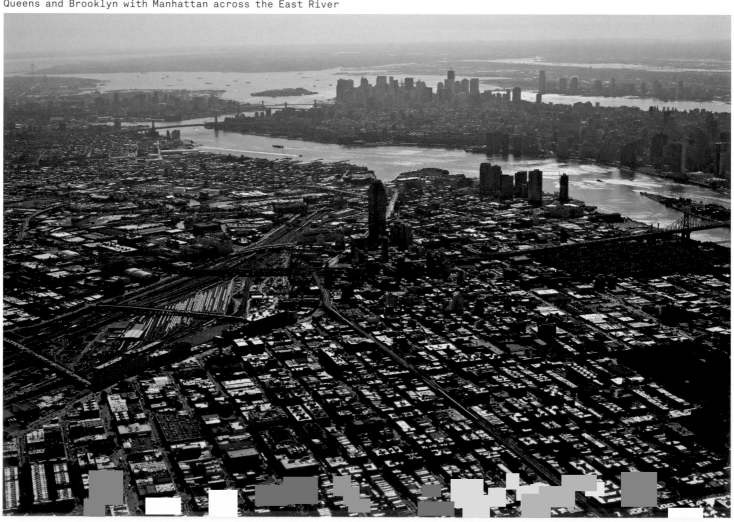

Introduction

Robert Campbell

Alex MacLean has long been celebrated for the astonishing photographs he takes from airplanes and helicopters. Looking down, MacLean sees a world few of us can even imagine. I've known MacLean and admired his work for thirty years, but for me, *Up on the Roof* is the most valuable of all his remarkable accomplishments. For the first time, he's focused on a single place—New York City—and he's photographed from a lower vantage point than usual in order to document the city more closely.

Most of us probably think we know New York. But we've been missing one whole dimension of the city: its vast, amazing roofscape, a world that is invisible except from above. It's the dimension MacLean calls "the fifth facade." MacLean perceives a flat roof as a facade, like the front, side, or rear wall of a building—one that can be as purposeful and beautiful as any other surface.

In his photos, the roofs of New York emerge as a kind of floating city in the sky, an Emerald City of Oz. Since we seldom see much of it, we usually aren't aware how extensive this world is. Just about one-third of the impermeable surfaces of Manhattan—that is to say, all the surfaces that don't let water through, as do yards and parks—is roofscape.

The colors green and white stand out immediately as we survey these photos. The green comes from the plants that cover so many of the city's roofs—more than you would ever imagine from the sidewalk. Sometimes these plantings exist to create a green roof: a surface that can deal efficiently with issues of rain collection, insulation, energy efficiency, and sustainability. These green roofs retain water that otherwise would run off uselessly into storm sewers. The water nourishes the plants and, through evaporation, helps to keep the roof cool. The green blanket also acts as a layer of insulation; the result is a significant reduction in energy consumption.

But just as often, the green appears in the form of the grass, shrubs, or trees of a private rooftop garden, someone's quiet getaway from the hurly-burly of life in the metropolis. Both uses of green are valuable. Either can generate delightful aerial oases, many of which appear in MacLean's photographs. And, of course, one roof can serve both purposes, becoming both a personal Eden and a model of sustainability.

Green we may expect, but a white roof comes as more of a shock. An enormous number of New York's roofs, which once were almost uniformly made of some form of black asphalt, have recently morphed into white. (The same is true in California, where a white roof is now mandatory on any new flat-roofed house.) Sometimes the white is a waterproof membrane, but often it's simply painted on—a task that supplies jobs for unskilled teenagers. By reflecting the heat of the sun instead of absorbing it as black does, the white roof helps a building's interior remain cool, with less need for air conditioning. (However, the heat that the roof keeps out of the building is instead reflected back up into the atmosphere. Some recent studies suggest that the white roofs, despite their good intentions, may thus be contributing to global warming. The jury is still out on this issue.)

The process of rooftop conversion has received an enormous boost from Mayor Michael Bloomberg. The Bloomberg administration has promoted

The Upper East Side along Central Park

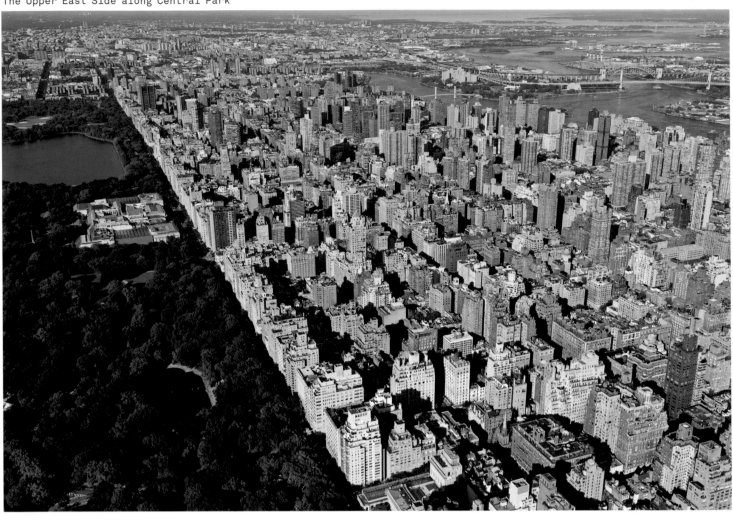

417 Lafayette Street, East Village, Manhattan

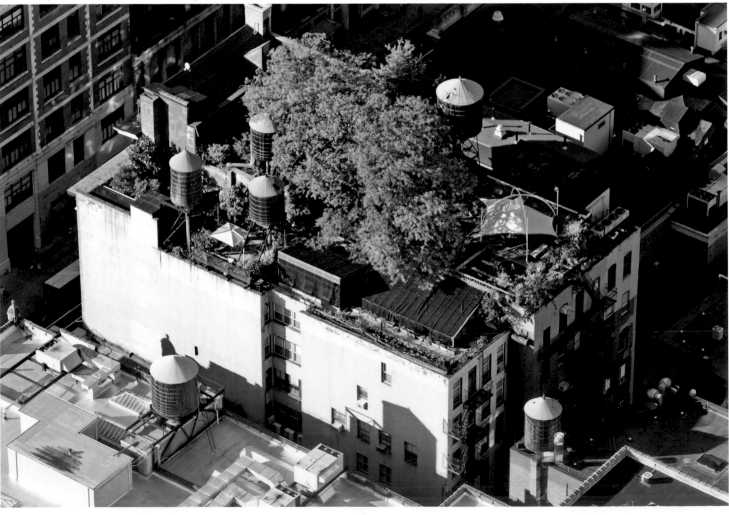

roofscaping since 2007 as part of one of its flagship initiatives, a long-range sustainability plan known as "PlaNYC: A Greener, Greater New York."

PlaNYC looks thirty years into the future and predicts that New York will grow from eight million to nine million residents. It proposes ways to accommodate this growth while also improving the quality of people's lives. Green roofs, and also white roofs, are specifically cited as ways of cooling the city and reducing its demand for energy. Hybrid cabs and buses, dozens of new parks, two hundred miles of bicycle lanes, and the planting of a million new trees are also included in this ambitious plan. New York has taken the lead among American cities in addressing the global crisis of climate change, although it's still embarrassingly far behind the achievements of such countries as Germany, where ten million square meters of new green roofs are constructed annually—that's about three times the area of New York's Central Park added every year.

New York City, Manhattan in particular, can be thought of as a laboratory for the kind of living we can expect in the era of global warming. It's already the most energy-efficient place in the United States—the one that uses the least amount of energy per resident and per dwelling unit. As MacLean points out, there are many reasons for this. Fewer New Yorkers own private cars than do Americans in other locations. New Yorkers take public transit, or ride bikes, or simply walk. Their homes are stacked beside and atop one another in apartment buildings, sharing walls, floors, and ceilings. Normally, only one or two surfaces of a Manhattan dwelling are exposed to the heat of the sun or the cold of winter; thus, less energy is required for heating and cooling. Homes in other parts of the city are usually less densely packed than those in Manhattan, but they're still closely spaced compared to what's typical in the United States, especially in the suburbs.

As the world's population grows, and as the supply of cheap energy continues to diminish, most observers believe that places like New York City will become more typical. To save energy, populations will concentrate in cities rather than spreading out more thinly in less efficient suburbs and rural areas. We'll live at a higher density, and that's where the rooftop revolution will really matter: green rooftops will reduce energy consumption while also providing the kind of open space and clean air that will make high-density living a pleasure. Rooftops will be the lungs of the denser city of the future. As the world urbanizes, the rooftops will connect us with nature, with wind and sun and rain and snow, with the natural processes of growth and decay.

MacLean's eye is magical. In this book, as in all his previous ones, he reveals unexpected patterns on the surface of the earth. They may be patterns of nature, or of agriculture, or, as in this project, of human settlement. The images are often unforgettably beautiful, thanks to MacLean's talent as a visual artist. But they're also full of lessons about how we human beings inhabit our earth—and sometimes about how we mess it up. That's MacLean's talent as an environmentalist. The artist and the environmentalist are both at their best in *Up on the Roof*.

Conversion to white roofs in Brooklyn

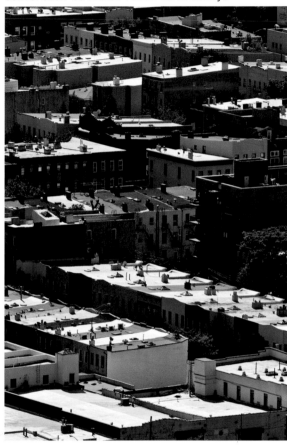

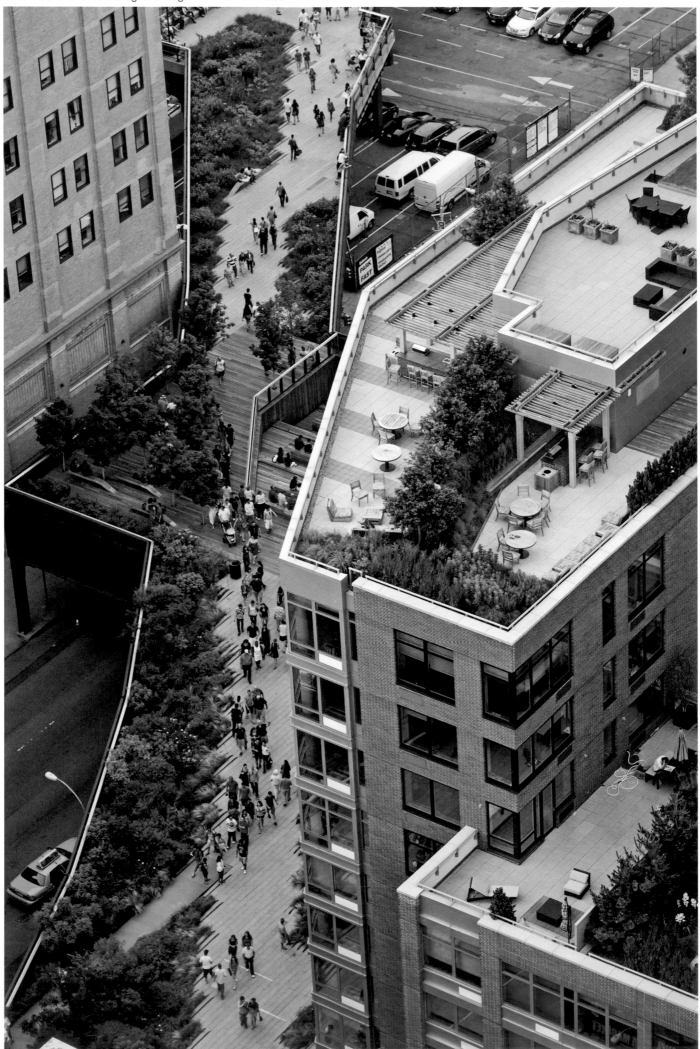

Looking at these fascinating photographs is, among other things, an act of fantasy and exploration. A viewer can play games with them: for instance, a version of *Where's Waldo?* involving a personal search for, let's say, a nude sunbather, or for that perfect Shangri-La where, if only you had the money, you could possess your own pied-à-terre in the great city.

For many years, we lost interest in the tops of buildings. In the art deco period of the Empire State and Chrysler Buildings, New York skyscrapers wore the architectural equivalent of party hats, lovingly and inventively styled to catch the eye and assert a bold identity. In even earlier eras, the tops of buildings were festooned with ornamental cornices and classical motifs. But after World War II, when modernism became the dominant style, most of the new towers were boxy flattops, looking as if they had been given businesslike crew cuts. Often a building looked like the packing crate the real building was supposed to have come in.

Now, though, a splash of green foliage or the tip of a parasol seen behind a parapet becomes a hint that fun and surprise can once again be present in the architecture of even the boxiest buildings. The whole city feels more alive, as indeed it is.

The idea of using roofs as livable open space isn't a new one. It was one of the five points of modern architecture set forth by the great French architect Le Corbusier in his 1923 book *Vers une architecture*. Le Corbusier argued that every building, especially every house, should be topped by a flat roof featuring a garden. This garden in the air would be a replacement for the open space lost on the ground by the construction of the house. Nature would flow across the site uninterrupted, merely hopping up to the roof and down again. (Le Corbusier also said, "By law, all buildings should be white," an opinion that, while founded in aesthetics, anticipated those white energy-saving roofs of today.)

We find an enormous variety of enhancements to the rooftops in MacLean's photos. There are dance floors, playgrounds, swimming pools, fruit and vegetable farms, flower gardens, sculptures, cottages, changing rooms for swimmers and sunbathers, patterned trellises, floor murals, cupolas, skylights, solar panels, dog and other pet houses, aviaries, birdfeeders, picnic grounds, sheltered groves, and painted abstractions to be seen by God, MacLean, or some other passing aviator. And, of course, there are the older mechanical elements: the air-handling ducts, the chimneys, and, especially, the water tanks that stand like sentinels atop so many roofs, sometimes with cables and pipes twisting around them. Today, our vision schooled by artists who treasure the visual richness of the industrial past, we may perceive such chance compositions as vernacular art pieces.

MacLean has done what every true artist does: he has opened a new world to our view. It's not only New York that will never again look the same. We'll now be aware of the fifth facade of every city.

Robert Campbell is a writer and architect. In 1996 he received the Pulitzer Prize for Criticism for his writing on architecture for the Boston Globe. *He has published more than one hundred feature articles in national periodicals and, for eight years, wrote the Critique column for* Architectural Record *magazine. Campbell is a fellow of the American Institute of Architects and graduated from Harvard University.*

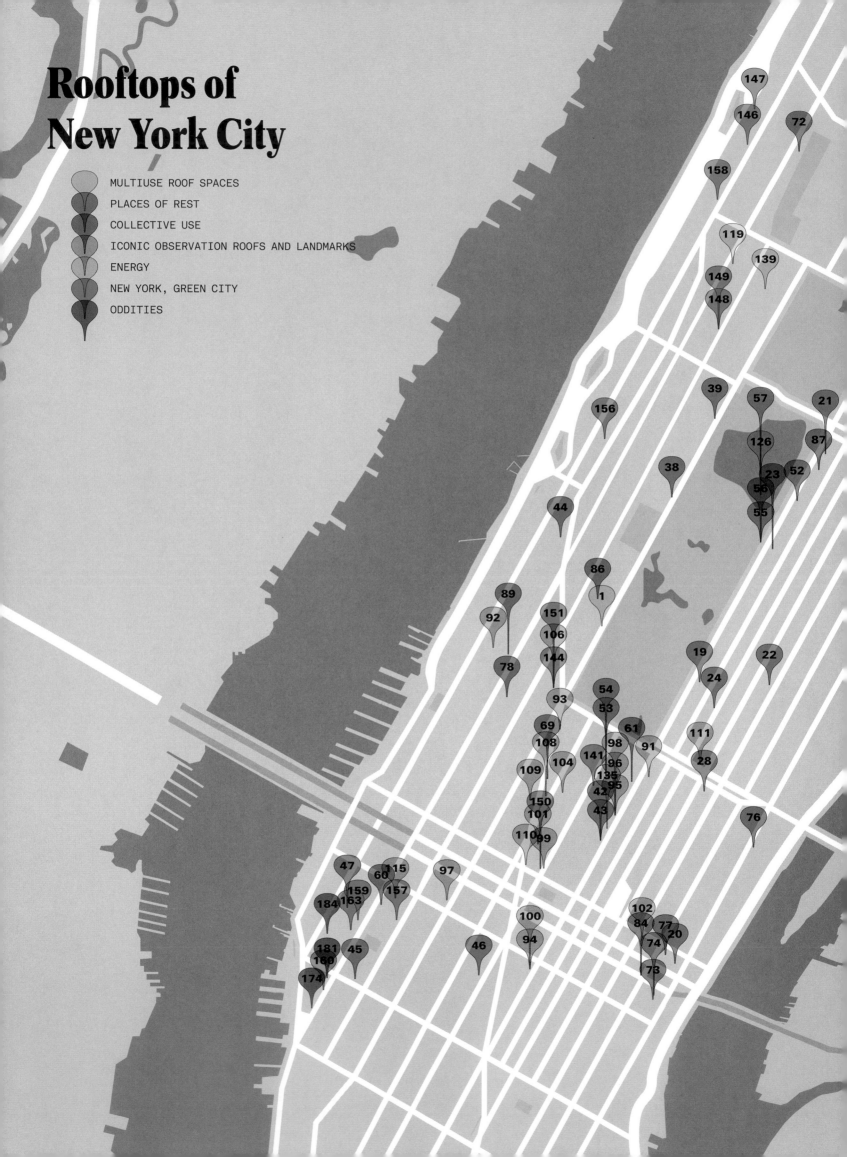

Rooftops of New York City

MULTIUSE ROOF SPACES

PLACES OF REST

COLLECTIVE USE

ICONIC OBSERVATION ROOFS AND LANDMARKS

ENERGY

NEW YORK, GREEN CITY

ODDITIES

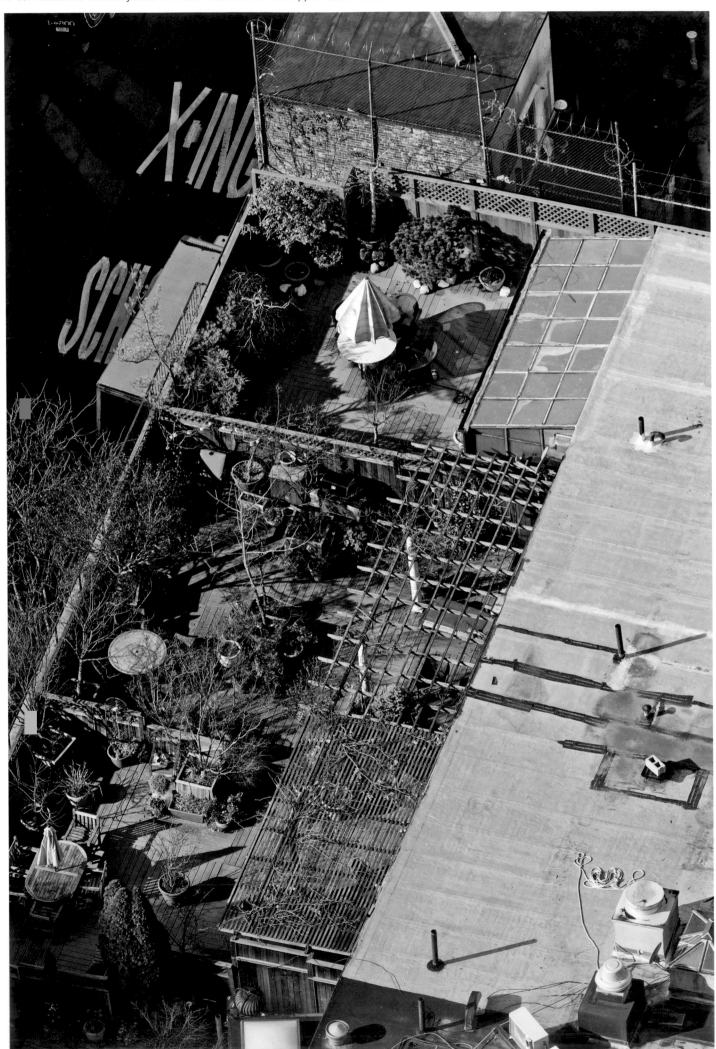

A terracelike countryside on 91st Street in the Upper East Side

Contents

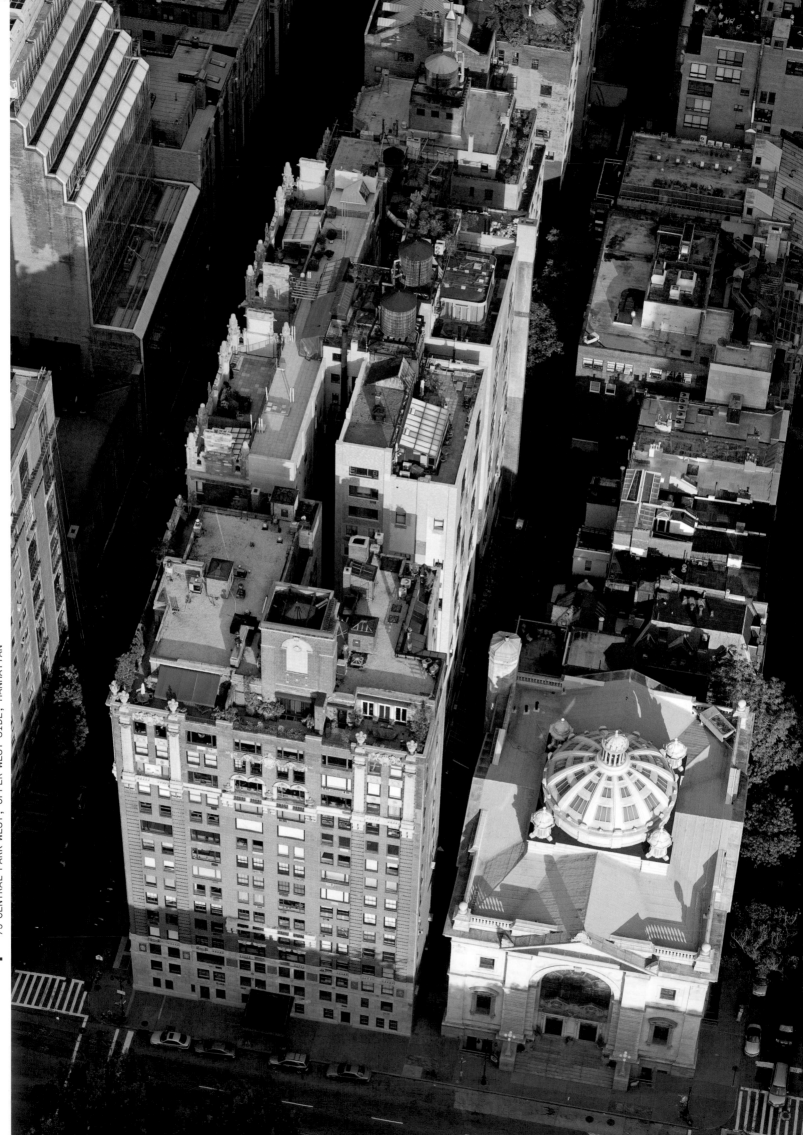

Multiuse Roof Spaces

This project of documenting New York City's rooftops was inspired by an image I viewed on Google Earth. Noticing a structure like a castle crowning a building in Tudor City, near the United Nations, I wondered what else could be found on the rooftops of the city's buildings, which, in Manhattan, occupy more than a third of the total impermeable surface area.

On a hot day in July 2010, I was working on an aerial assignment to photograph the construction of Brooklyn Bridge Park. I was in a helicopter, and while I waited for some cloud shadows to pass, I spun off to take a quick look at the rooftops of Manhattan.

I first went to Tudor City, where I realized that its faux-castle roof facade was not nearly as dramatic as the surrounding plant-covered roof terraces. I then flew across town to look at Hudson River Park and the High Line. I had followed with interest the development of the High Line on the west side of Manhattan from an abandoned elevated rail line into a linear park that extended from Hell's Kitchen through West Chelsea to the Meatpacking District.

While flying over West Chelsea, I became aware of multiuse roof spaces that seemed to be everywhere. It was obvious that a recent shift in culture and in financial resources had led to the construction of these new outdoor spaces; it was as if the spirit of the High Line had spread to rooftop conversions throughout the neighborhood.

In later flights over the city I began to recognize a range of rooftop configurations, from those that looked almost as though they were occupied by squatters, with light portable furnishings and ill-defined spaces, to lavish patios delineated by privacy fences and equipped with barbecue grills, tables and chairs, chaise lounges, large potted plants, and even basketball hoops and playground equipment. In the latter, measures had been taken to screen and enclose noisy compressors and heating and ventilating units. These elaborate roof spaces are the urban equivalent of suburban backyards.

It is a luxury for a city-dweller to have the same easy, private access to the outdoors as a suburbanite. Roof access for apartment owners and tenants can increase the desirability of marginal buildings, which in turn can bring stability to their surrounding neighborhoods. Already the tops of new rectangular midrise apartment buildings in Williamsburg and Long Island City are starting to resemble ice trays, divided into cubicles to be sold as rooftop cabanas.

Access to rooftops makes cities much more livable, which has its own value. But amenities that make an urban lifestyle easier and more appealing are also valuable for the world at large, since cities are the most energy-efficient places to live, on a per-capita basis. Compared to their rural and suburban counterparts, New York City residents on average live in smaller dwelling units (which are stacked and share common walls, requiring less energy to heat and cool). New Yorkers also conserve energy by owning fewer cars, walking more, using public transportation, and are now starting to use bikes more frequently. For these reasons, it is important to improve the quality of life for city-dwellers.

Considering the shortage of outdoor space in New York City and the richness of existing roof decks and terraces, one can see great potential in the vast, vacant expanse of the city's flat rooftops.

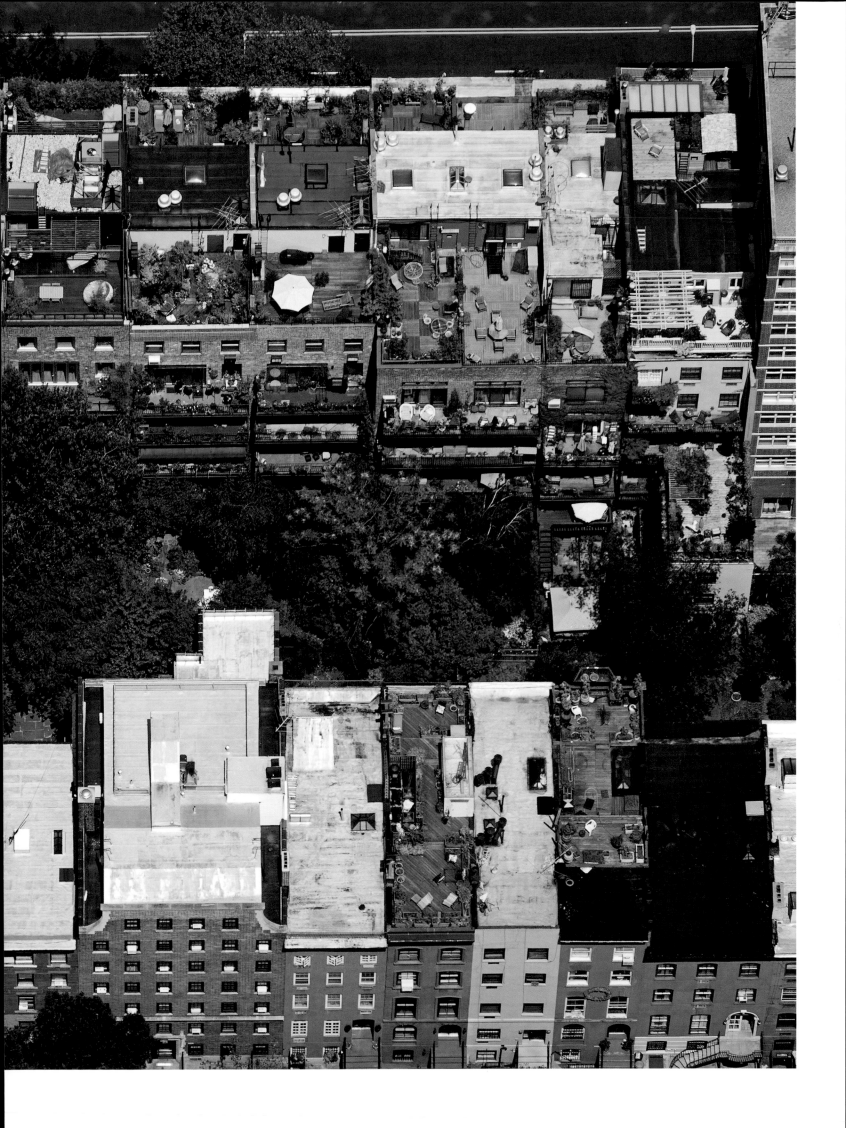

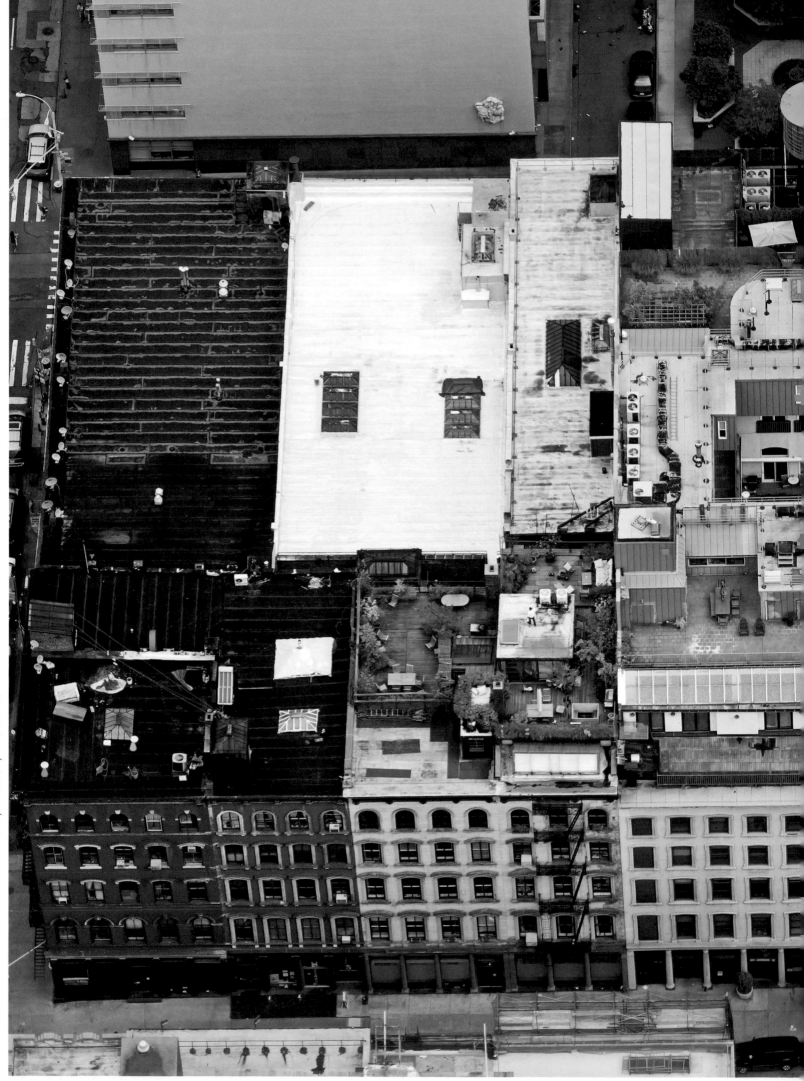

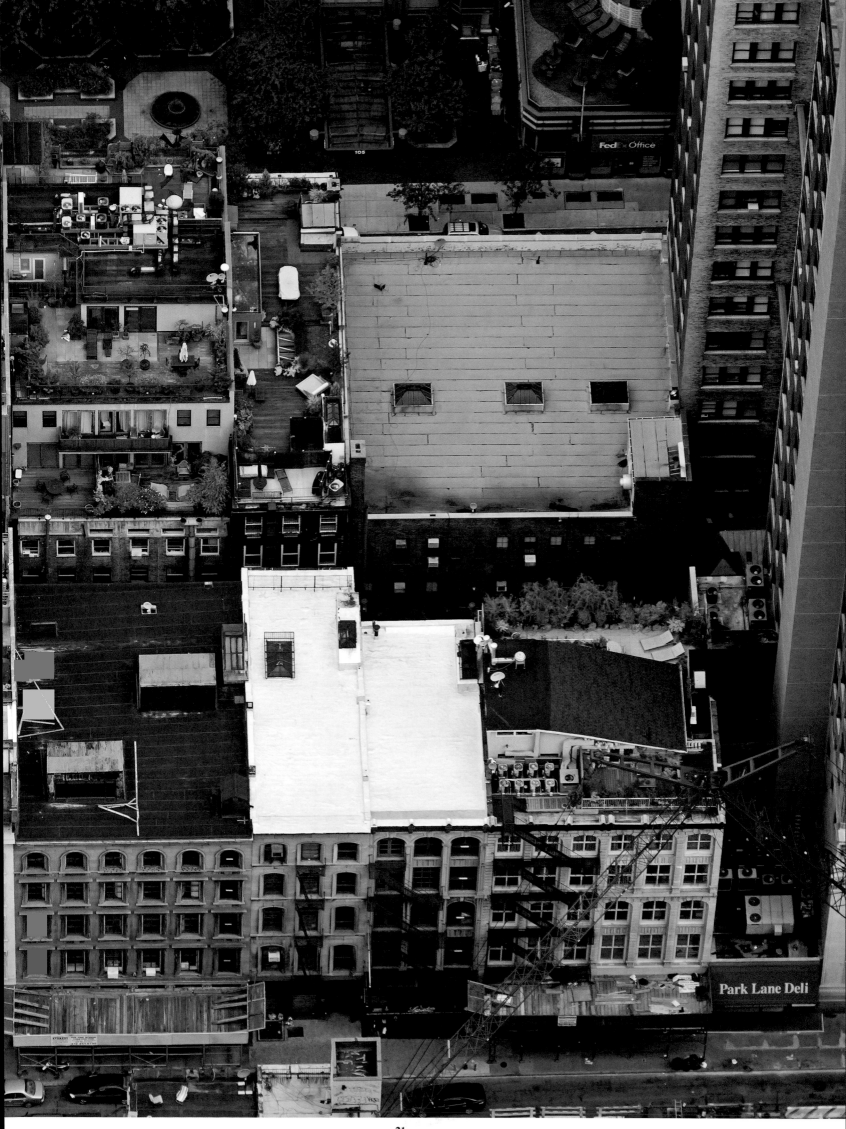

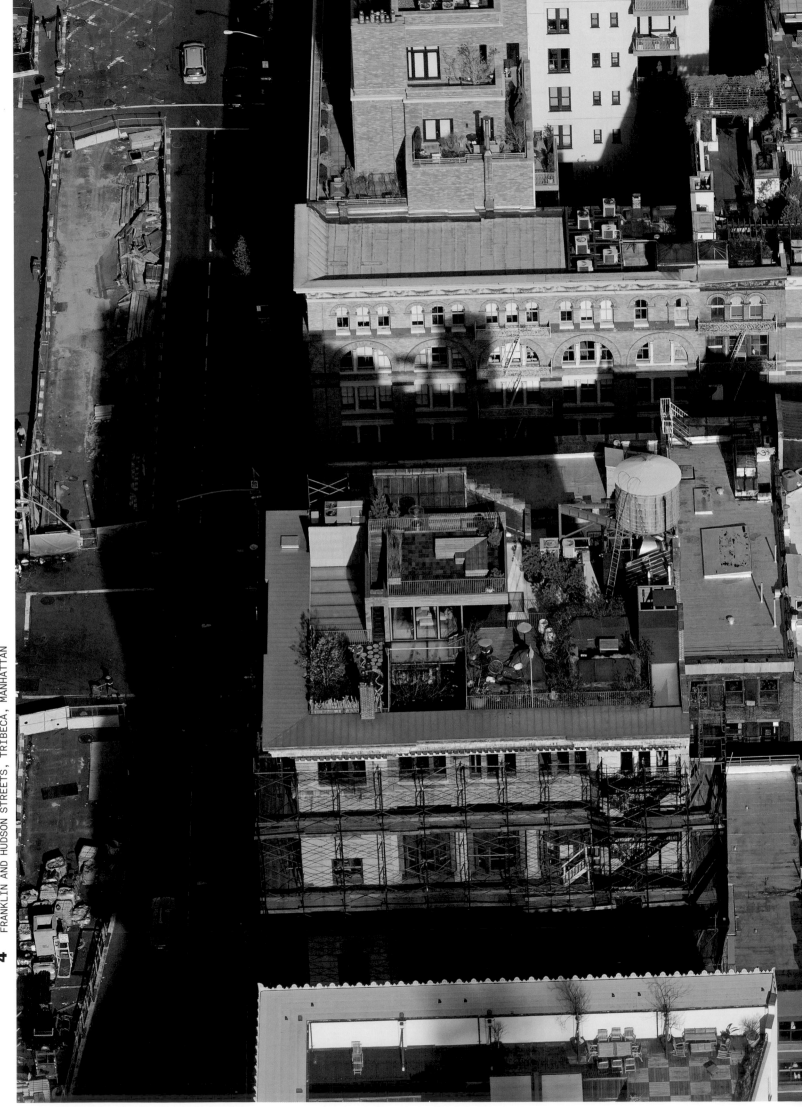

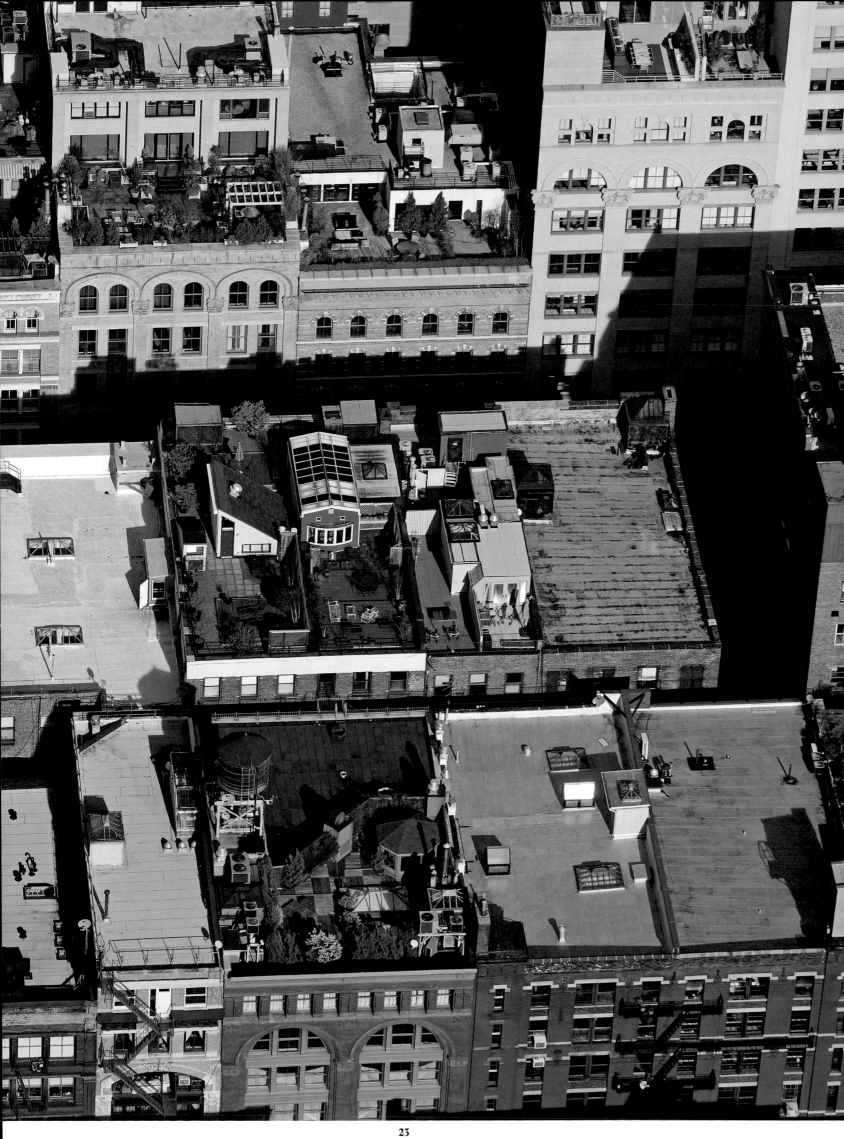

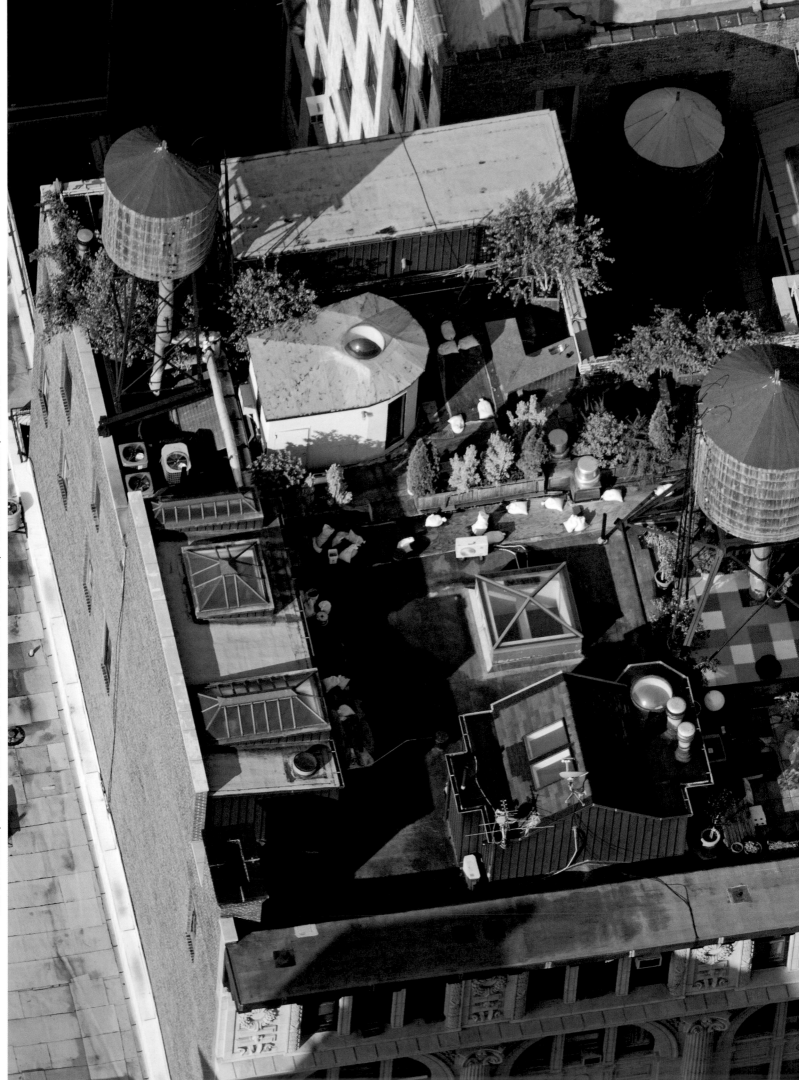

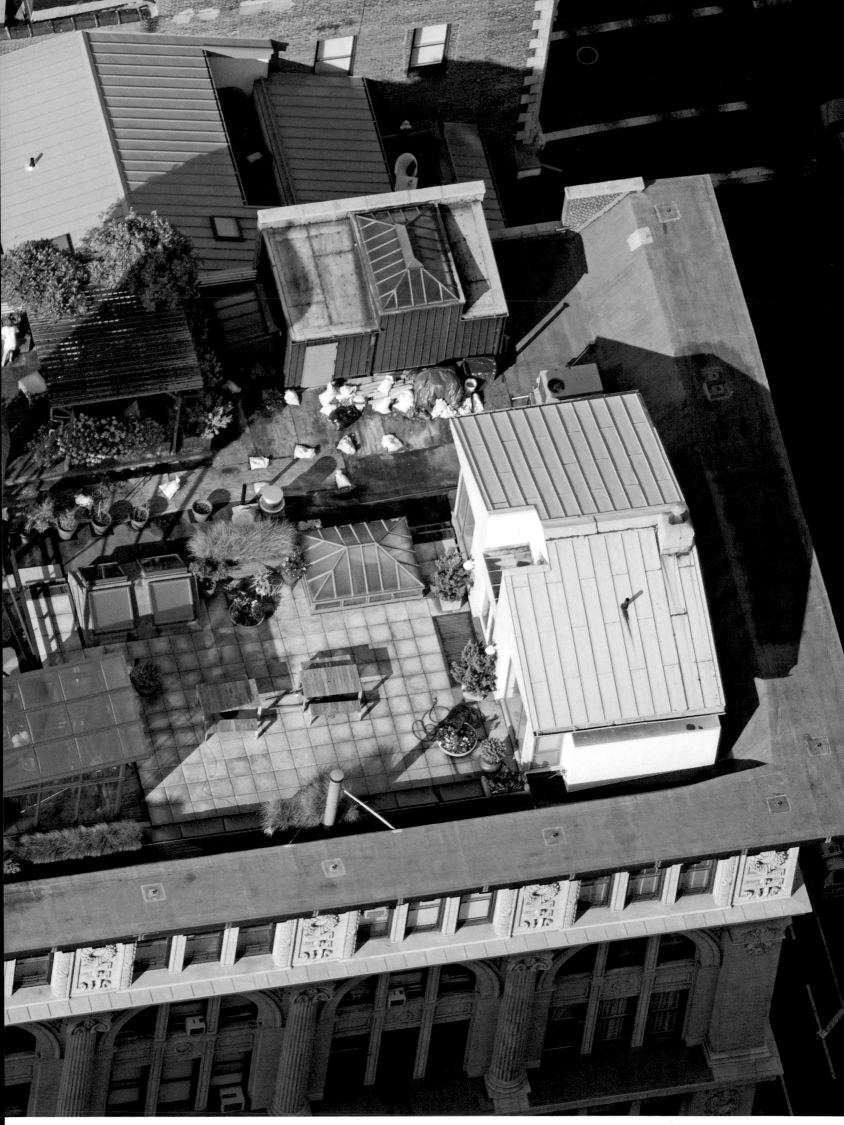

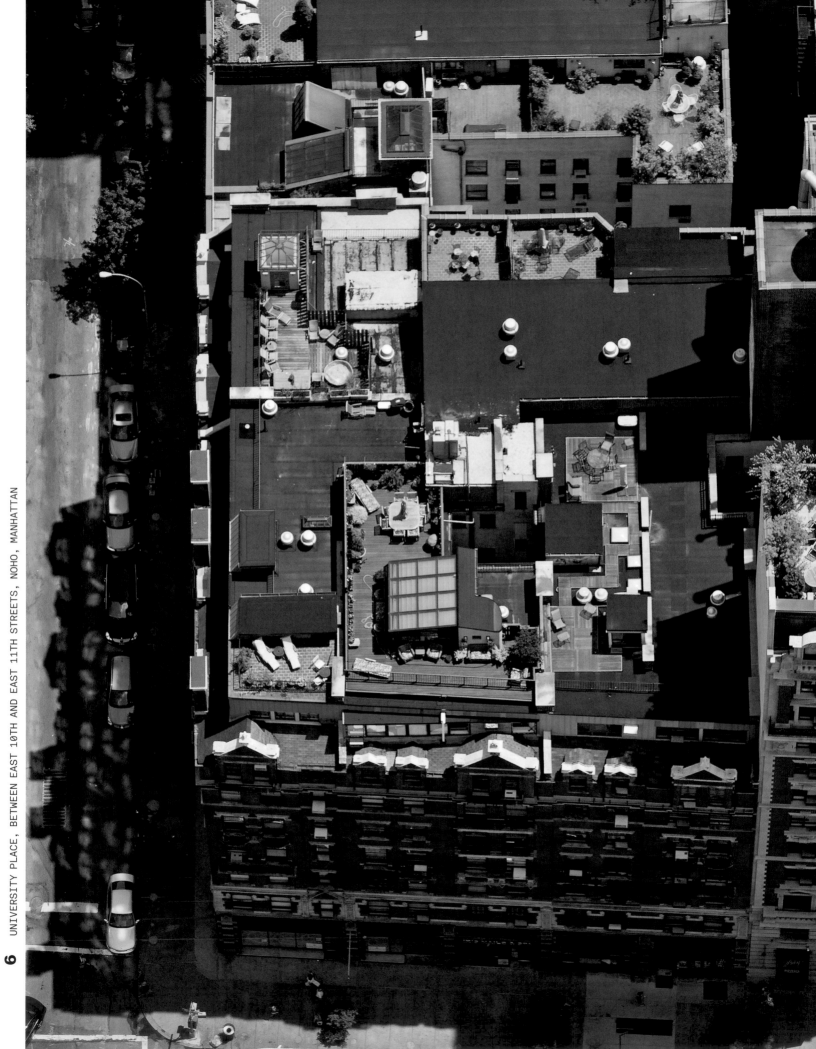

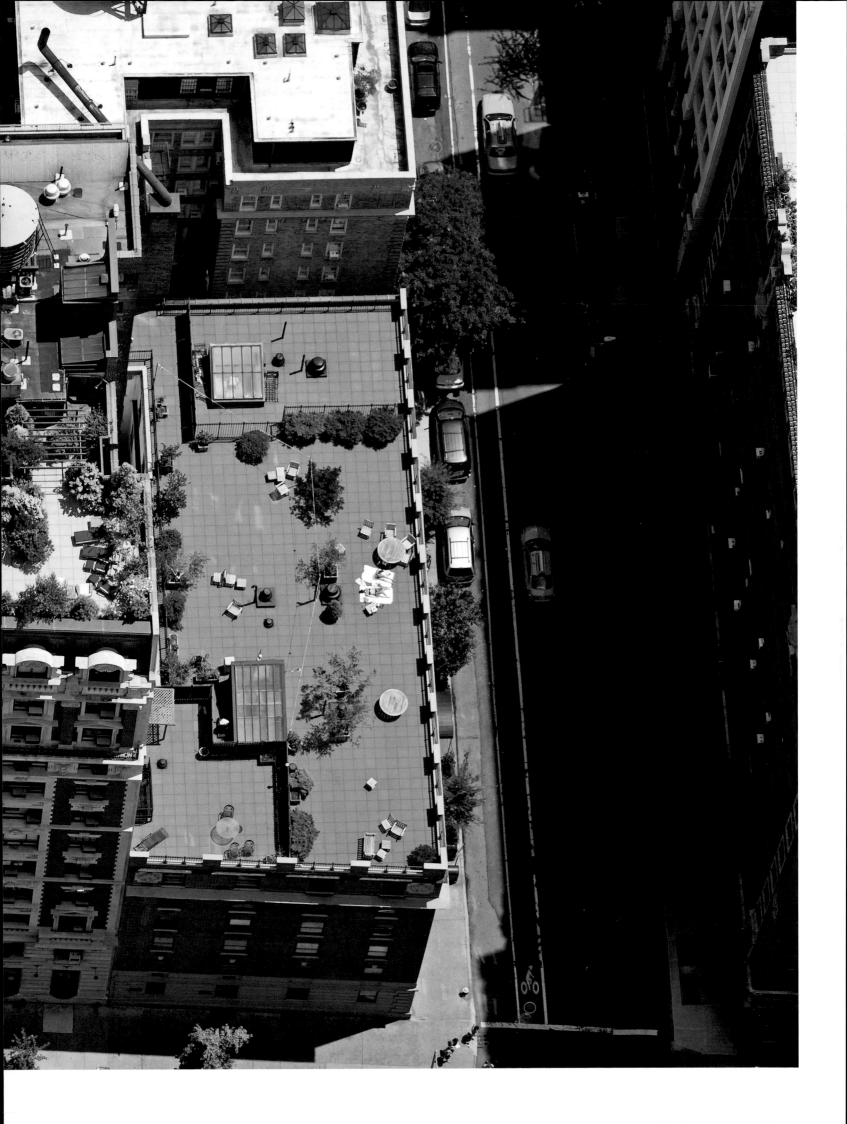

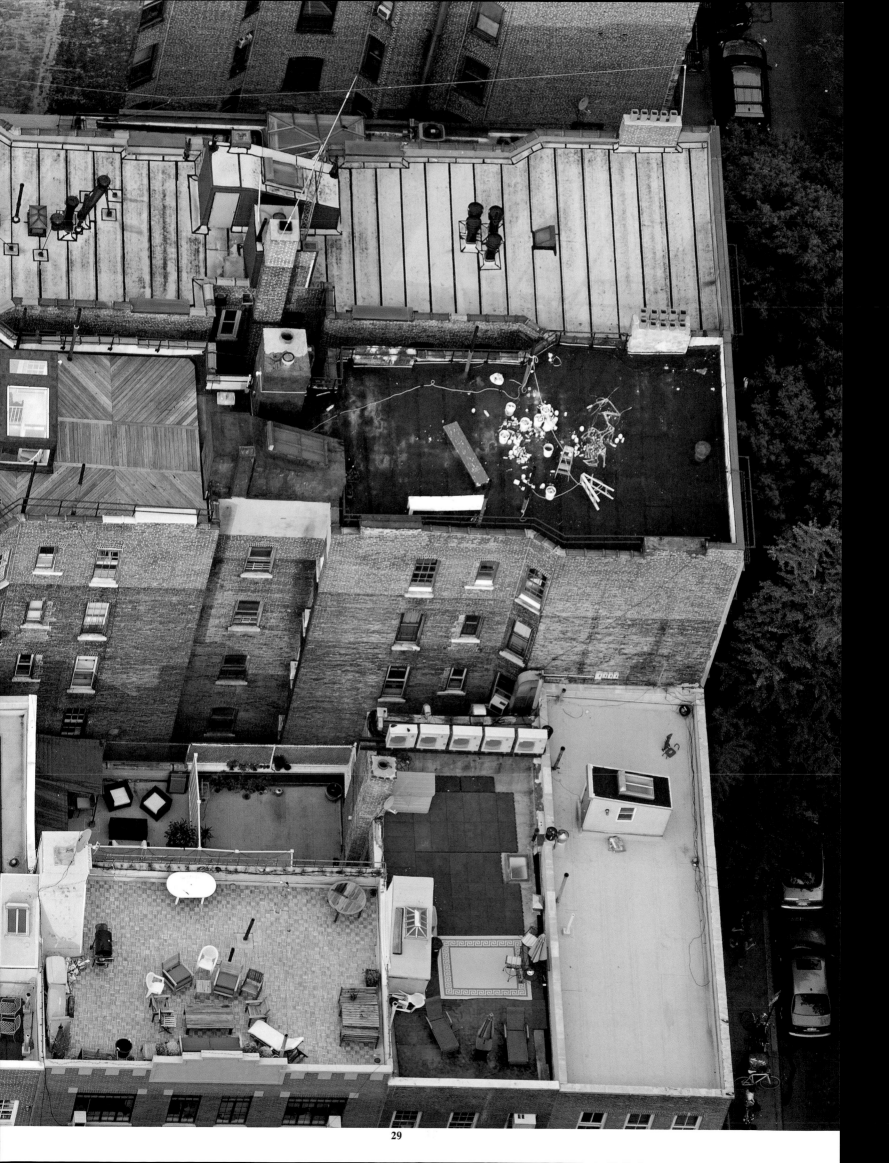

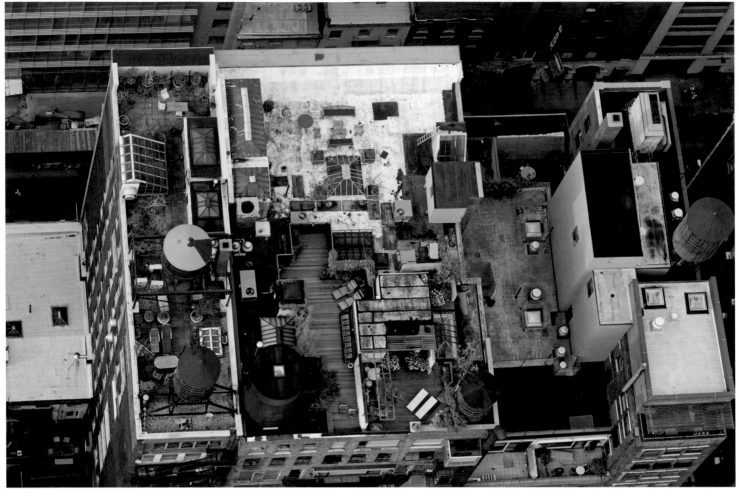

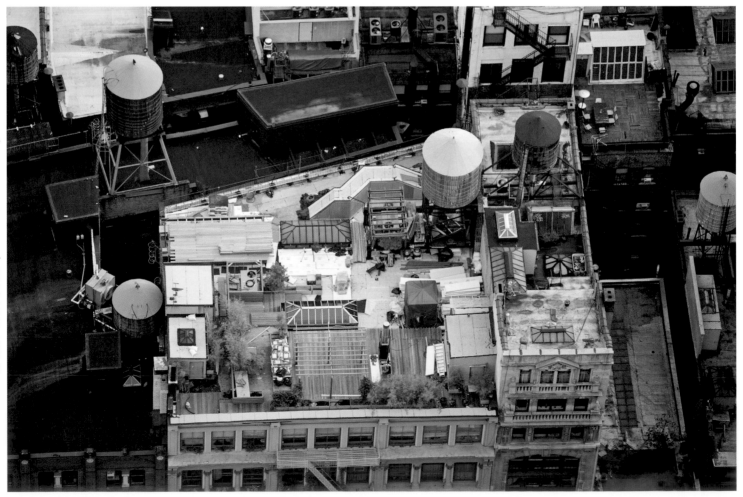

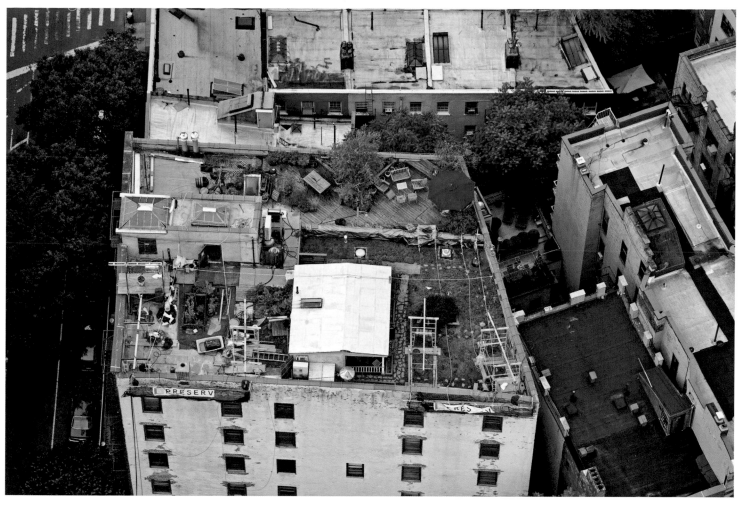

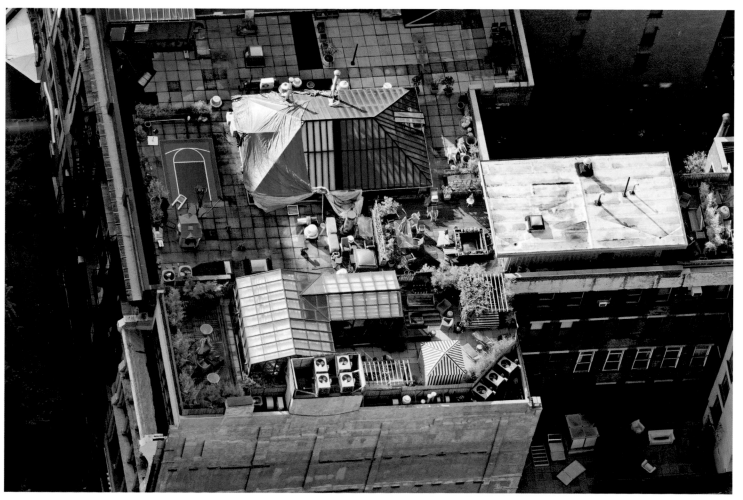

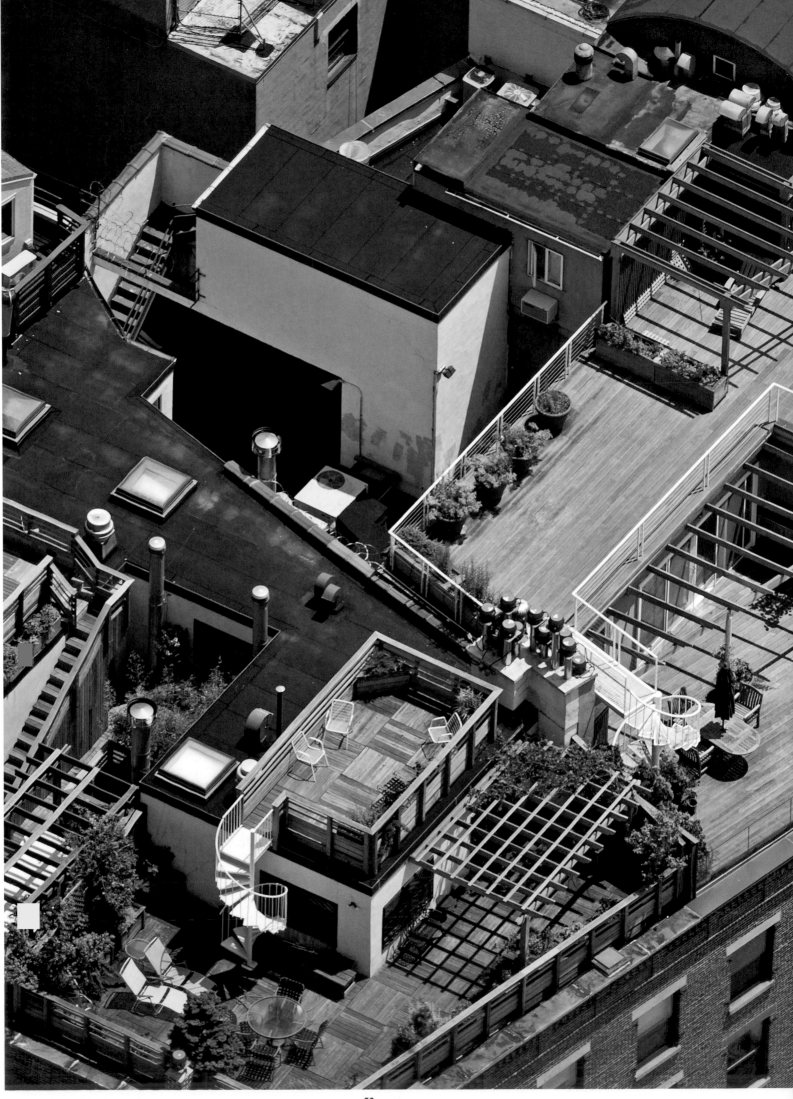

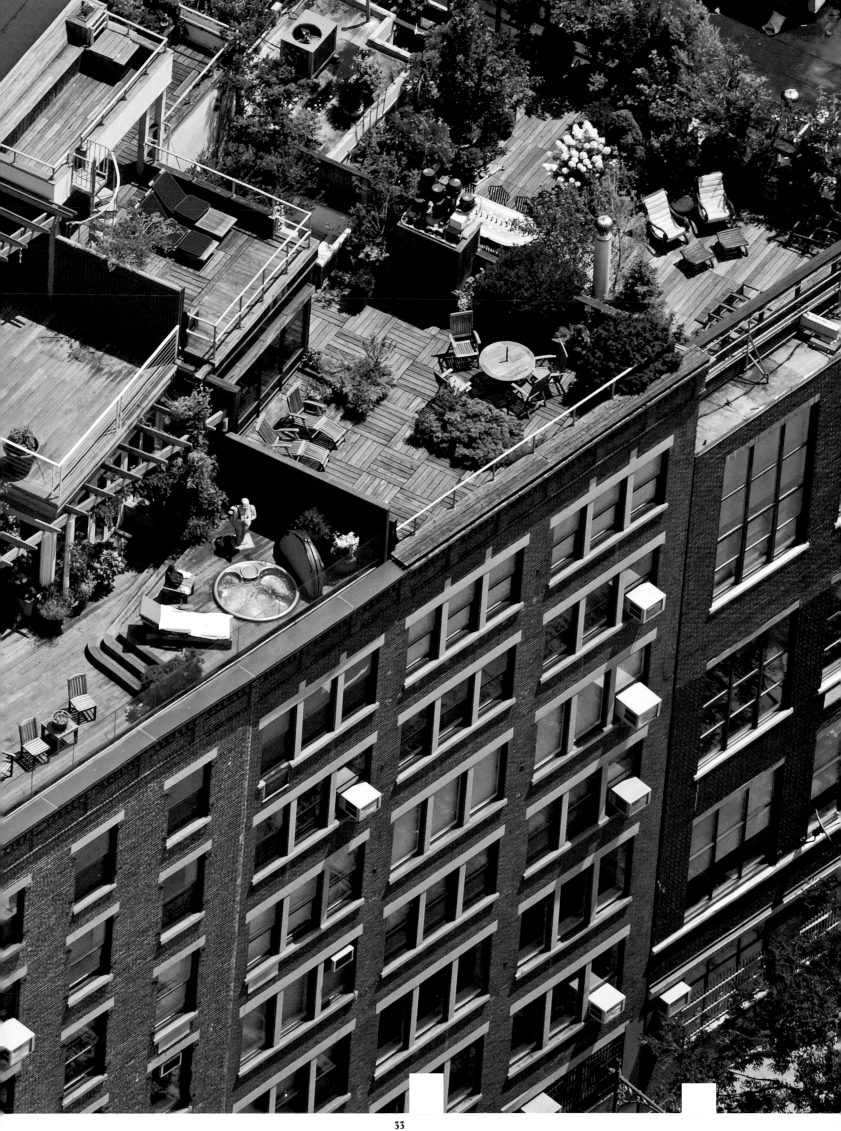

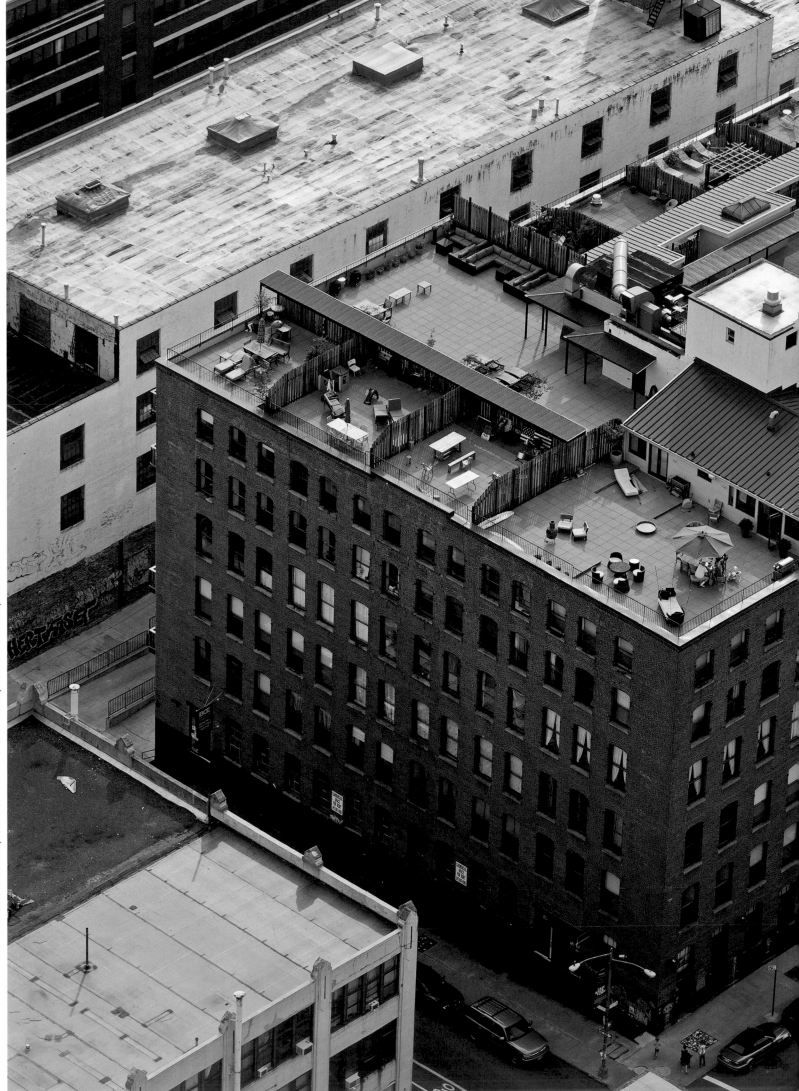

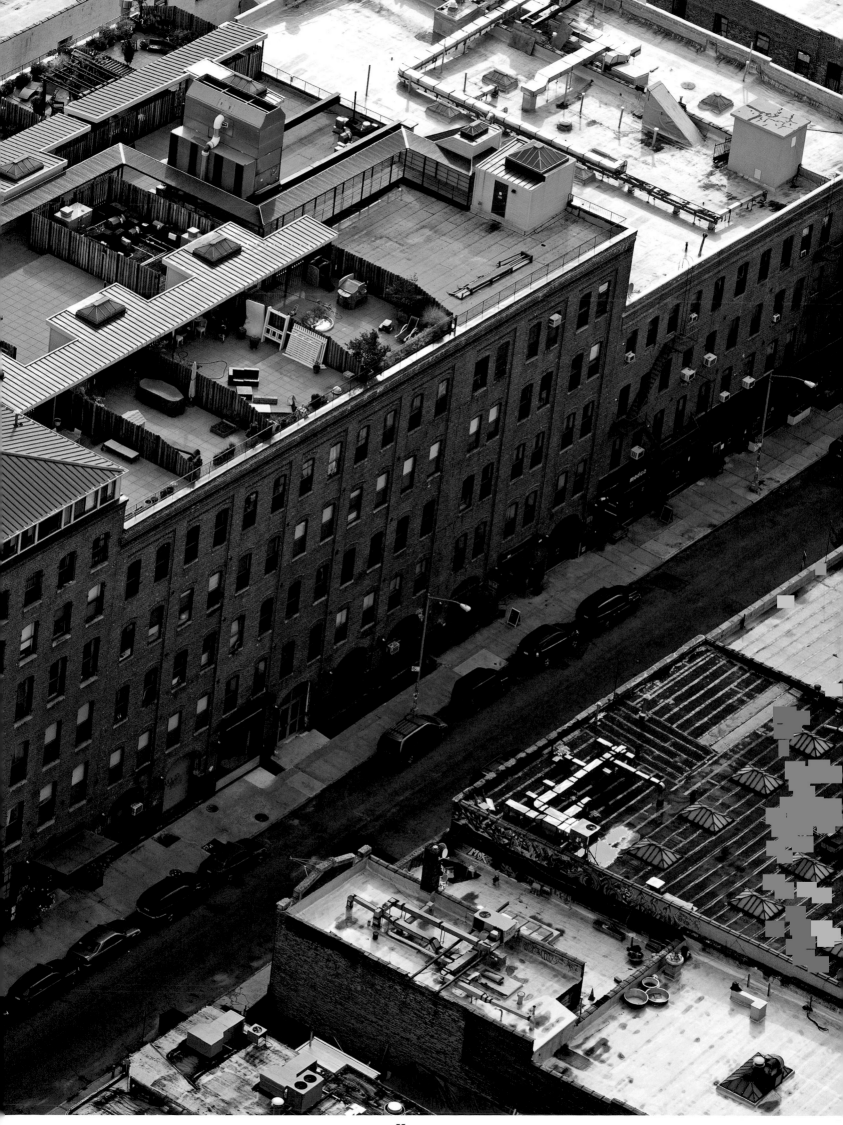

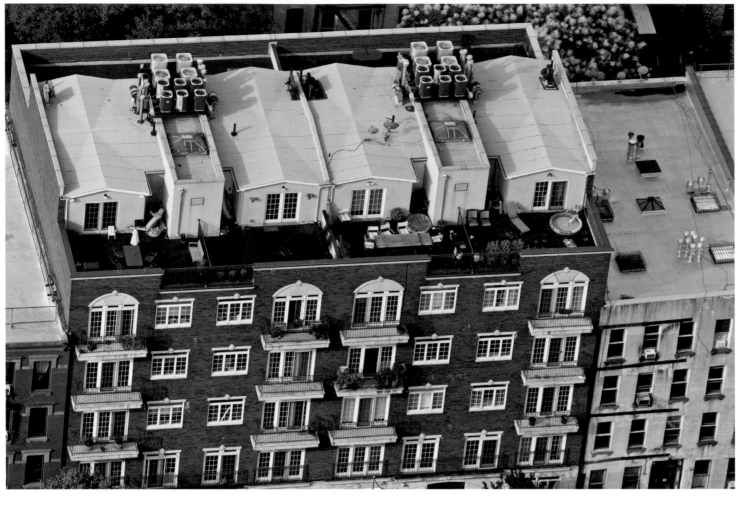

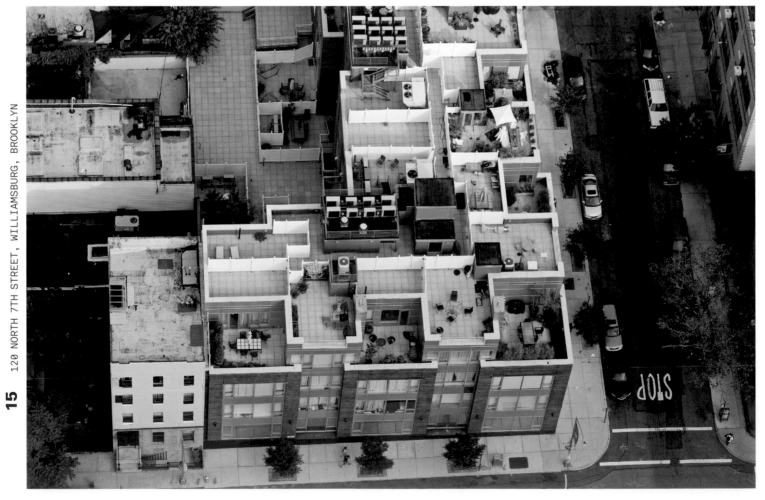

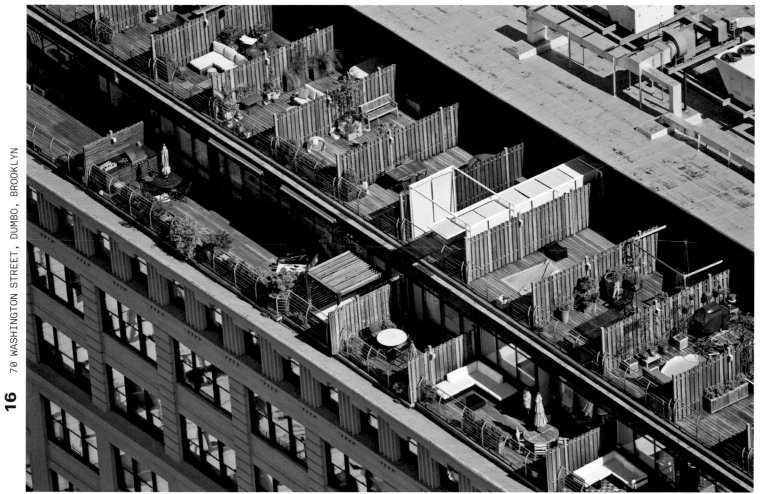

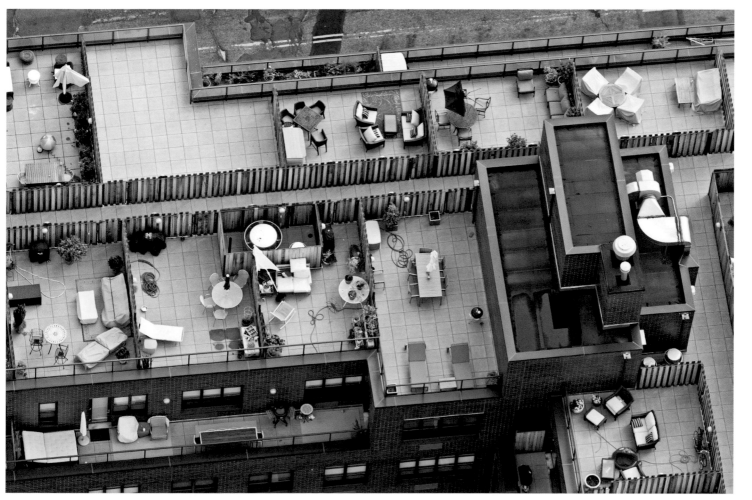

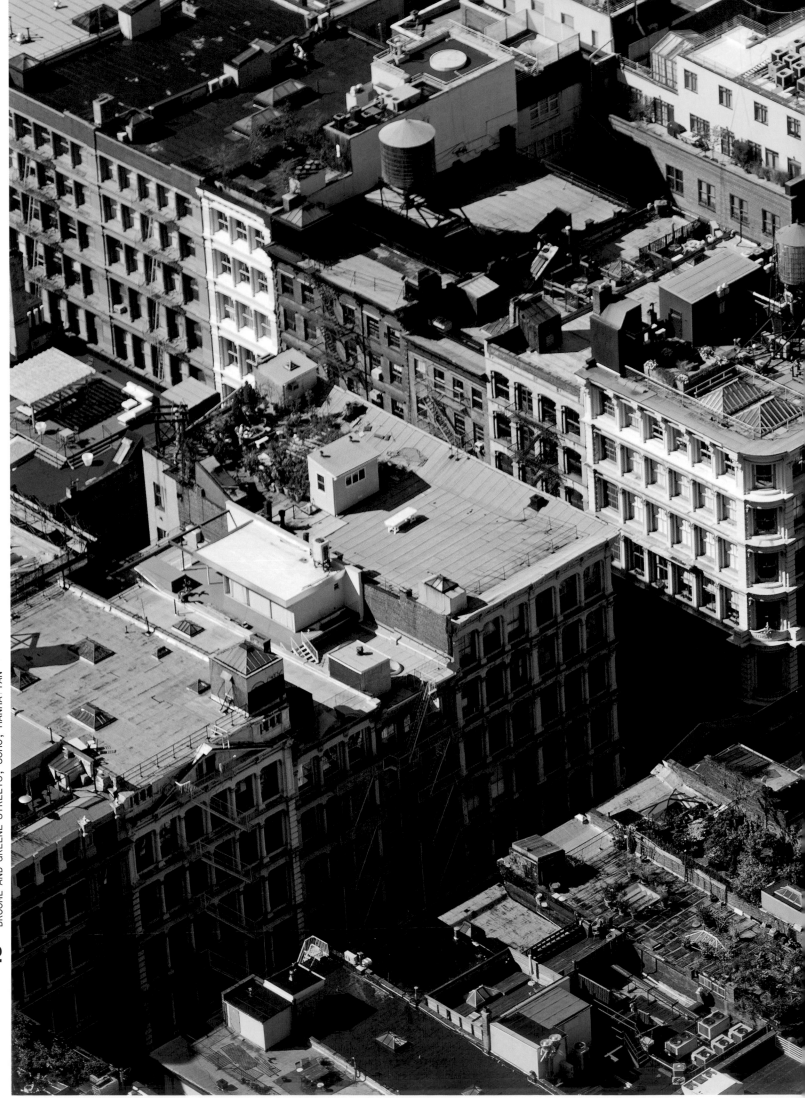

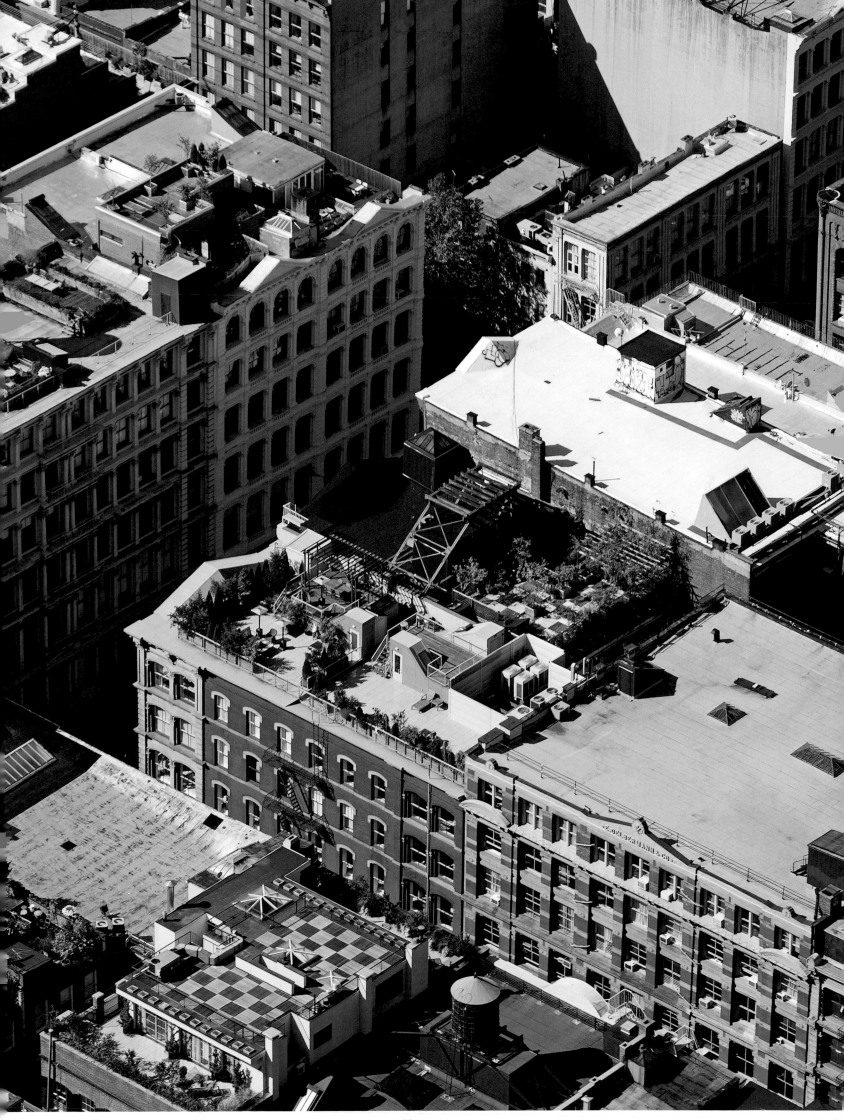

Places of Rest

The aerial view of New York City changes dramatically as one descends in altitude. The mosaic of city blocks defined by streets morphs into blocks composed of individual buildings, and eventually individual features on each building's rooftop become recognizable.

City rooftops seem to be filled predominantly with mechanical systems. They are loaded with compressors and fans for heating and cooling; pipes and ducts zigzag over much of the surface; and larger buildings feature the classic barrel tanks that ensure water pressure in case of fire.

In the midst of all this mechanical equipment, planned gardens of green trees and plants catch the eye, forming miniature oases perched high under open sky. These gardens, which tend to have a less chaotic appearance than multiuse spaces, could be characterized as "places of rest."

Tranquil garden terraces often are located on the upper floors of older buildings. Sometimes they are organized in a stepped design to achieve maximum sun exposure for tenants and for the streets below. These terraces, most commonly found on the Upper East and Upper West Sides, look and feel as though they belong to a bygone era; their mature vegetation appears sedate and formal. The furnishings and personal accessories, although minimal, add a functional elegance, and the manicured plantings suggest professional care. The views from these terraces extend across the green canopy and lawns of Central Park, providing a relaxing departure from the busy city.

On a far more modest scale, and perhaps more interesting, are the individual rooftop gardens on the flat roofs of brownstones, walkups, and manufacturing and warehouse buildings that have been converted to lofts. These spaces have a more homemade and spontaneous aesthetic, creatively adapting to the individual constraints of each roof with its preexisting mechanical systems, headhouses, and skylights.

Rooftop additions—in the form of either stand-alone penthouses or extensions added to existing apartments—offer a completely different model for how outdoor and indoor space can work together. It is interesting to note that these additions often have nothing to do stylistically with the buildings they rest upon, and often are made of prefabricated materials.

Places of rest can also be found on the shared roof spaces and terraces of large commercial and residential buildings. These large spaces have quiet seating areas or distinct outdoor rooms defined by plantings and furnishings. In contemporary architecture, these spaces often can be quite stark, with a minimalist design that matches the building's overall aesthetic.

All of these elevated places of rest offer a needed antidote to the accelerated pace of city life and provide a setting for personal reflection and a connection to the natural world.

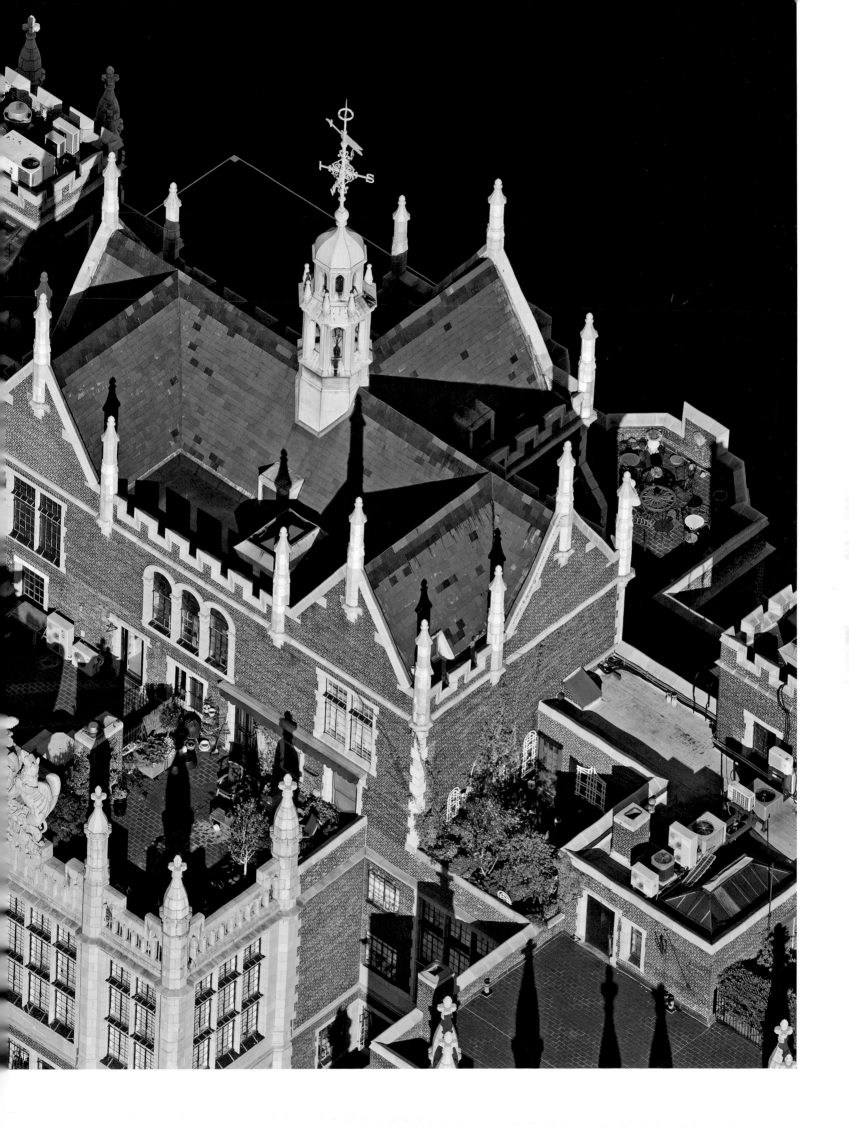

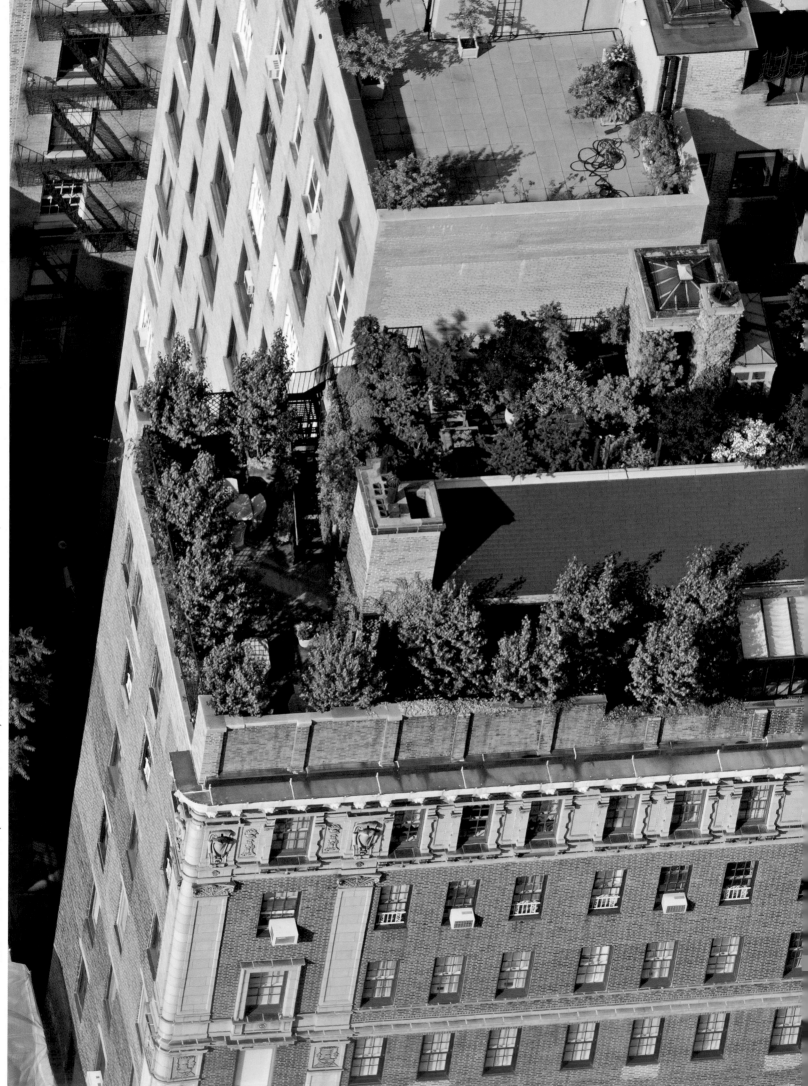

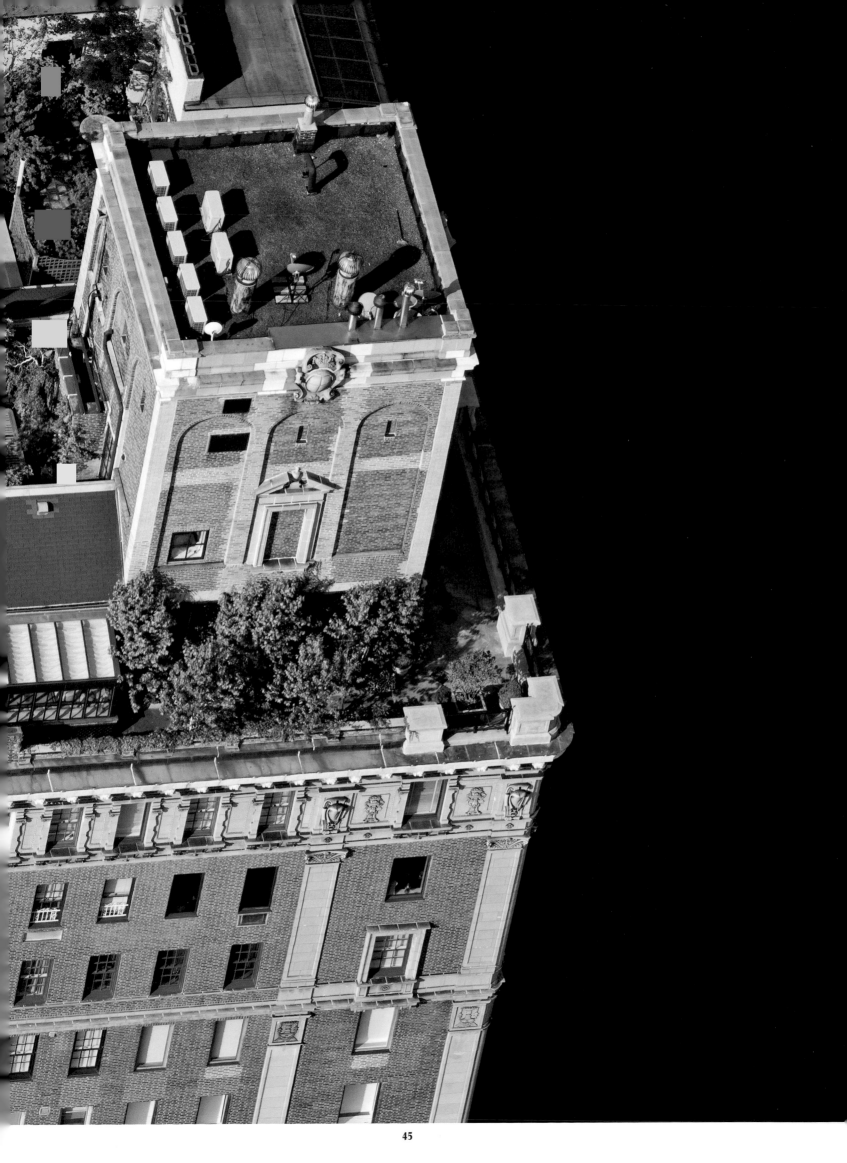

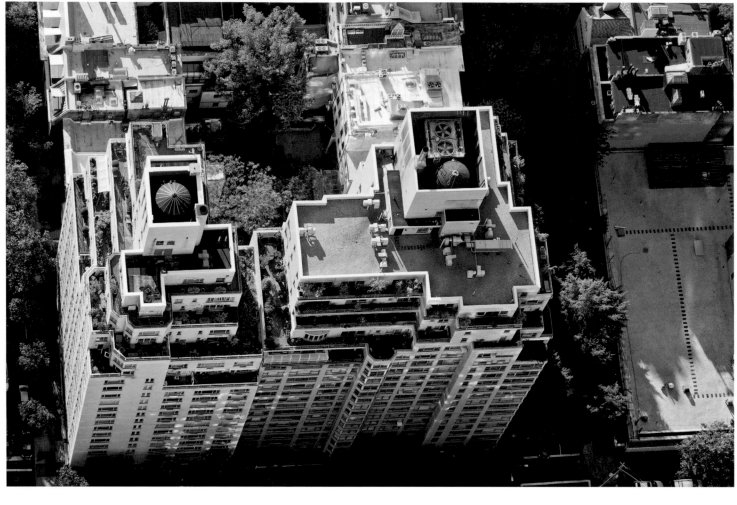

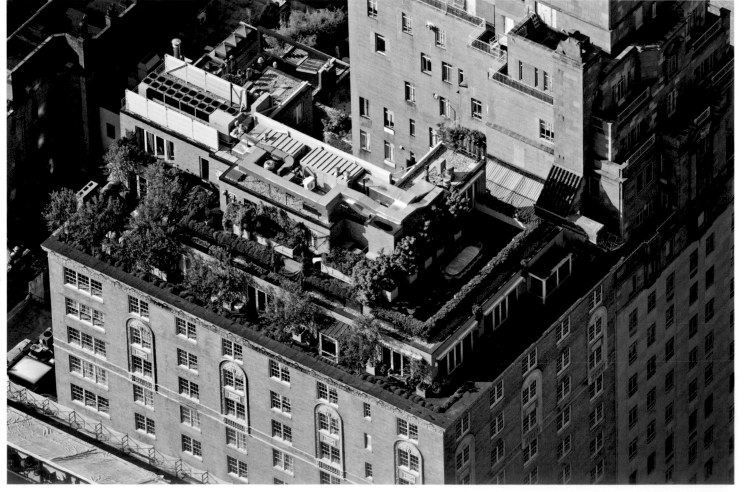

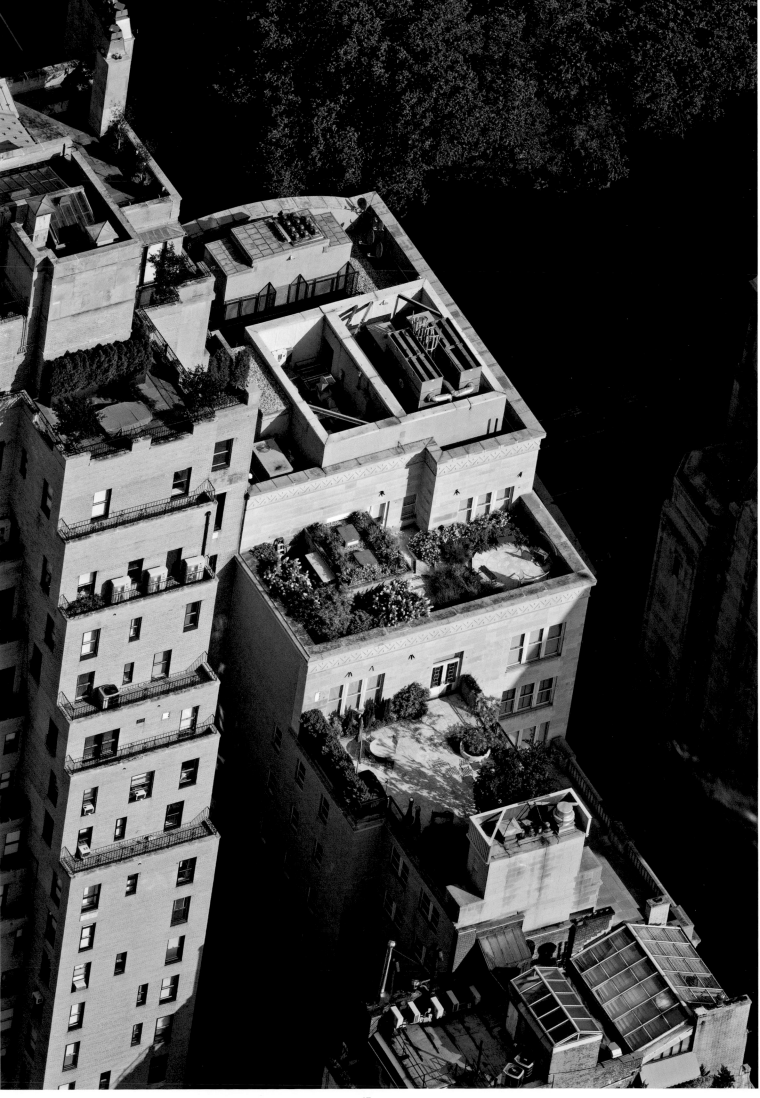

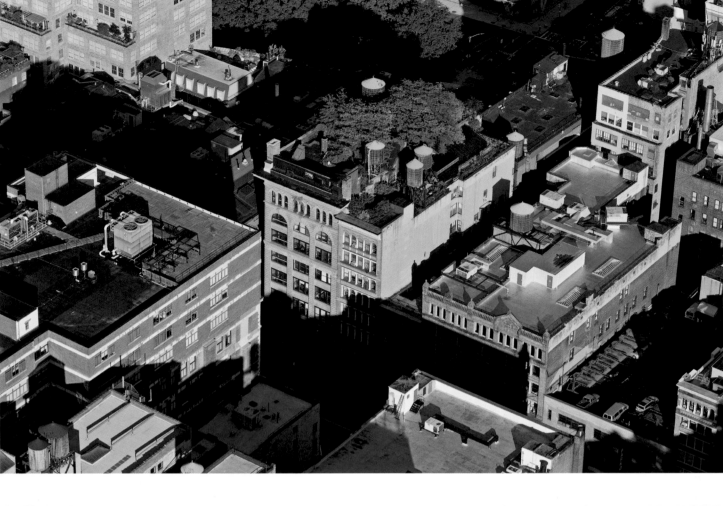

25 417–419 LAFAYETTE STREET, NOHO, MANHATTAN

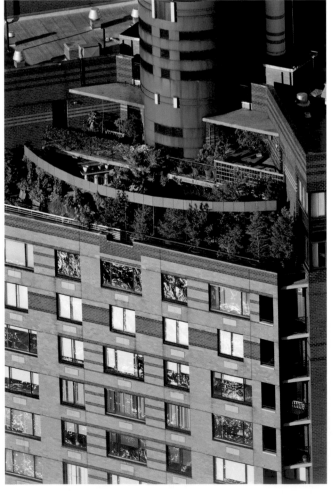

26 377 RECTOR PLACE, BATTERY PARK CITY, MANHATTAN

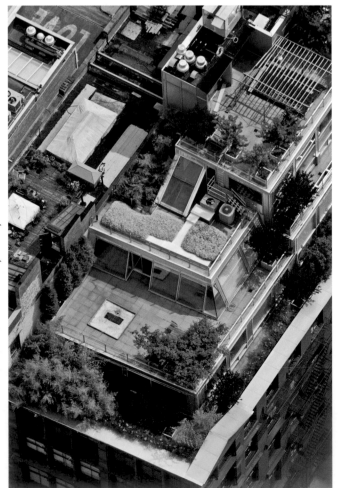

27 3925 CROSBY STREET, SOHO, MANHATTAN

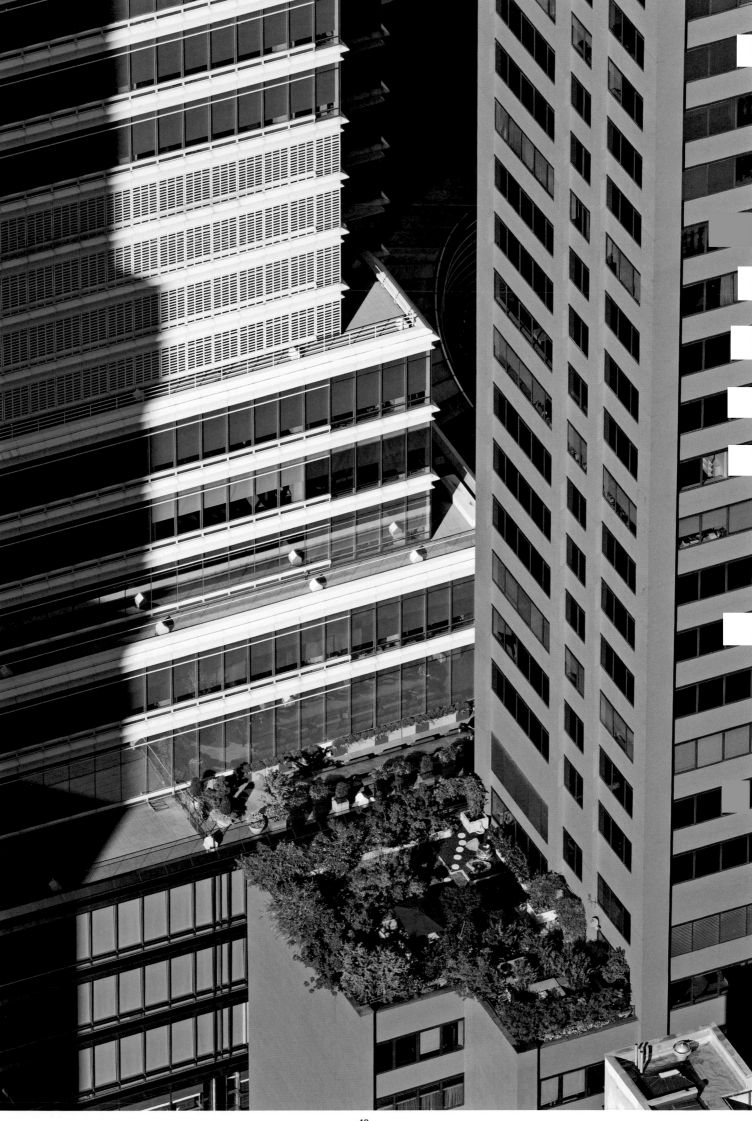

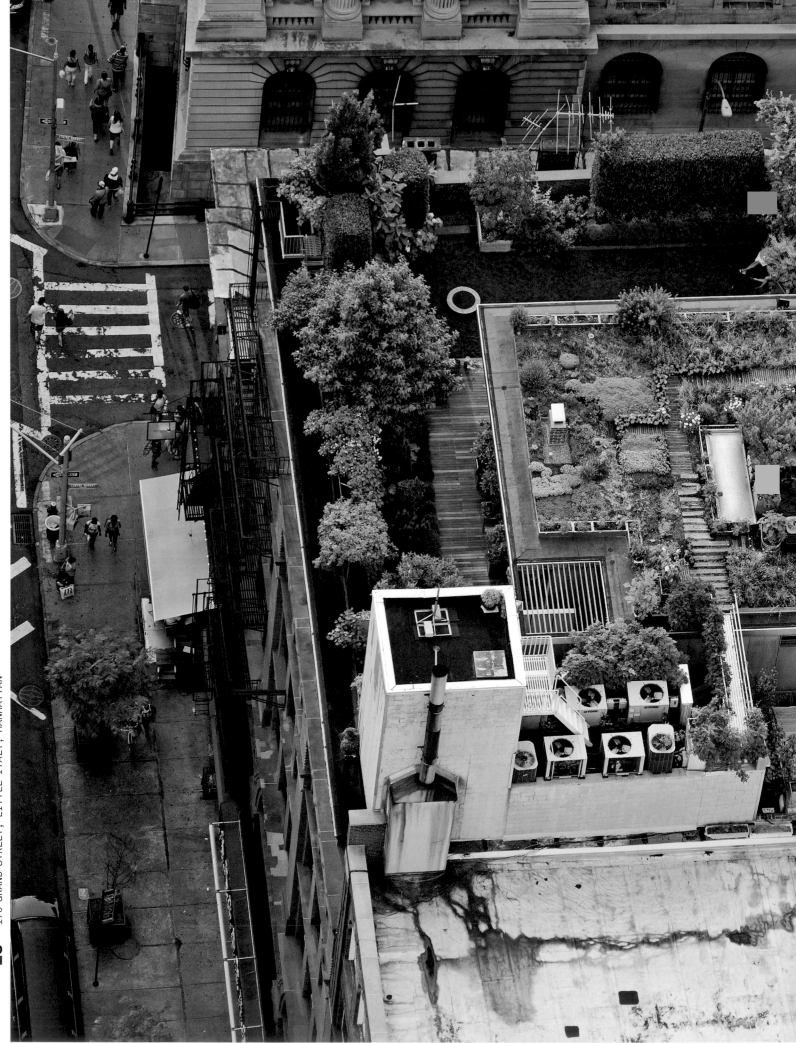

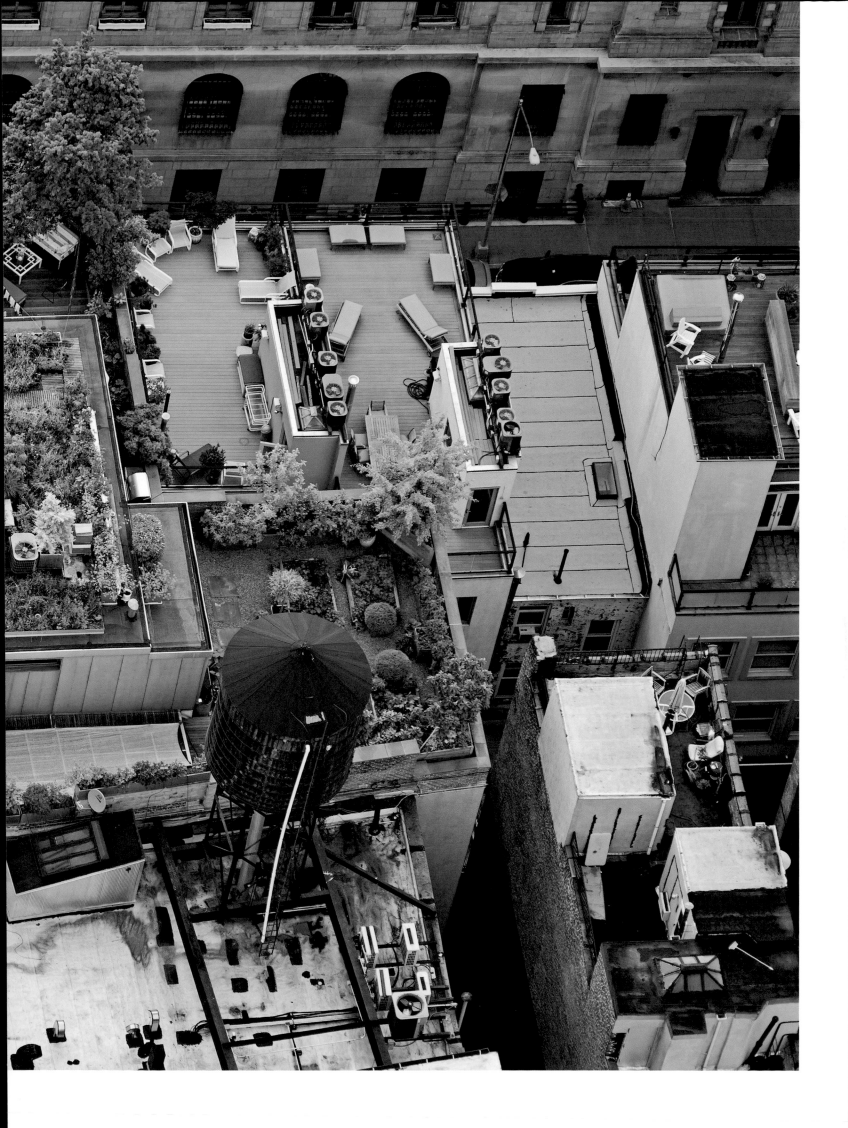

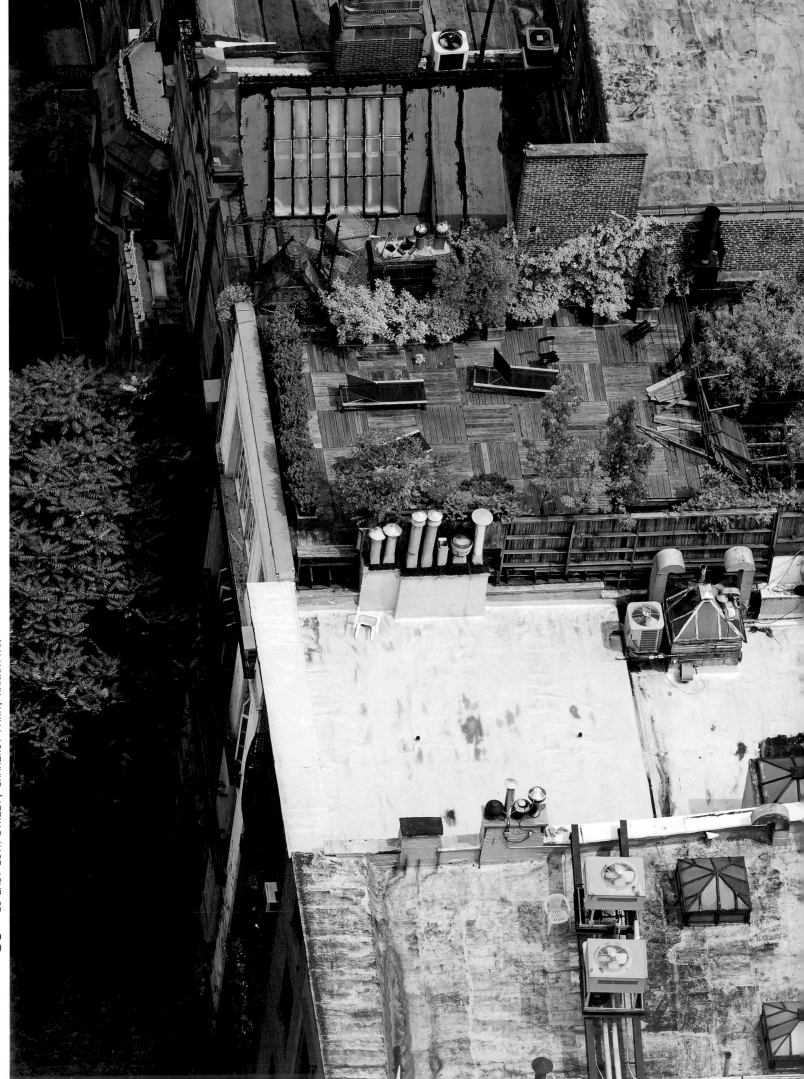

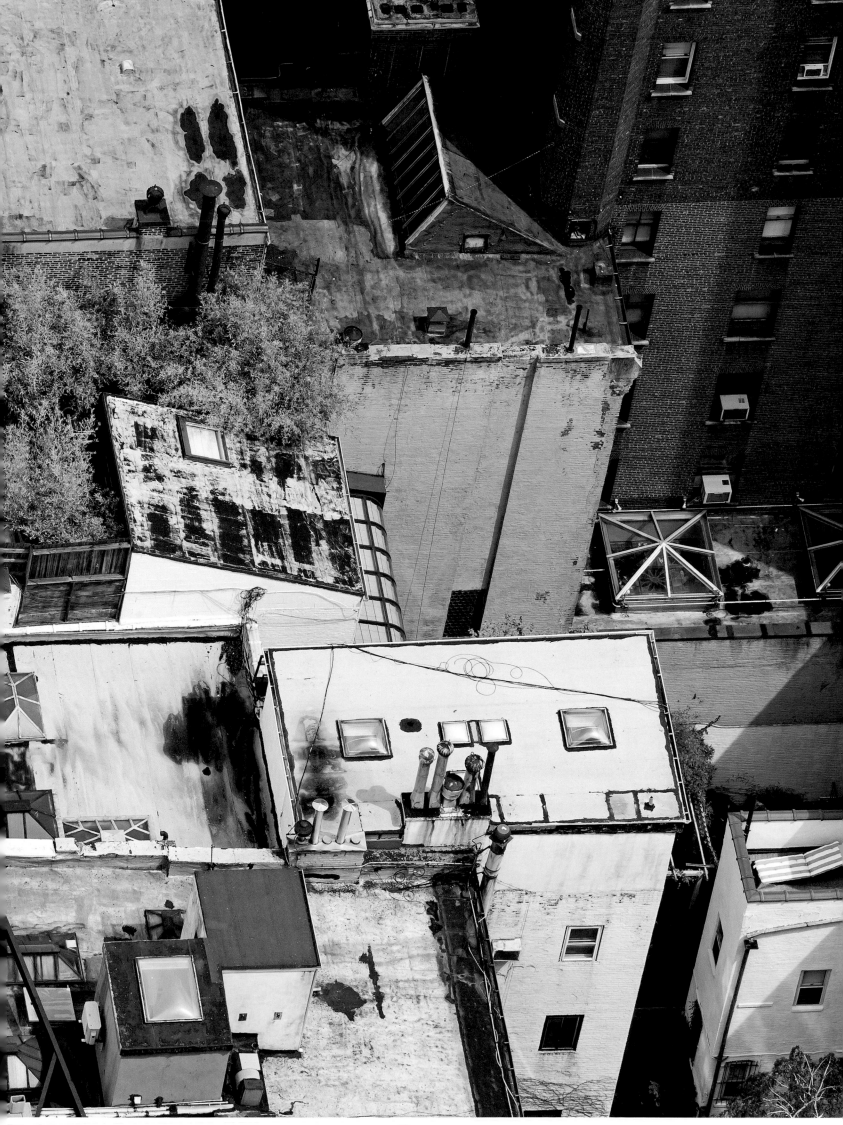

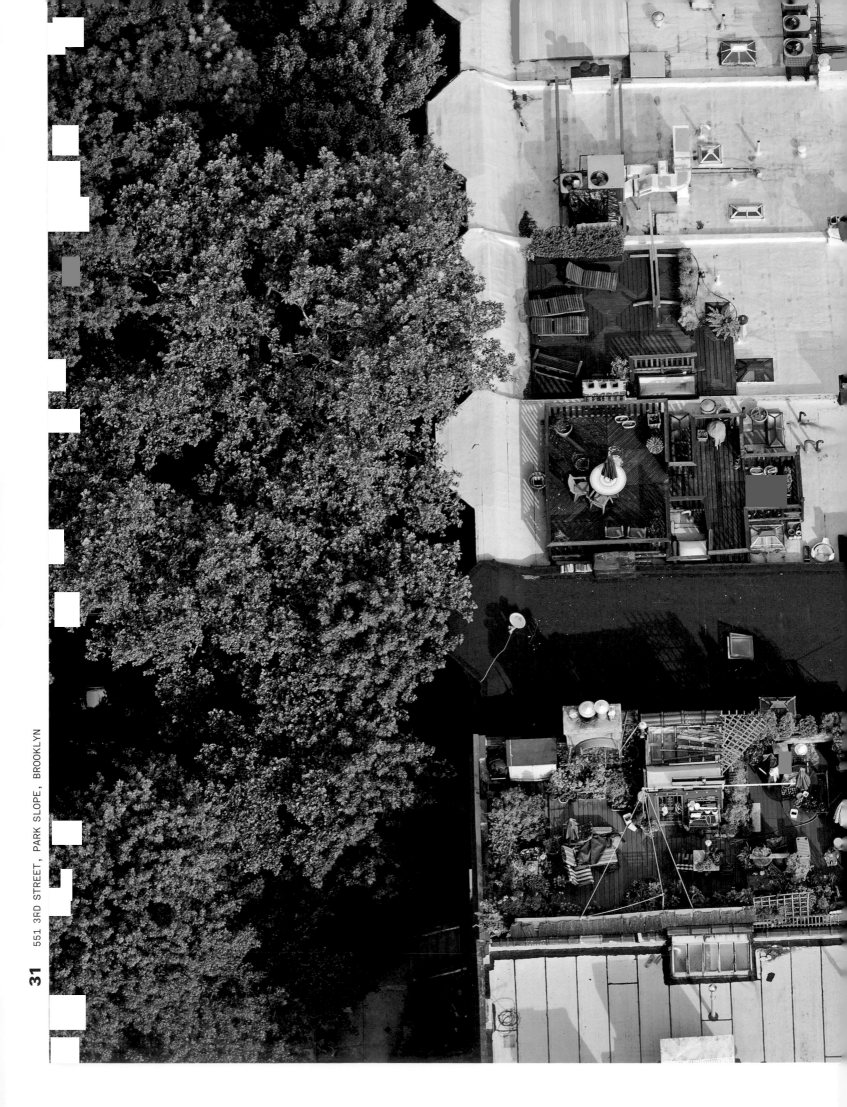

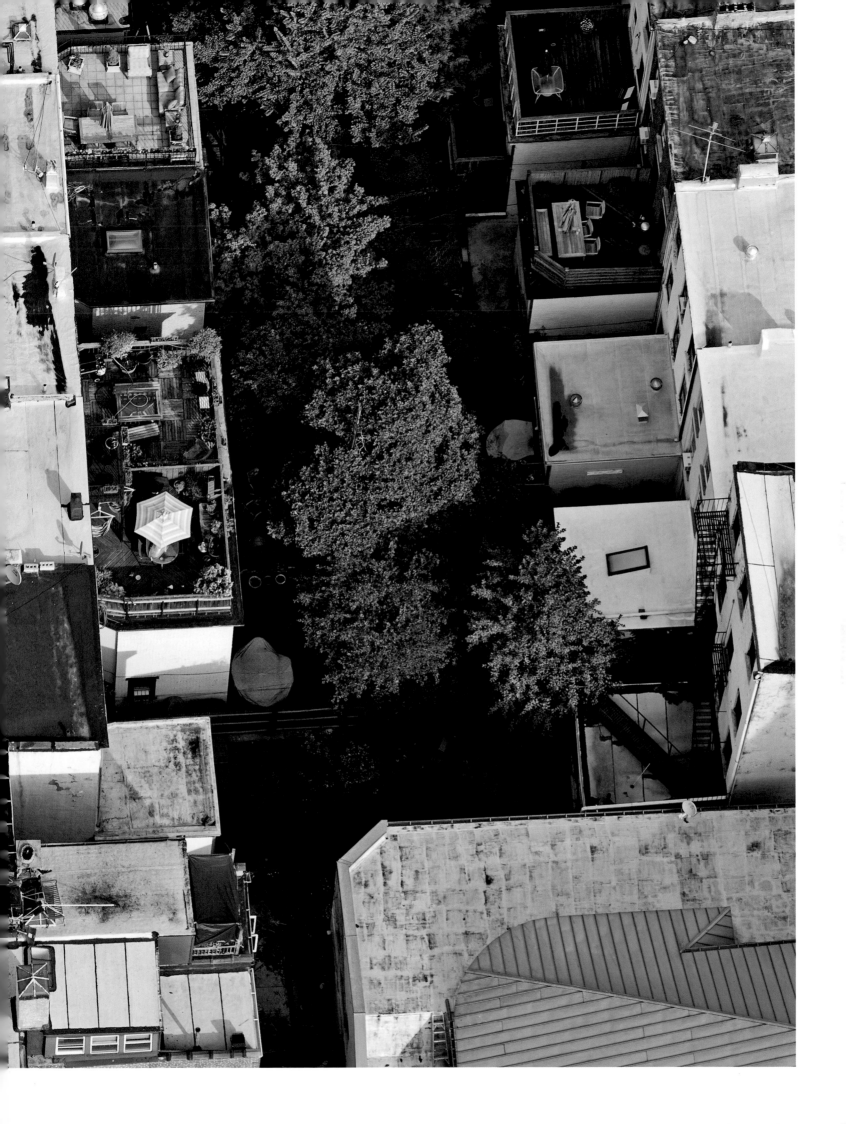

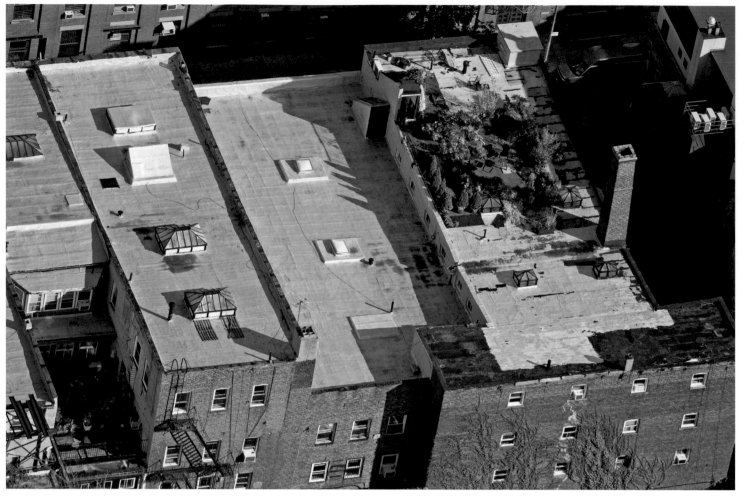

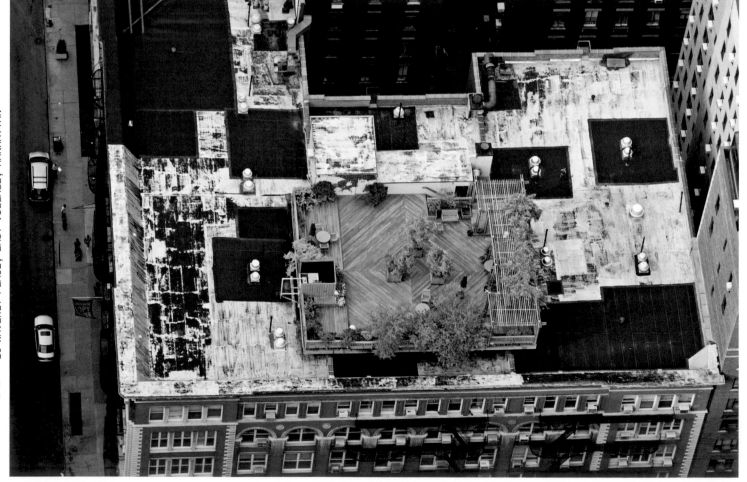

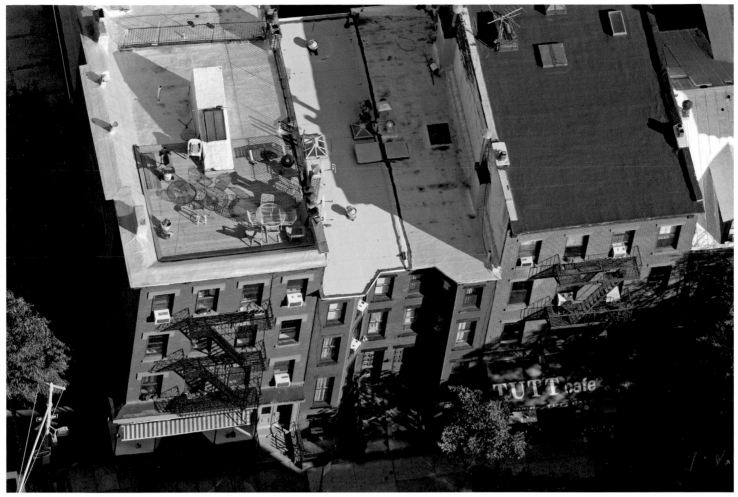

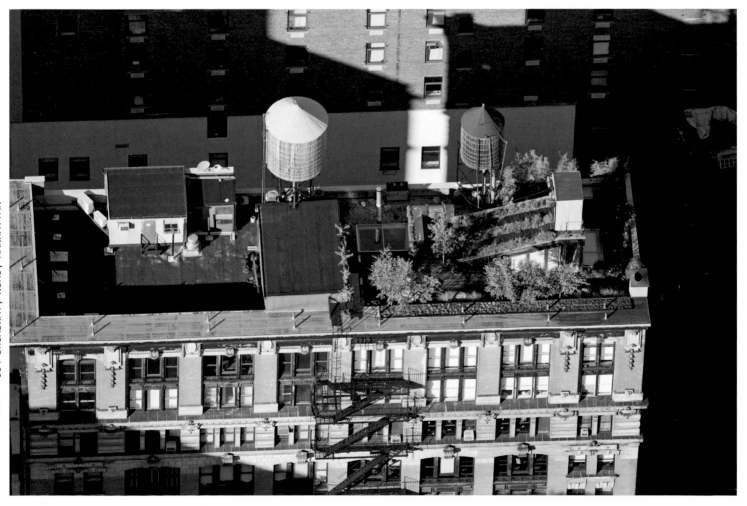

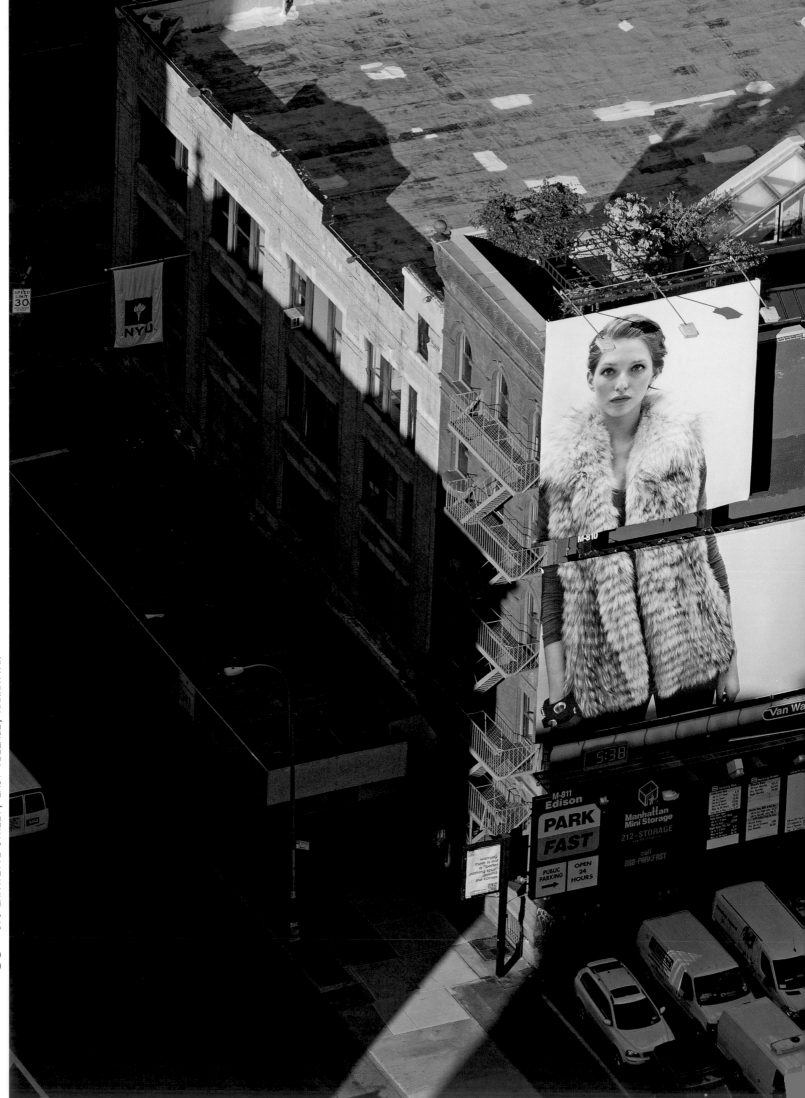

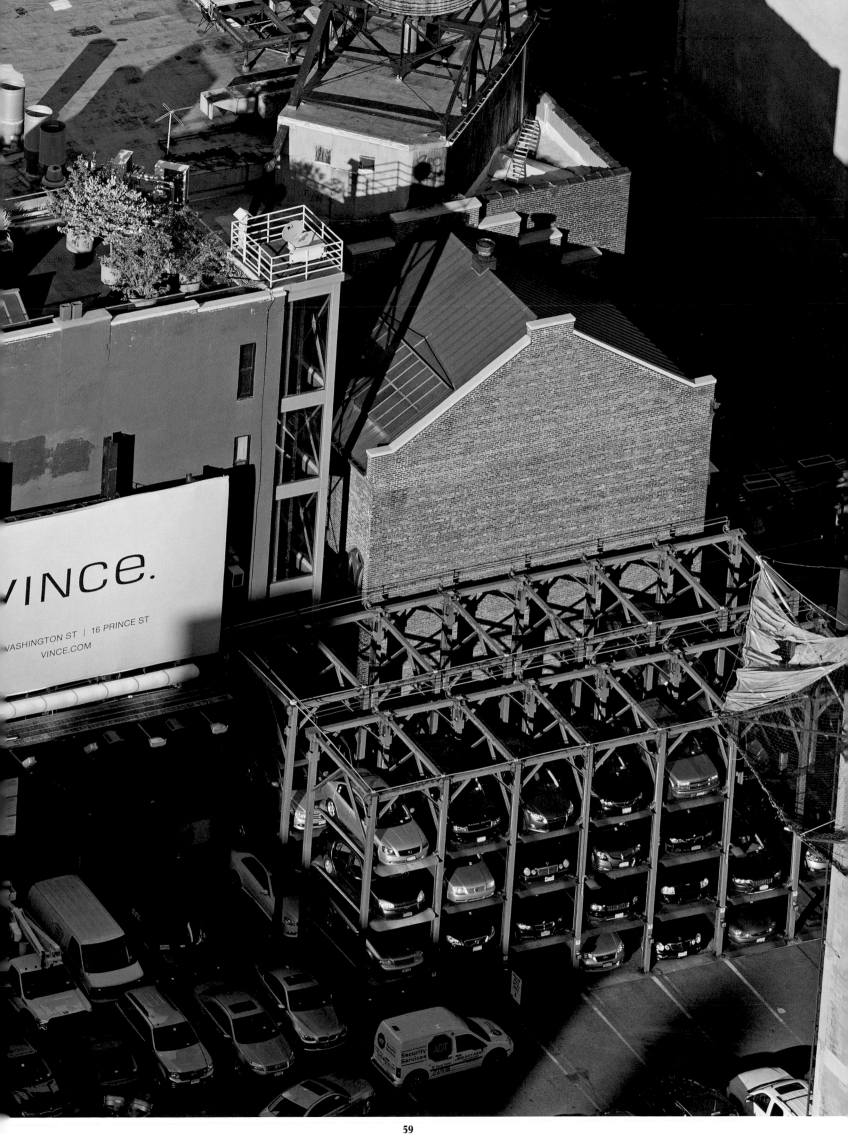

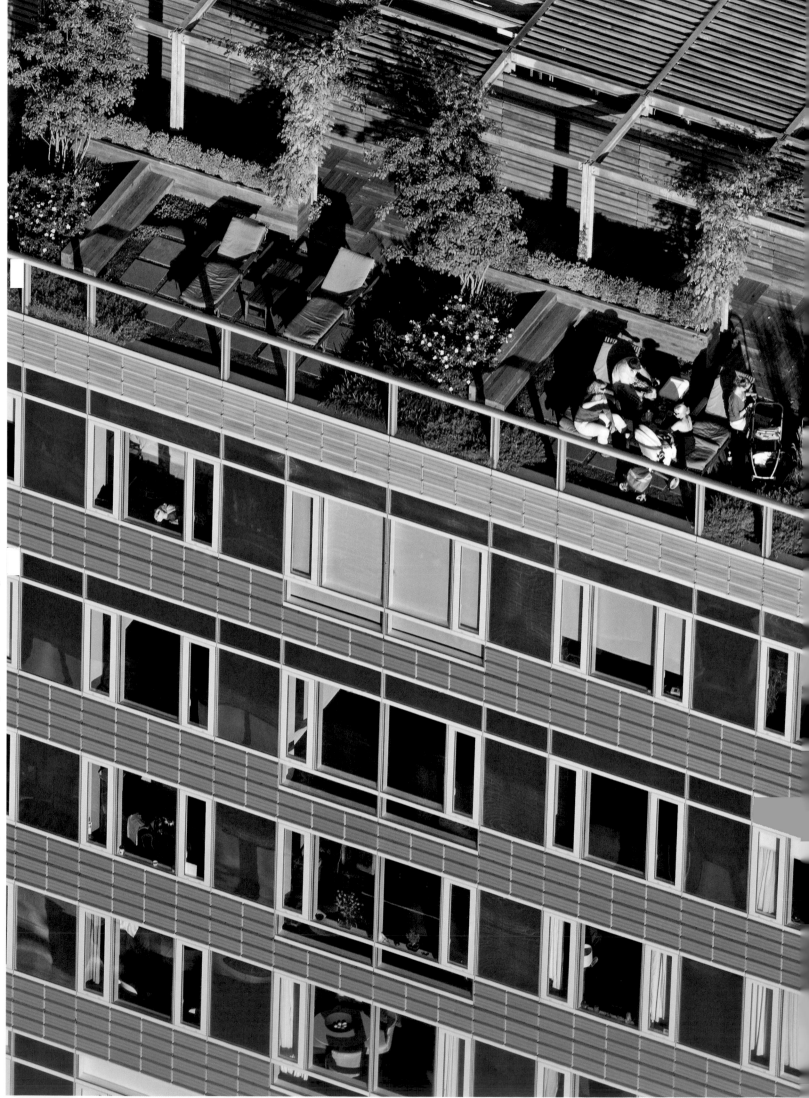

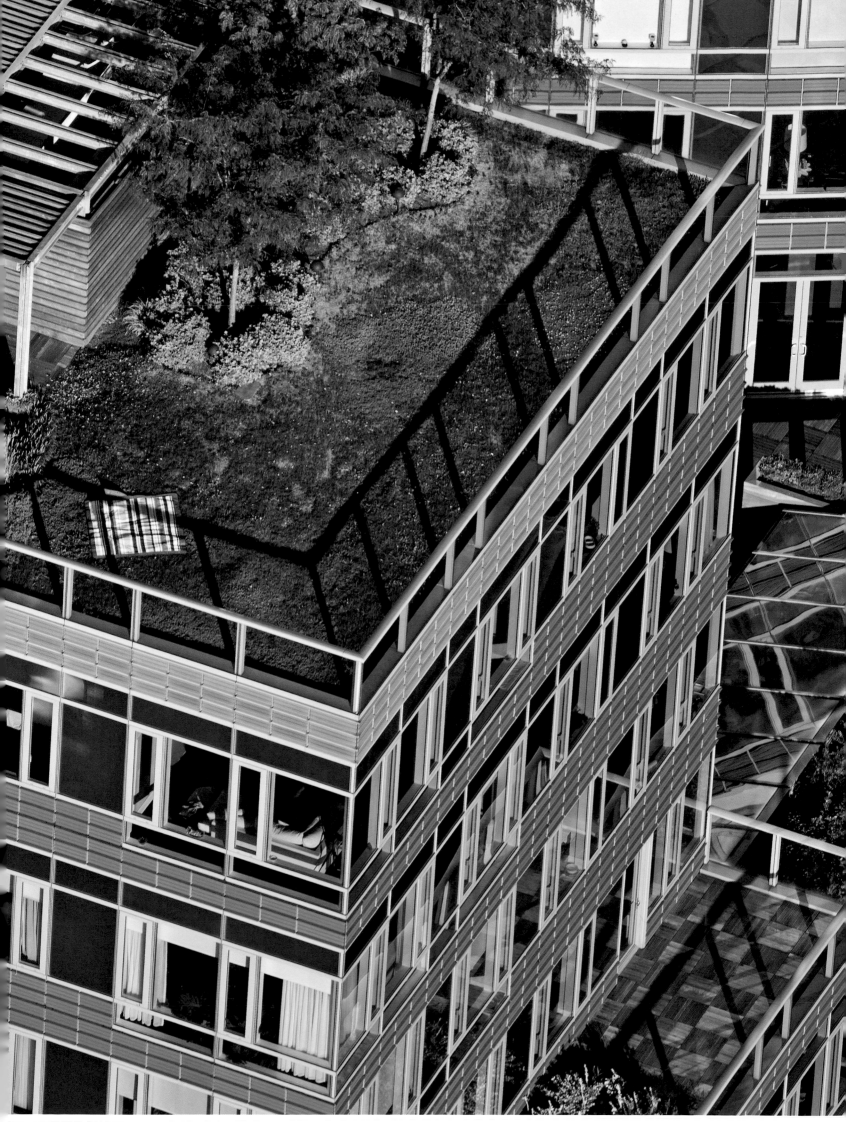

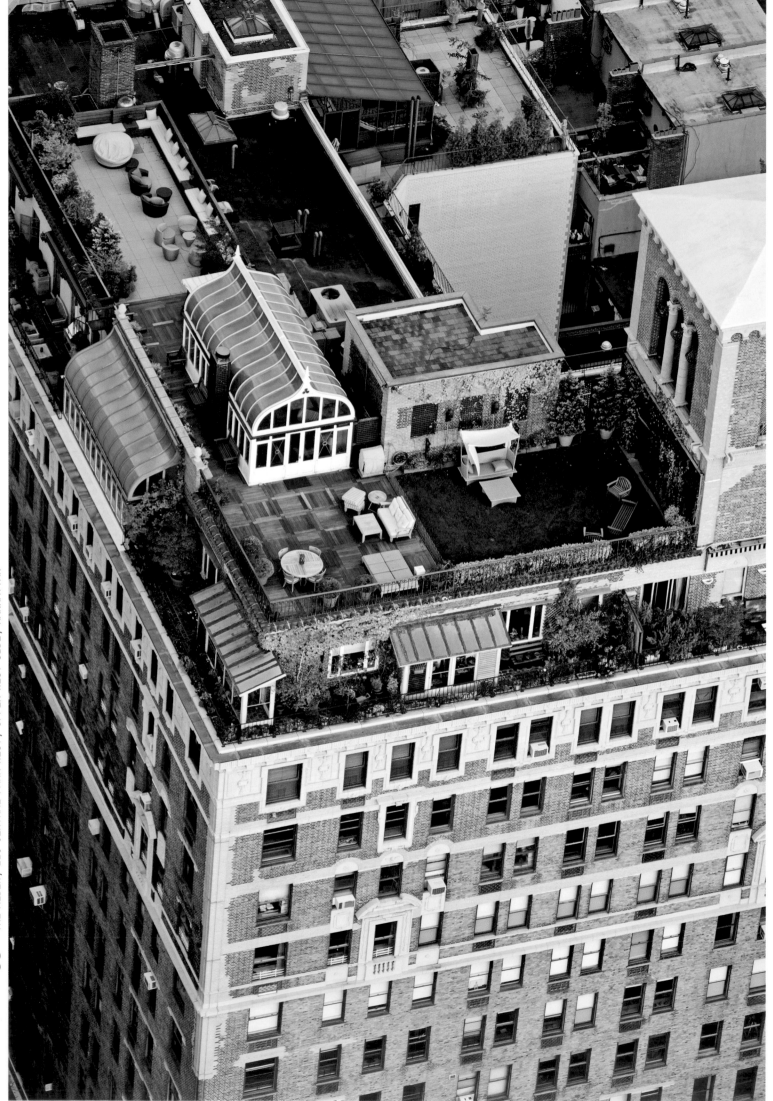

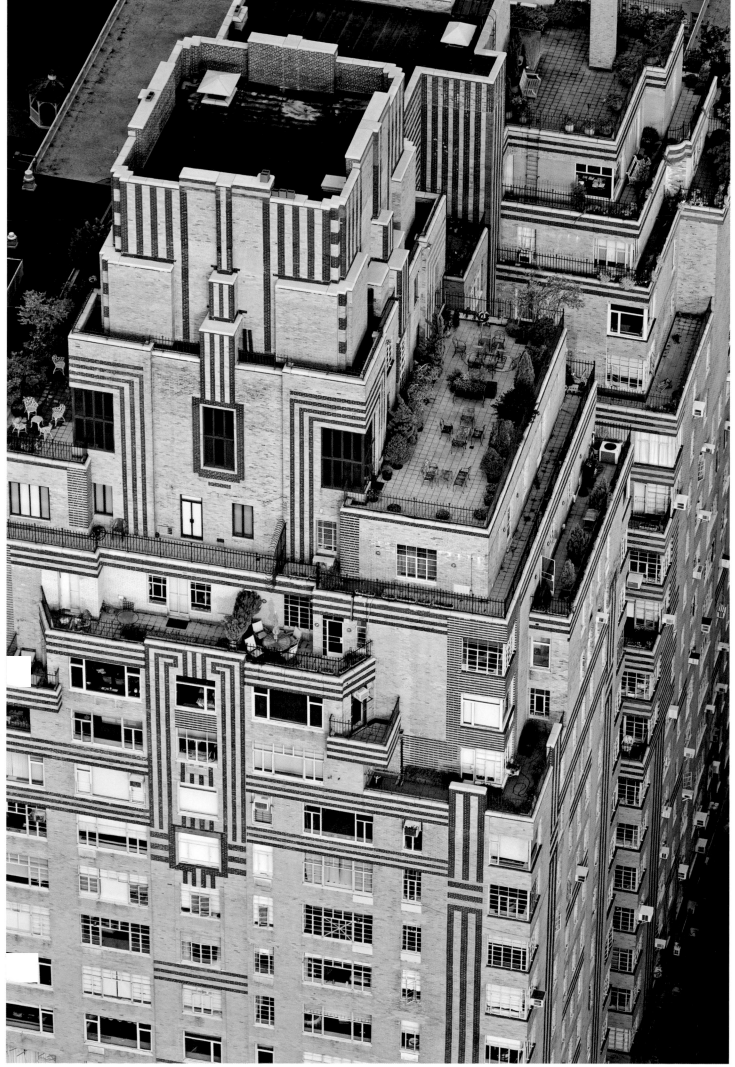

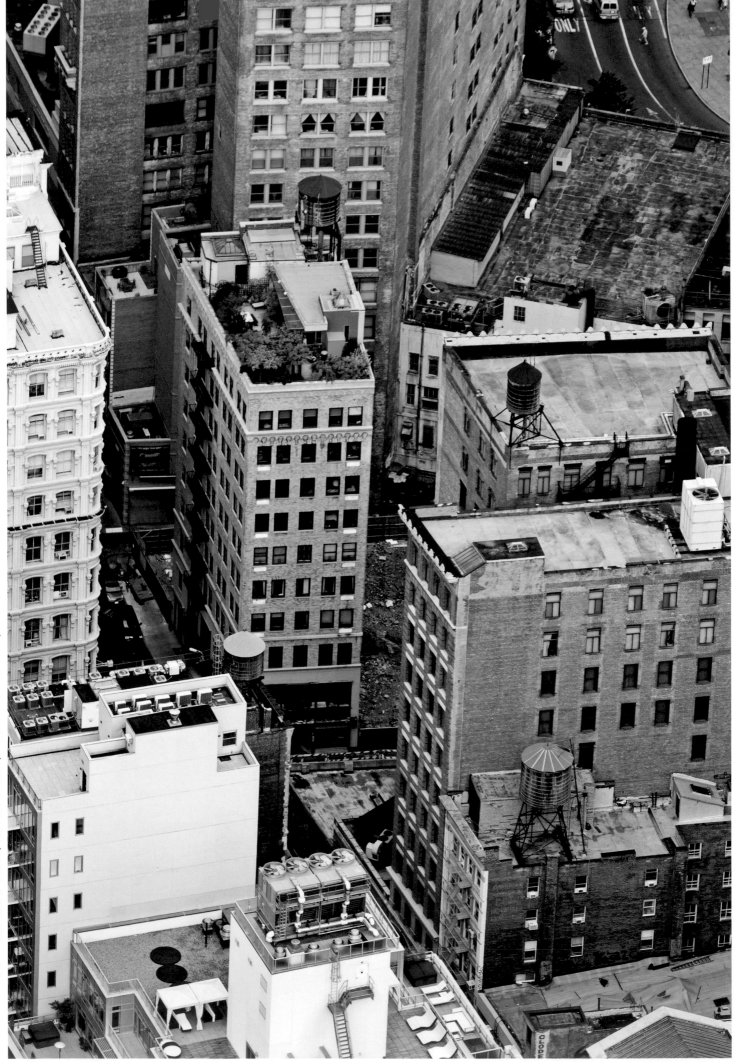

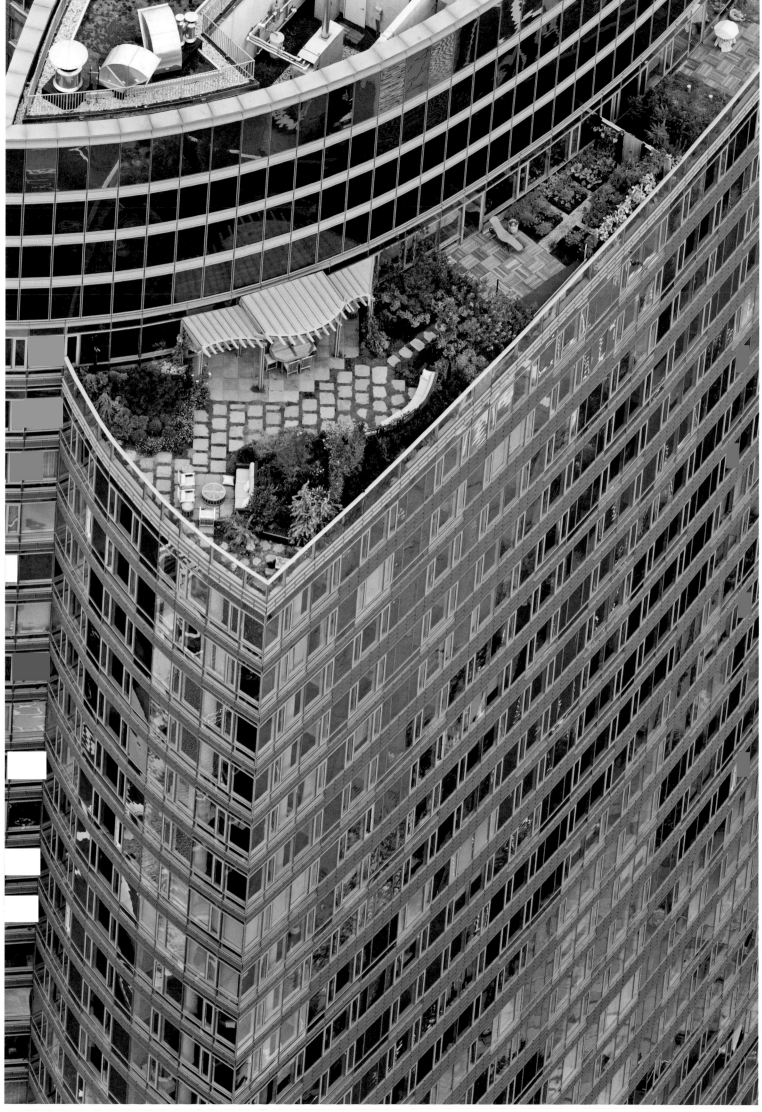

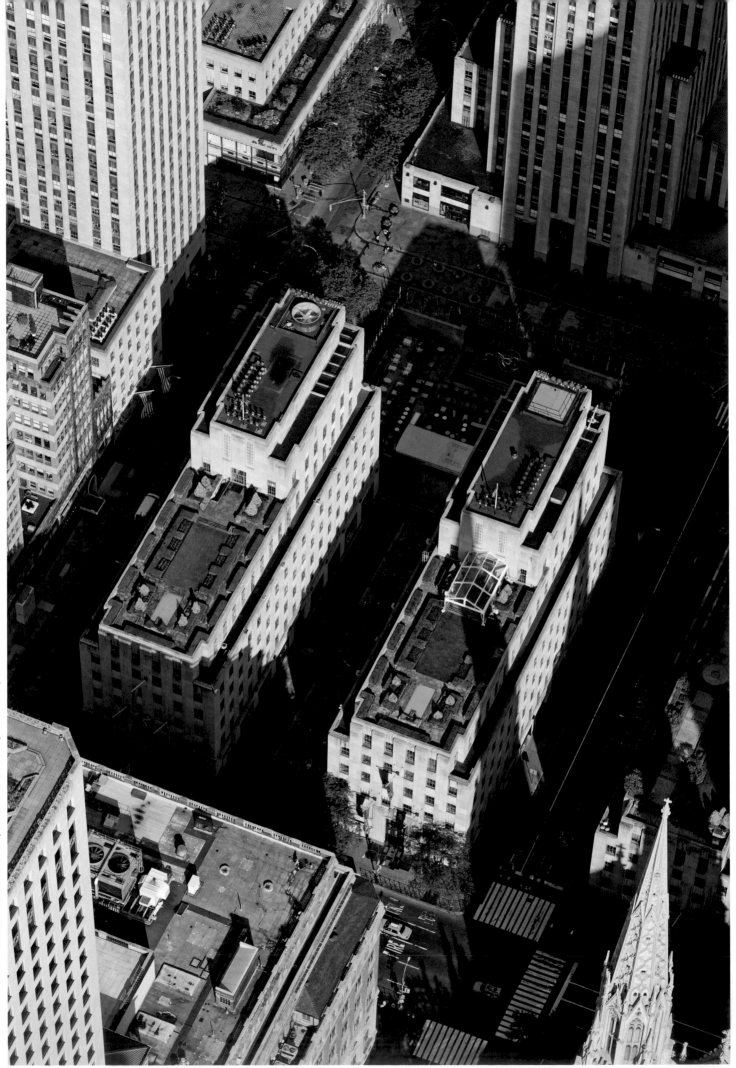

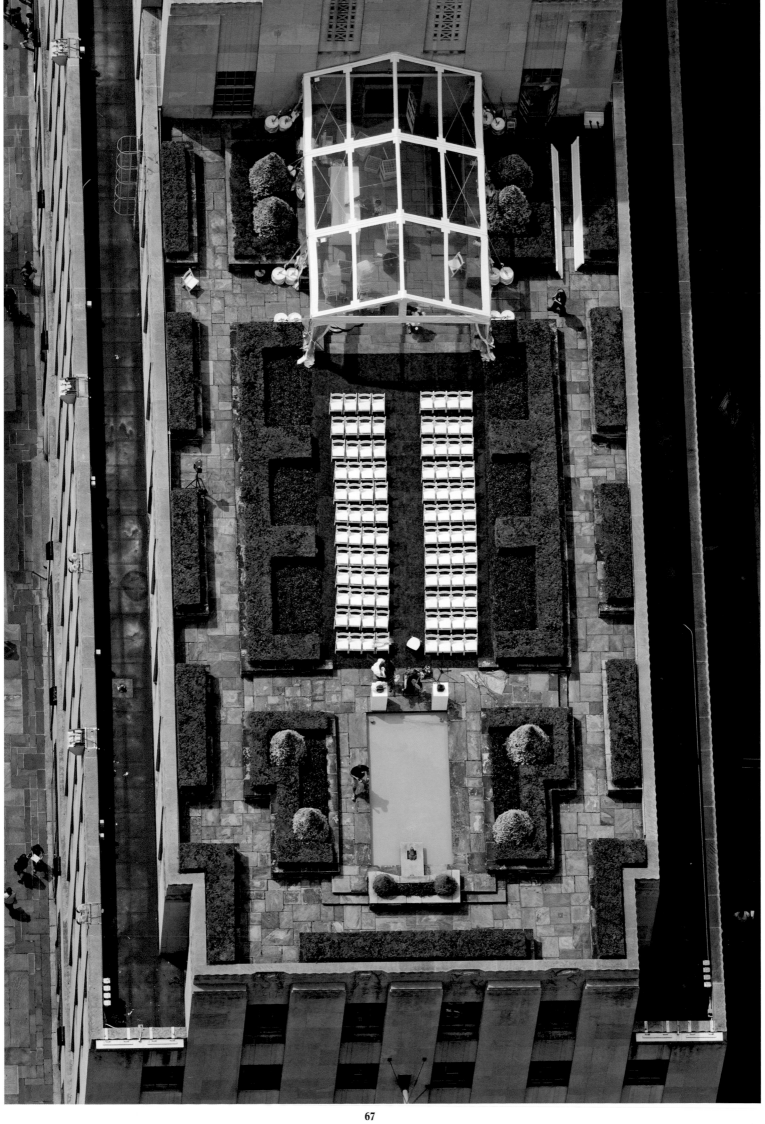

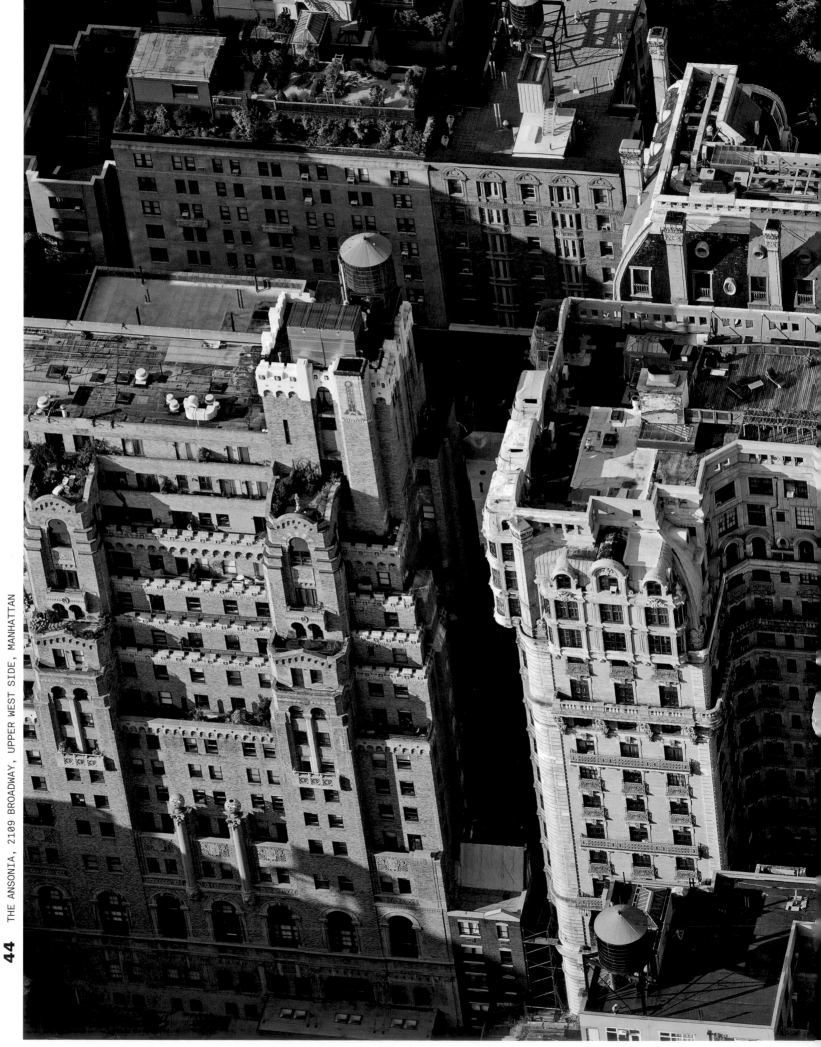

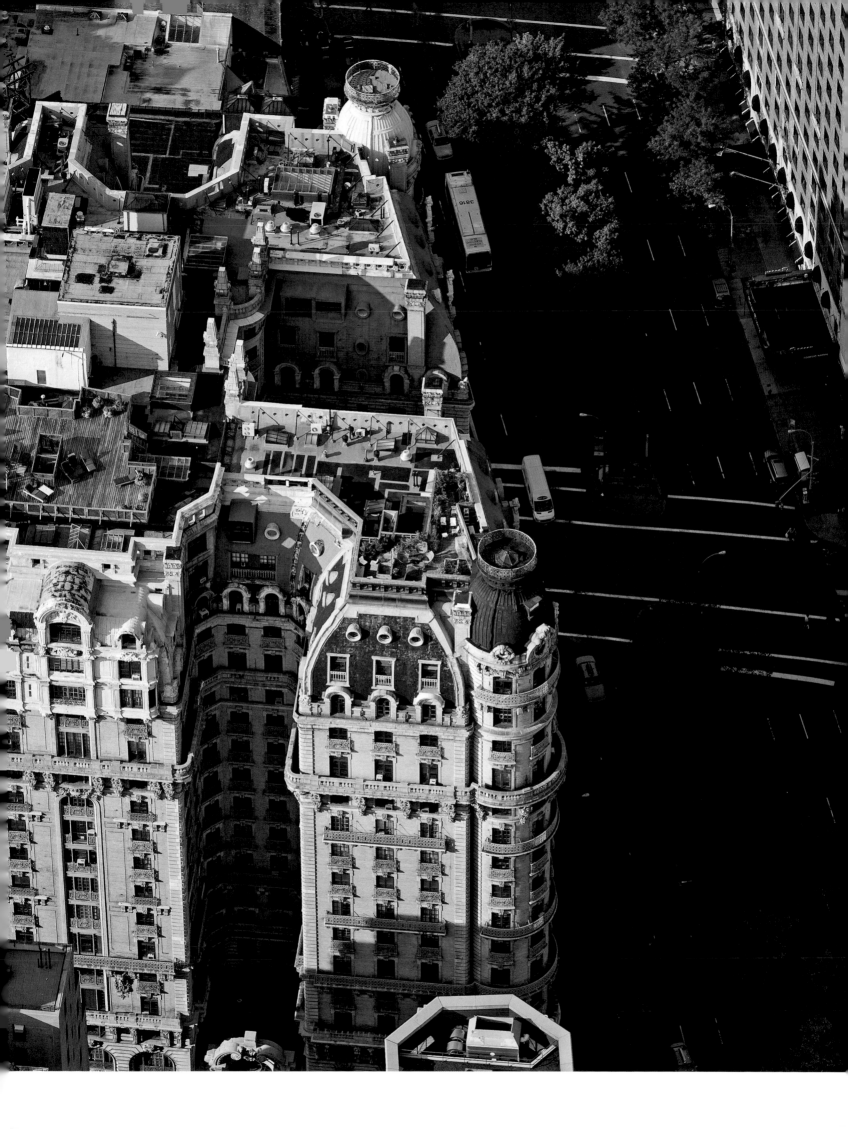

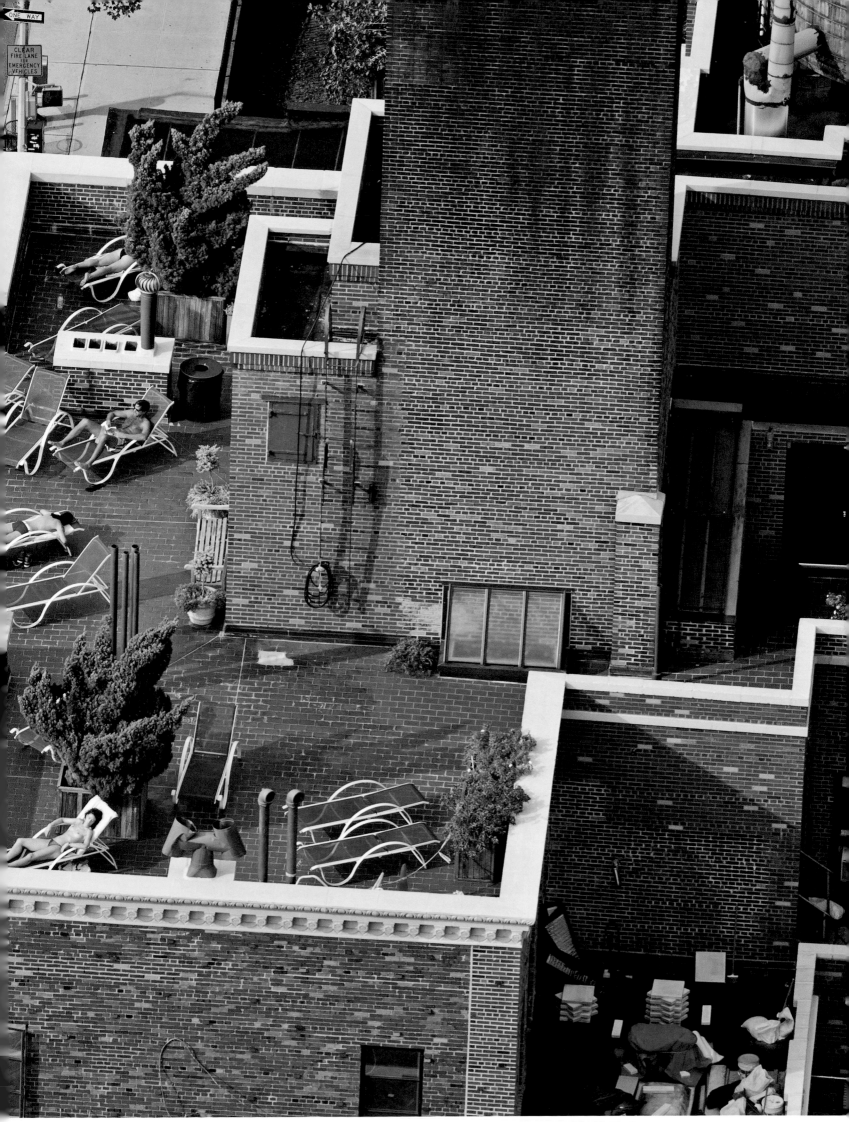

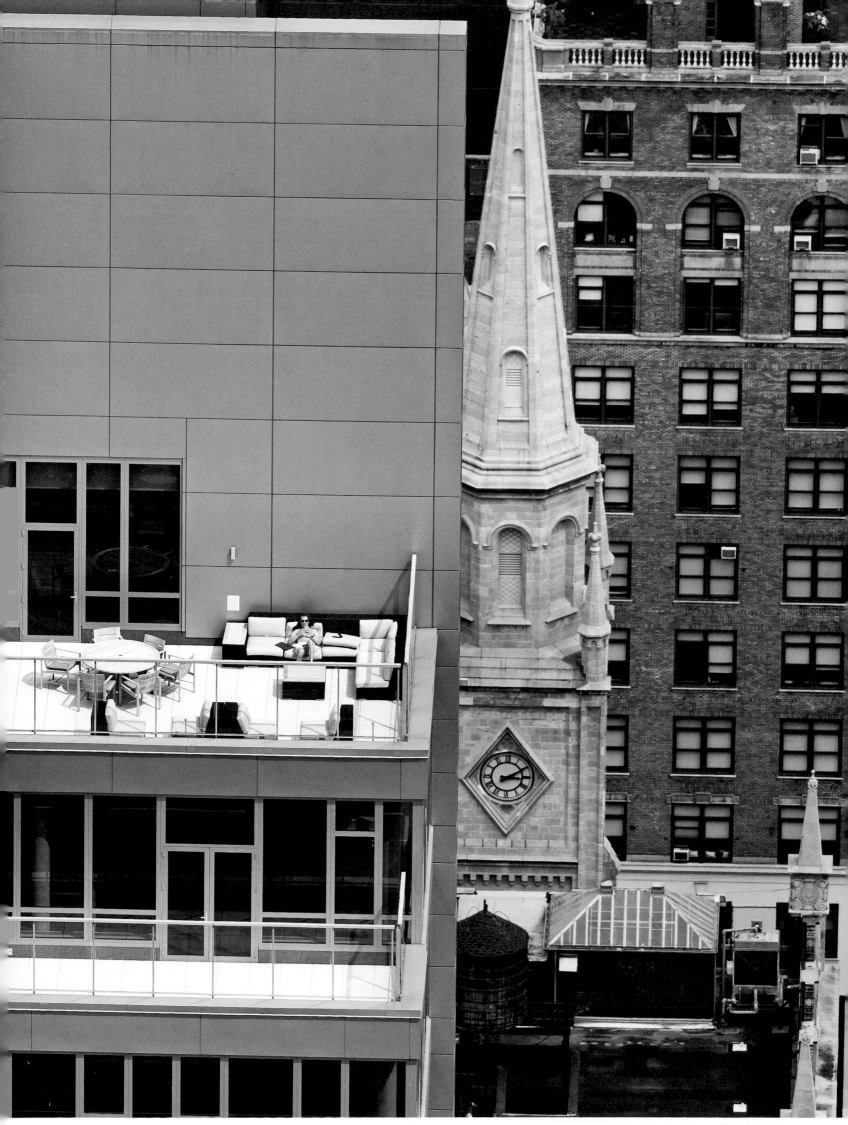

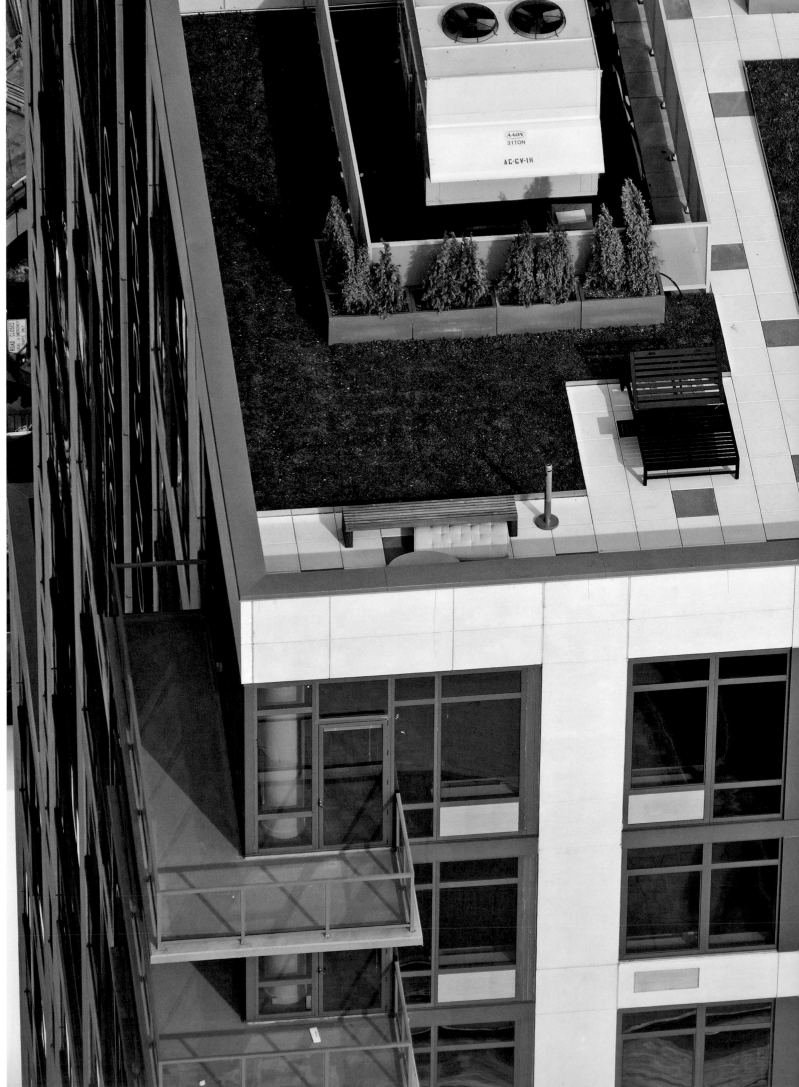

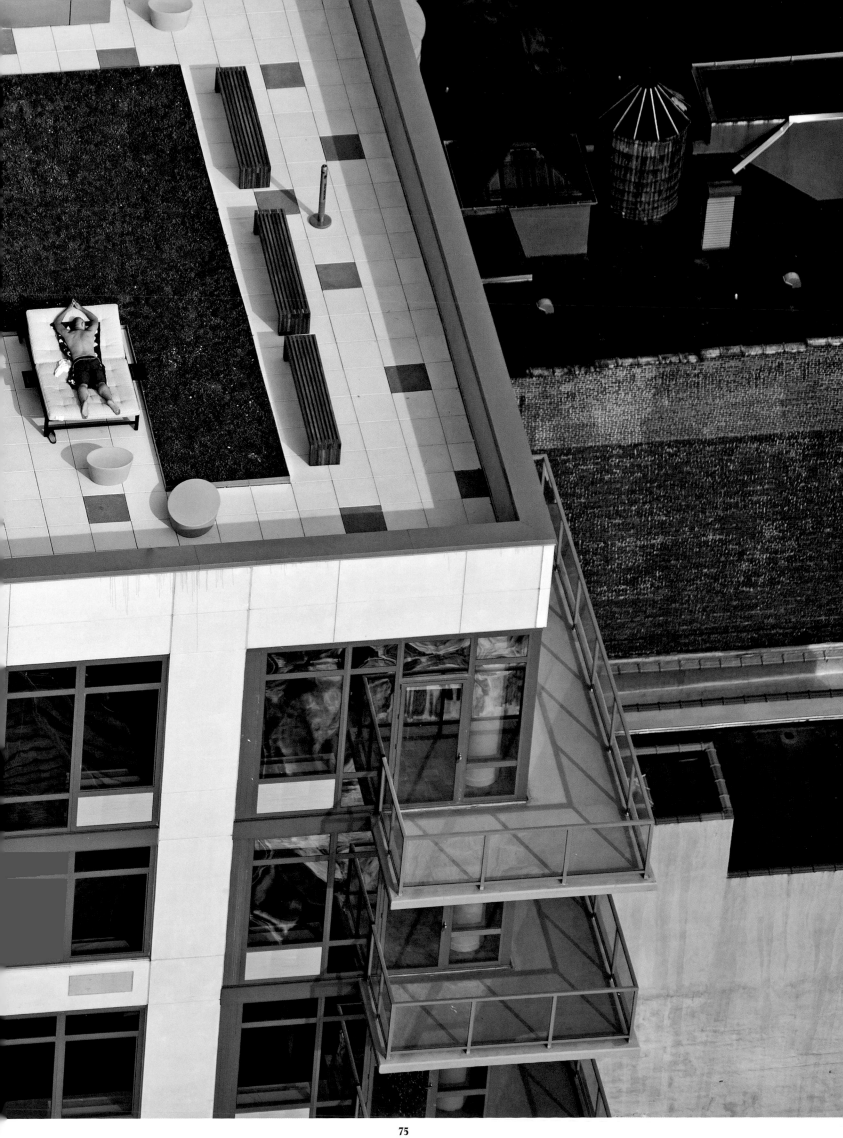

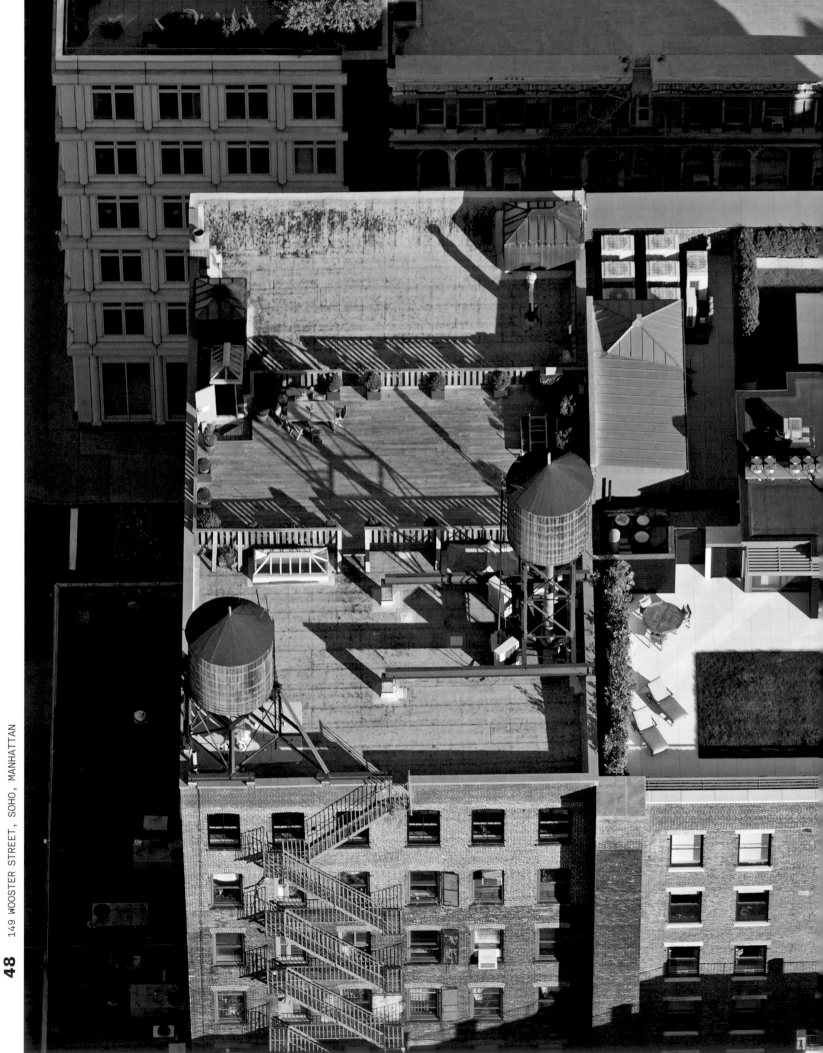

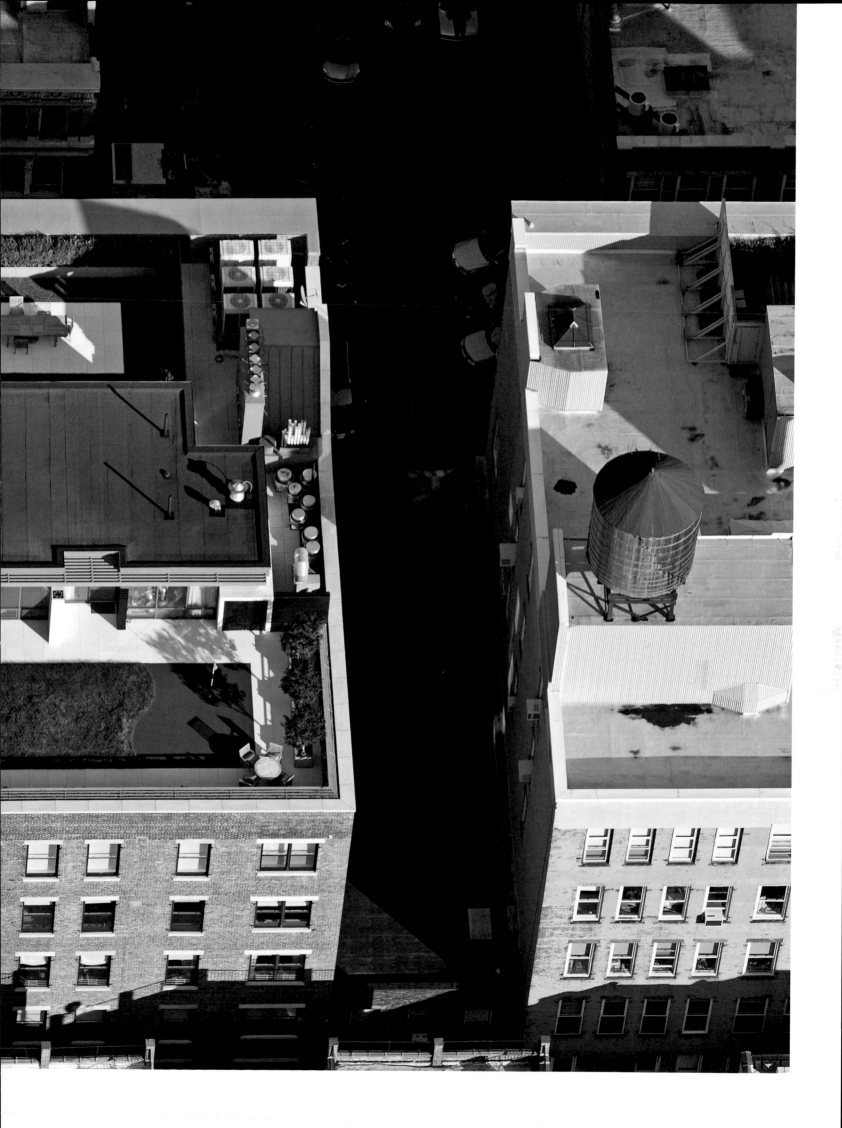

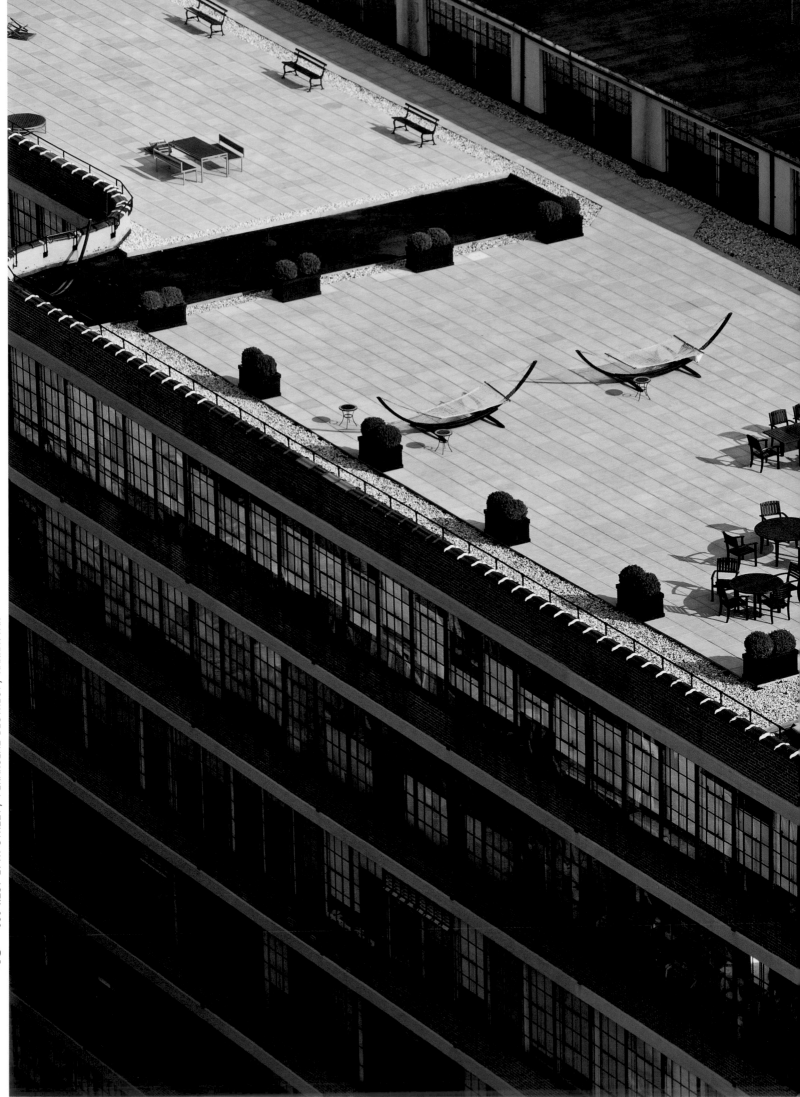

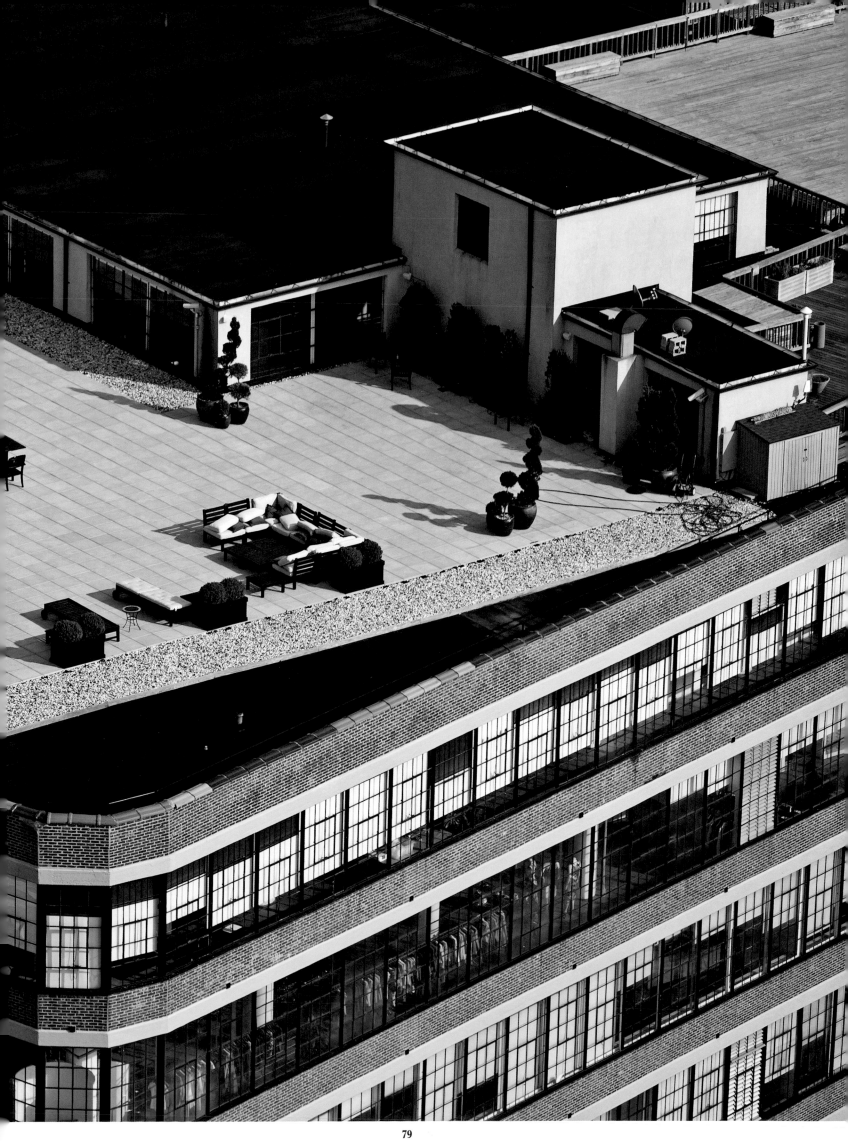

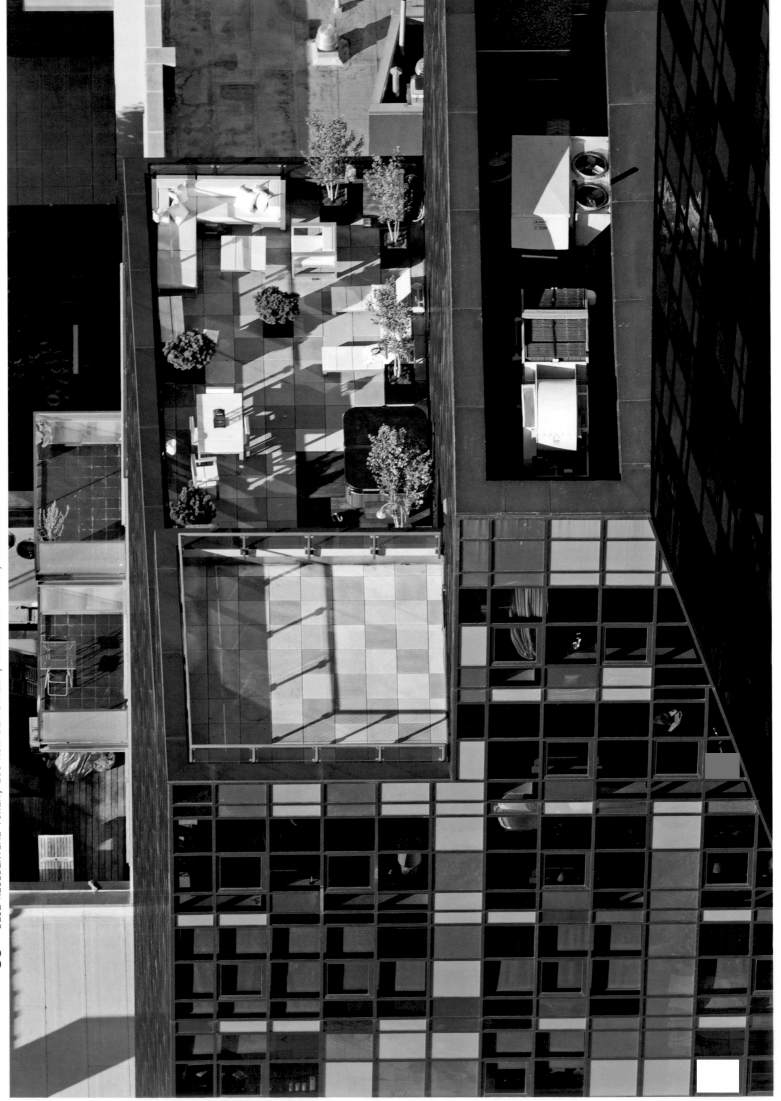

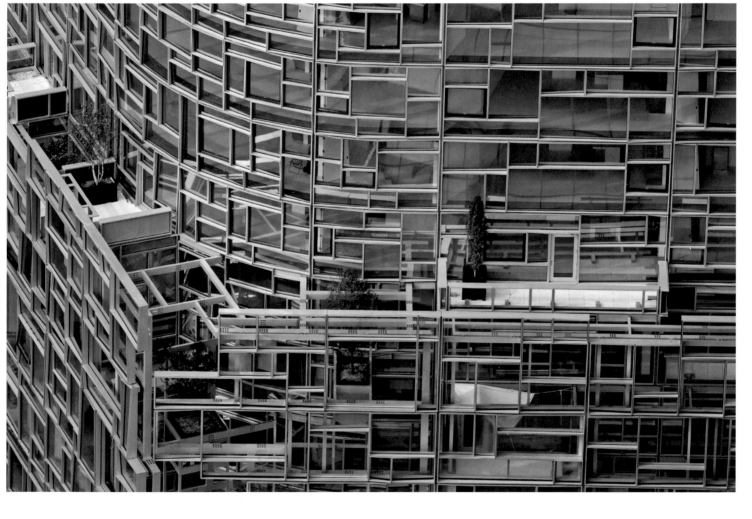

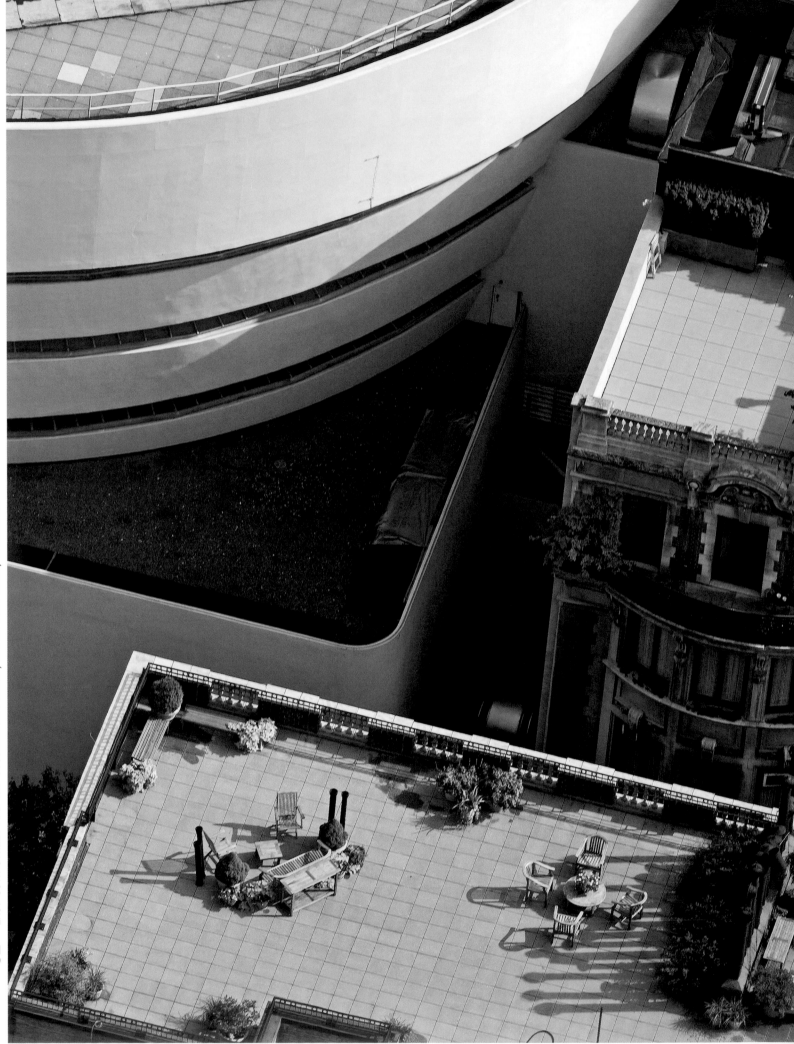

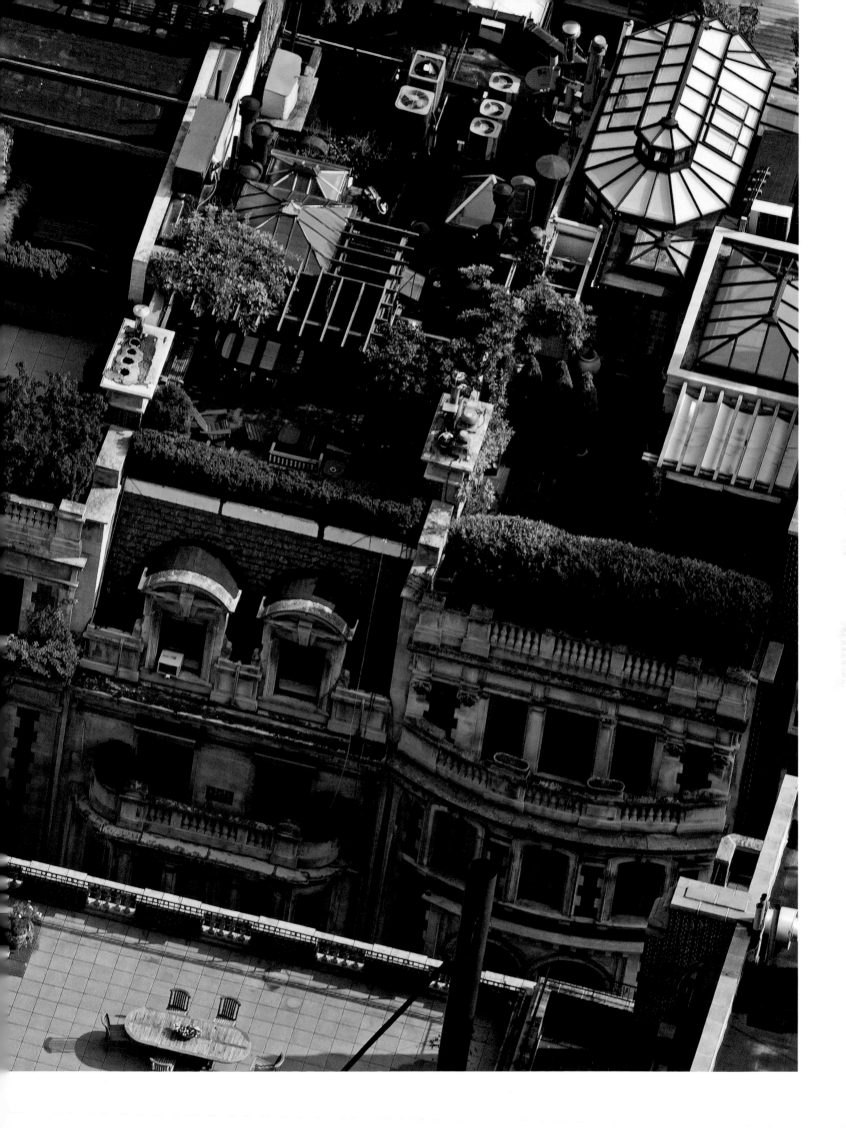

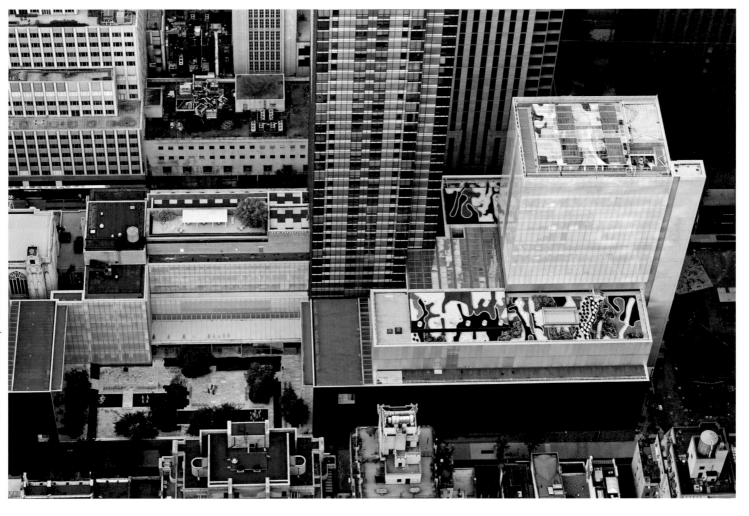

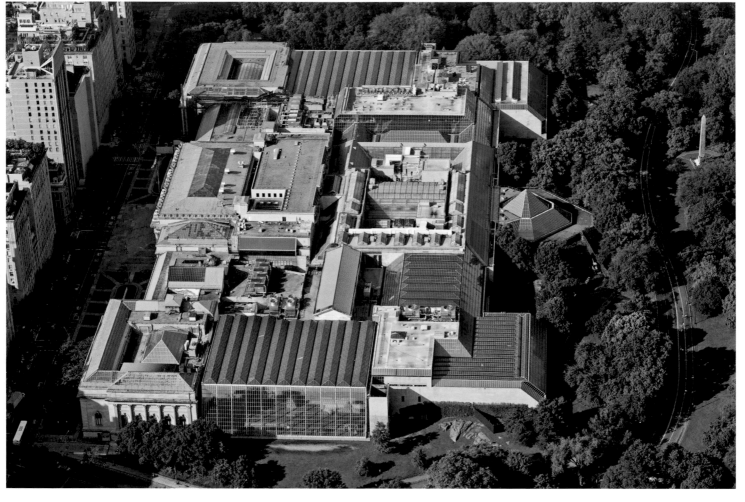

56 METROPOLITAN MUSEUM OF ART, 1000 5TH AVENUE,
UPPER EAST SIDE, MANHATTAN

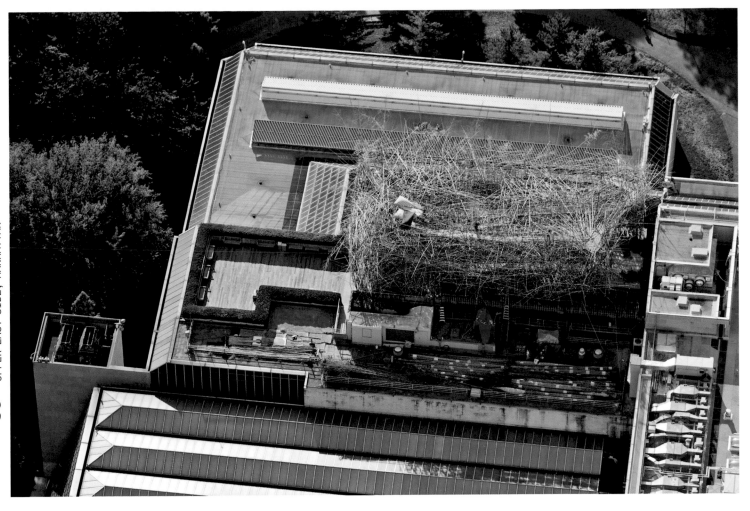

57 METROPOLITAN MUSEUM OF ART, 1000 5TH AVENUE,
UPPER EAST SIDE, MANHATTAN

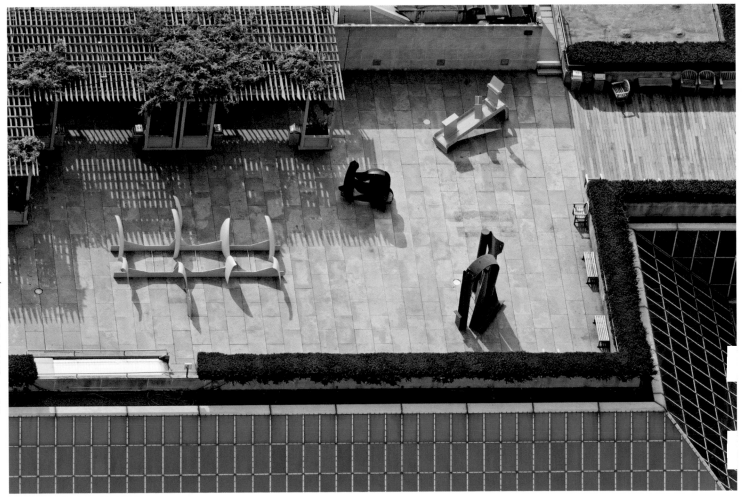

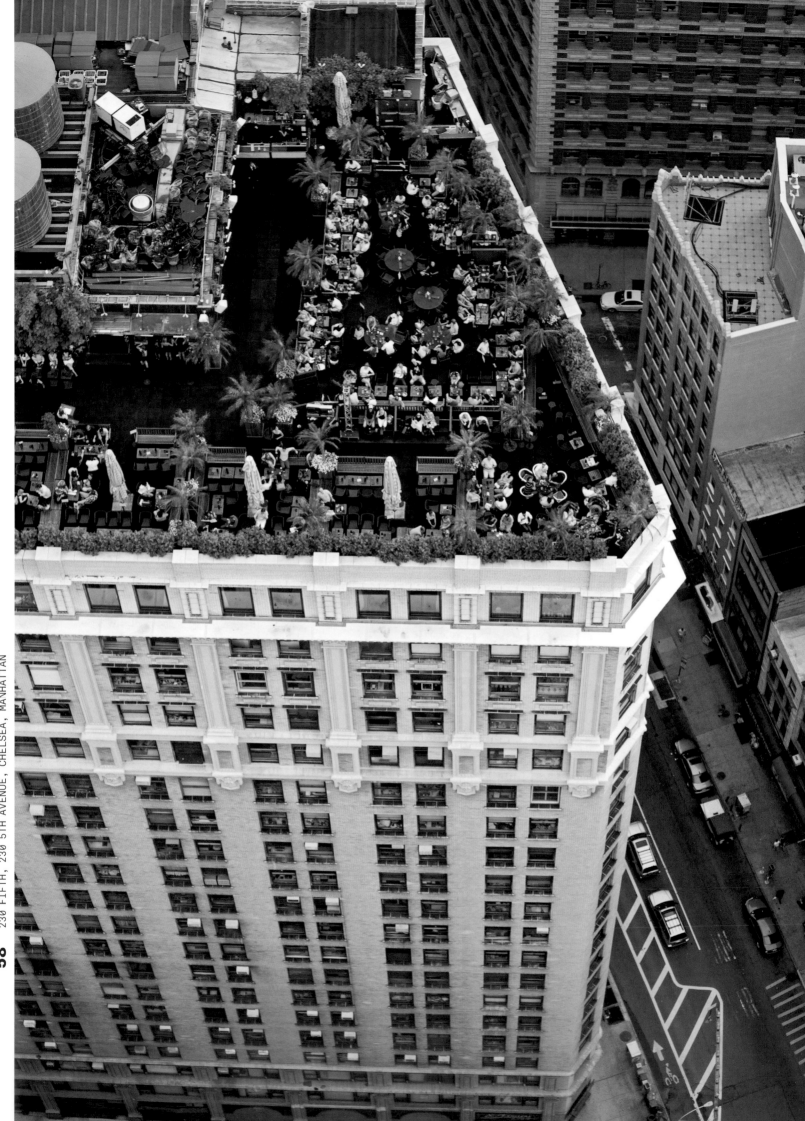

Collective Use

Many of New York City's rooftops are to some extent shared, featuring restaurants and bars, pools and playgrounds, or parks serving the occupants of office and apartment buildings. These settings offer individuals the opportunity to be outdoors in a semiprivate space that is buffered from the dense city by its altitude (although use is often restricted to a building's occupants and their guests).

The dramatic effect of this vertical separation is apparent in a photograph of poolside sunbathers. Lying on deck chairs, they are oblivious to the traffic that appears to pass right next to them, but which actually flows twenty-odd floors below. These outdoor spaces float above the city like elevated islands. They lack a horizontal connection to the streetscape, and therefore it seems as though they have escaped its grid. This three-dimensional matrix of mixed uses in city buildings creates the functional density that makes urban environments so rich and interesting.

Collective rooftops are not subdivided for individual use but are lightly partitioned with devices like planters to create small, semiprivate areas for sitting or picnicking. These socially valuable spaces provide far better opportunities to meet and connect with neighbors than spaces of transience like lobbies or elevators. The collective roofs also provide more secluded areas for those who desire to be outdoors alone.

Collective spaces offer office employees the opportunity to take an outdoor break and to experience the weather, feel the sun's rays, and briefly reconnect with the rhythms of nature. They serve as informal meeting places and foster chance social interactions during which employees can exchange information.

It seems natural that play spaces would be located on these collective rooftops, since New York City does not have enough open ground space to accommodate the demand for playgrounds, exercise tracks, and tennis and basketball courts. For nursery-school and grade-school children, rooftop playgrounds can be situated in close proximity to indoor classrooms a few floors down. The roof offers private outdoor play space that might not otherwise be available within blocks.

New York City recently has invested heavily in converting many waterfront piers into elaborately landscaped parks that are tied to natural features and have views of the horizon. Likewise the High Line has proven to be successful beyond expectations. Both were created from land that had been sitting idle, and both have become highly popular public amenities.

It seems logical that new development projects should include rooftop designs that further this effort to increase public outdoor space. Already, large parks have been placed on top of wastewater treatment plants and parking garages. More thought should be given to smaller park opportunities on the rooftops of public buildings. With forethought, new public and private building projects could accommodate these spaces that magnify our awareness of weather, seasonal change, and nature, and that keep us from feeling anonymous in a big city.

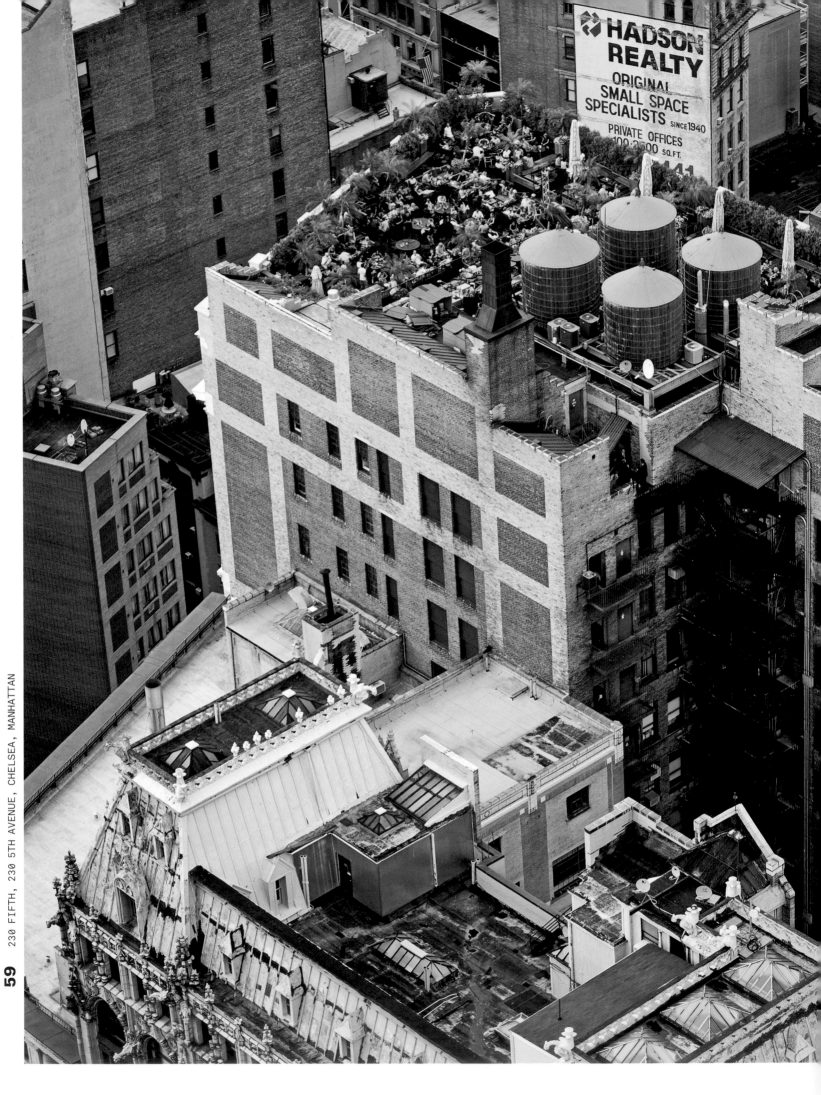

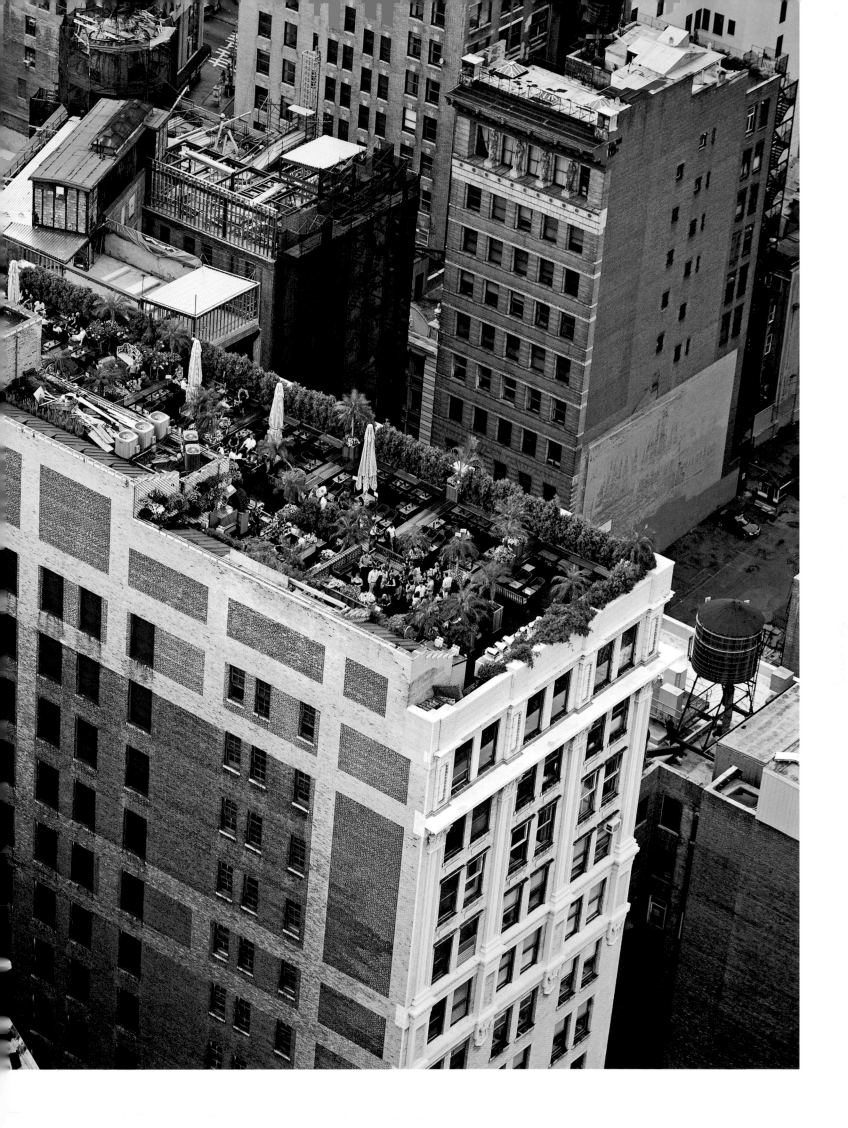

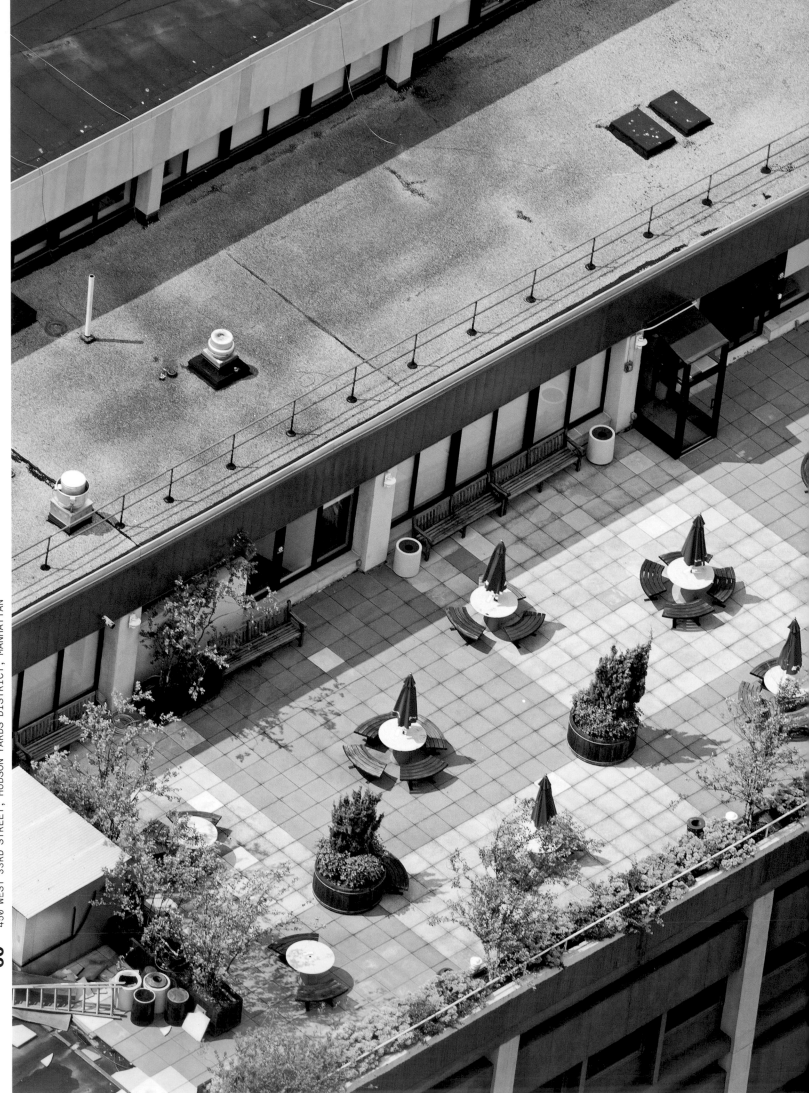

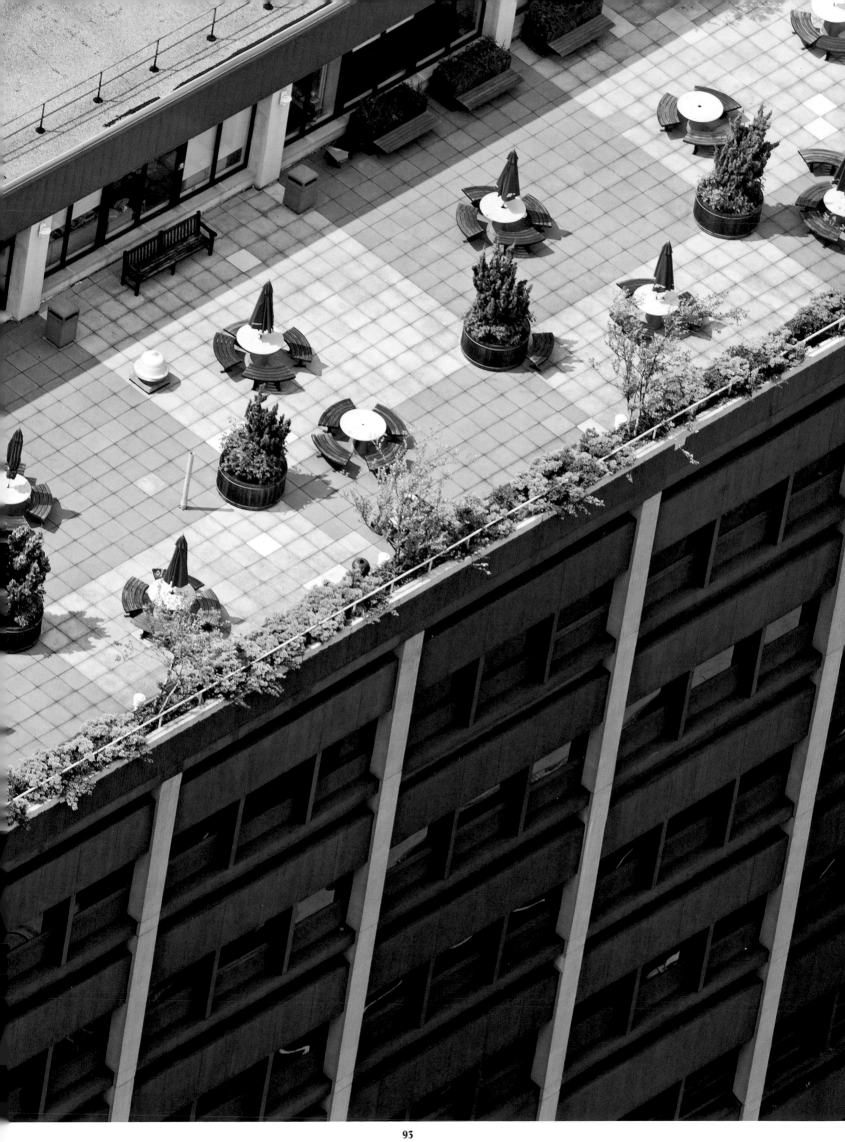

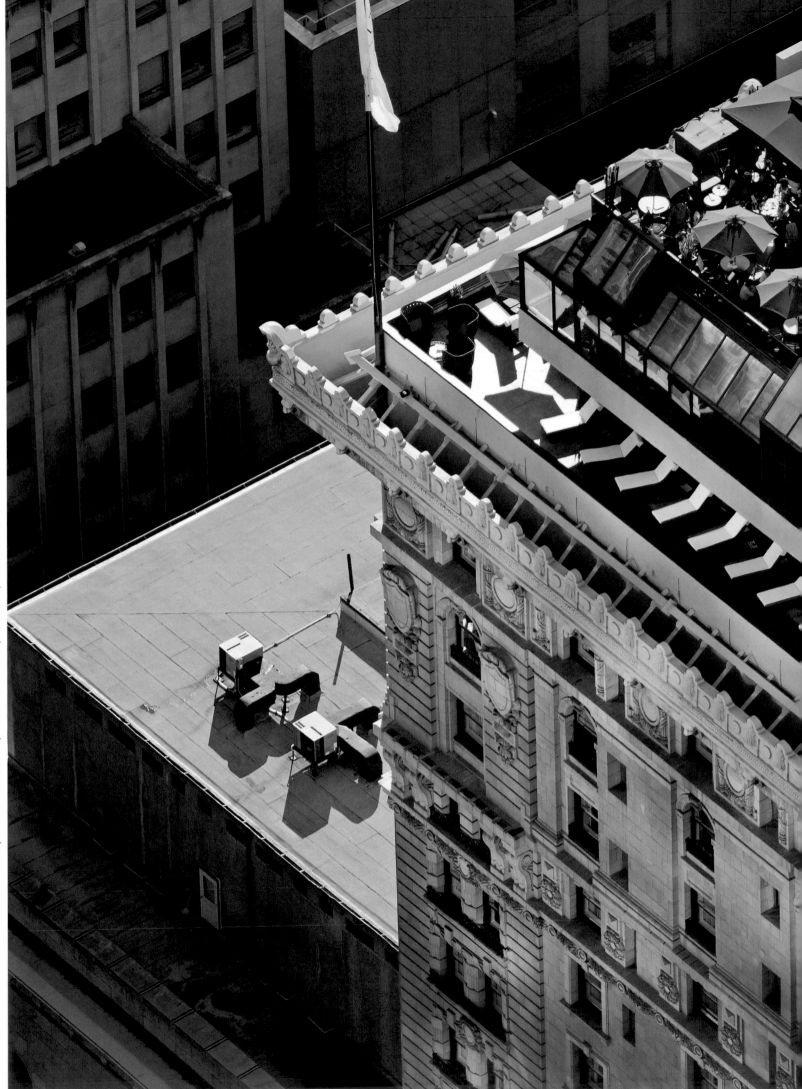

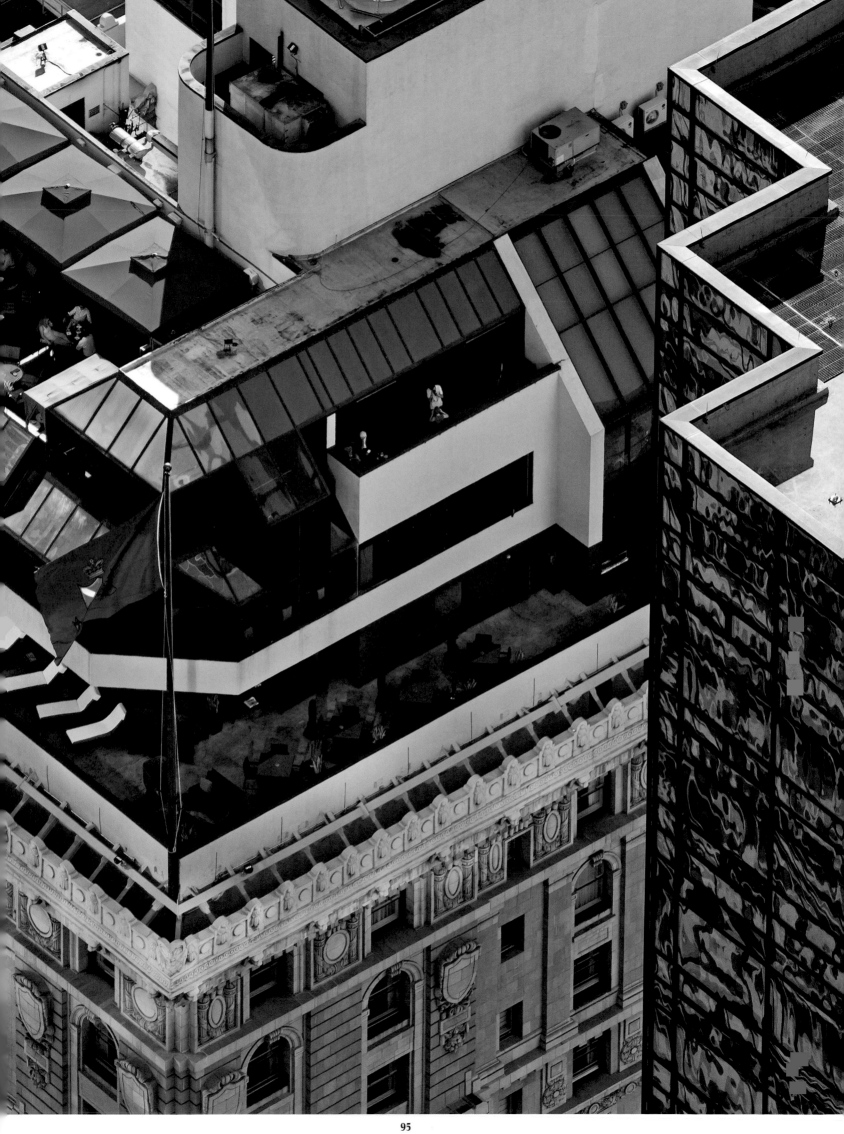

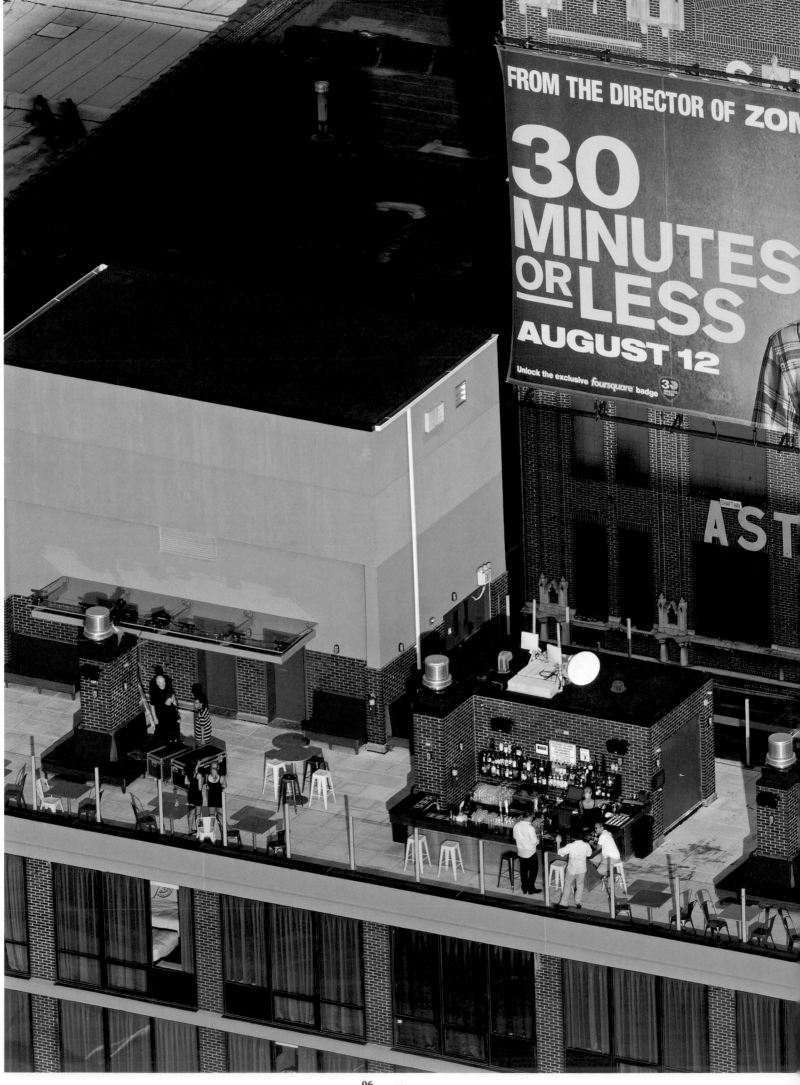

RAVEL HOTEL, 11-01 43RD AVENUE, LONG ISLAND CITY, QUEENS

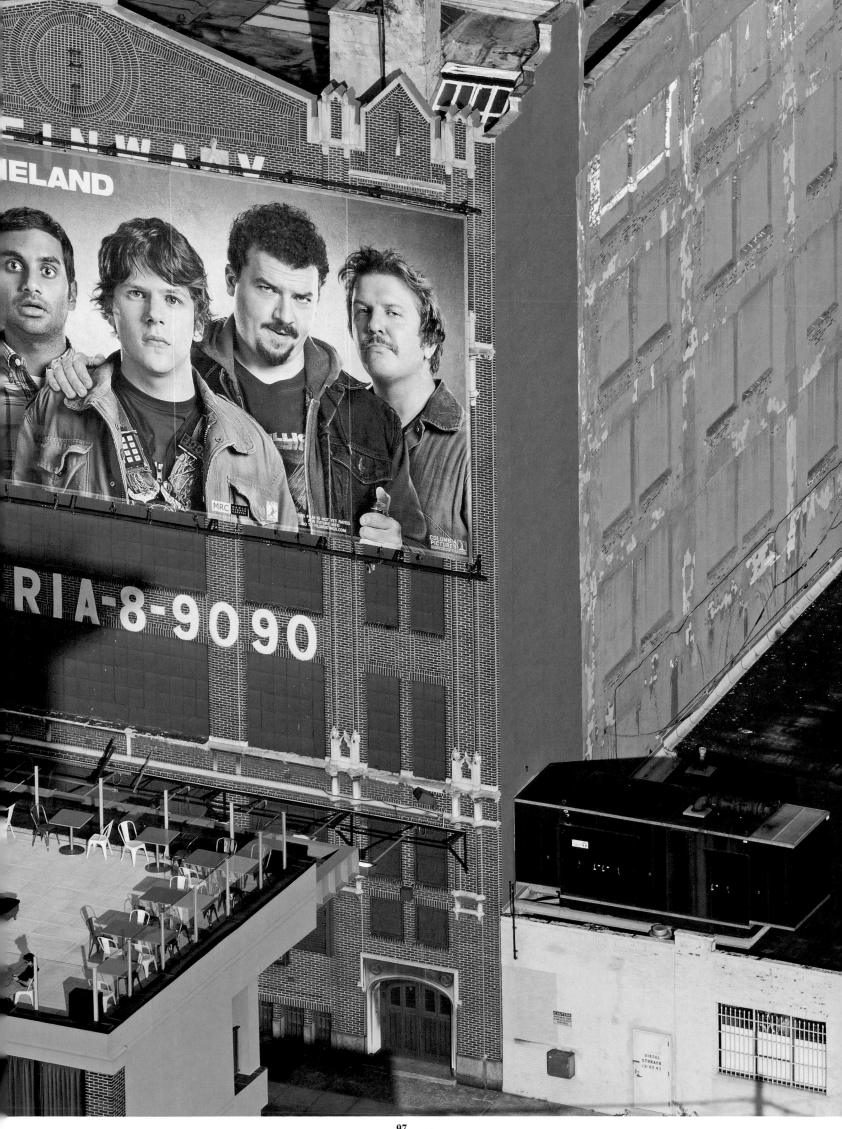

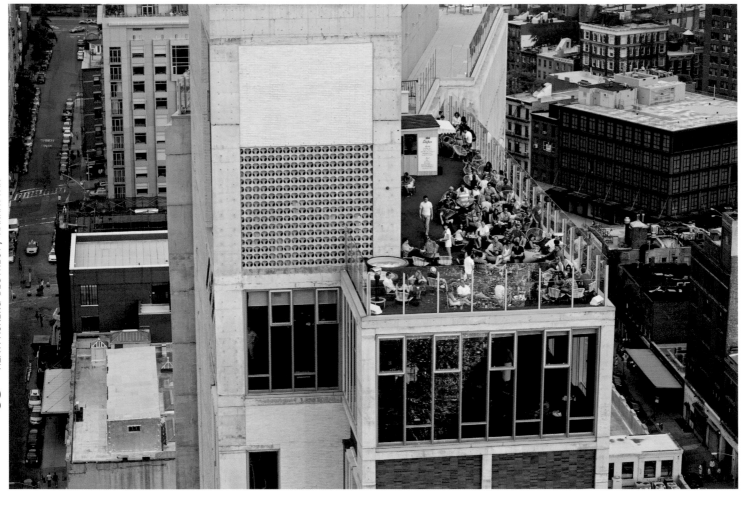

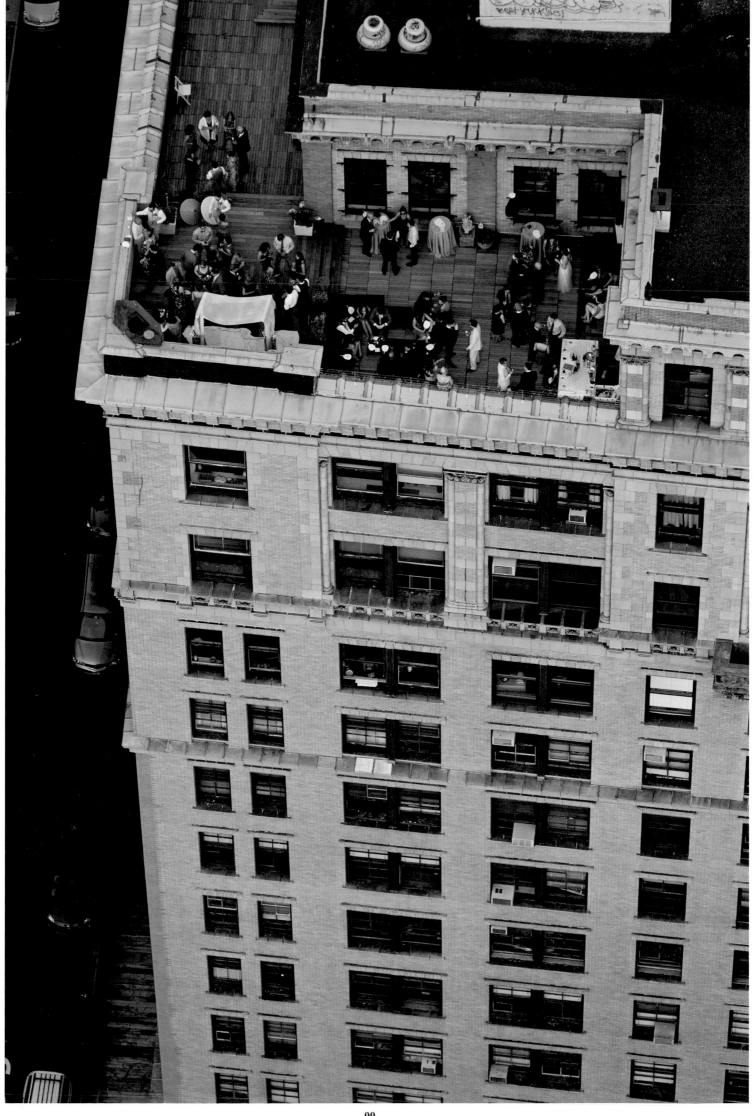

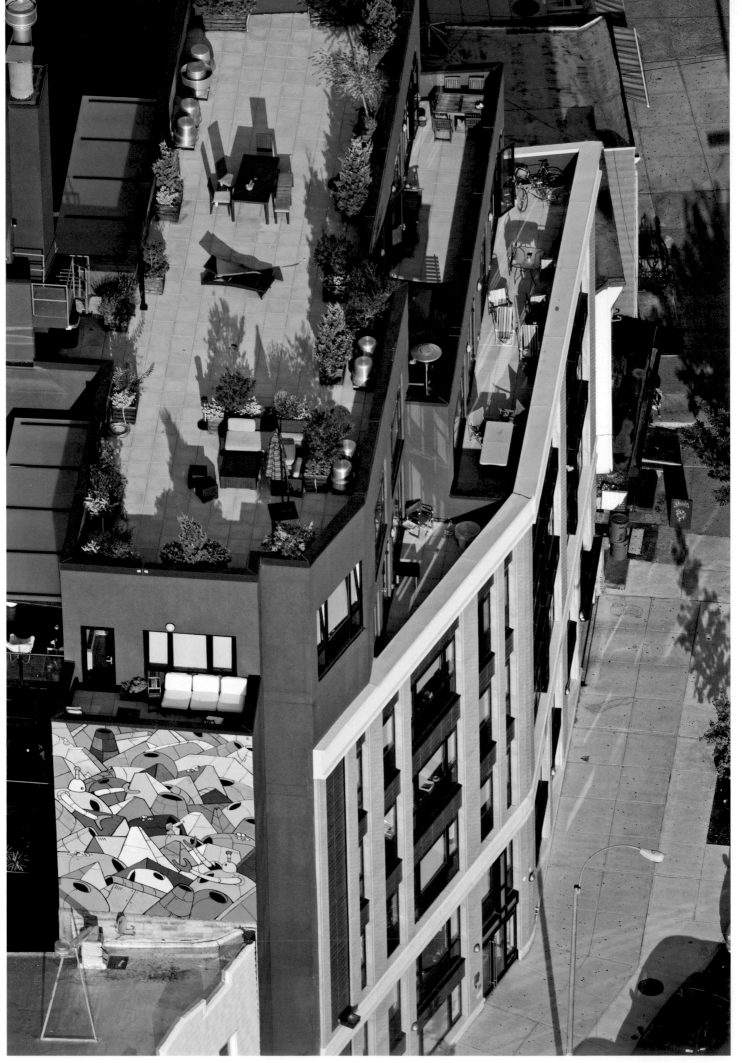

66

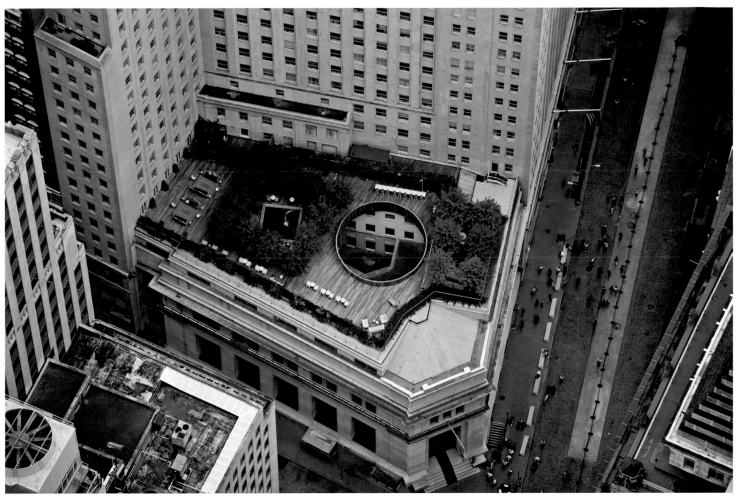

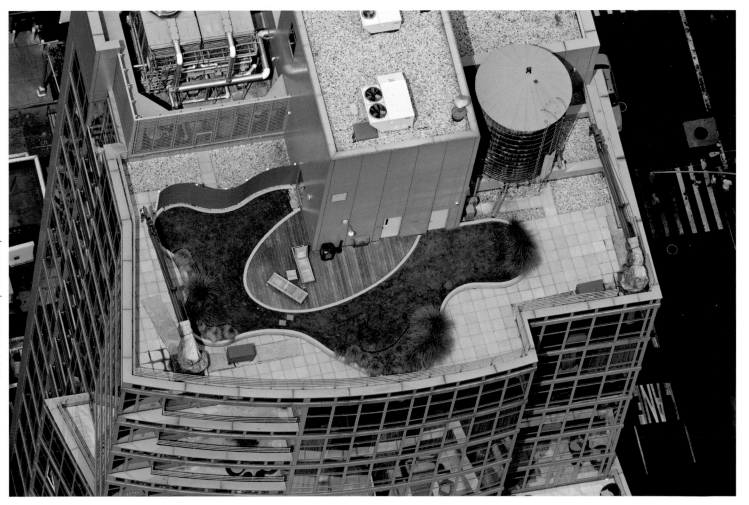

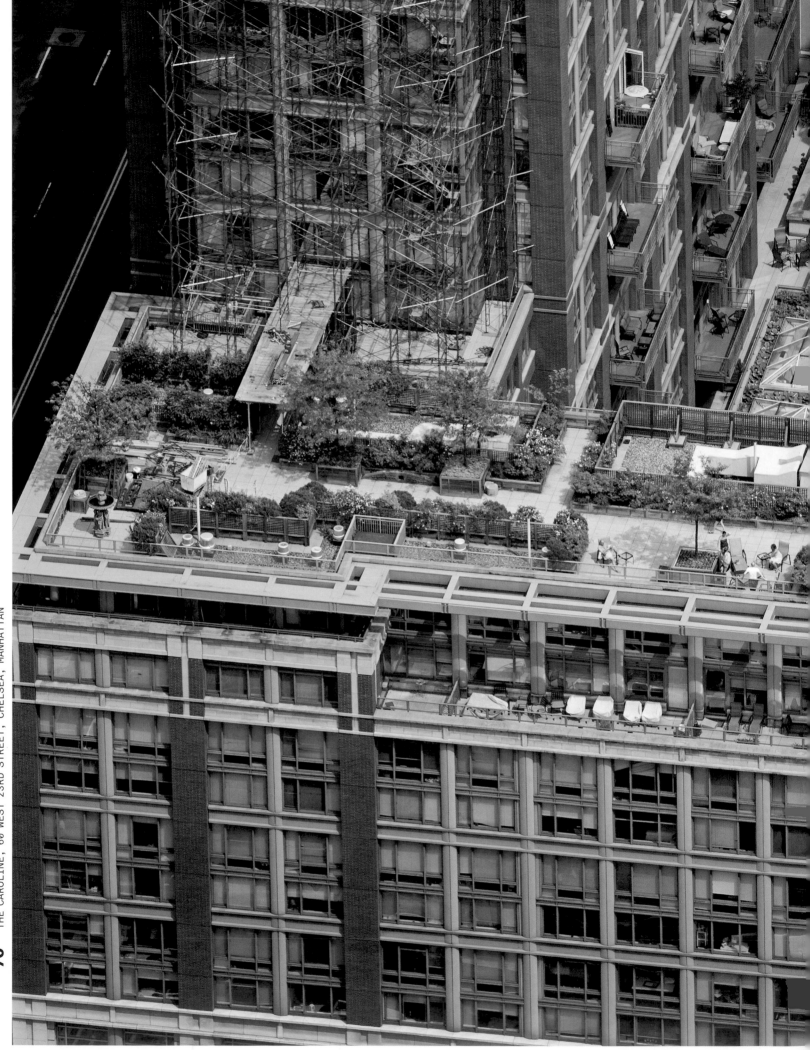

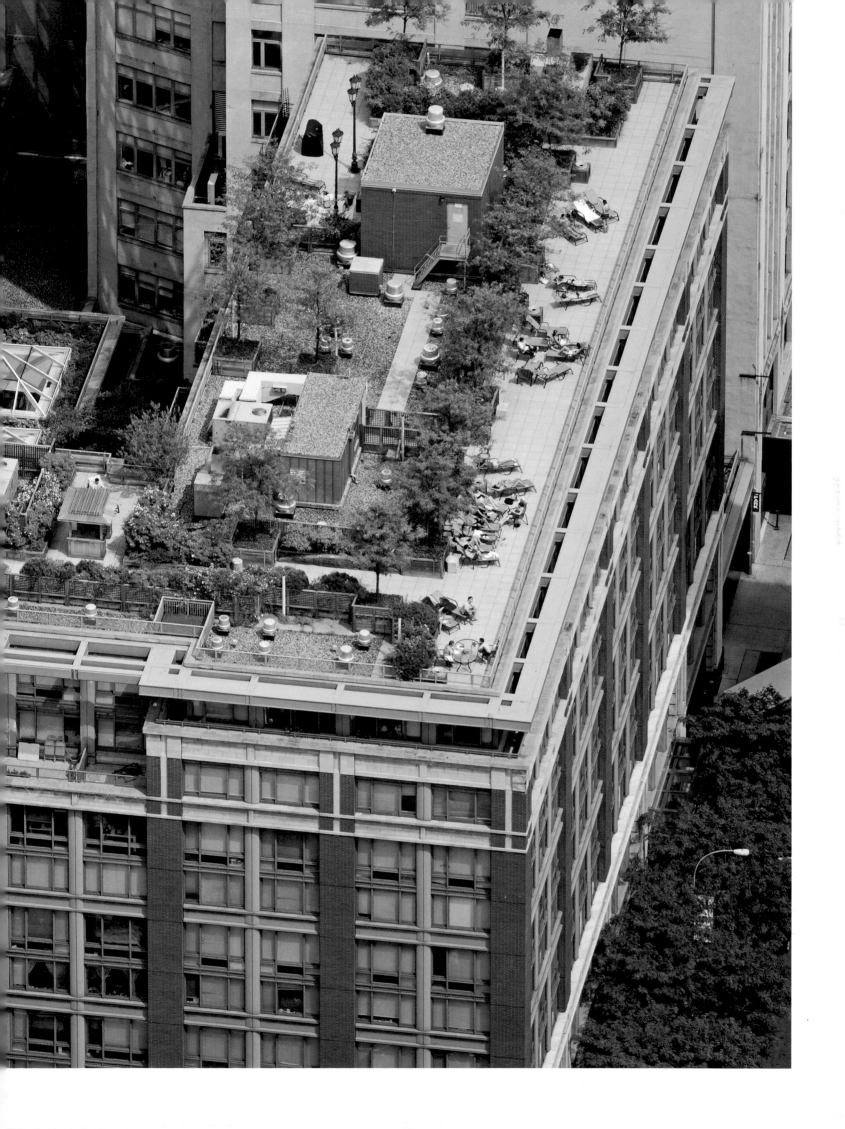

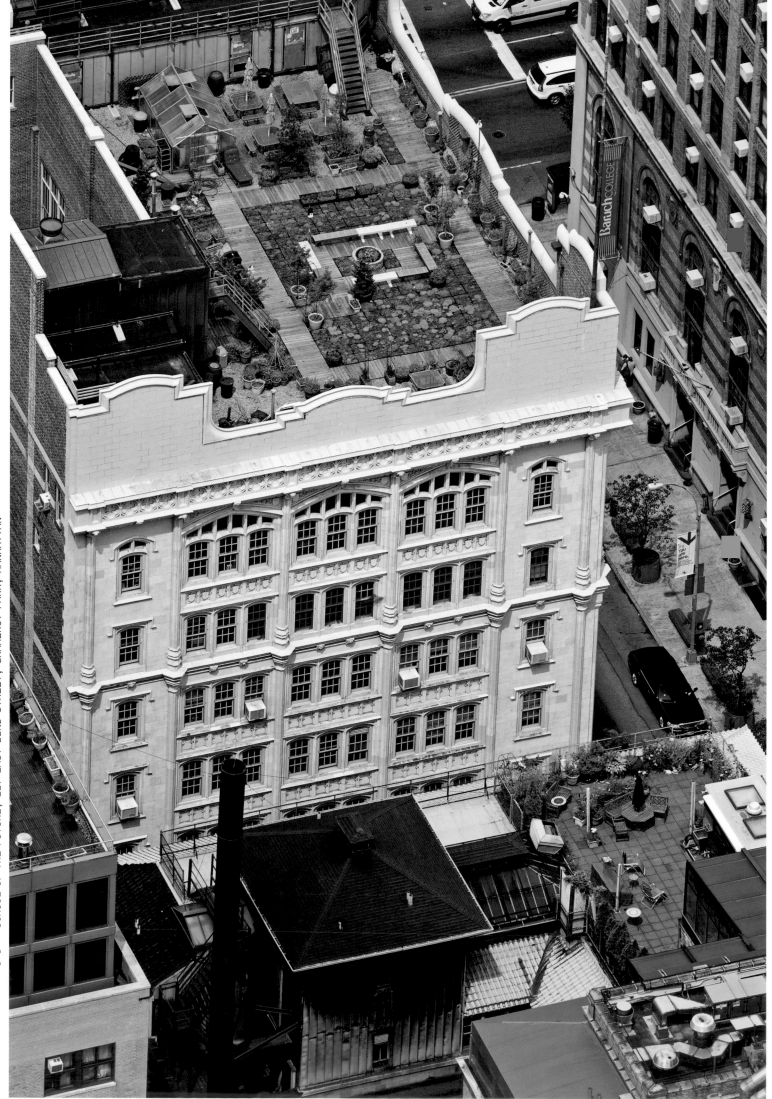

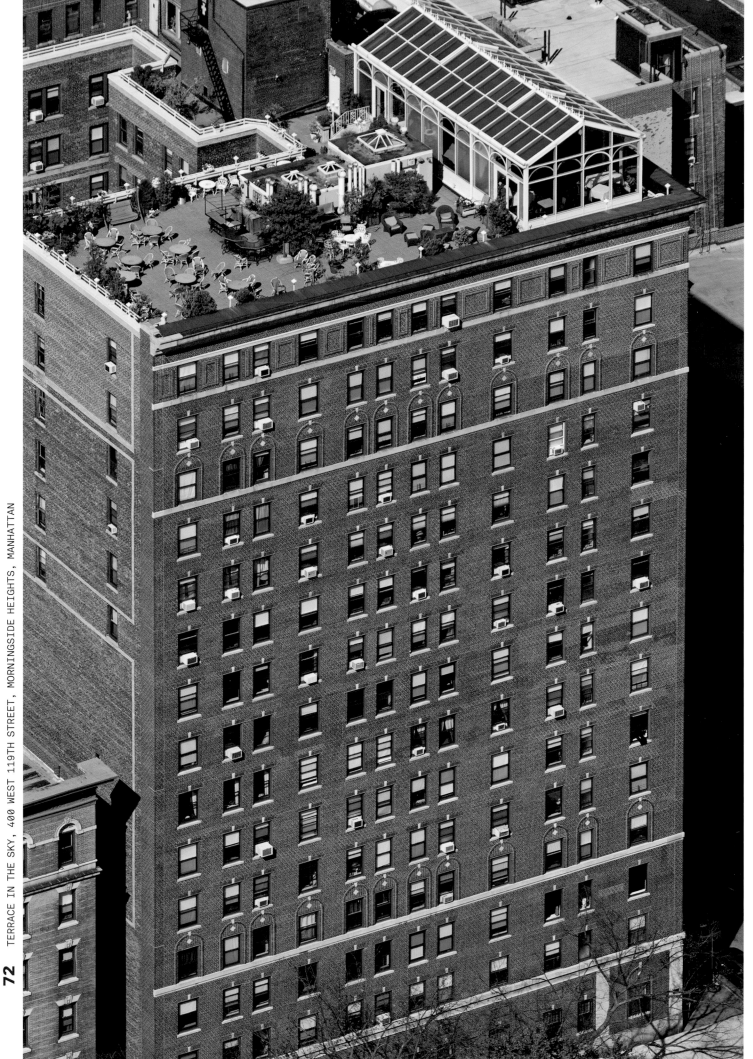

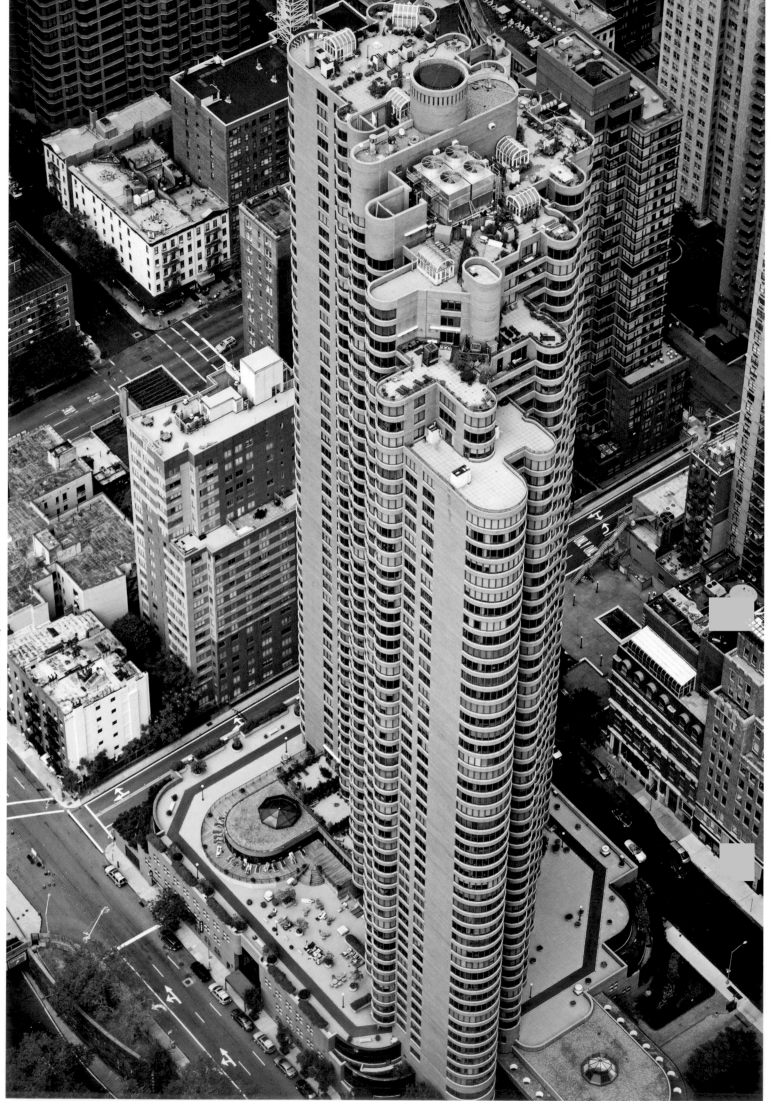

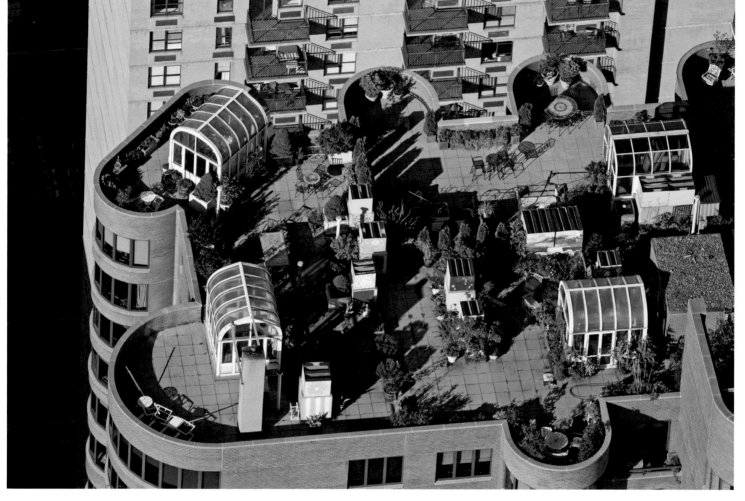

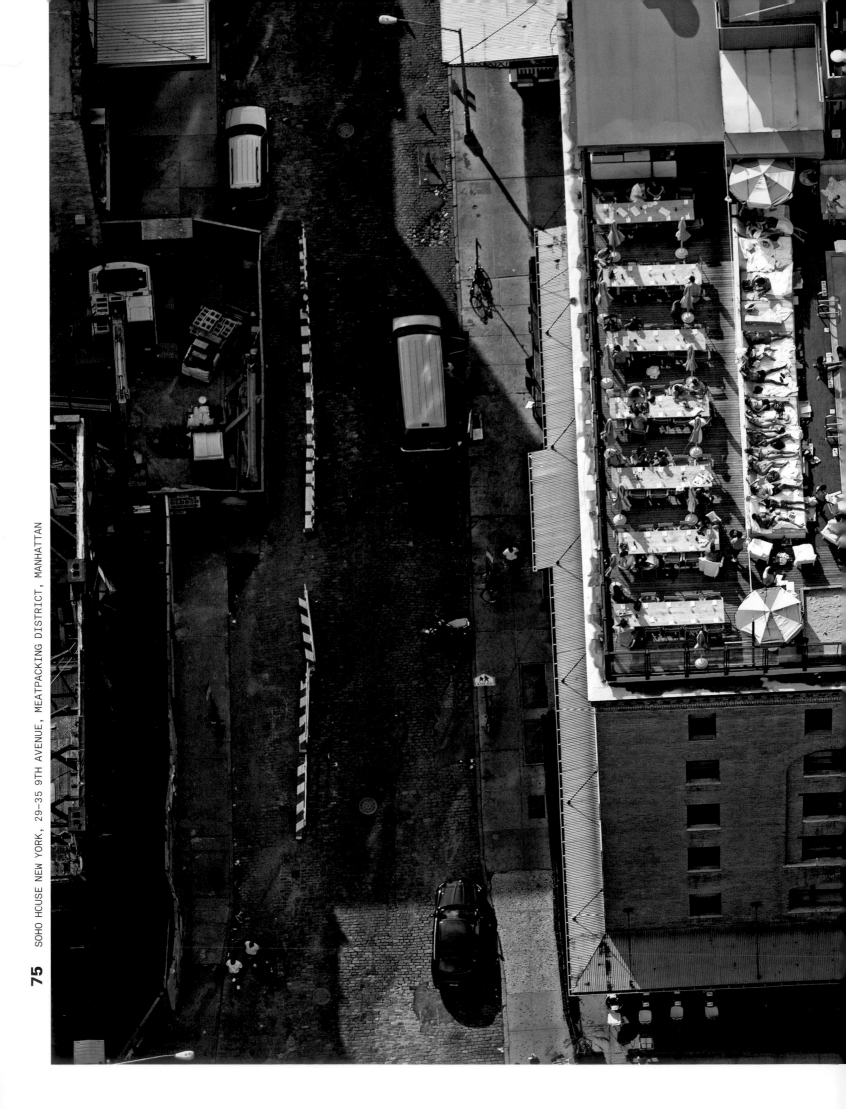

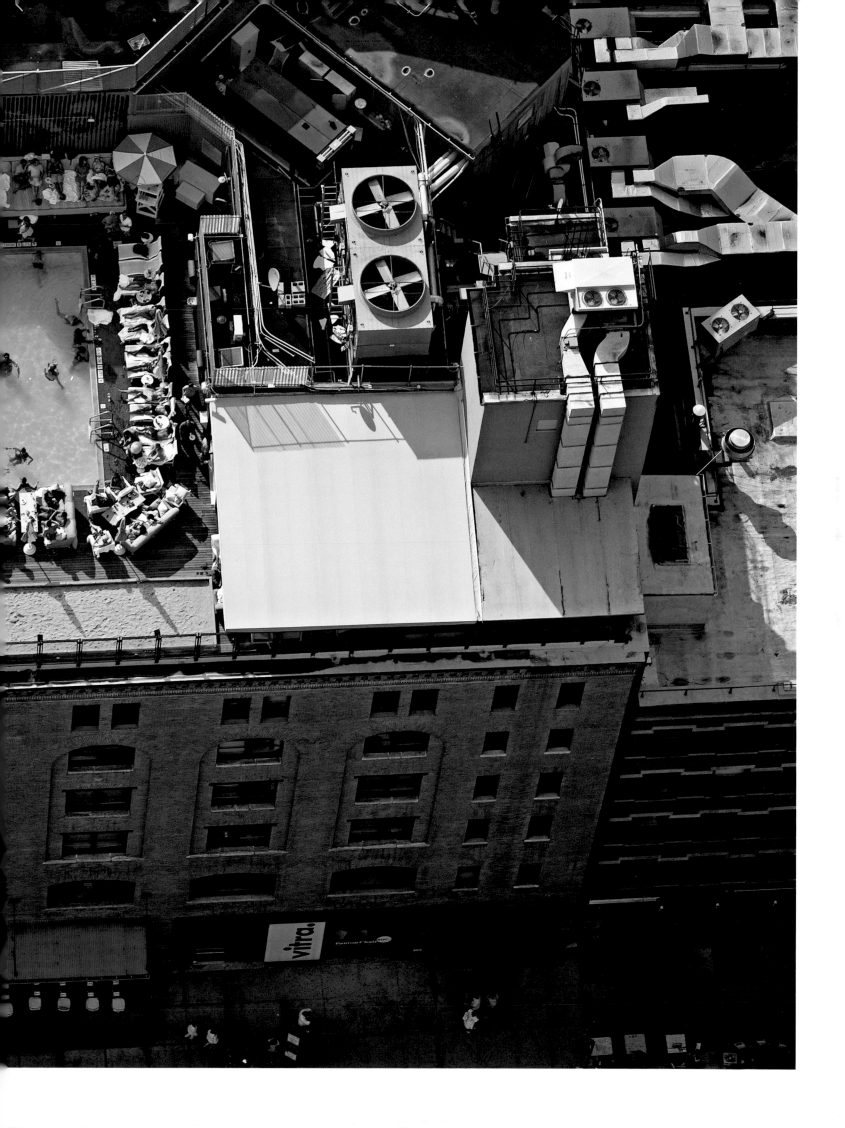

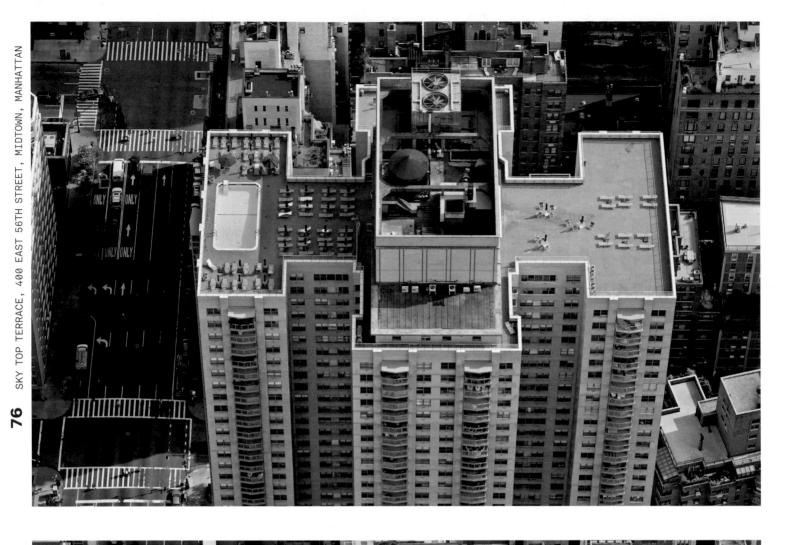

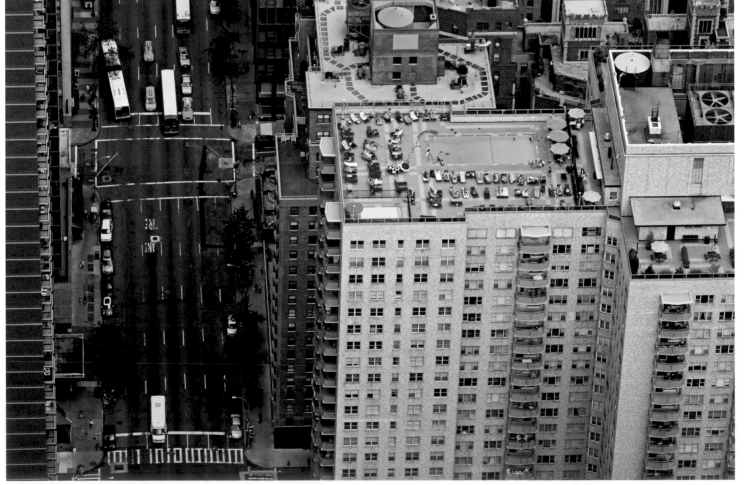

79 60 EAST 8TH STREET AND THE HILARY GARDENS, 300 MERCER, NOHO, MANHATTAN

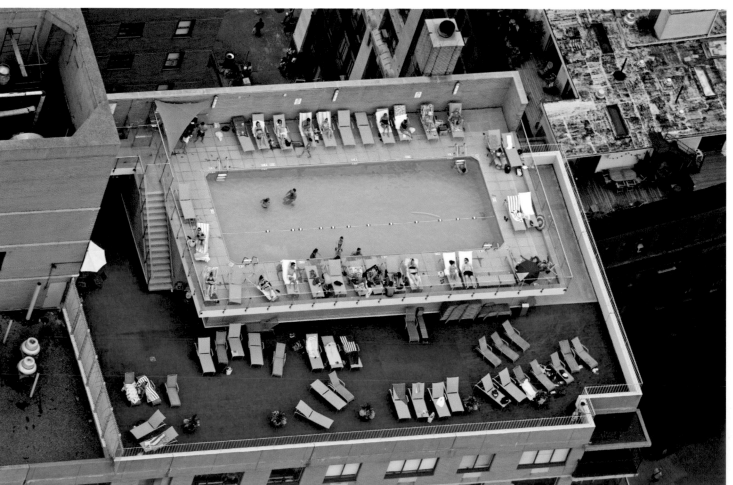

80 1 WAVERLY PLACE, NOHO, MANHATTAN

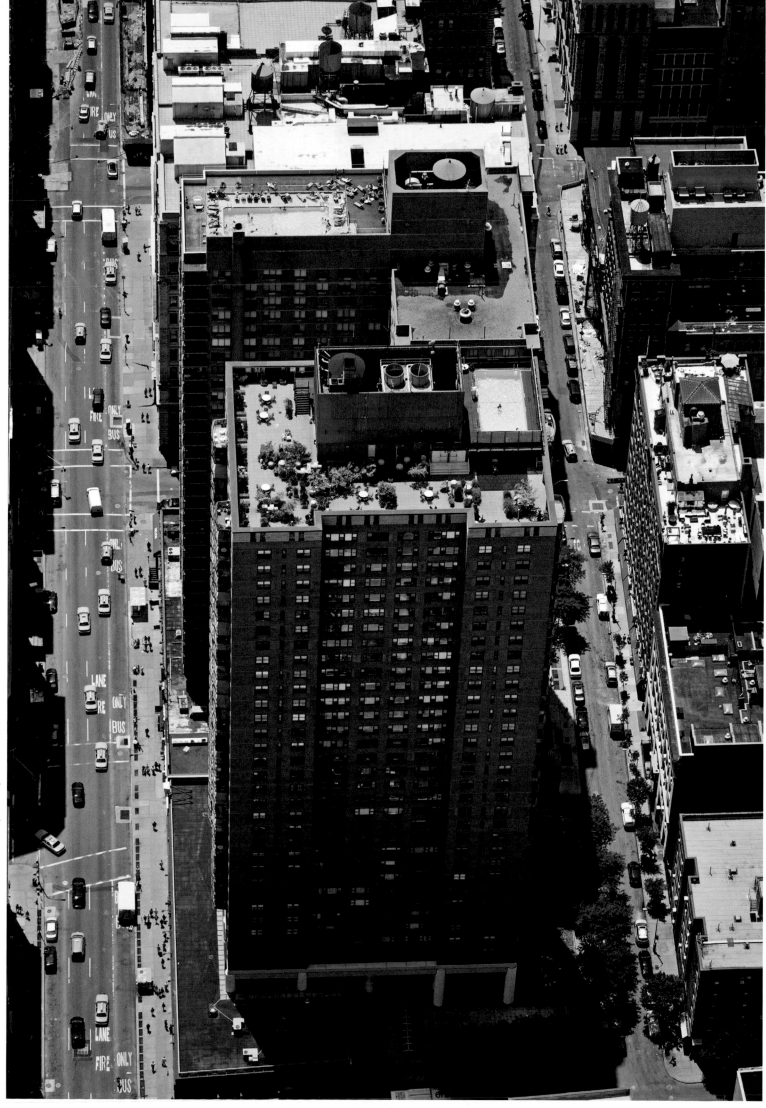

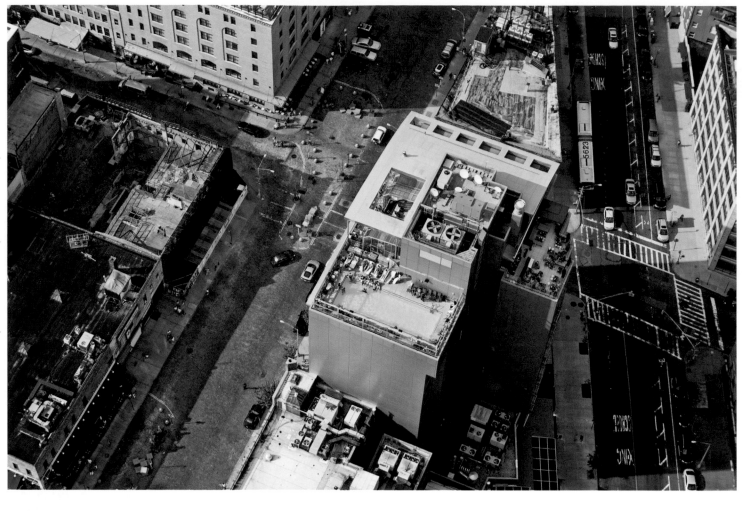

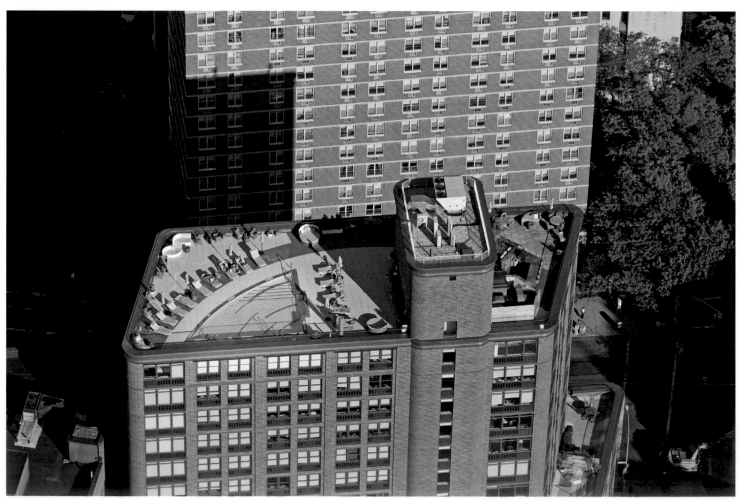

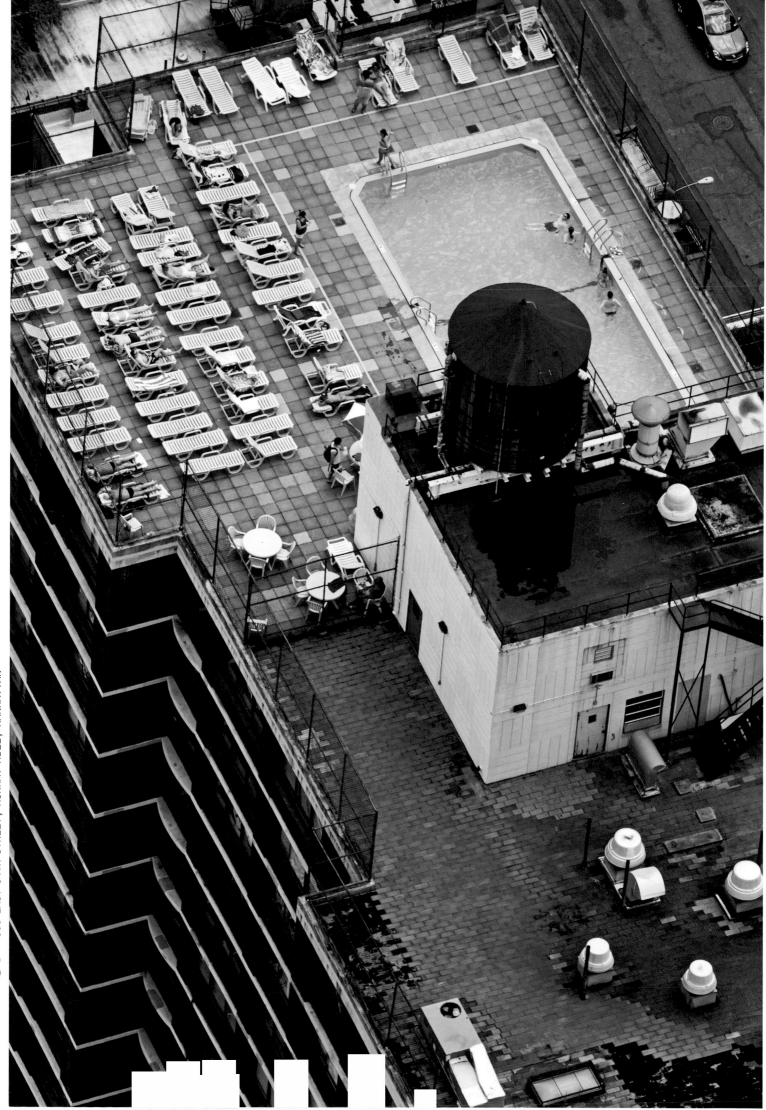

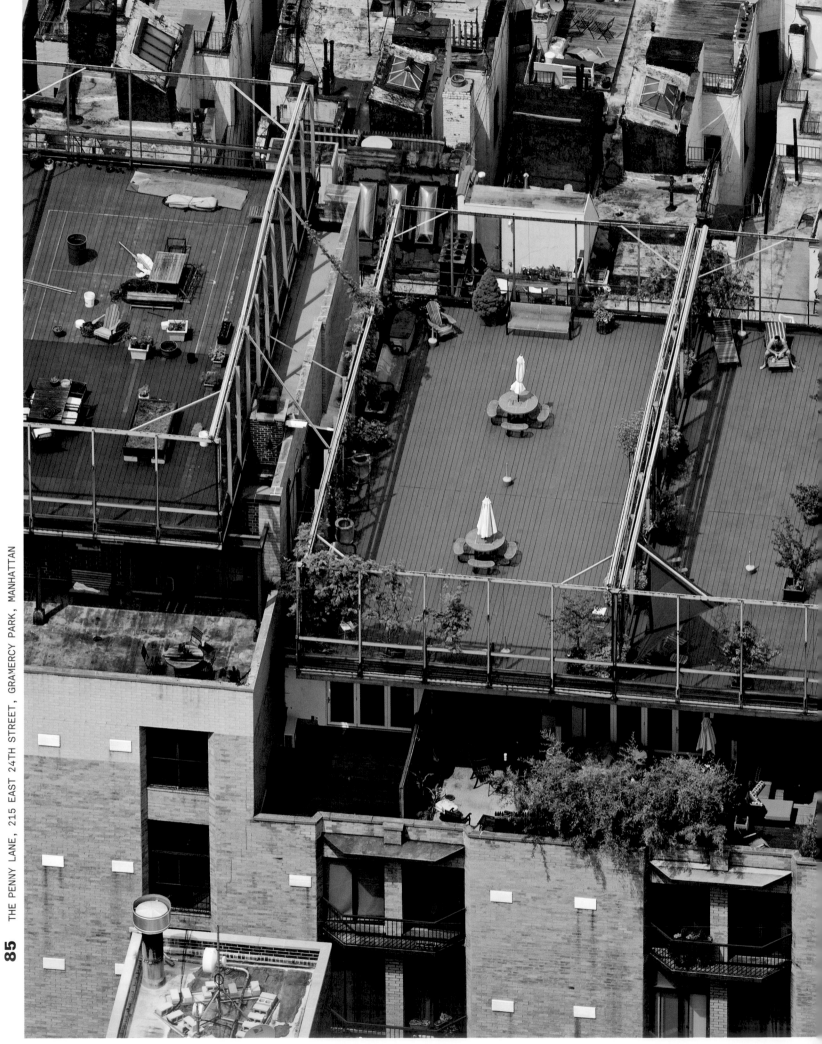

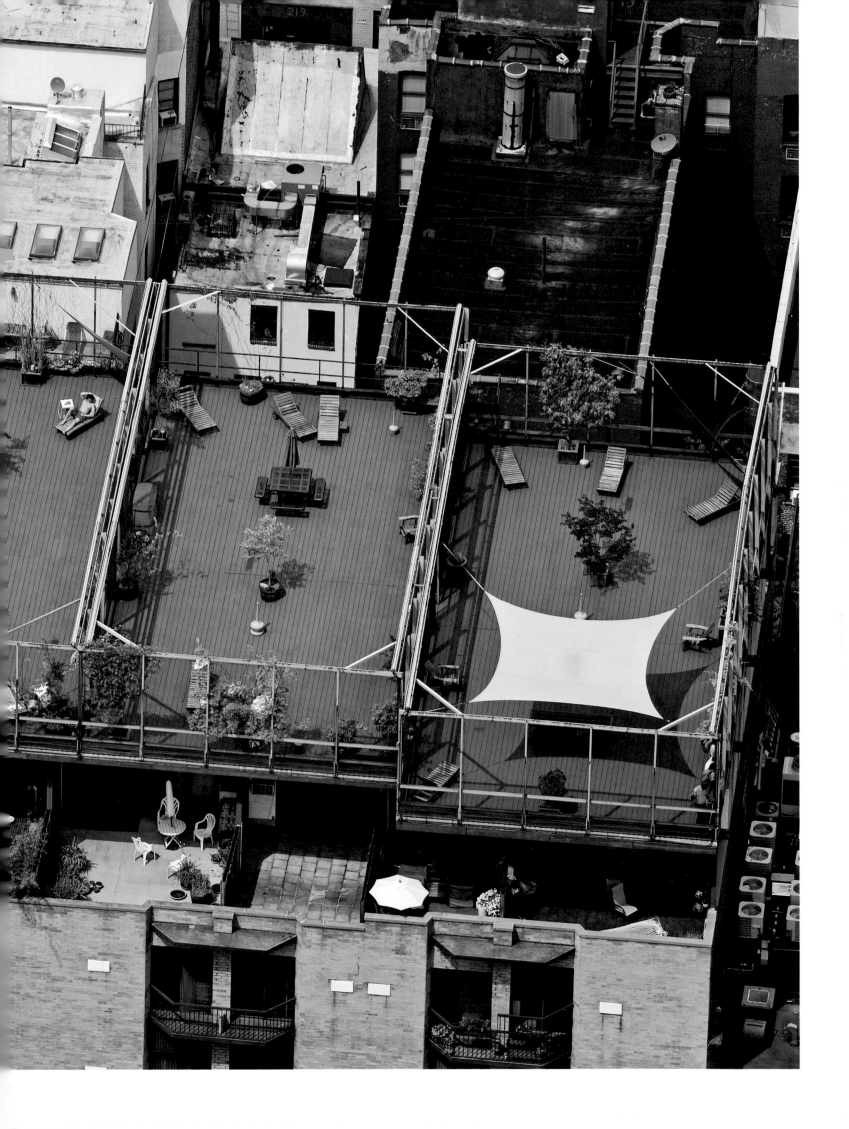

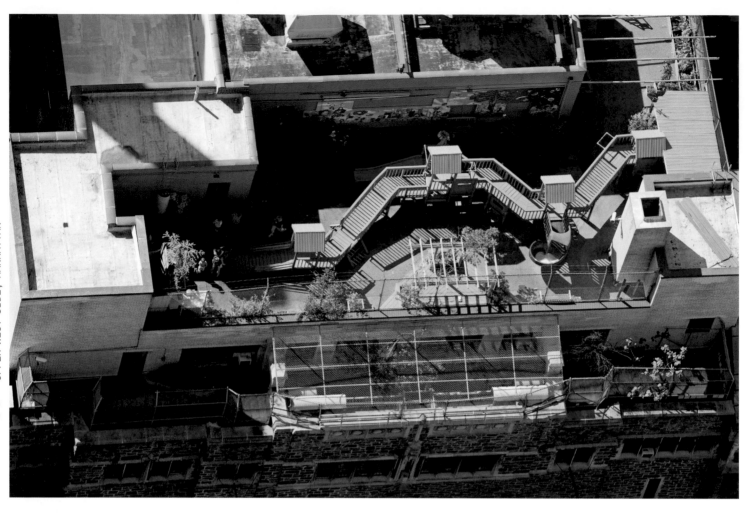

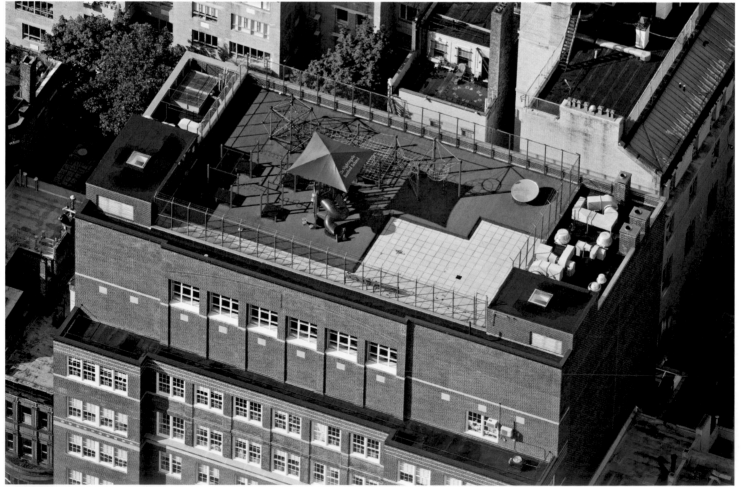

MIDDLE SCHOOL 260, 315 WEST 21ST STREET,
CHELSEA, MANHATTAN

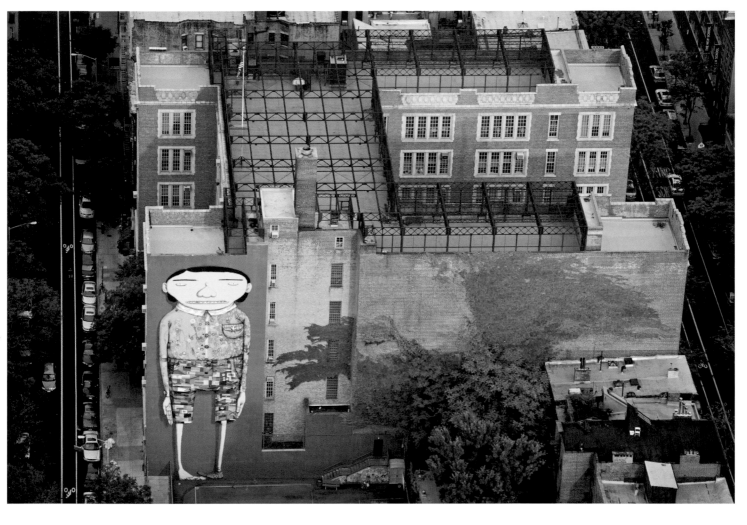

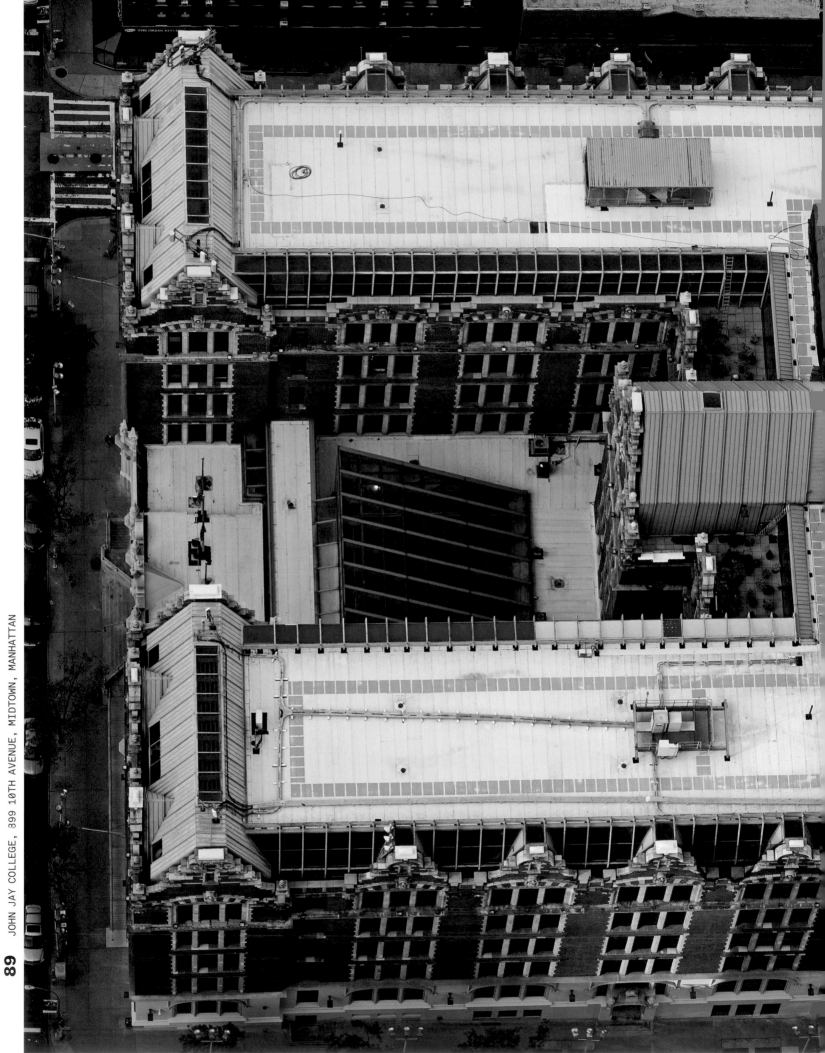

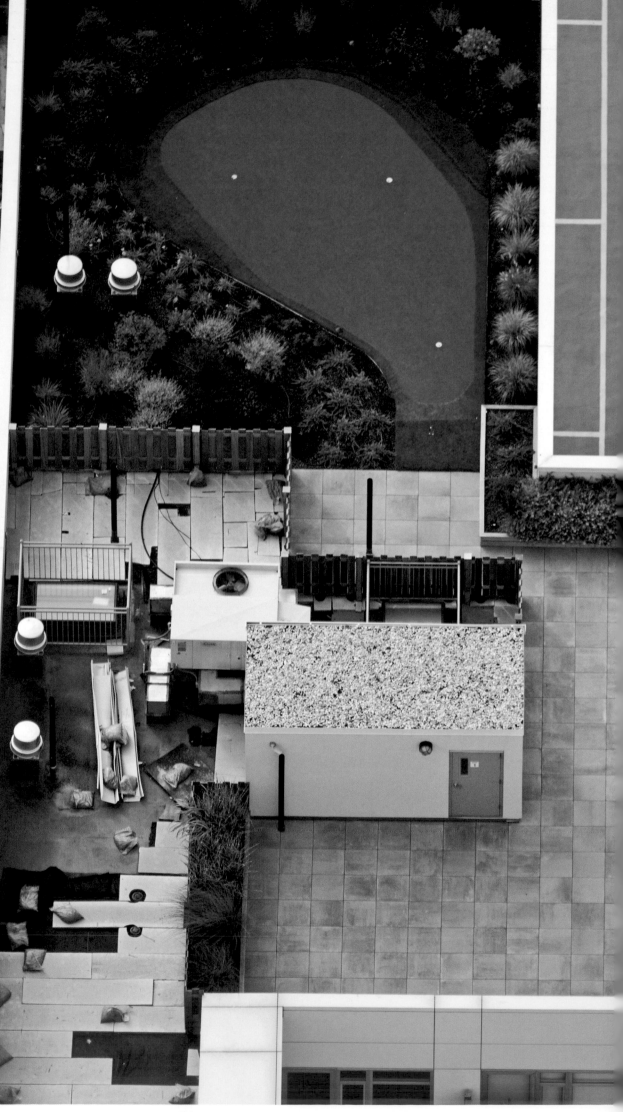

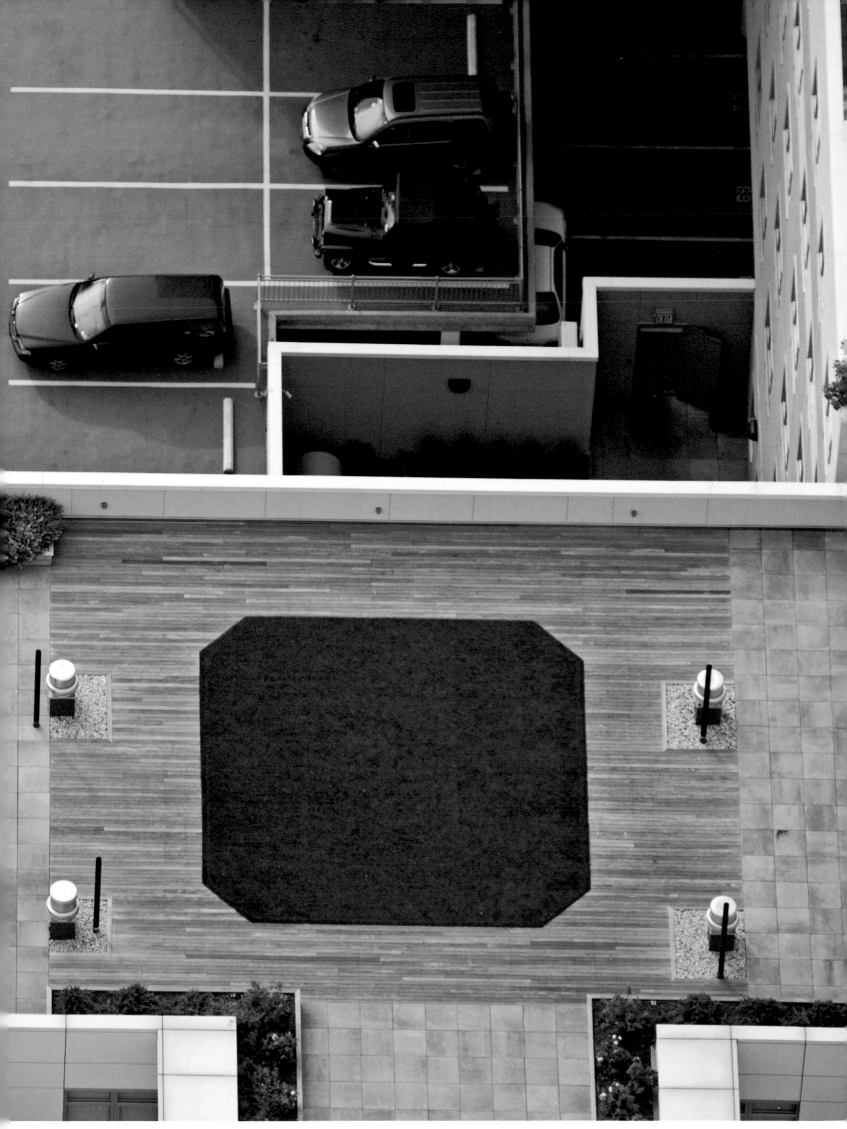

Iconic Observation Roofs and Landmarks

When flying above New York City, I orient myself first by the prominent features of the Hudson and East Rivers, then by Central Park and the squares, and finally by the two masses of high-rise buildings marking Midtown and the Financial District. Each notable high-rise building—the Empire State, the Chrysler, and, most recently, the Beekman Tower—also acts as a signpost.

A true urban landmark serves to locate you within the city; it works as a wayfinder on both a conscious and subliminal level. If a single landmark is symmetrical, it may be difficult to know which side of the building you are facing, but you can naturally triangulate your location if you can see more than one. High-rise buildings extend your range for visual orientation (though even the tallest buildings can become lost in the canyons of New York's streets and avenues). Those with distinctive lighting also can be effective beacons in the darkness of night.

In addition, landmarks are specific to the time in which they were built, providing information about the development of the neighborhoods in which they reside. The distinctive cap or cornice of a building often reveals, through its architectural style, an indication of the period in which it was designed. These buildings are not simply geographic markers but also landmarks in time, revealing their places in the city's history.

Conversely, a high-rise building can orient an observer looking out from its upper floors and roof decks to the neighborhood, city, and region below. Being oriented to the time of day or the weather is healthful and expansive to the mind.

It is not surprising that tourists to New York City will wait in long lines to visit one of its public observation decks. Looking out over the city provides an understanding of its layout and the spatial relationships among landmarks.

The usefulness of a building as a landmark depends on where it falls within the city and where it appears on the skyline. A lower outlying building can very well be a visual landmark if it rises above those around it. These buildings give a three-dimensional contour to the city's plan.

The attack on the World Trade Center towers on September 11, 2001, was an immense tragedy both for the loss of life and for the fear it engendered. But adding to the trauma was the lasting disorientation created by the disappearance of the towers that for so long had defined the skyline from almost all directions. It is fitting that it has taken many years of debate and planning to rebuild this area. The rebuilt site will redefine the skyline: One World Trade Center (the Freedom Tower) will be the tallest building in America at 1,776 feet and will have an observation deck. Two World Trade Center, with a diamond-shaped top, has been billed as "the crowning landmark in Manhattan's new skyline."

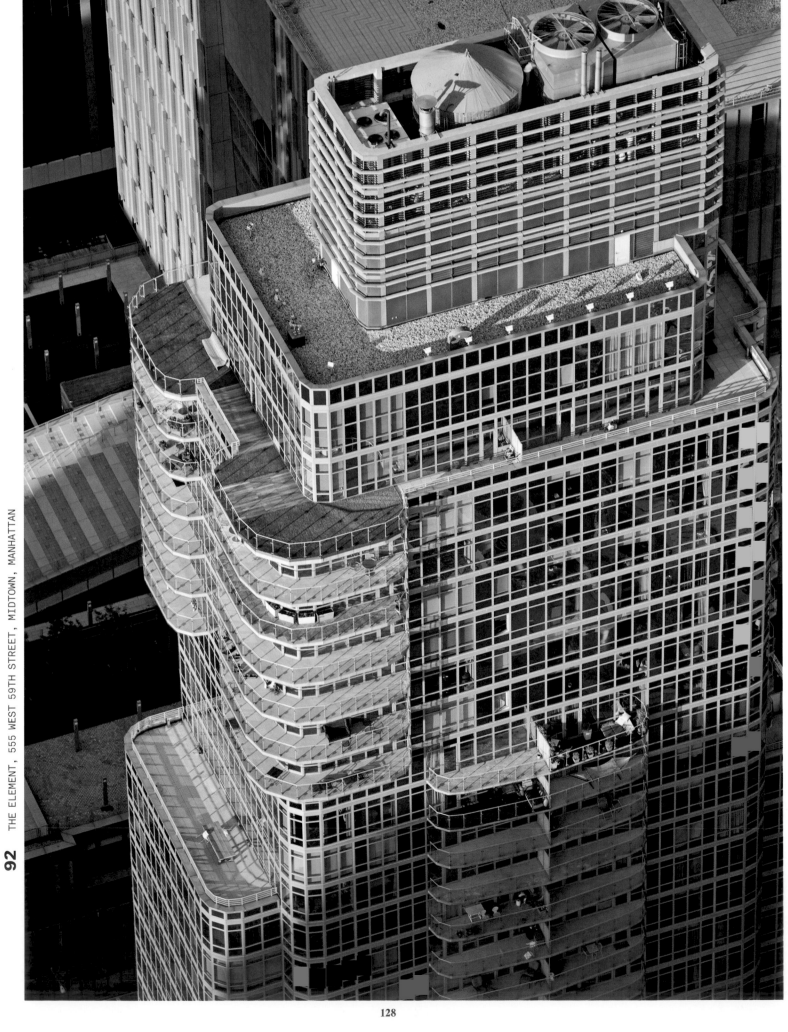

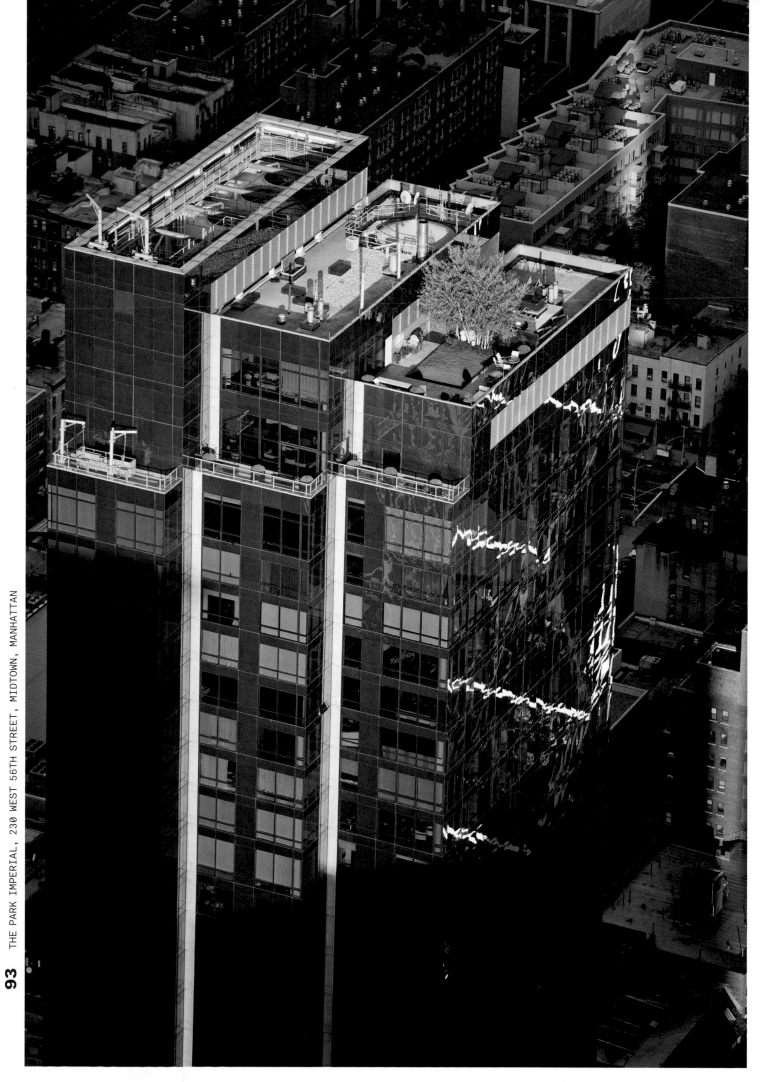

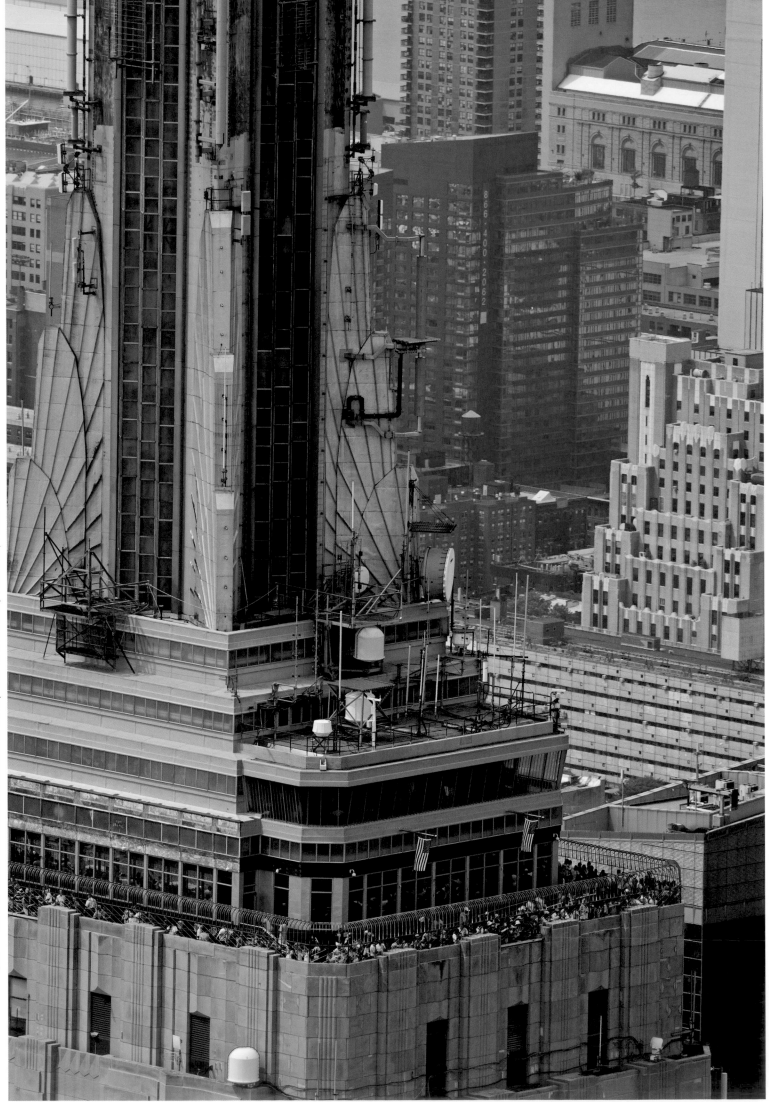

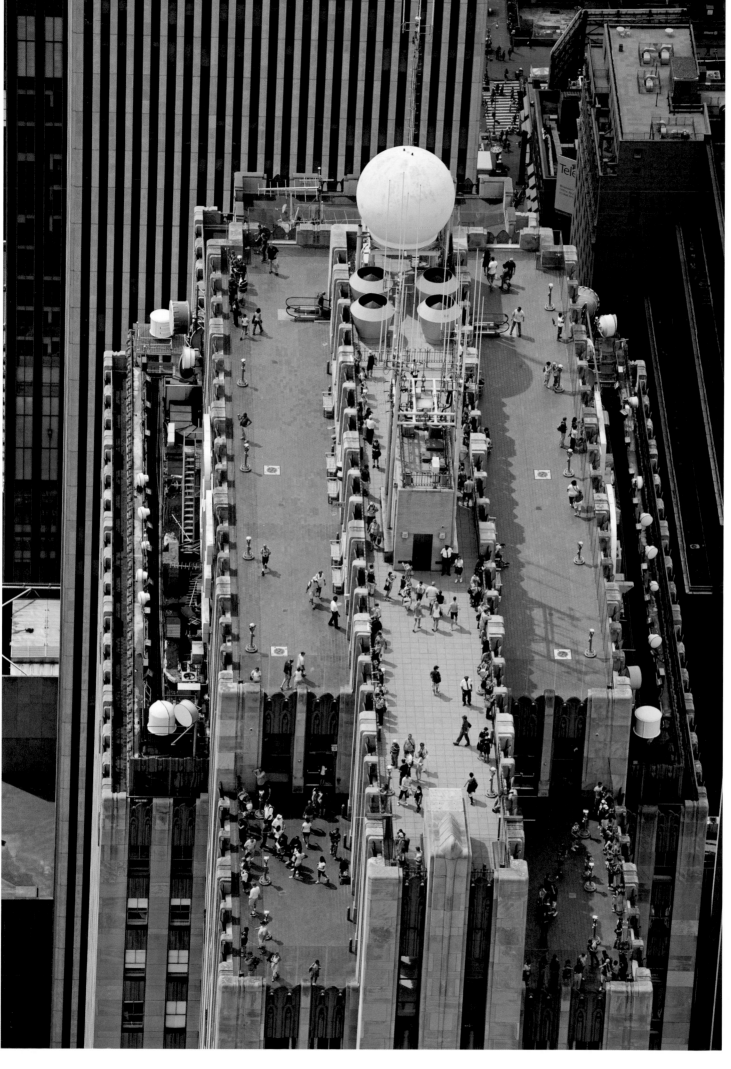

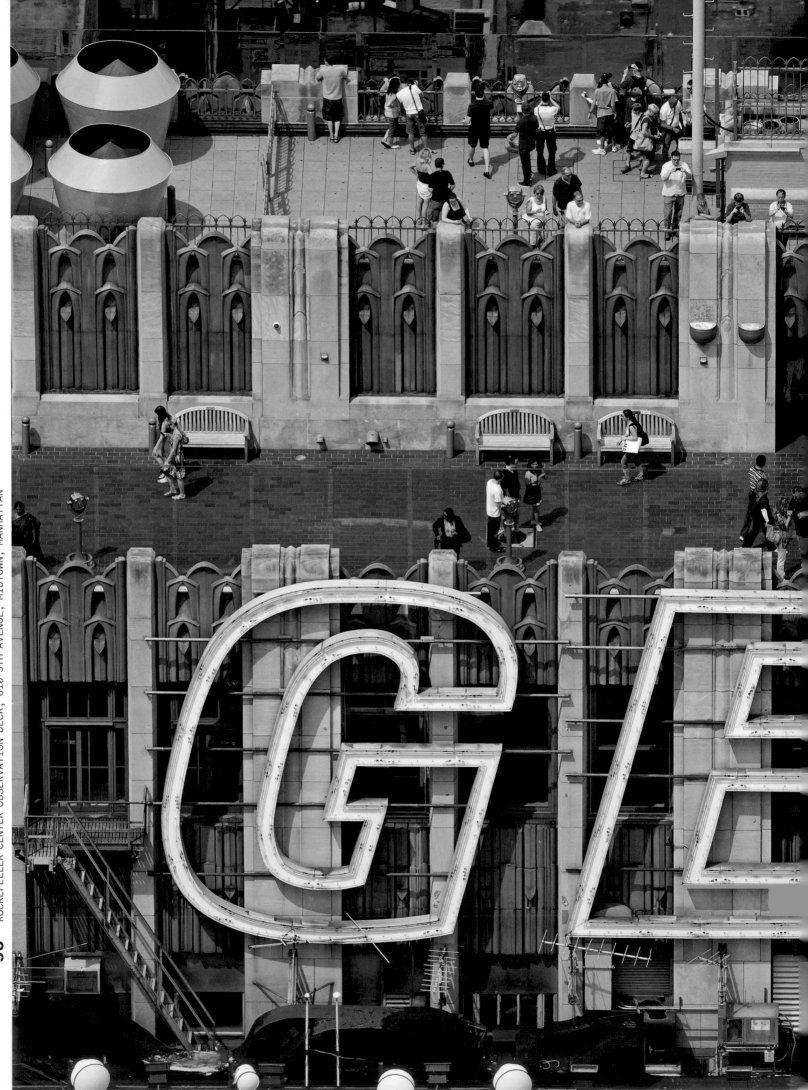

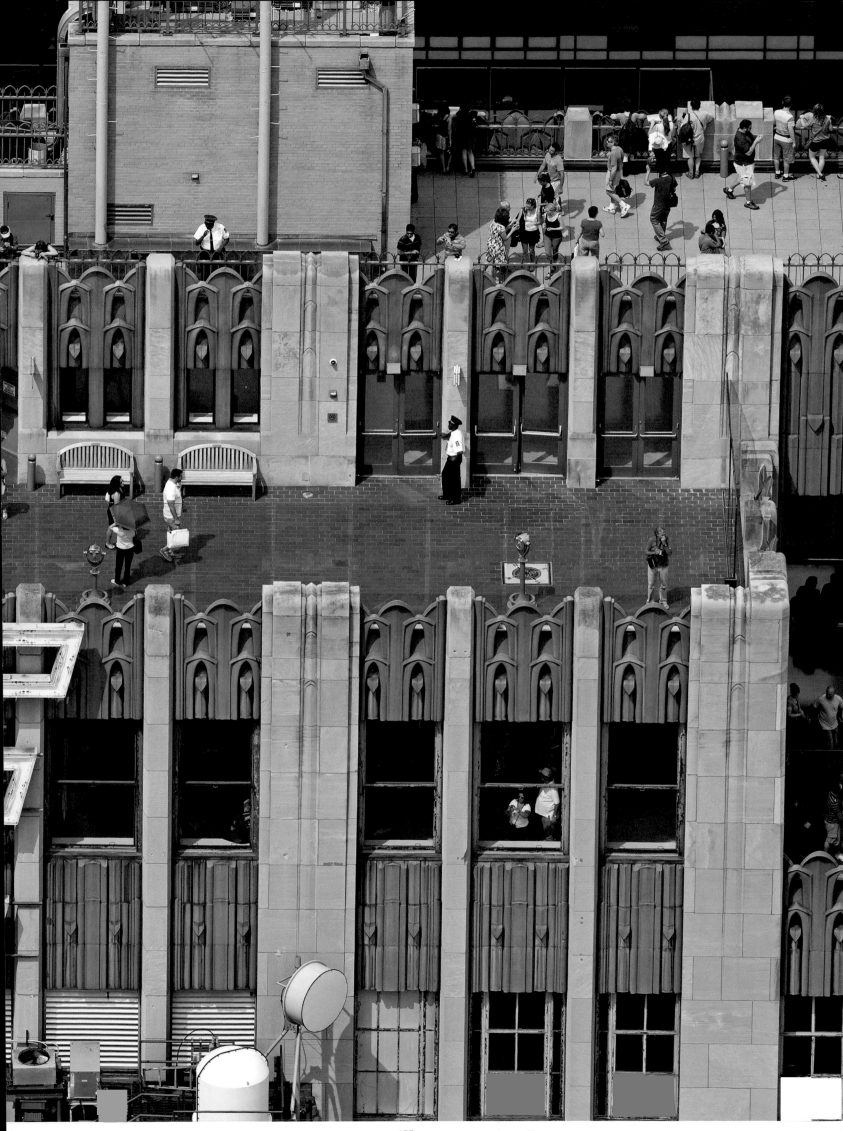

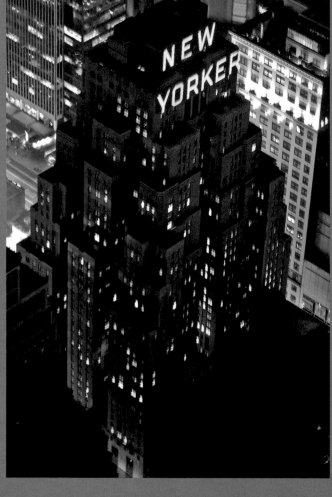

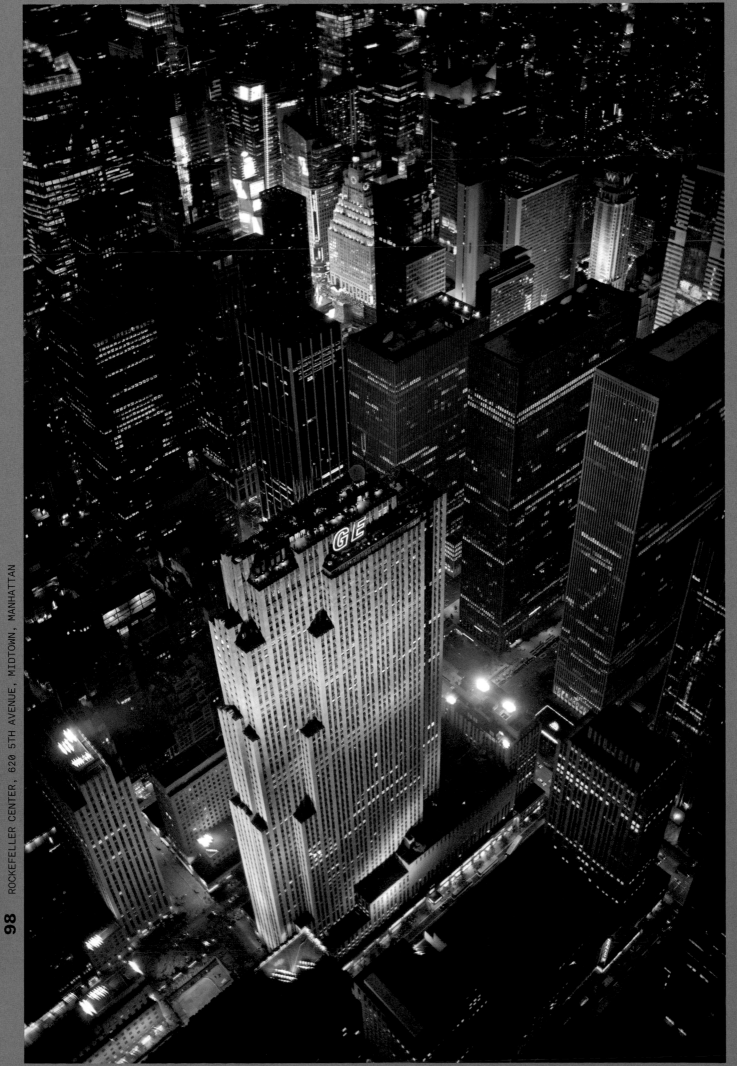

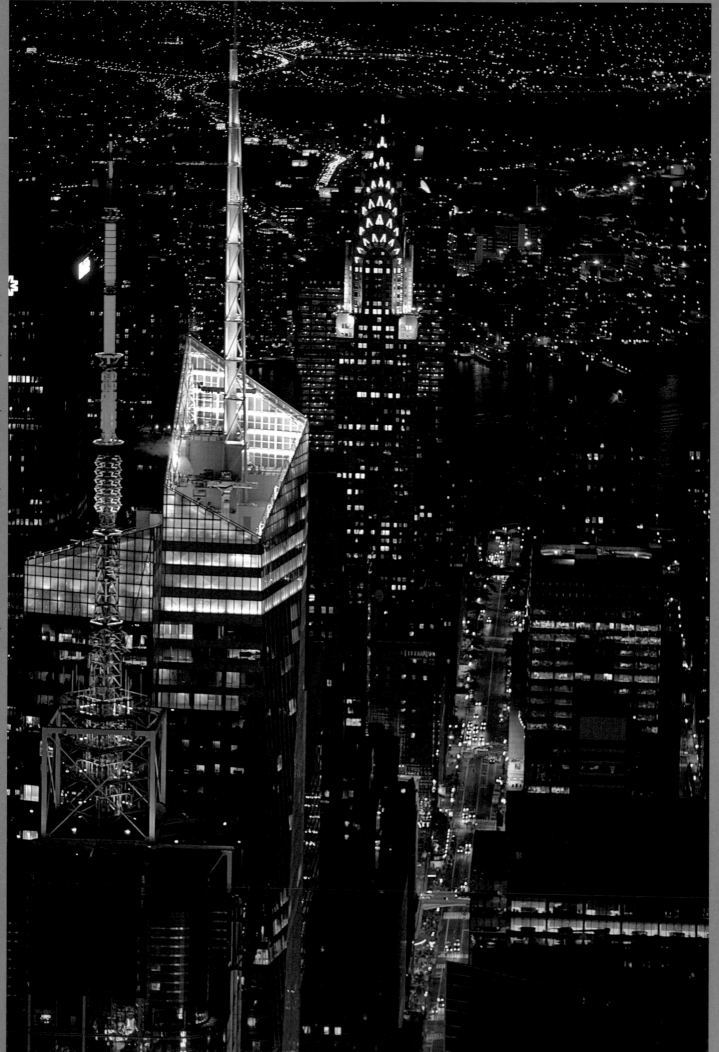

100 EMPIRE STATE BUILDING, 350 5TH AVENUE, MIDTOWN, MANHATTAN

101 BANK OF AMERICA TOWER, 115 WEST 42ND STREET, TIMES SQUARE, MANHATTAN

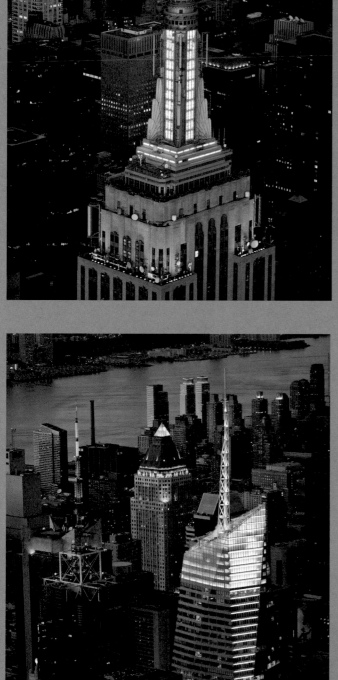

102 CHRYSLER BUILDING, 405 LEXINGTON AVENUE, MIDTOWN, MANHATTAN

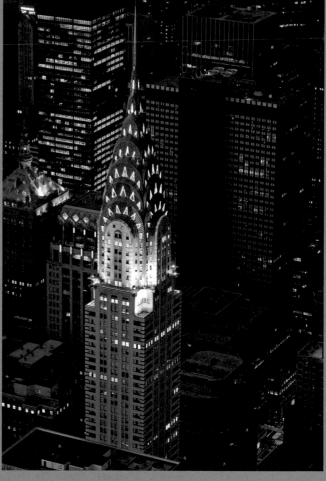

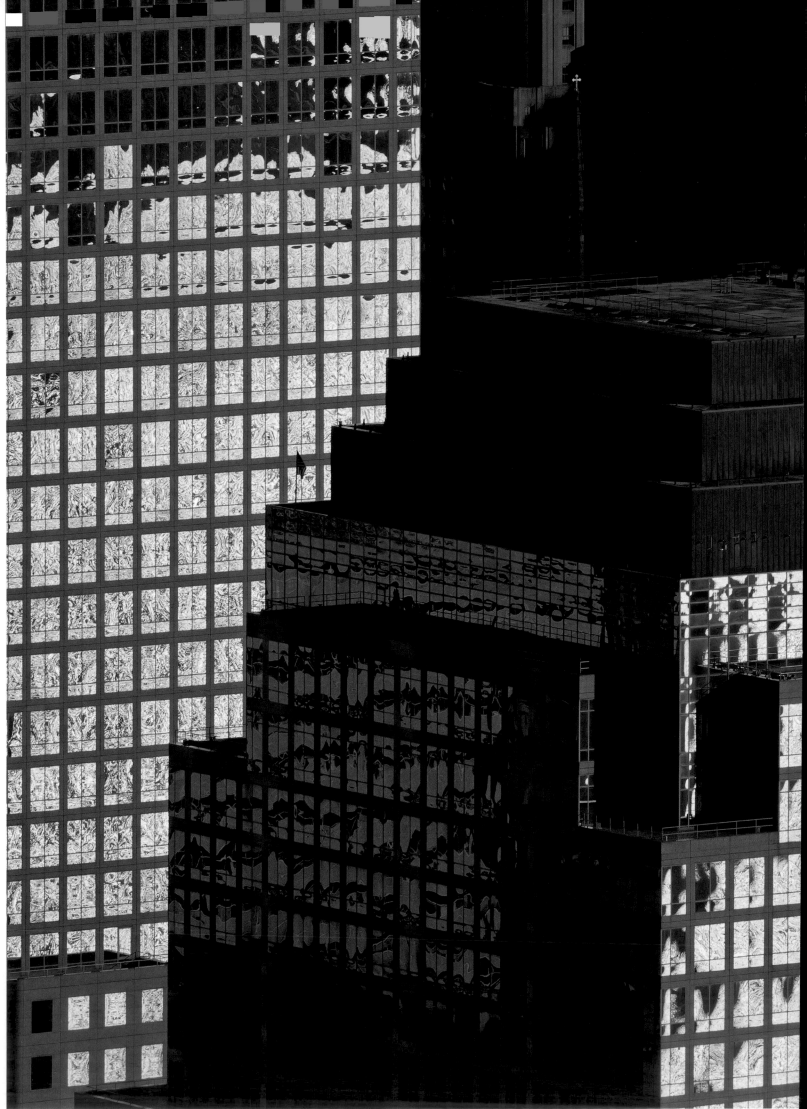

105 WORLD FINANCIAL CENTER, 1 VESEY STREET, FINANCIAL DISTRICT, MANHATTAN

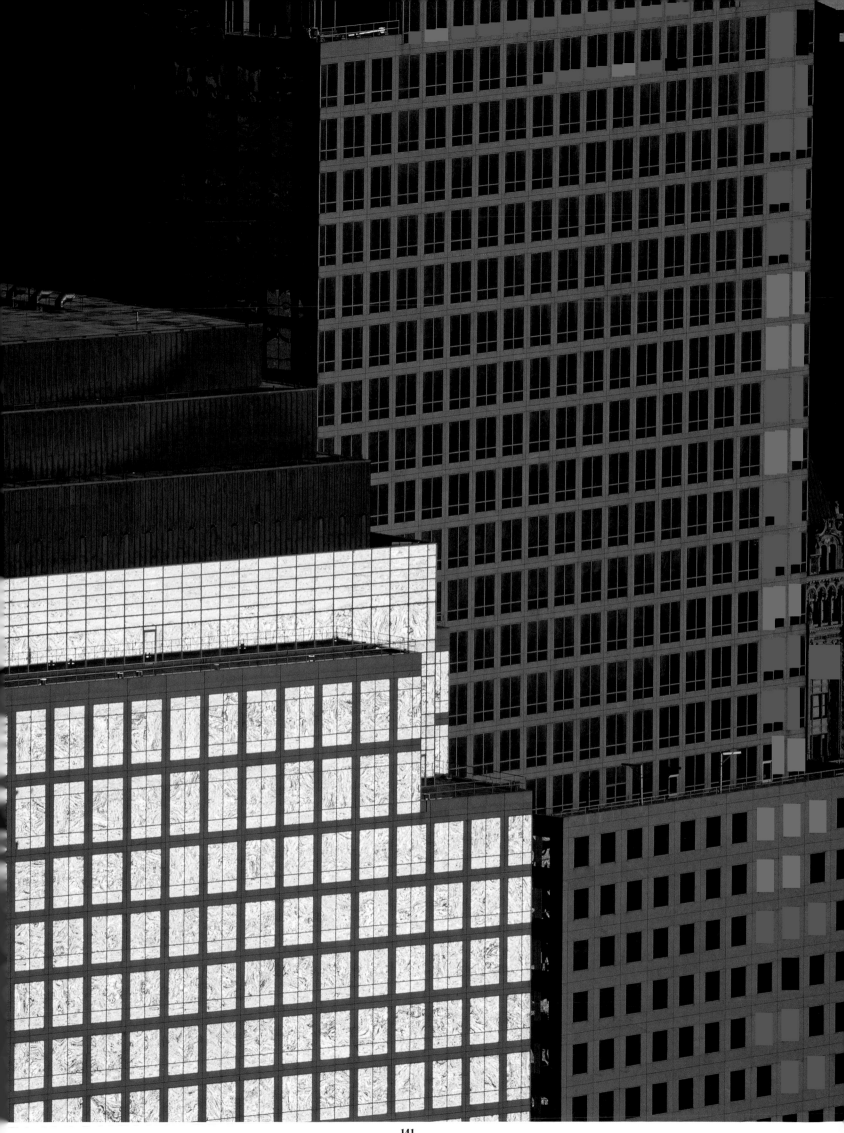

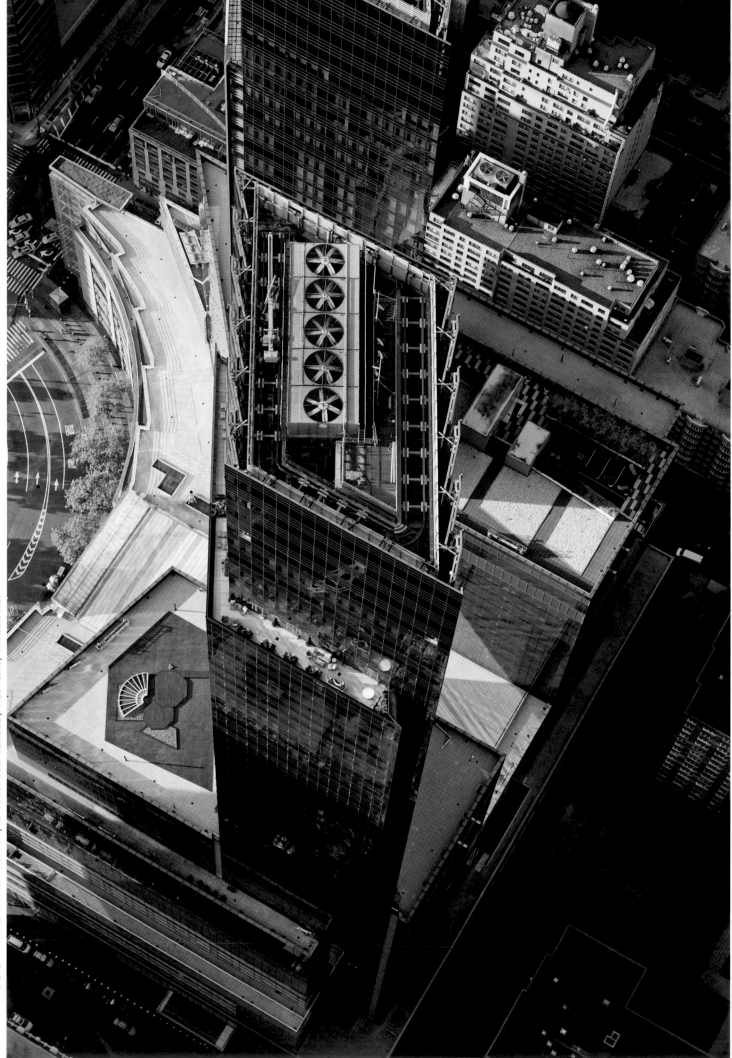

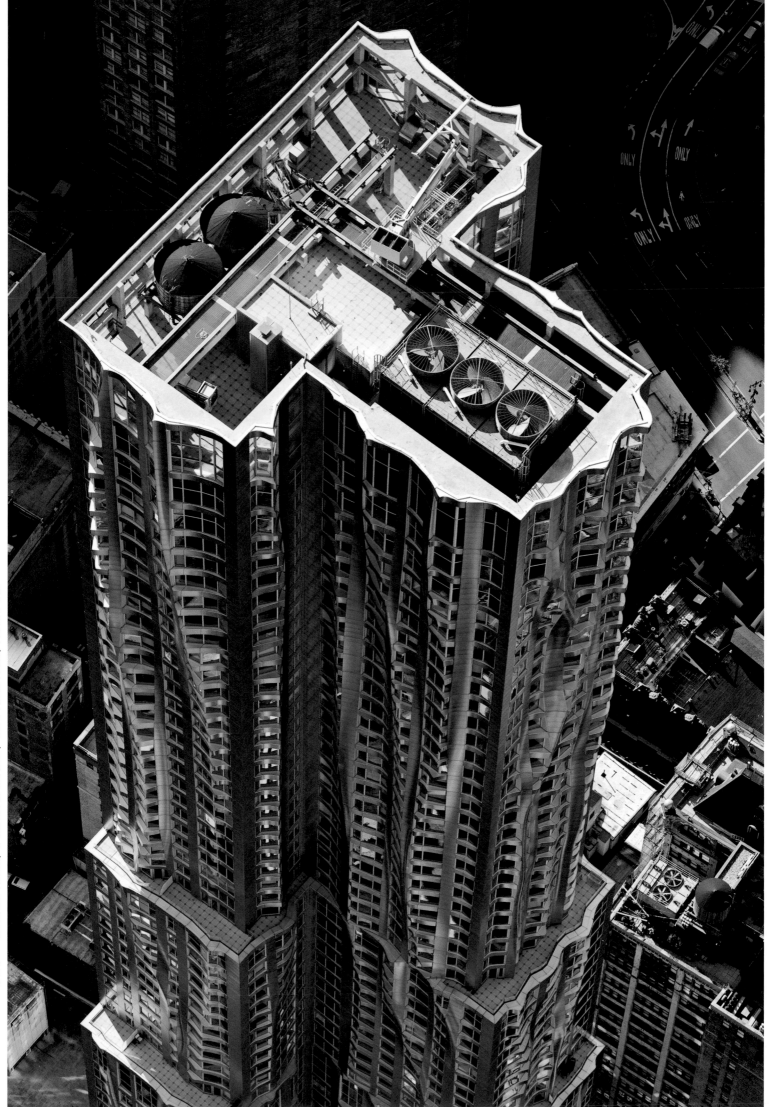

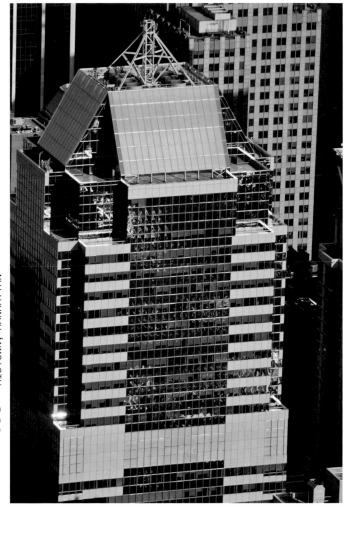

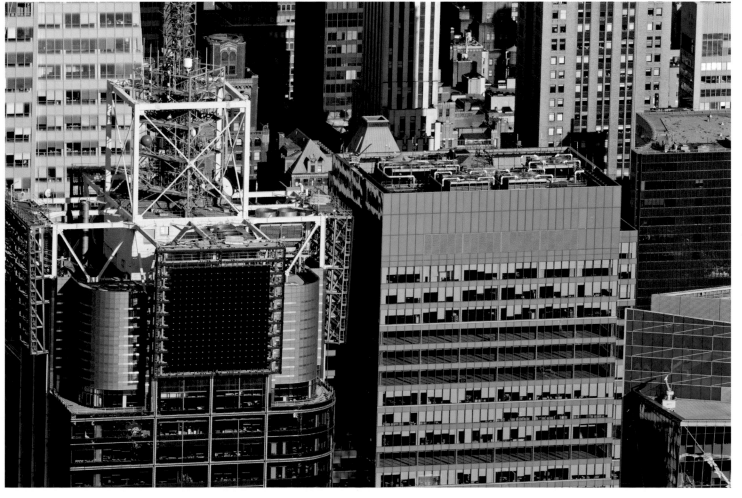

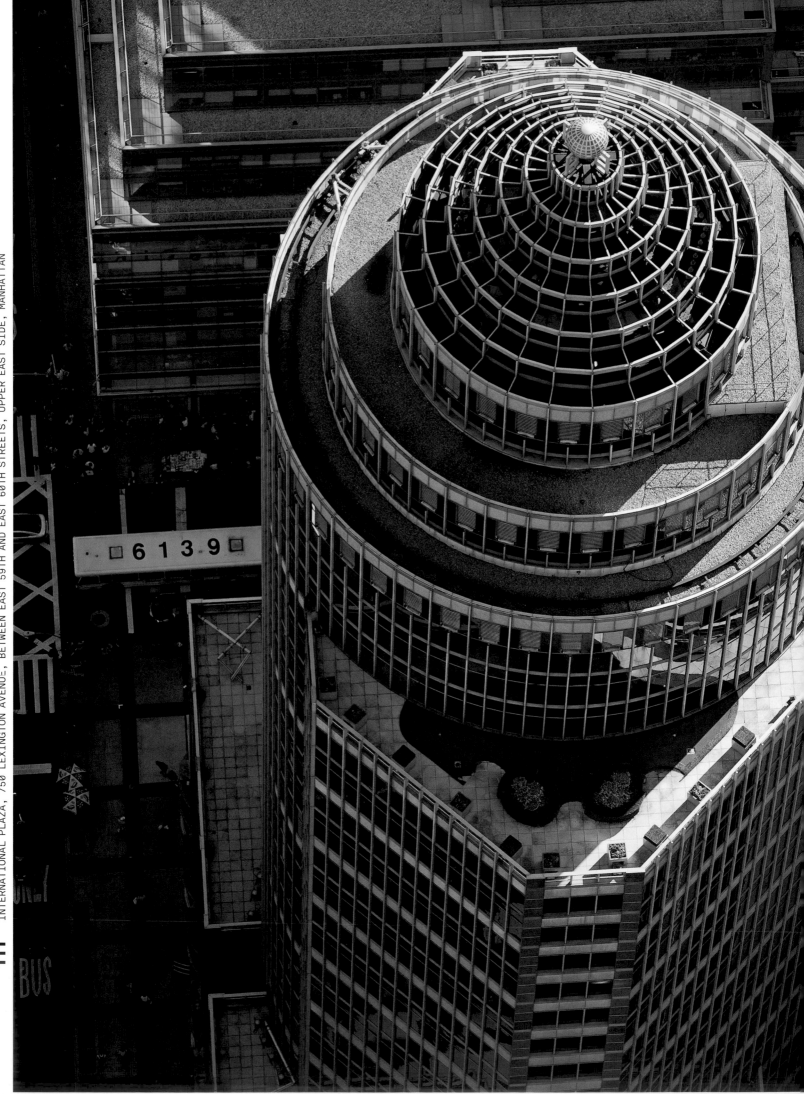

111 INTERNATIONAL PLAZA, 750 LEXINGTON AVENUE, BETWEEN EAST 59TH AND EAST 60TH STREETS, UPPER EAST SIDE, MANHATTAN

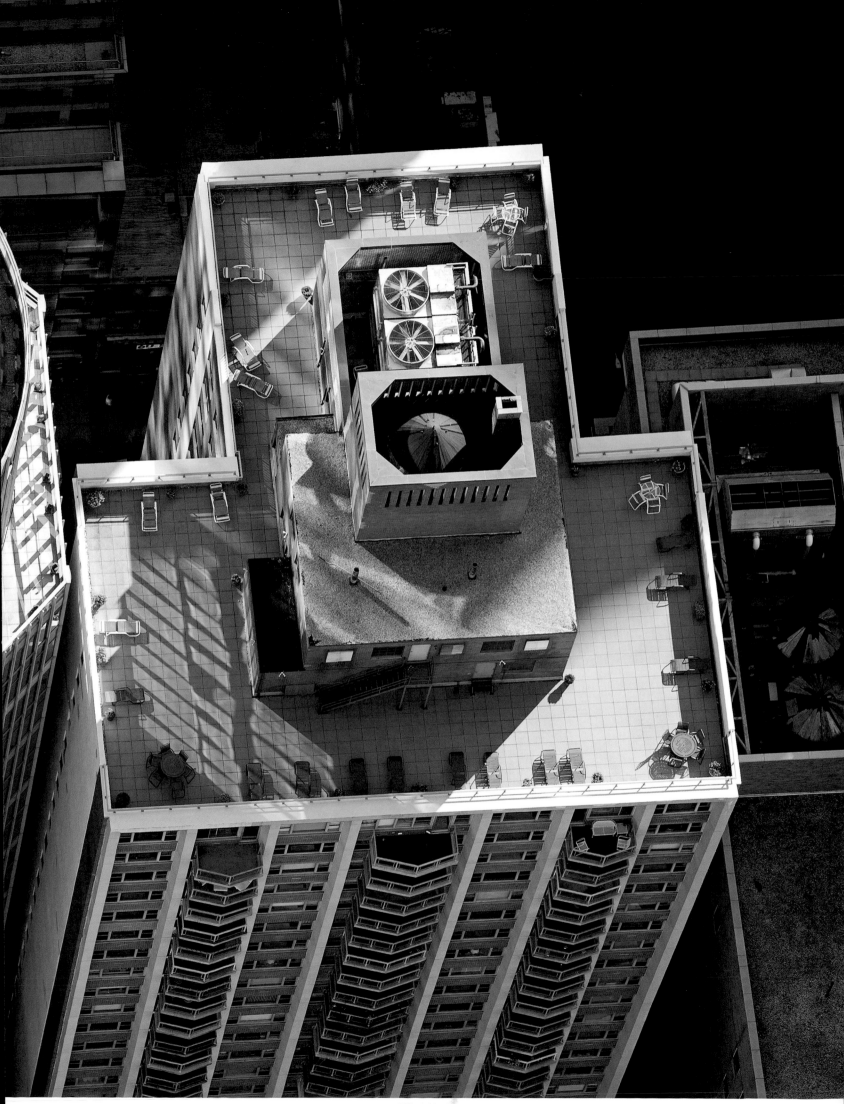

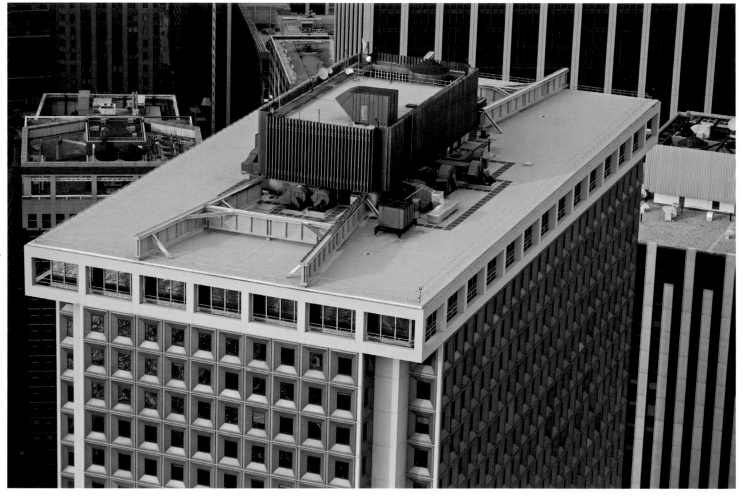

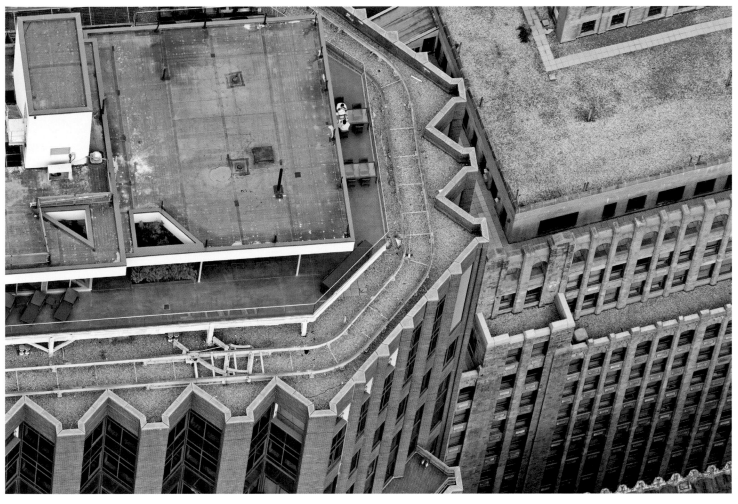

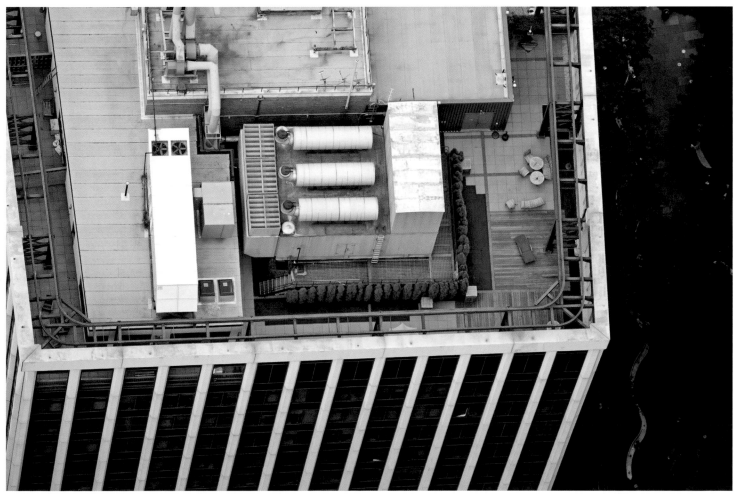

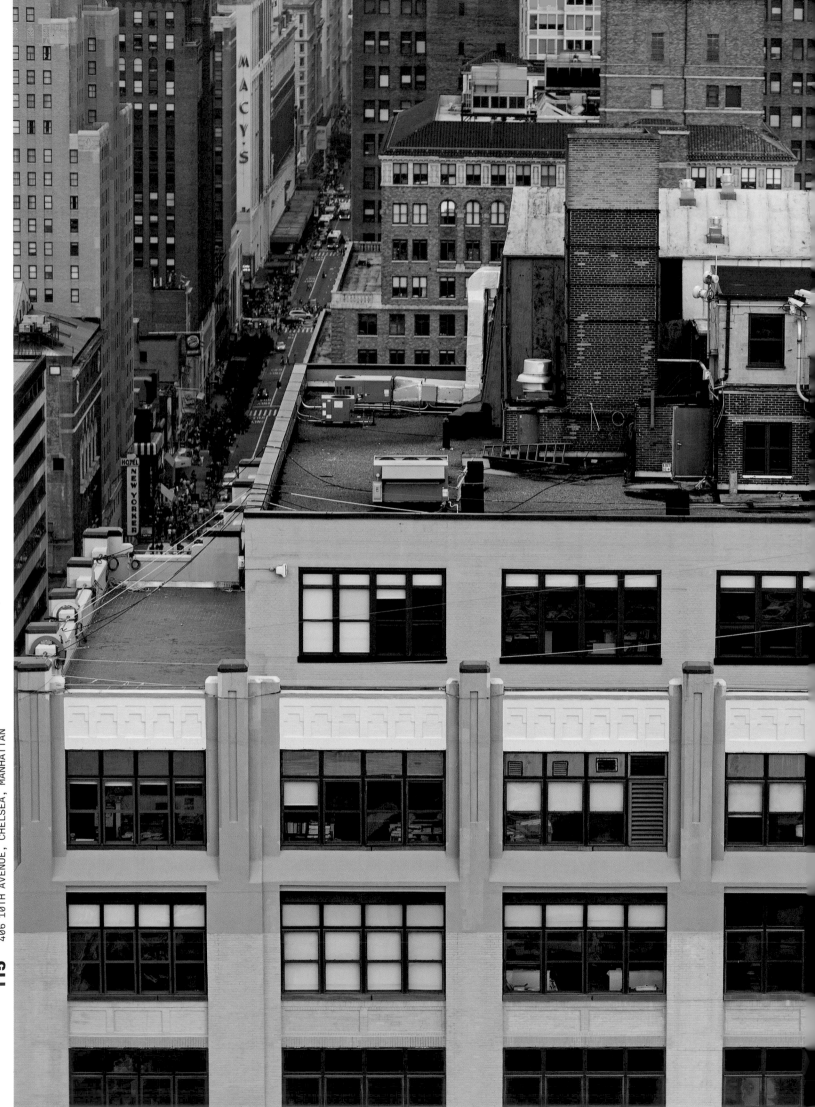

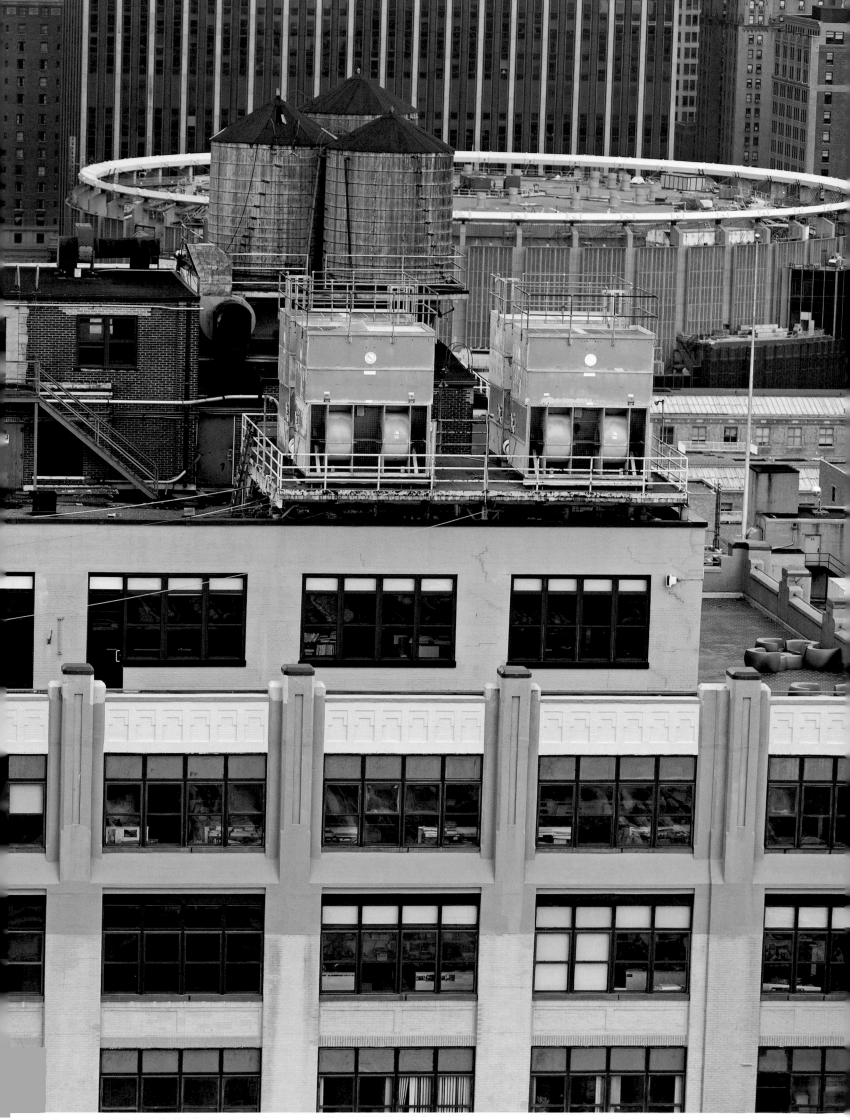

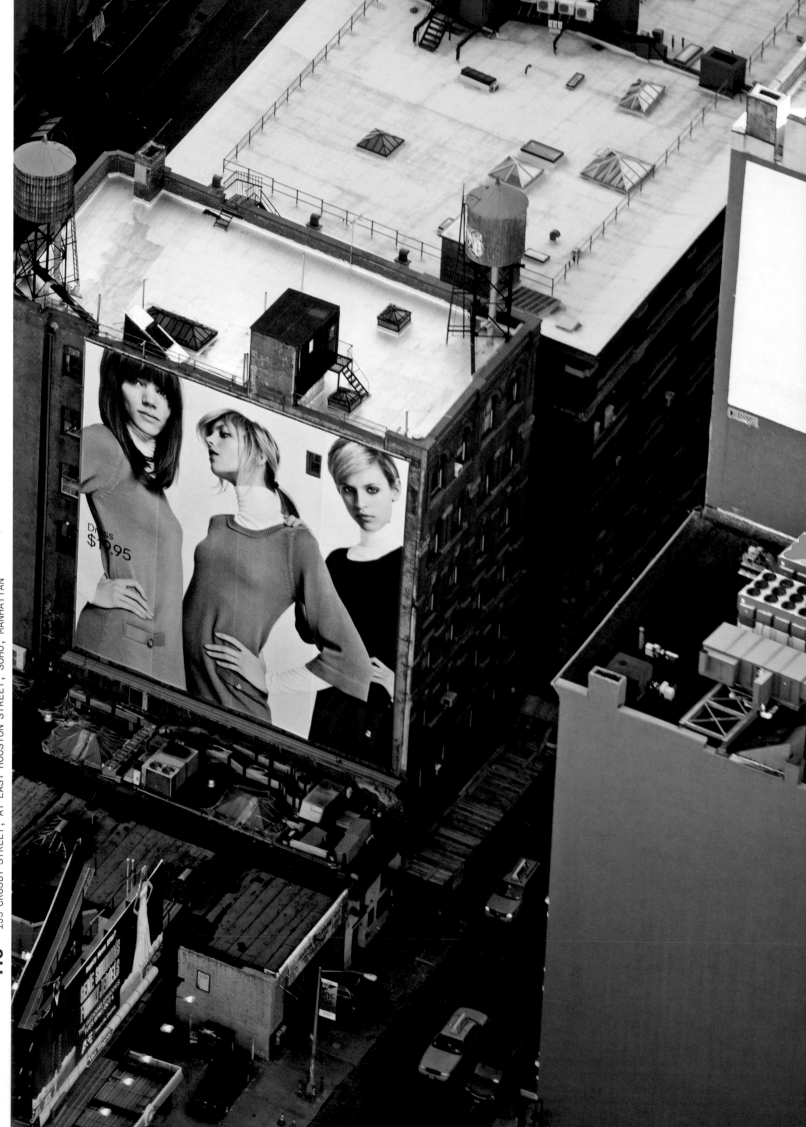

Energy

In August 2011 I was photographing rooftops just north of Brooklyn's Gowanus Canal in early-morning light. I was looking east into the sun, toward Prospect Park, and was almost blinded by the silvery-white reflections from all the rooftops. I wondered, "Were these rooftops always white?"

The city's black asphalt roofs had either been replaced with white membranes or had been painted white. During the years that I had been flying over New York, the roofs had gone from black to a black-and-white checkerboard. But the checkerboard was suddenly gone. The transition to a city of mostly white roofs had happened surprisingly quickly, especially since it involved the efforts of tens of thousands of building owners. It is one of the most dramatic displays of incremental change to the built environment that I have seen from the air.

This move to white roofs is significant because black roofs can reach a temperature of 160 degrees in the summer, collectively lifting the ambient temperature of the city by as much as six degrees. A white roof reflects back into space ninety percent of the sun's rays that would otherwise be turned into convective heat energy if absorbed by a dark roof surface. An added incentive to convert to a white roof is that it reduces the cost of air-conditioning the rooms below. Reduced air-conditioning also means less noise and heat emissions from rooftop compressors, making rooftops that much more pleasant.

New York's conversion to white roofs demonstrates how relatively small, individual actions can collectively change the comfort level of an entire city. It is human nature to dismiss small changes as insignificant, especially when they require us to change our own behavior for the public good. I know I often question whether it really makes a difference when I go out of my way to turn off an unneeded light.

I have also questioned the impact of solar arrays that look miniscule on top of skyscrapers. While solar collectors on skyscrapers could be construed as tokenism or greenwashing, I like to think they represent the beginning of incremental change, in conjunction with the smattering of photovoltaic collectors that have been installed around the city. It is remarkable seeing industrial warehouses completely covered with solar panels in Brooklyn and Queens. This trend could well follow the same trajectory as the white-roof phenomenon, since photovoltaic technology is continuing to improve while its cost goes down. New York City has an estimated fourteen thousand acres of rooftops, of which a good portion could be used for solar collectors with minimal impact.

Another, simpler solar technology is to "daylight" buildings with skylights, daylight pipes, and light wells. These devices bring natural light into a building, reducing the need for artificial lighting. Natural light has been proven to have beneficial mood and health benefits and is another small component that makes the city and its buildings more habitable.

Several other energy-conservation initiatives by the city help to make urban life more pleasant: encouraging the development of green roofs, planting more than a million trees, inaugurating a hybrid taxi fleet, and designating hundreds of miles of bicycle lanes throughout the streets. Many of these programs, which make an impact through numerous small, incremental changes, will involve the rooftops of New York City, making these spaces more alive and livable. It is said that good urbanism can be measured by the happiness of a city's residents, for this is what draws people to urban areas and keeps them there.

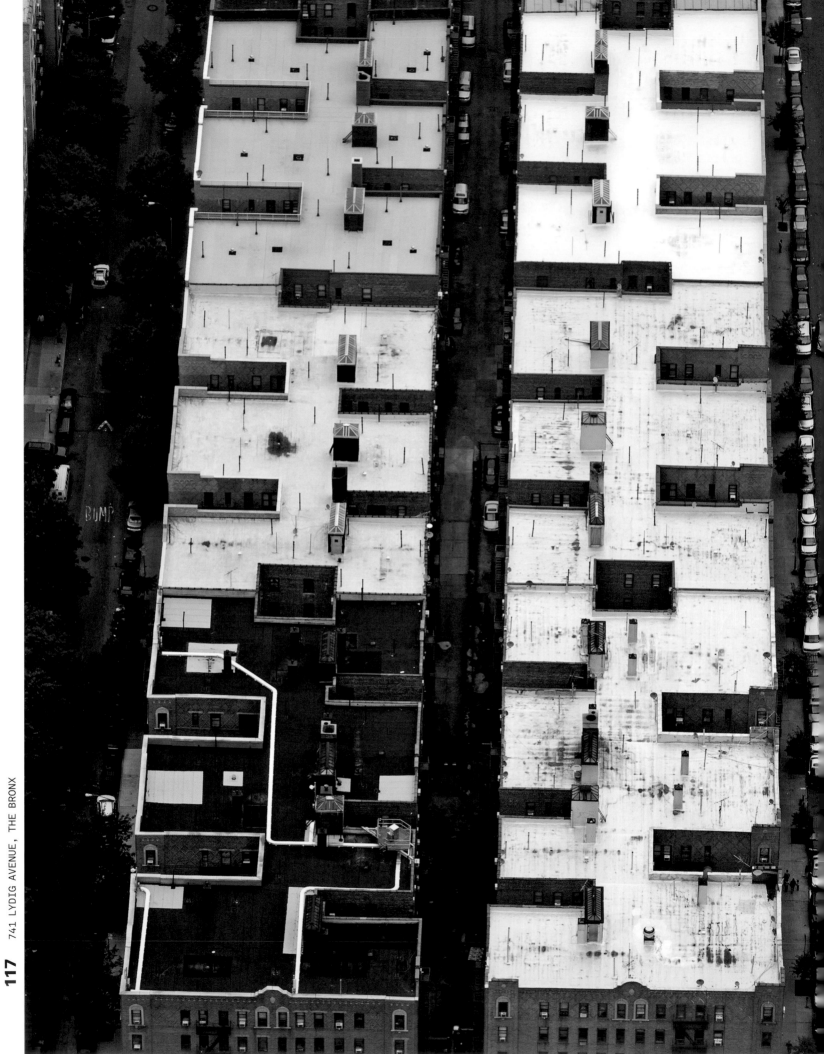

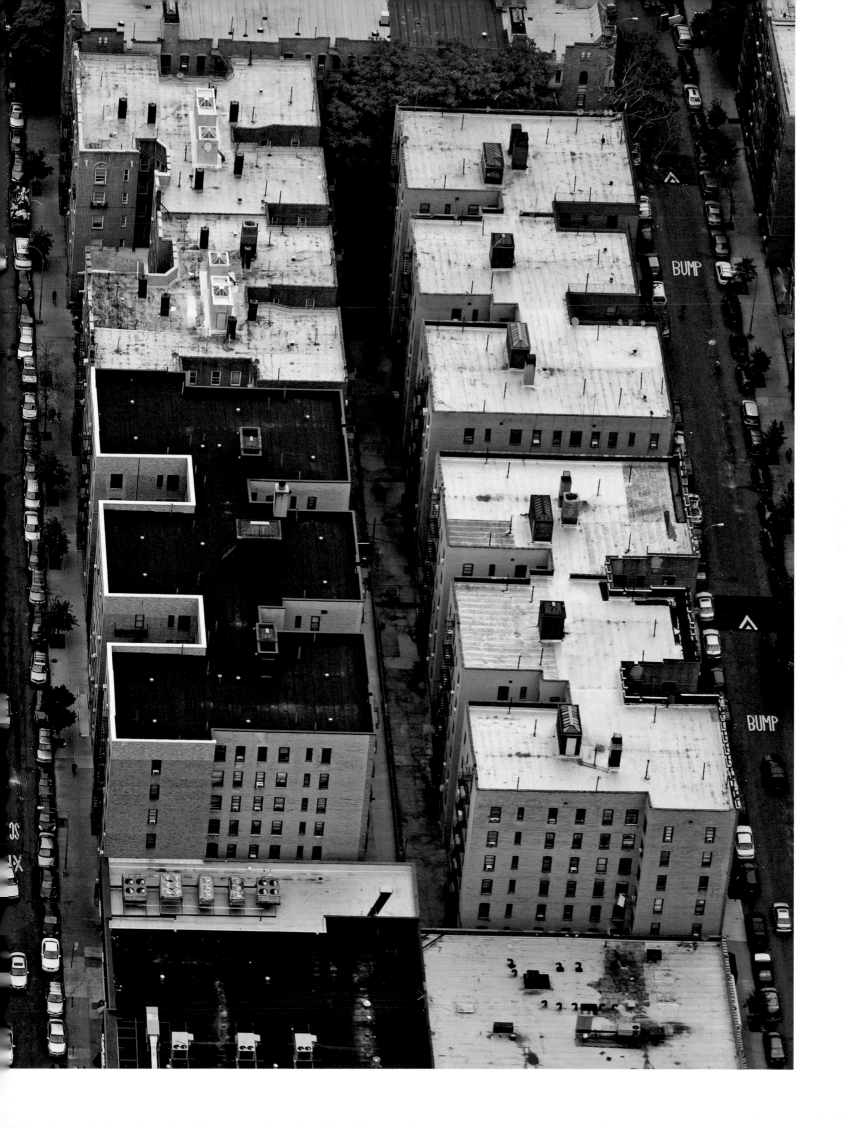

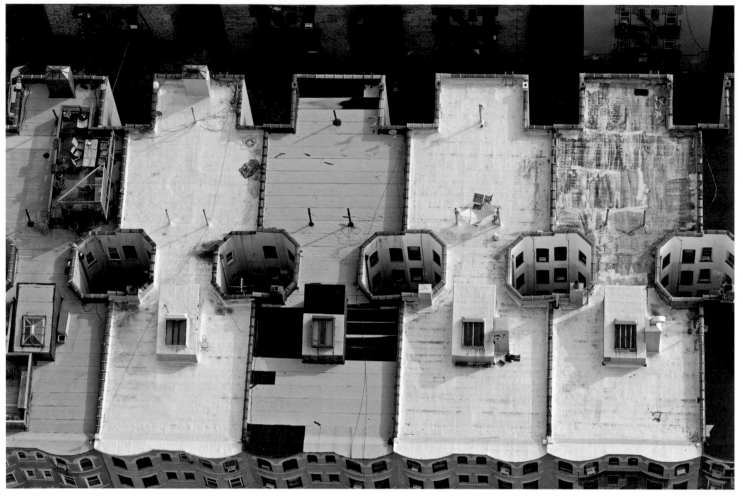

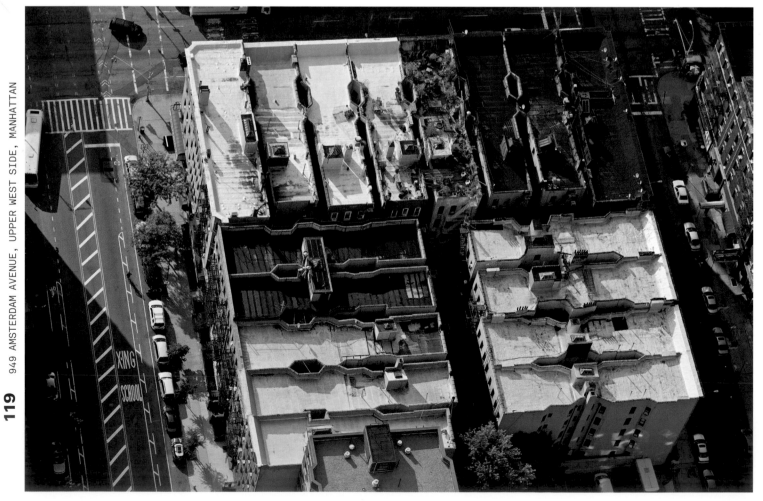

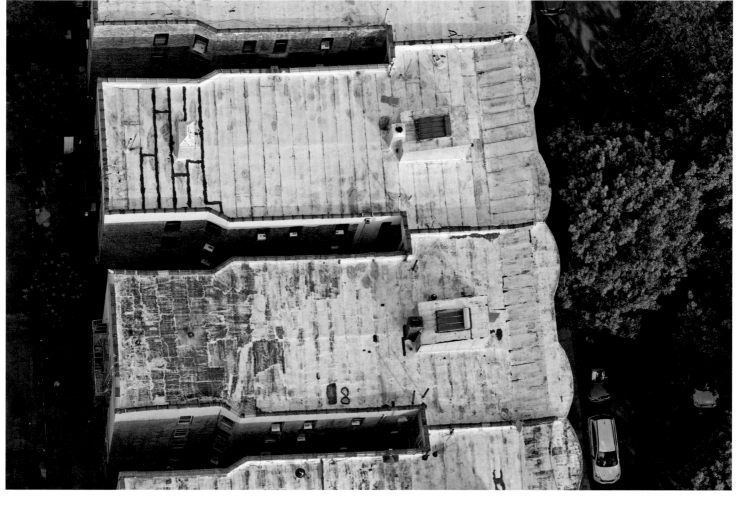

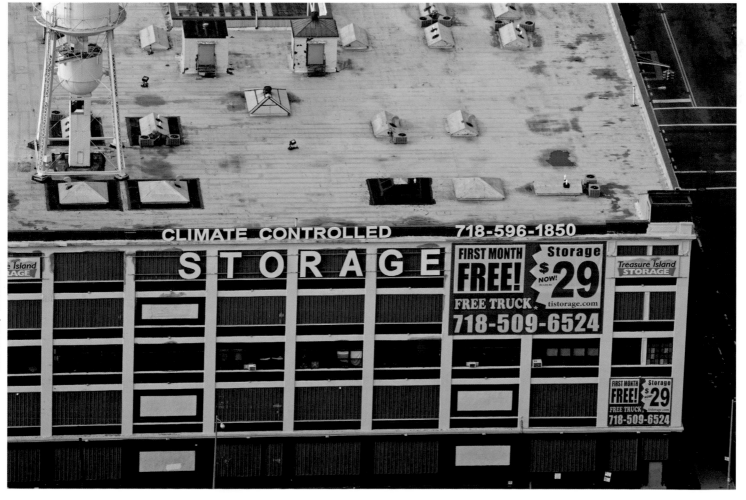

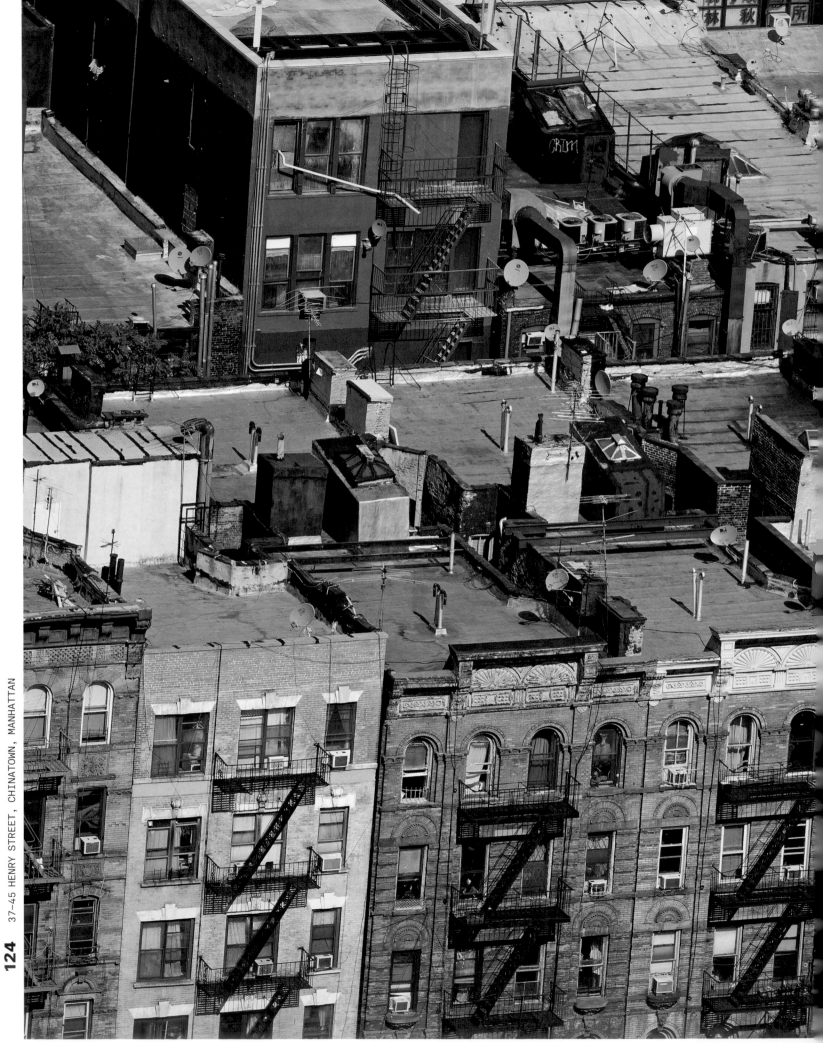

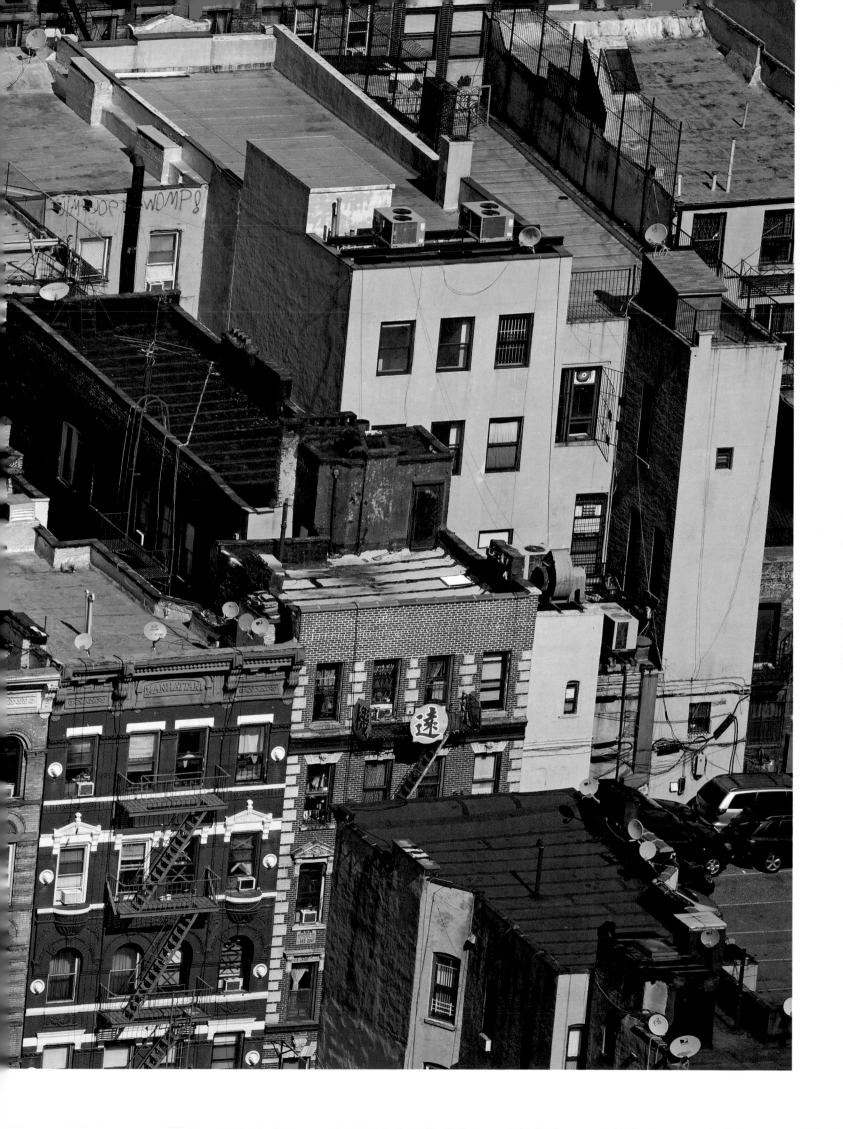

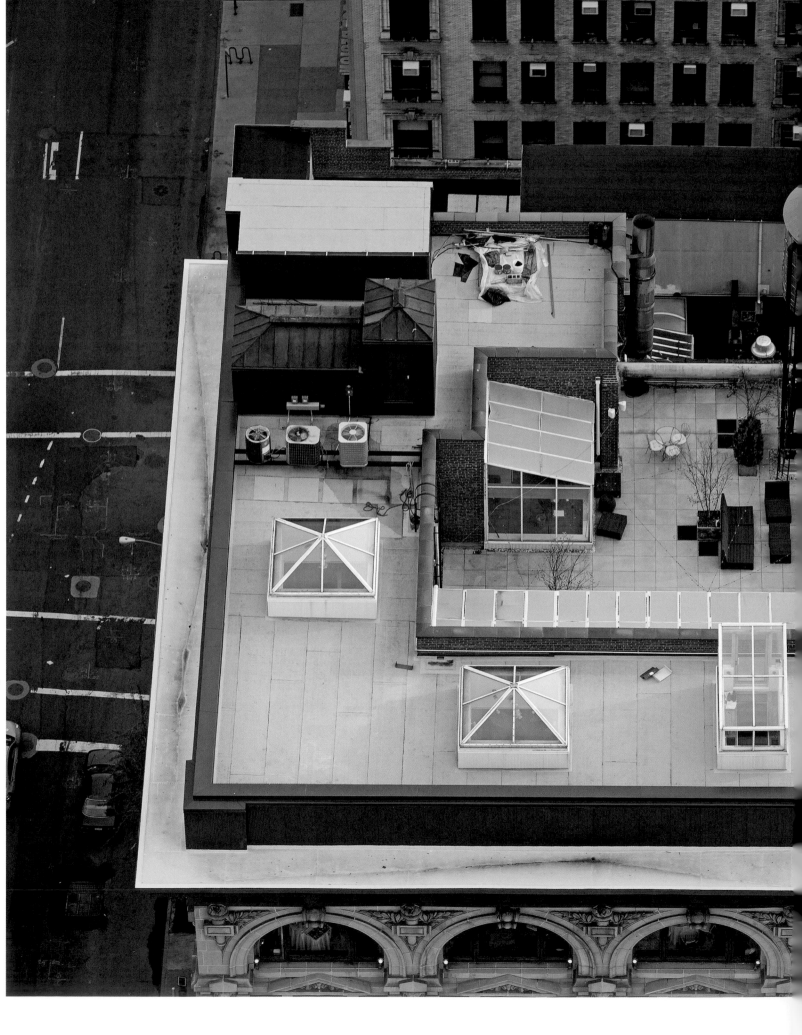

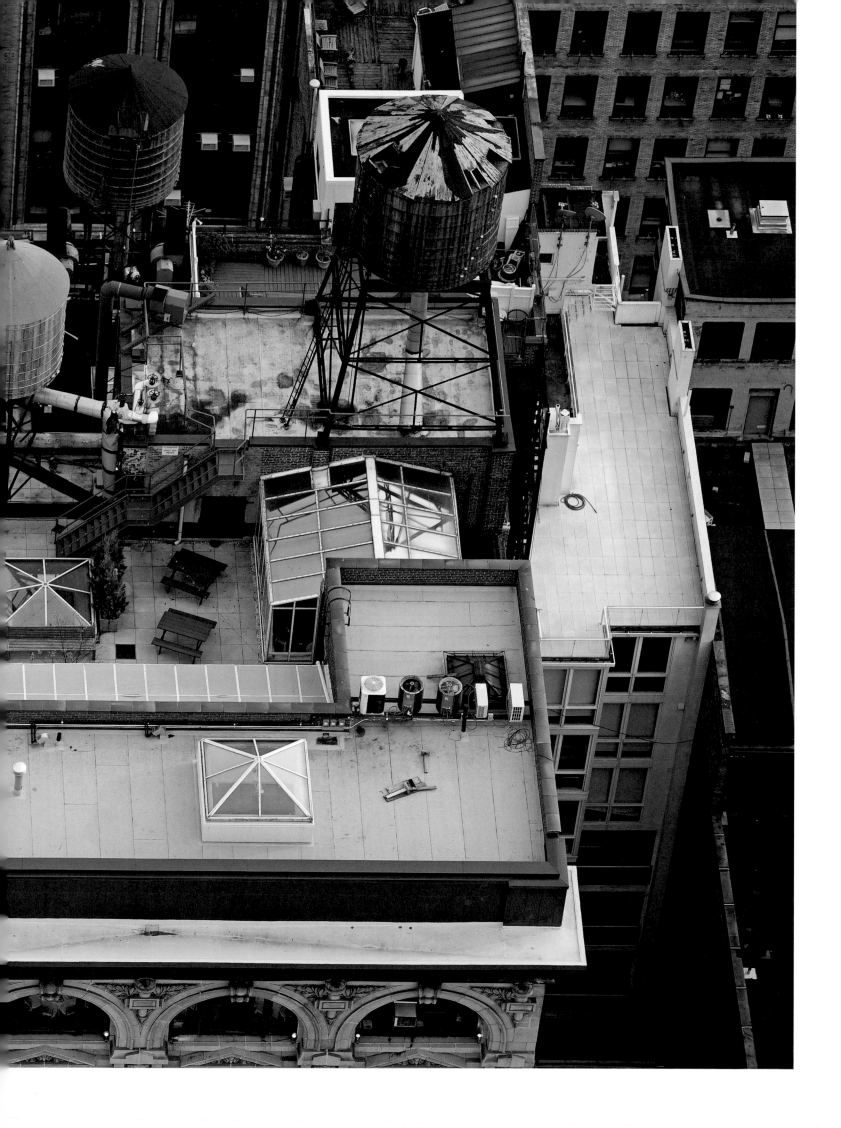

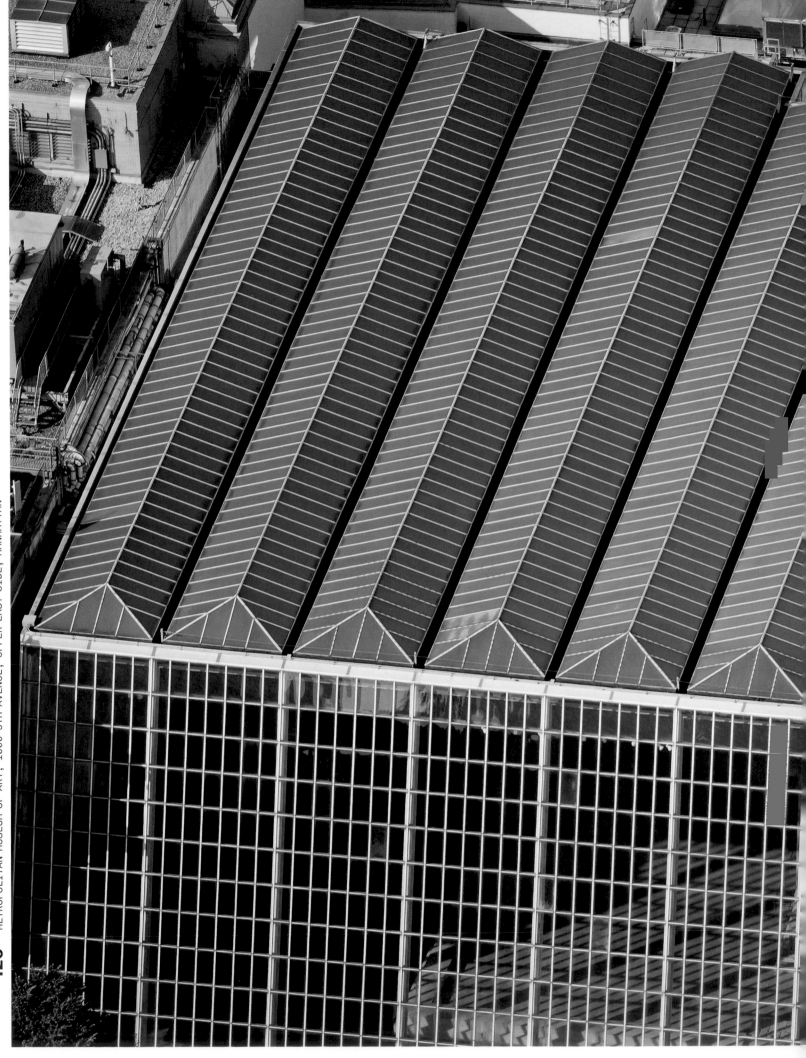

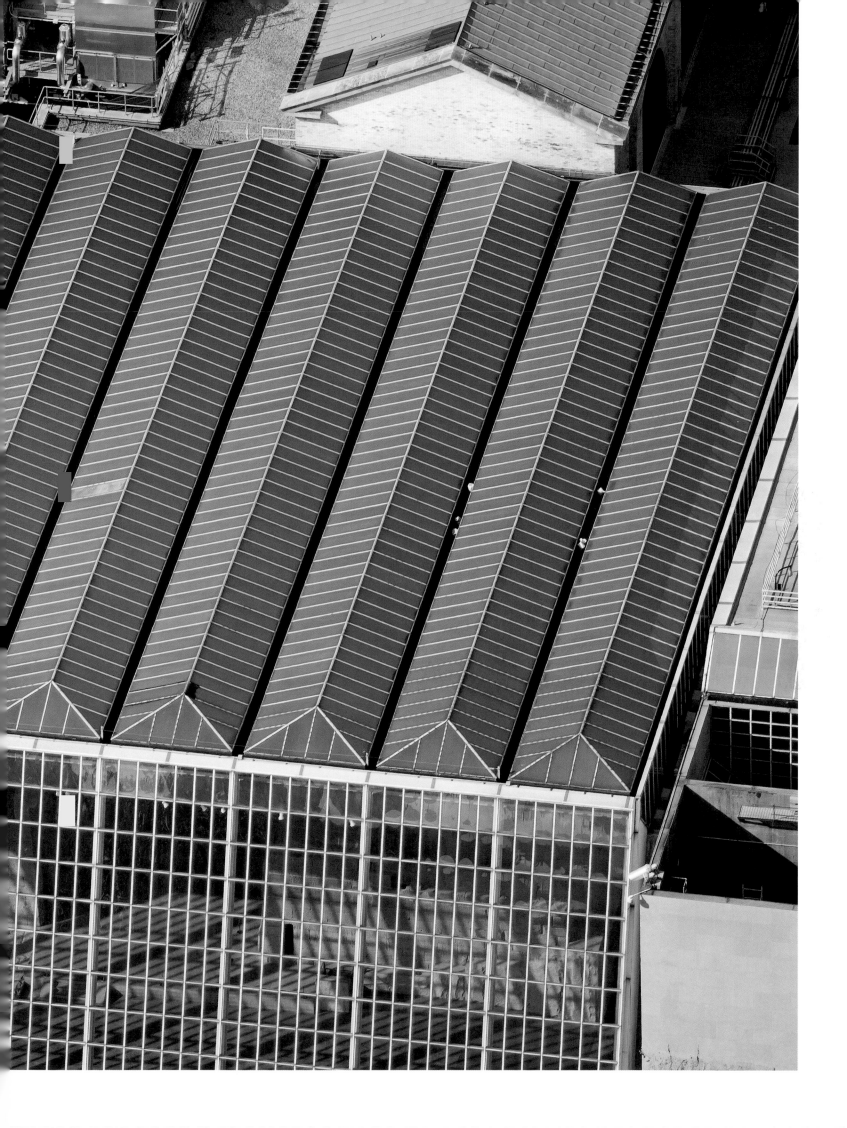

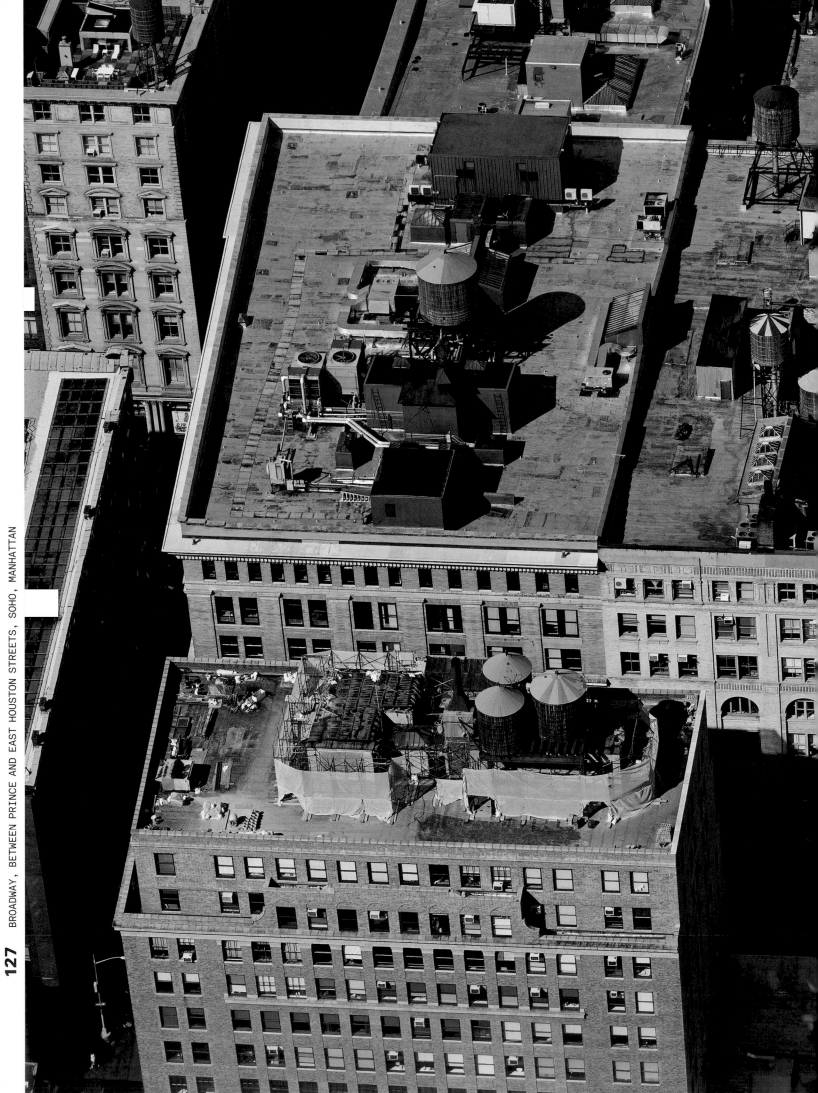

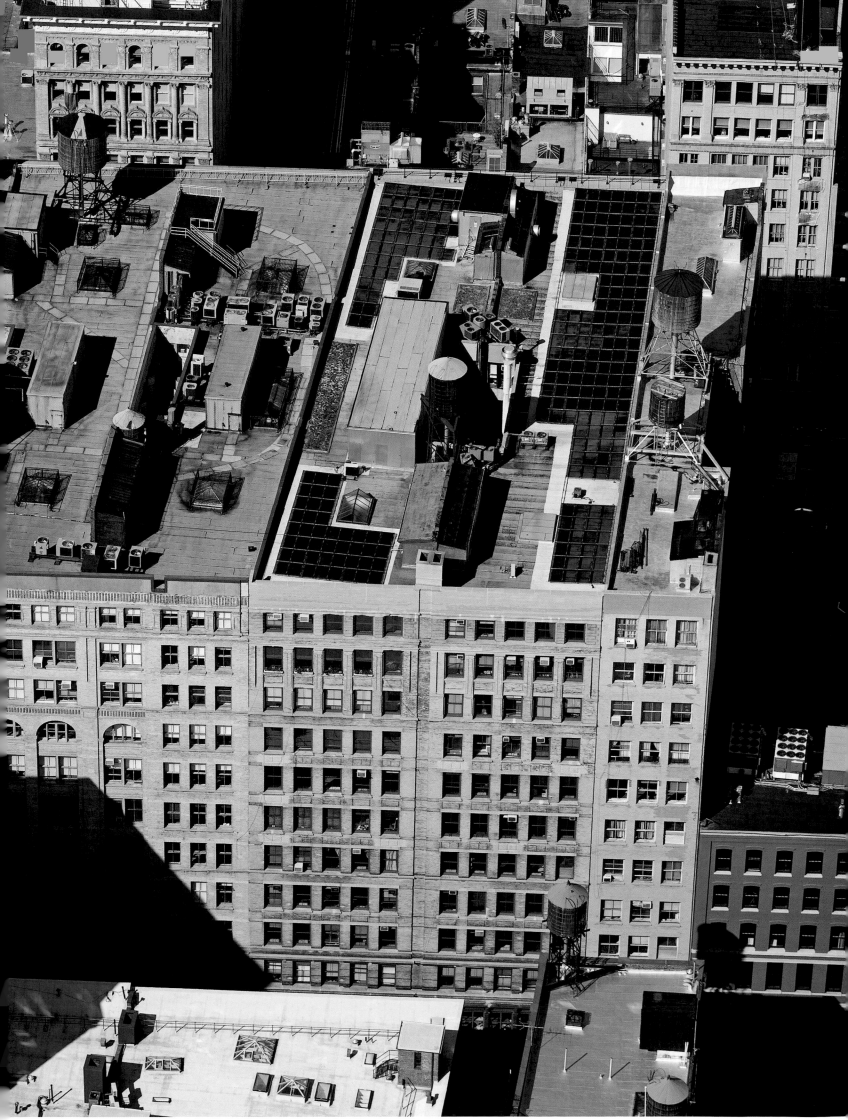

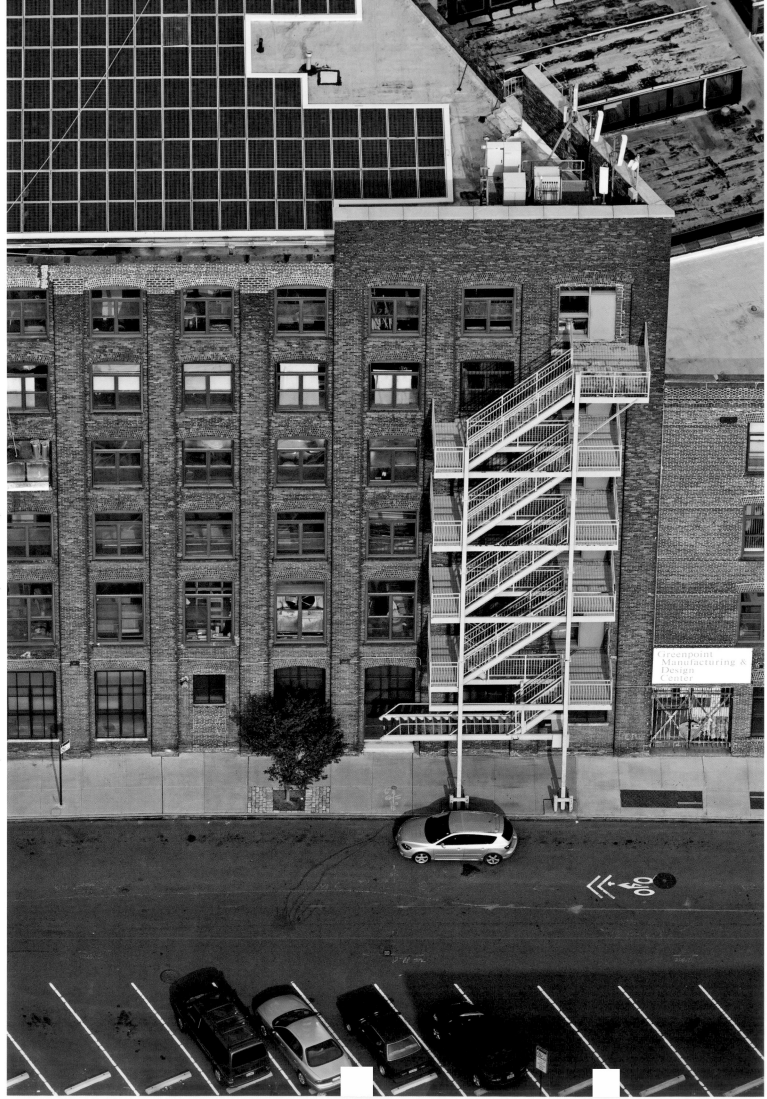

Greenpoint
Manufacturing &
Design
Center

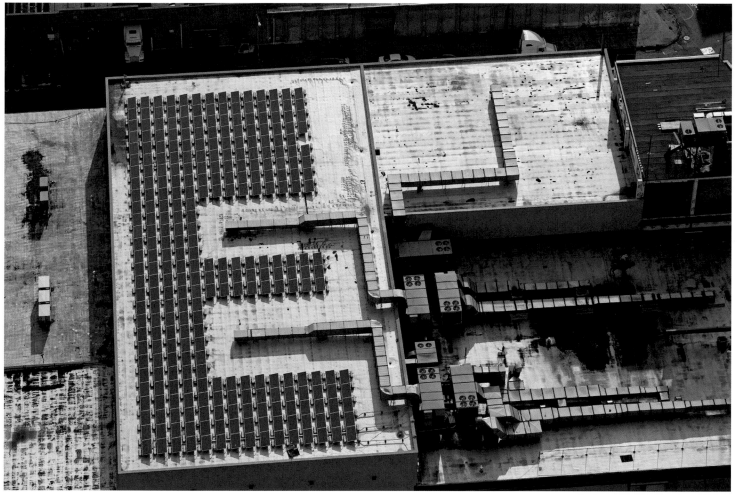

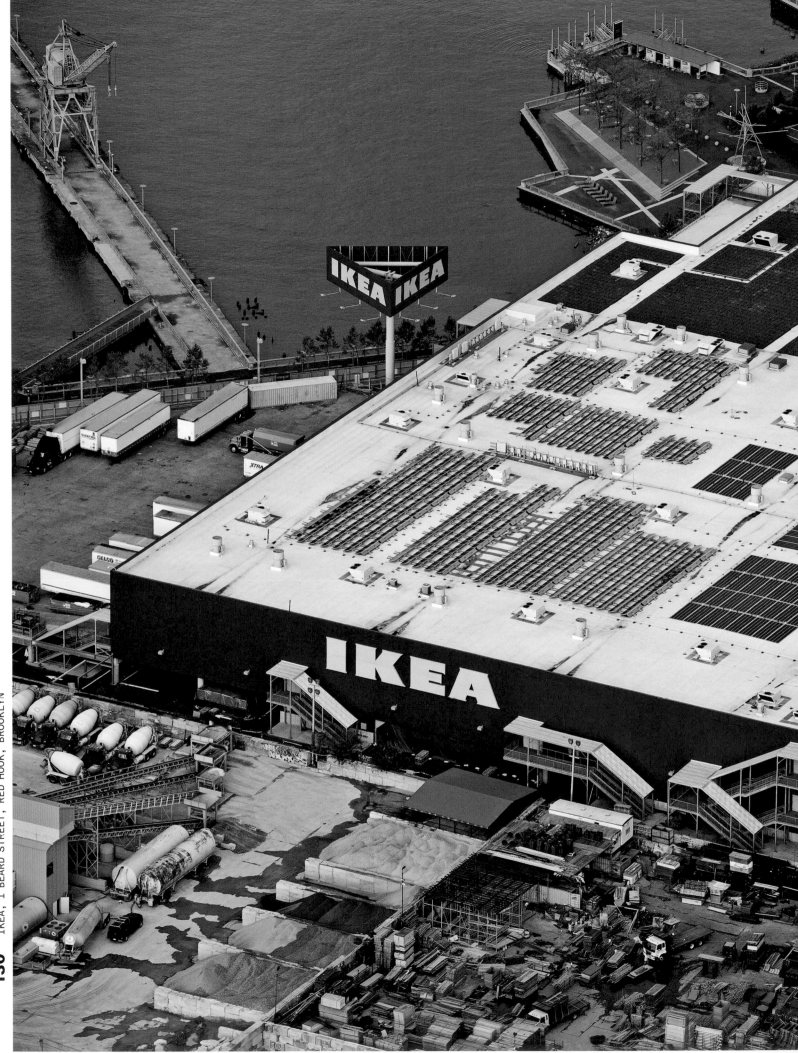

130 IKEA, 1 BEARD STREET, RED HOOK, BROOKLYN

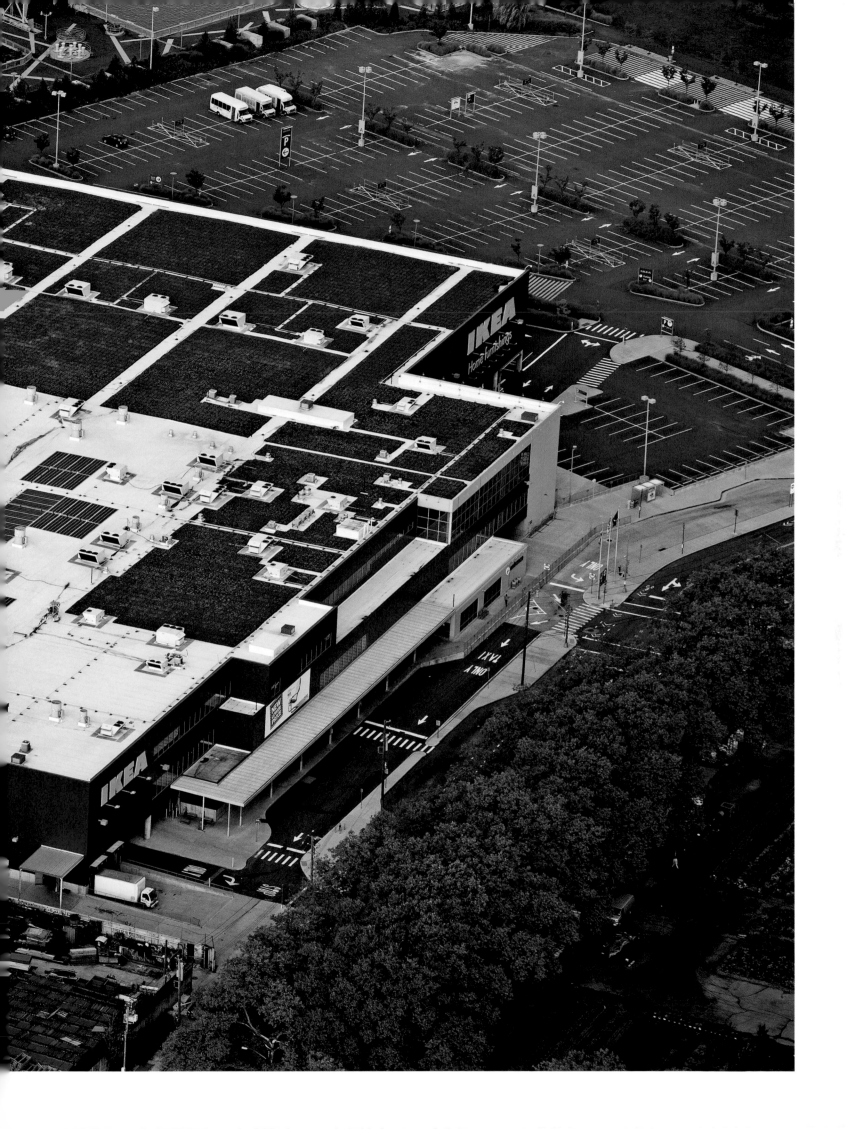

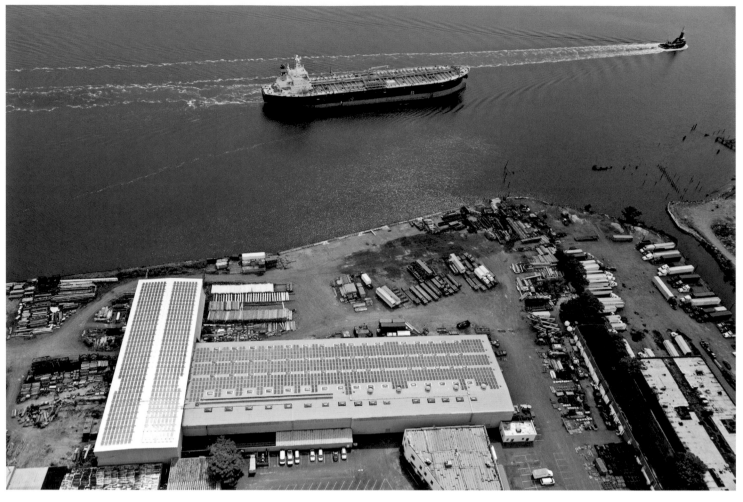

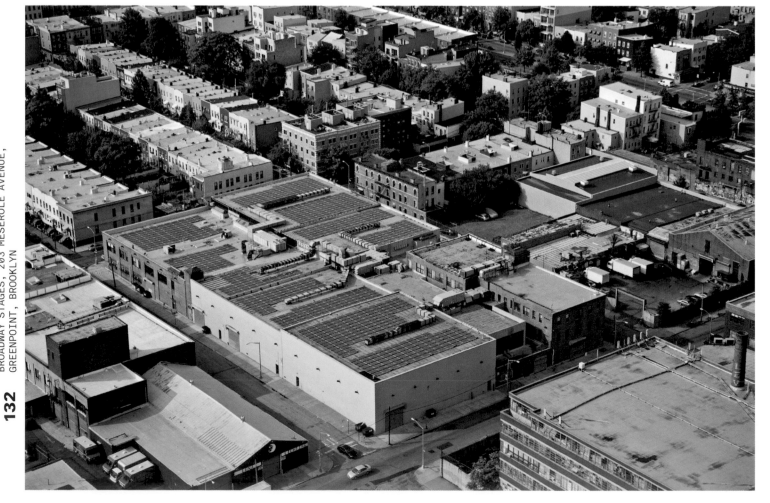

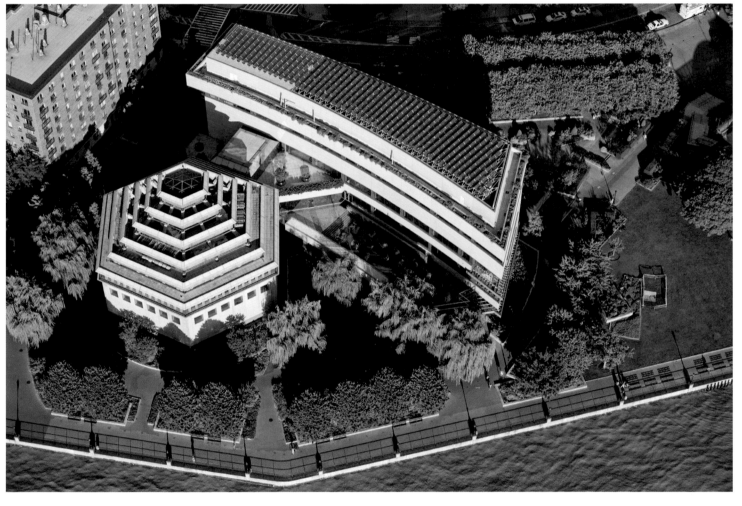

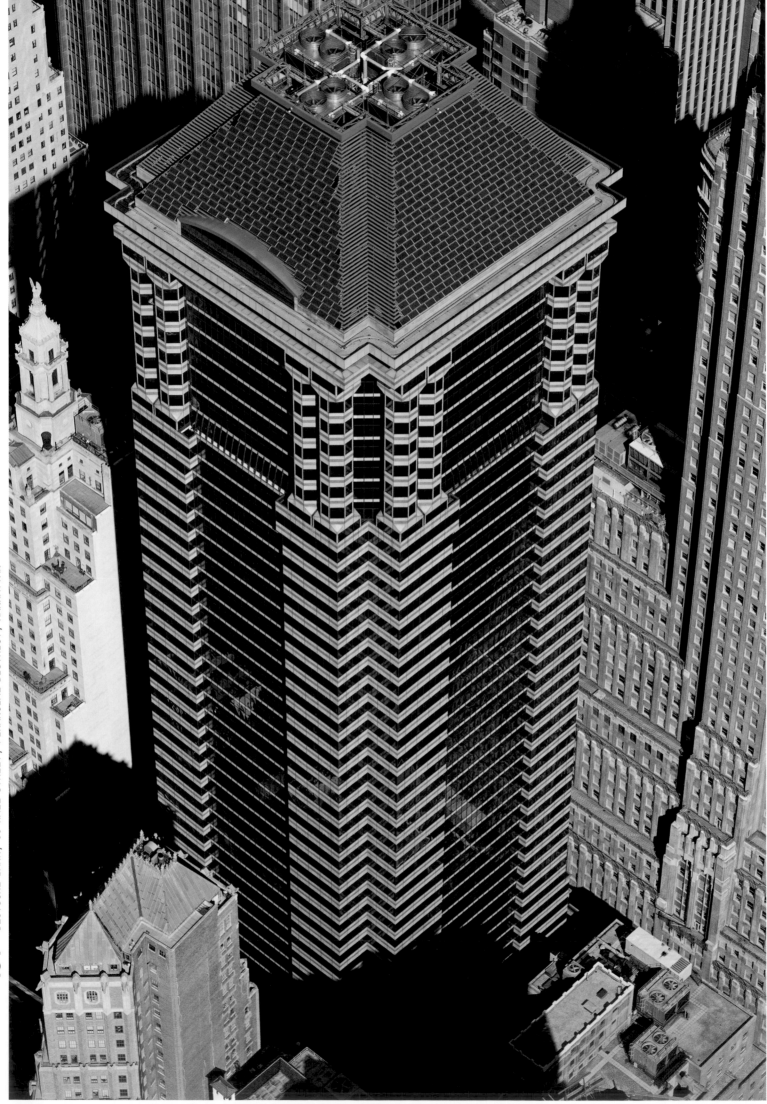

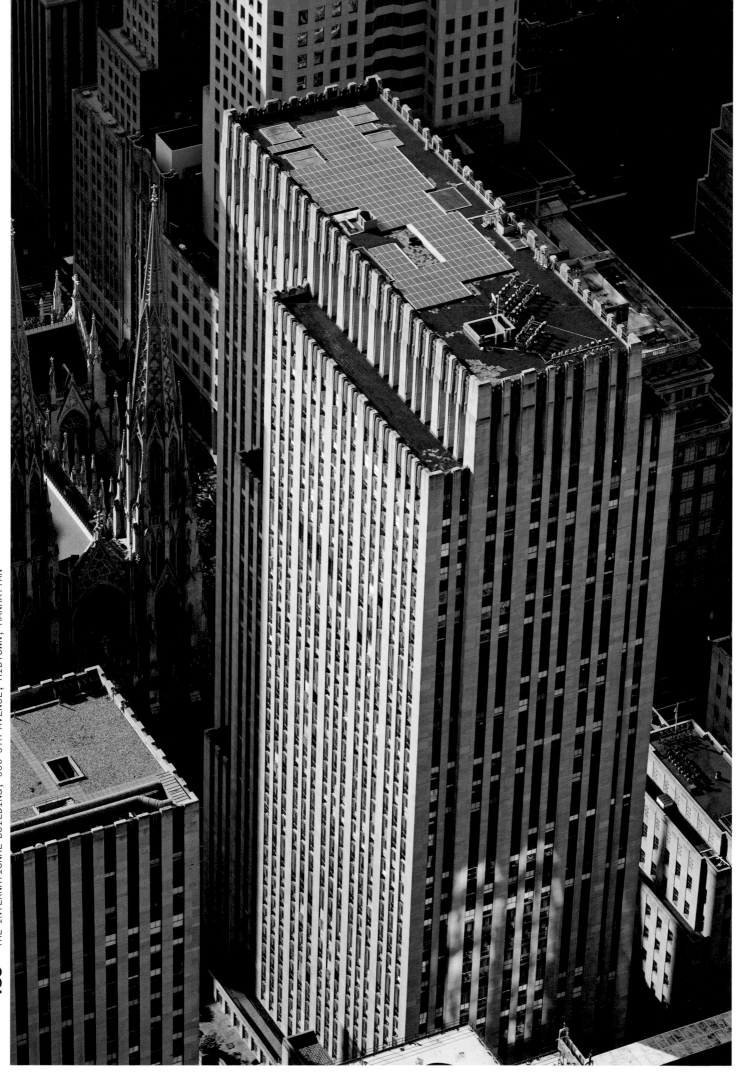

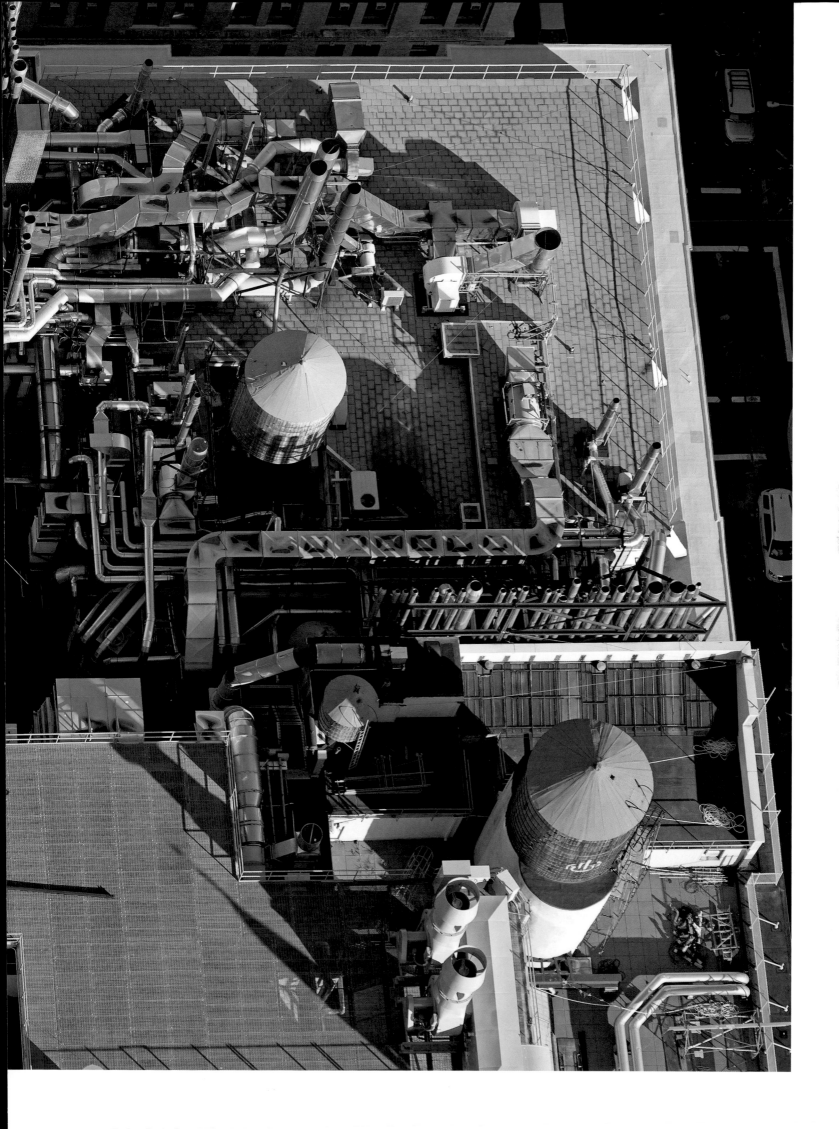

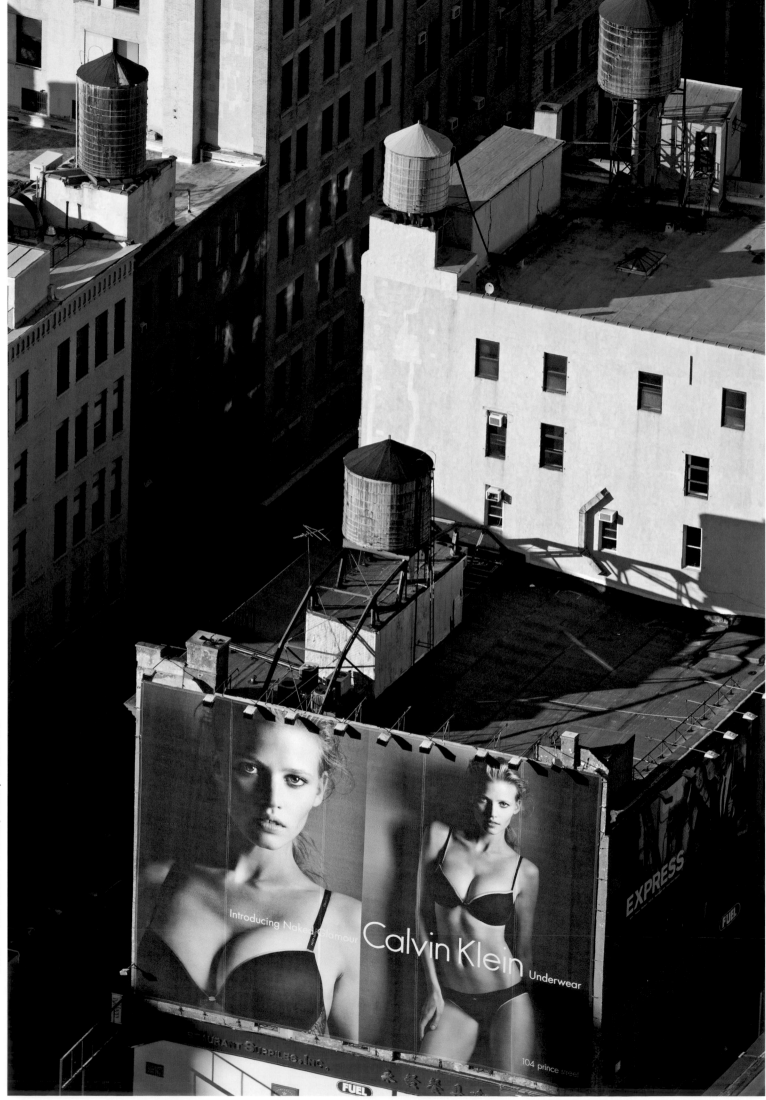

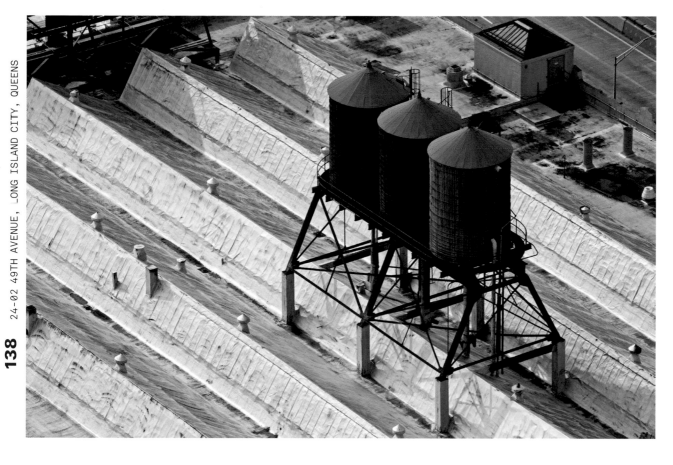

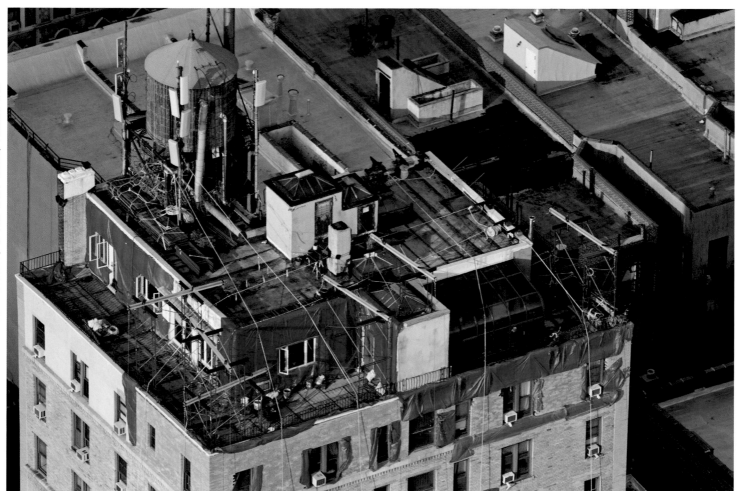

BROOKLYN GRANGE, 37-18 NORTHERN BOULEVARD, LONG ISLAND CITY, QUEENS

New York, Green City

It is ironic that although New York City is America's greenest place on a per-capita basis, its residents live surrounded by a dense hardscape. Part of the irony is that knowledge and experience of nature are crucial in finding solutions to problems such as global warming. But in urban environments, humans' symbiotic relationship with nature can easily be forgotten.

New York City has been aggressively pursuing many green initiatives that help to counter this alienation. One such strategy is to encourage the planting of green roofs to reduce the heat-island effect and storm-water runoff. Like solar panels, planted roofs are becoming increasingly common on New York rooftops. There are two basic types of green roofs: "extensive" and "intensive." An extensive roof is not very decorative; it is covered with a thin layer of light soil and low-maintenance plants, such as sedum, that are resistant to weather extremes and do not need to be trimmed. The intensive roof is covered with a deeper soil layer and is populated with plants that usually require more maintenance.

One of the chief benefits of a planted roof is its cooling effect through transpiration, or the evaporation of moisture from the plants. The underlying soil and plant materials have high insulation value for the rooms below, conserving heat in the winter and blocking heat gain in the summer. Another less obvious benefit is that the plants clean the air by filtering and trapping particulate matter.

In addition, planted roofs reduce the sudden flow of rainwater runoff during storms, which are becoming increasingly intense as a result of global warming. Green roofs absorb rainwater in the soil as well as in plants. Collectively, these roofs help to reduce street flooding and overflows at waste treatment plants, which often are forced to discharge untreated waste into adjacent water bodies during torrential rainstorms. This effect was most dramatic in New York Harbor after Hurricane Irene in 2011, when the Hudson and East Rivers were a light cocoa color instead of their usual dark-bluish gray. Such discharges often result in beach closings for public health reasons; green roofs help to ensure that city beaches remain open and that outdoor space can be fully enjoyed.

Green roofs have a calming effect and bring residents closer to nature. It could be argued that the local-and-organic-food movement in this county have been in part a reaction to our alienation from nature. Their success can be seen in the proliferation of farmers' markets in cities across the county and in the local-food offerings on restaurant menus. These venues orient city-dwellers to the growing seasons and to where their food originates.

Rooftop gardens in Queens and Brooklyn provide an unlikely food source for New York City. It is startling to see a one-acre-plus garden laid out with rows of vegetables on the roof of a six-story industrial building. Although any one of these gardens supplies a relatively small amount of produce compared to the total needs of the surrounding population, they collectively inspire an awareness of food issues and the possibilities for local food production. As with the white roofs, collective, incremental adoption could add up to significant change if such gardens could be developed throughout the city. Commercial hydroponic farming on warehouse roofs appears to be another practical option for urban agriculture, since costs can be amortized with a year-round growing season.

Rooftop beekeeping also has been flourishing in recent years. Urban beehives are as productive as any, which seems counterintuitive until one considers the variety and abundance of blossoms that can be found in the city during the entire growing season.

It is commonly assumed that solutions to climate change will come from breakthroughs in technology. However, new technologies can be mixed creatively with age-old agricultural practices to enhance our relationship to the natural world.

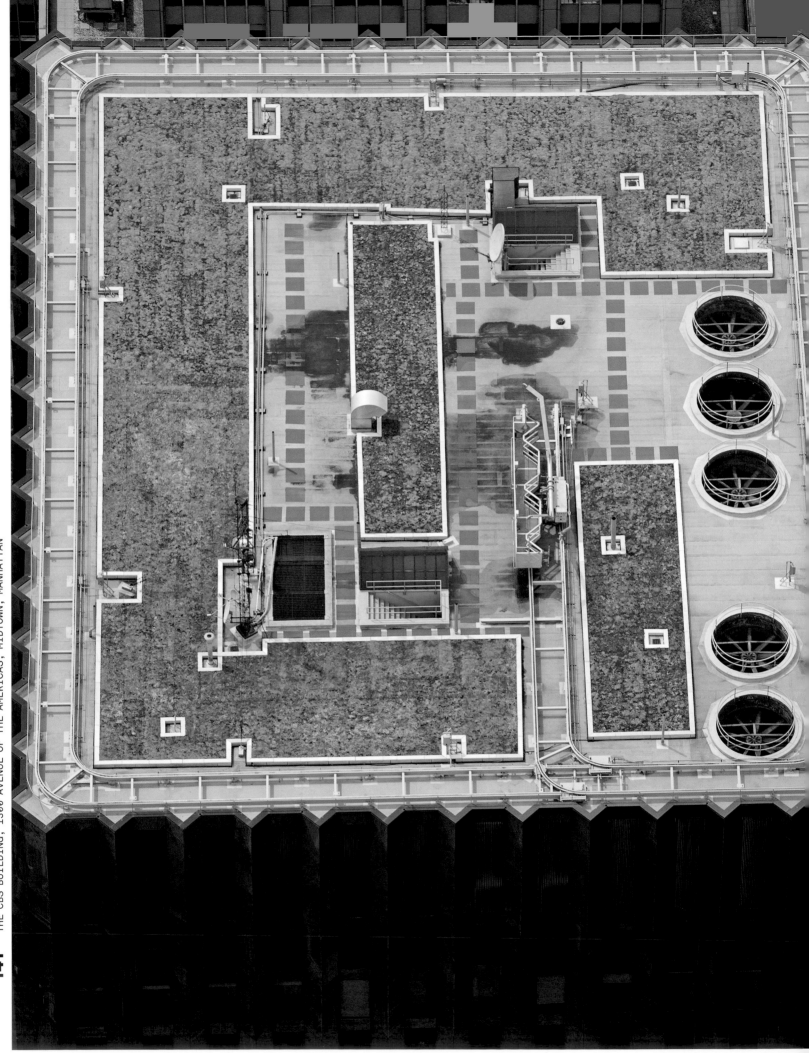

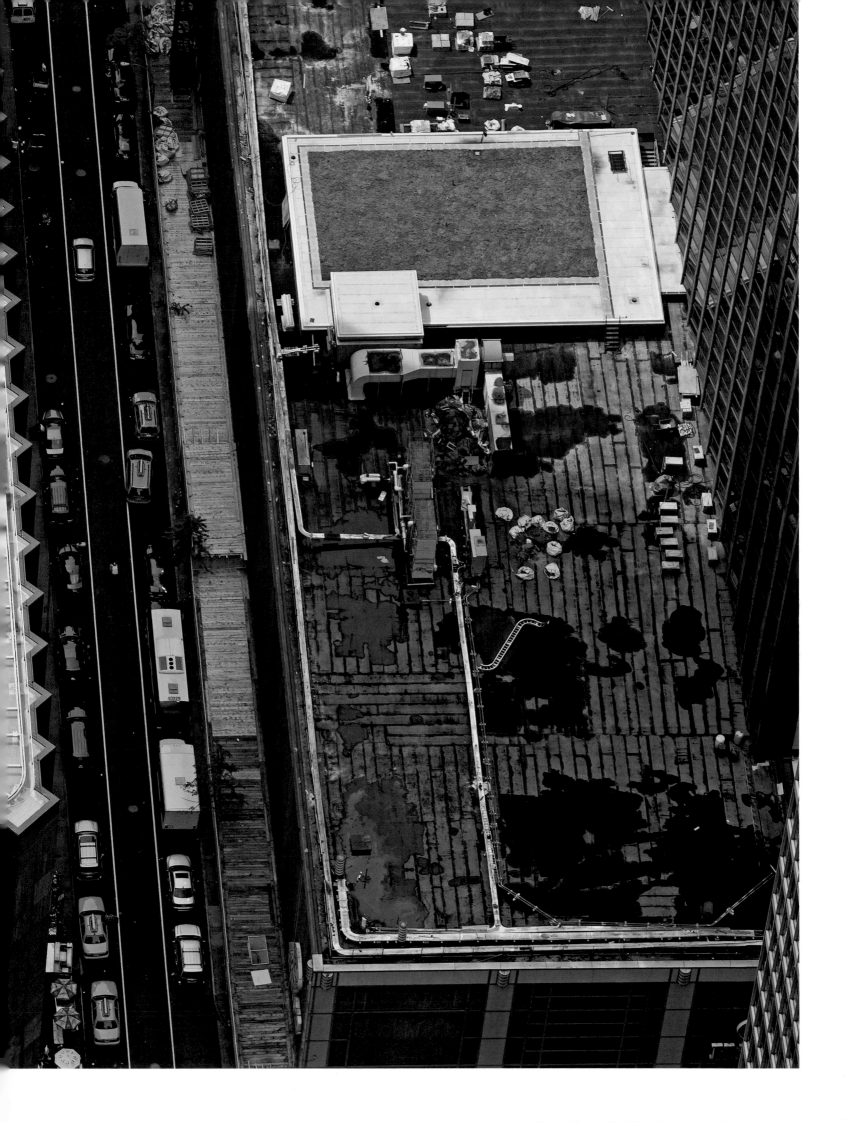

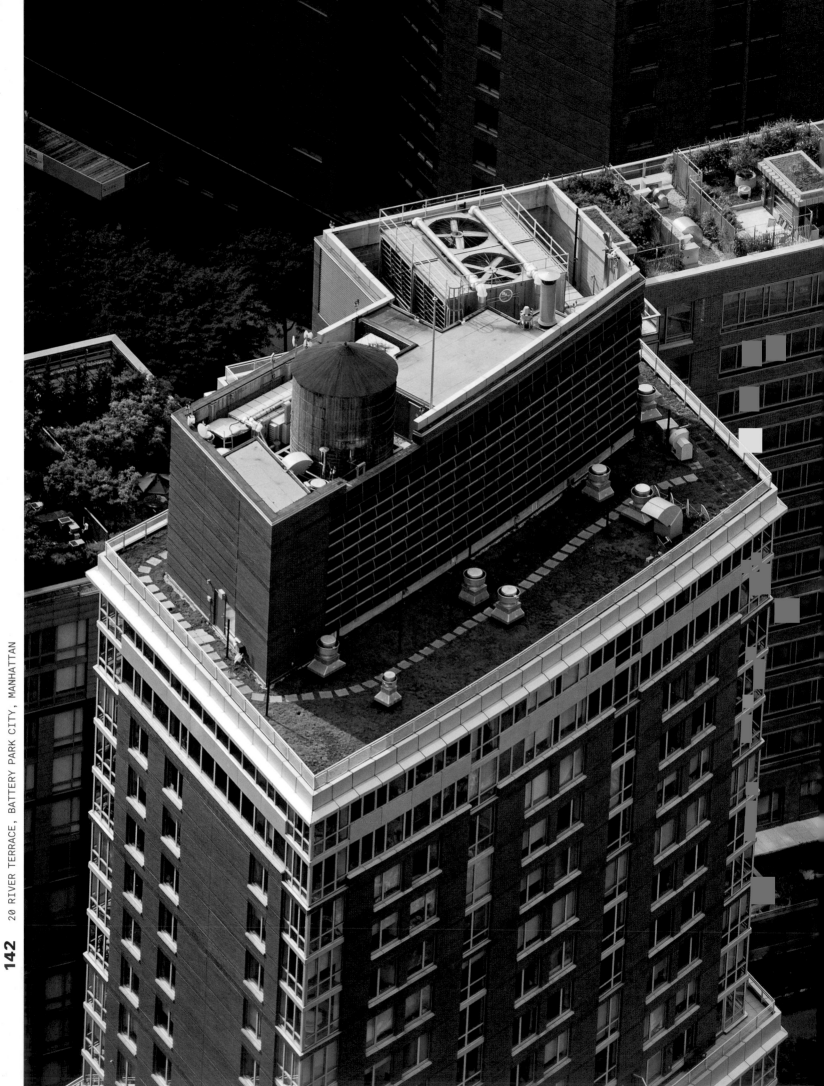

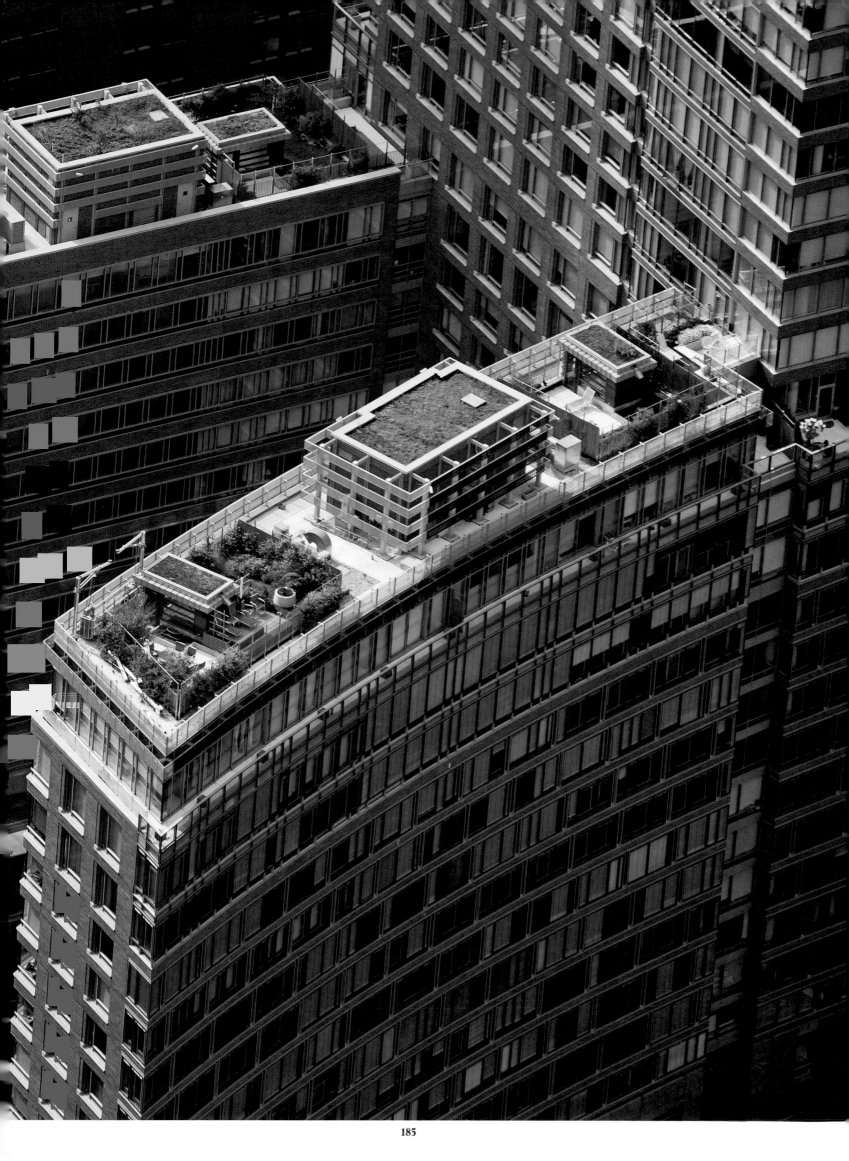

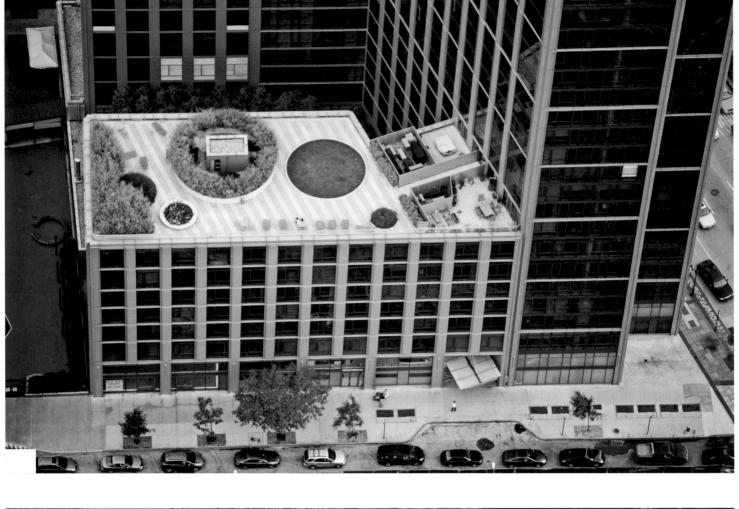

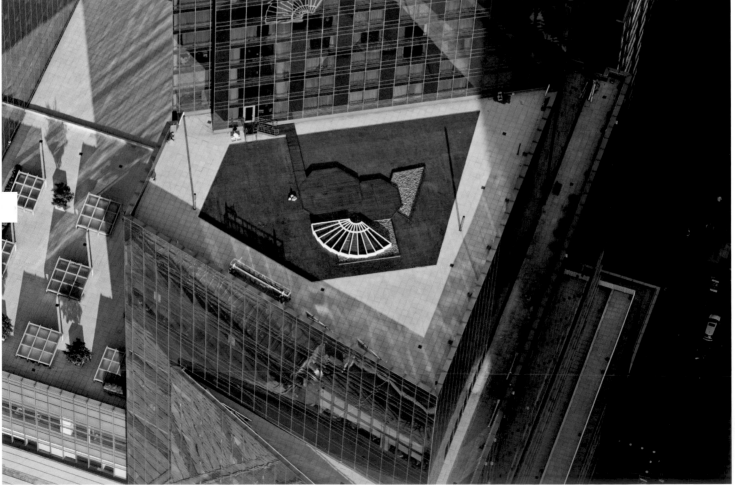

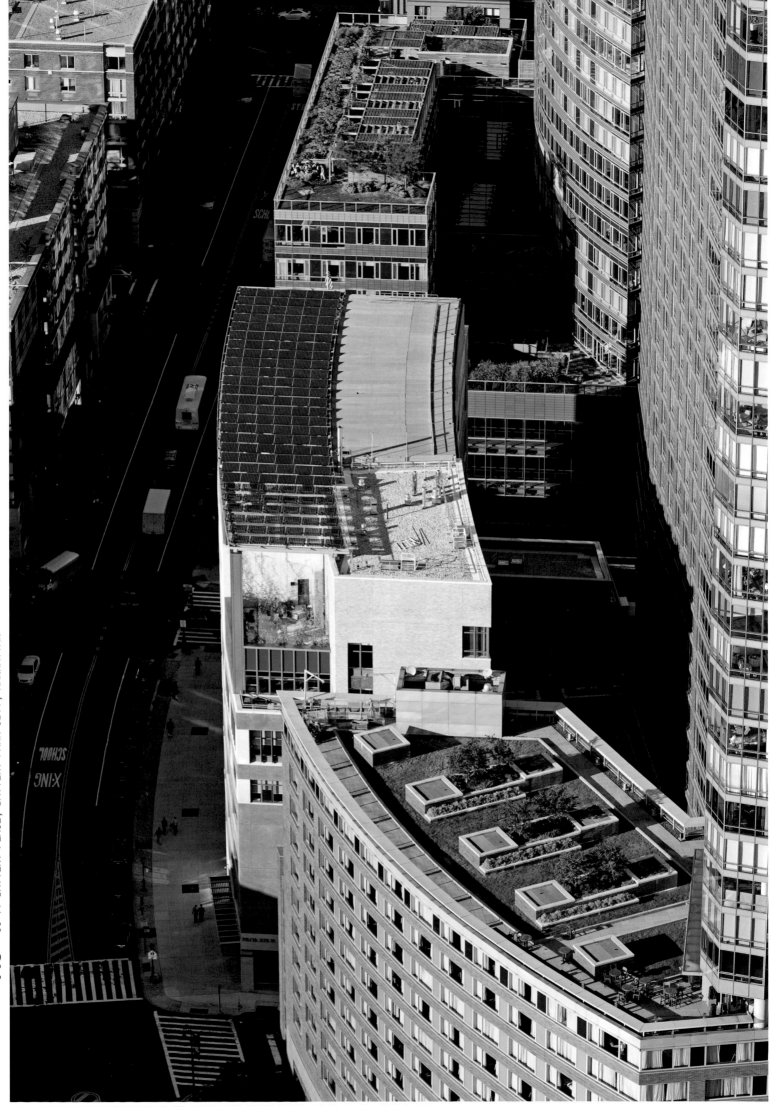

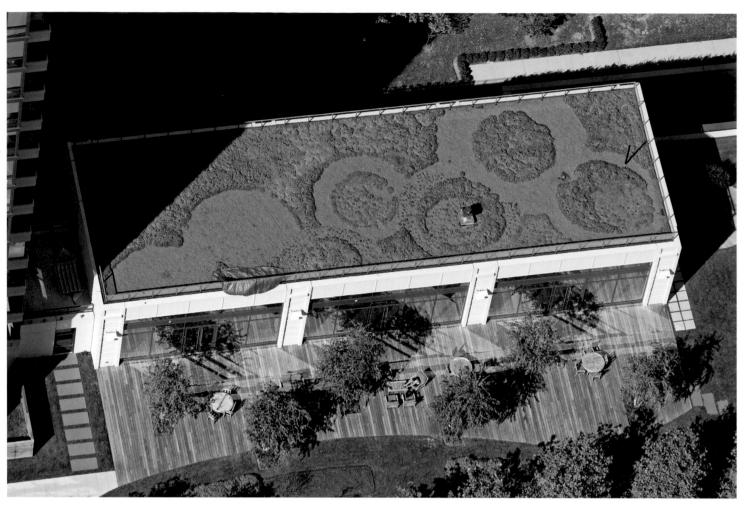

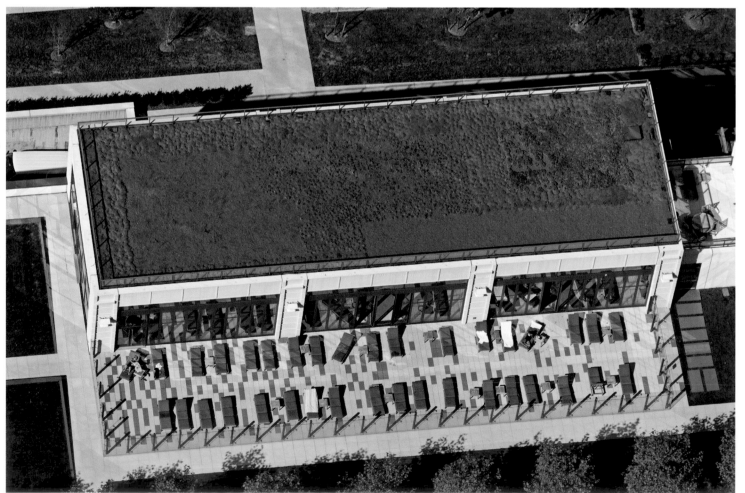

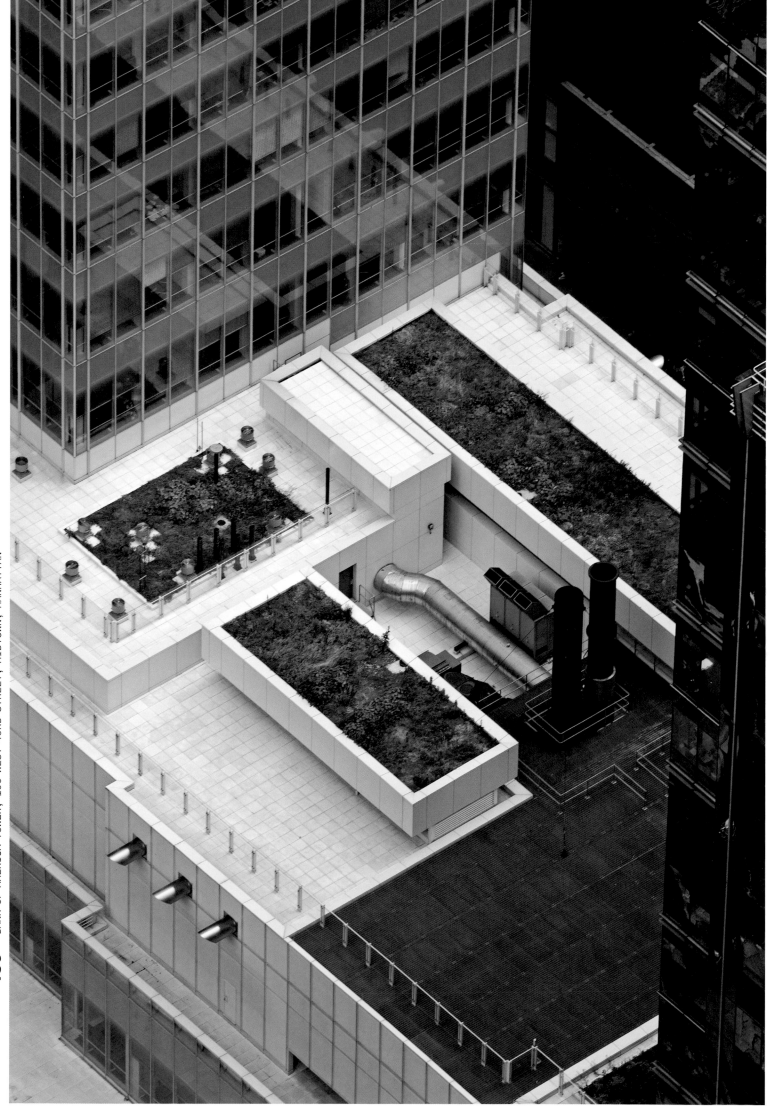

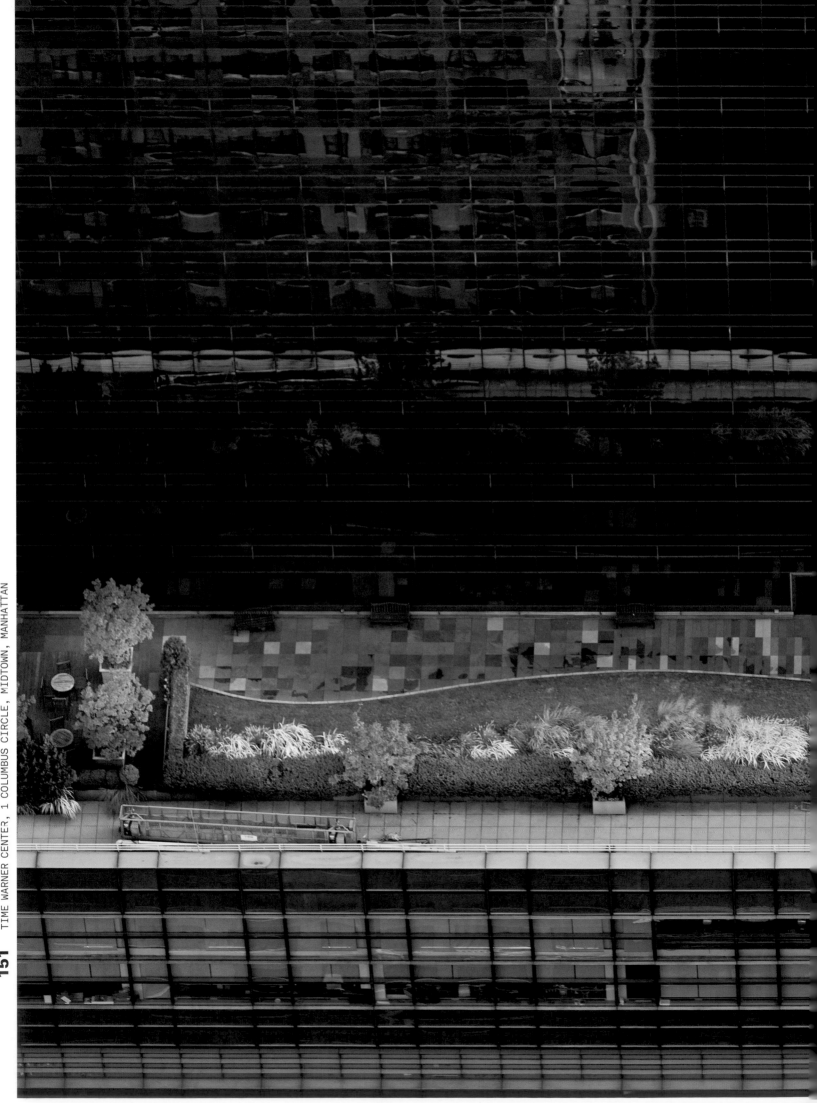

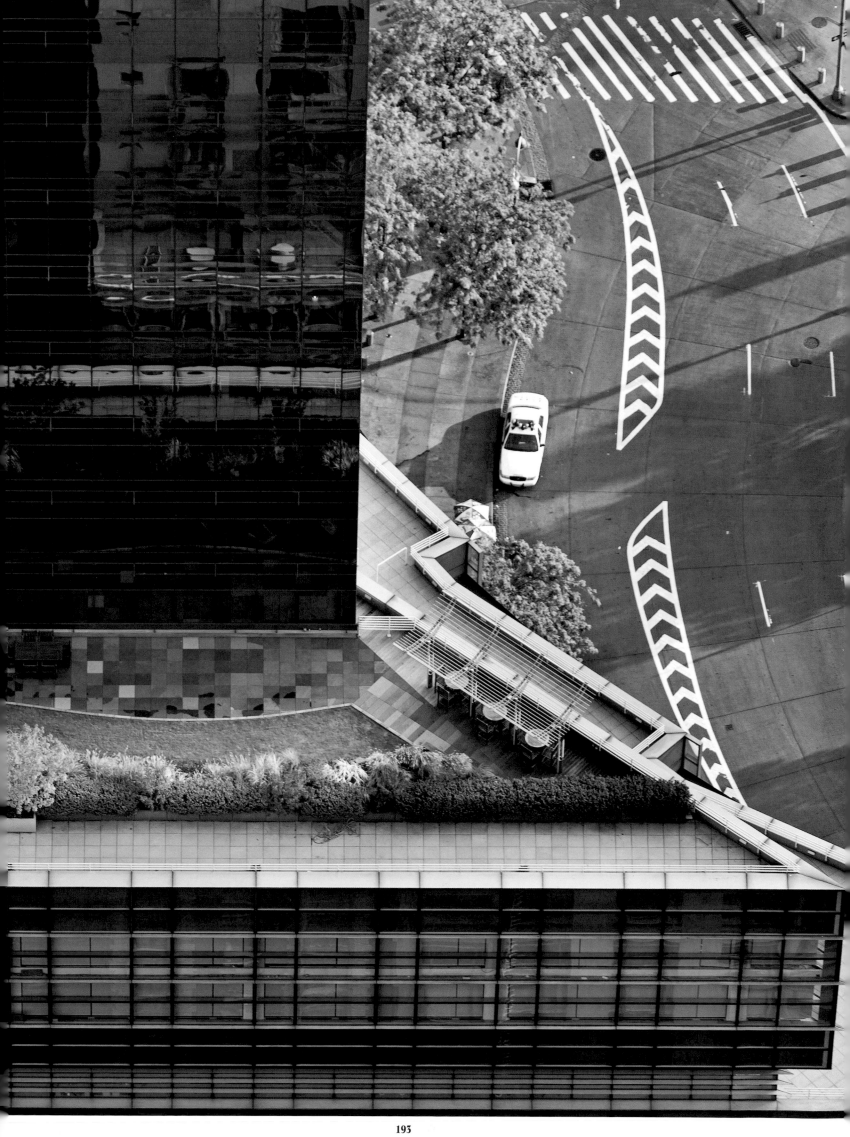

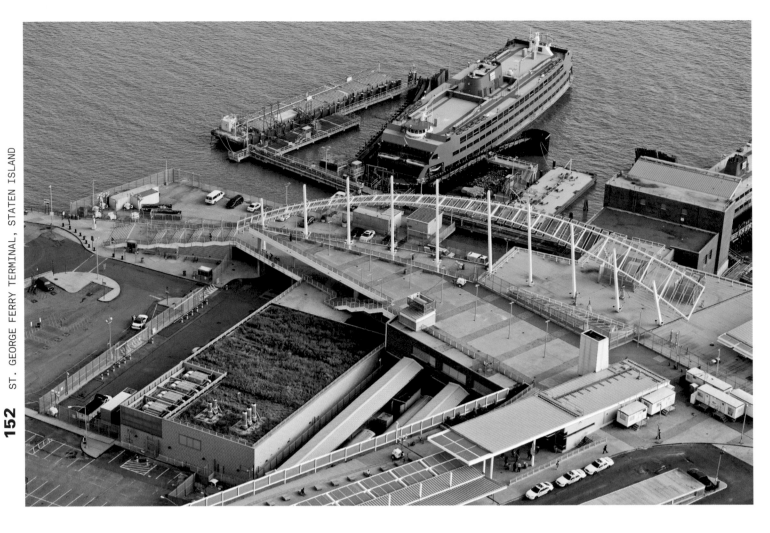

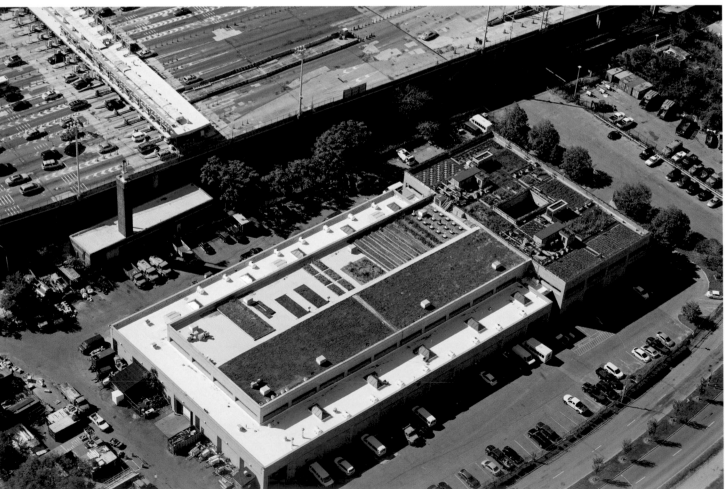

153 FIVE BOROUGH ADMINISTRATIVE BUILDING, BRONX SHORE ROAD, RANDALL'S ISLAND, THE BRONX

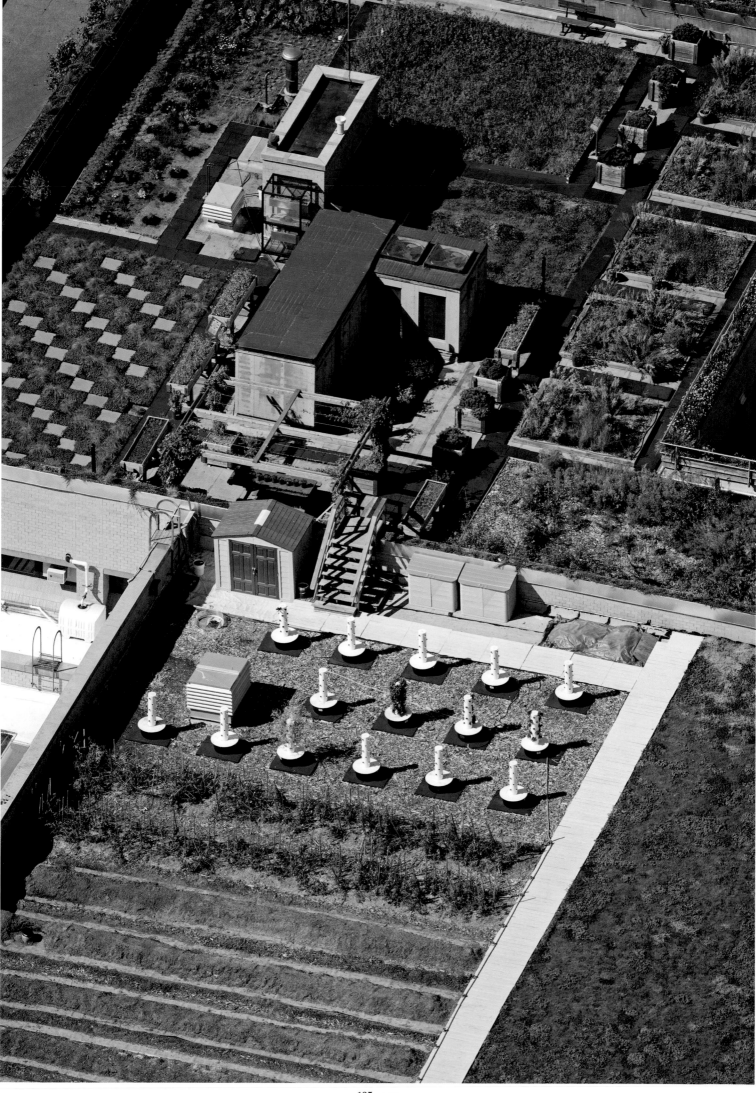

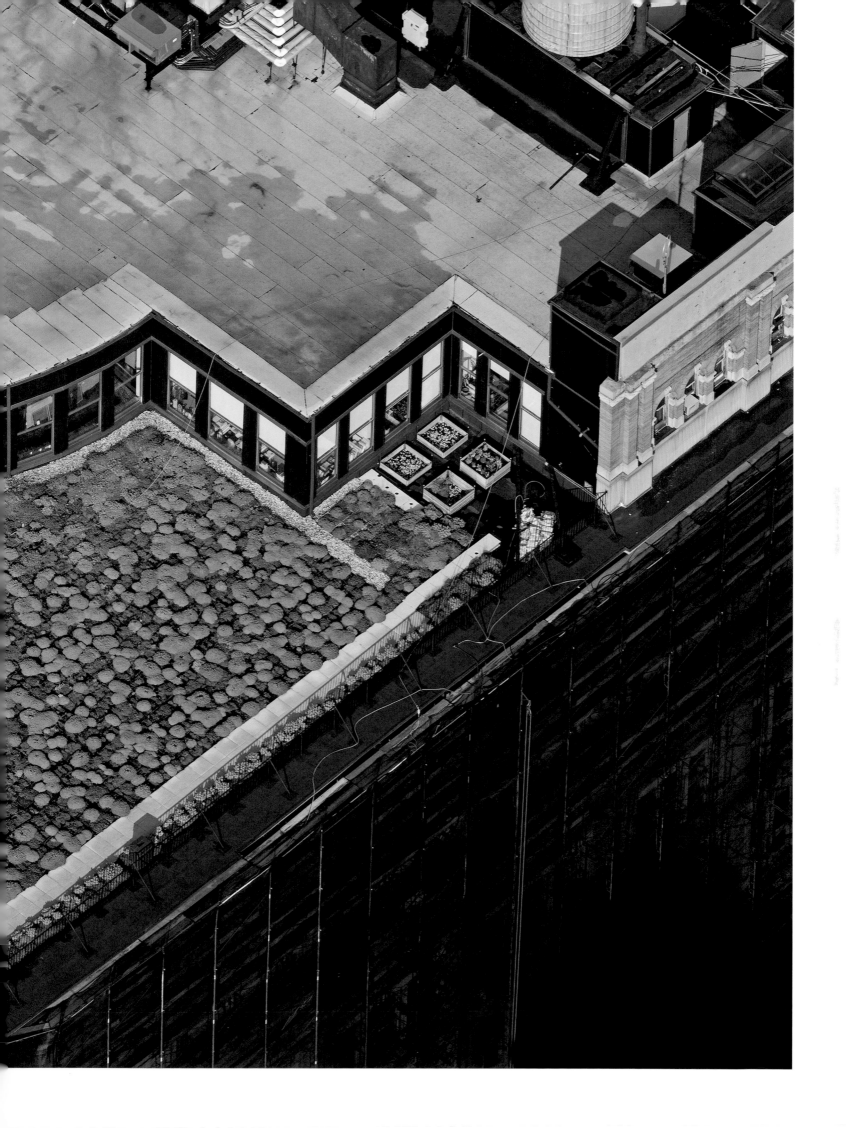

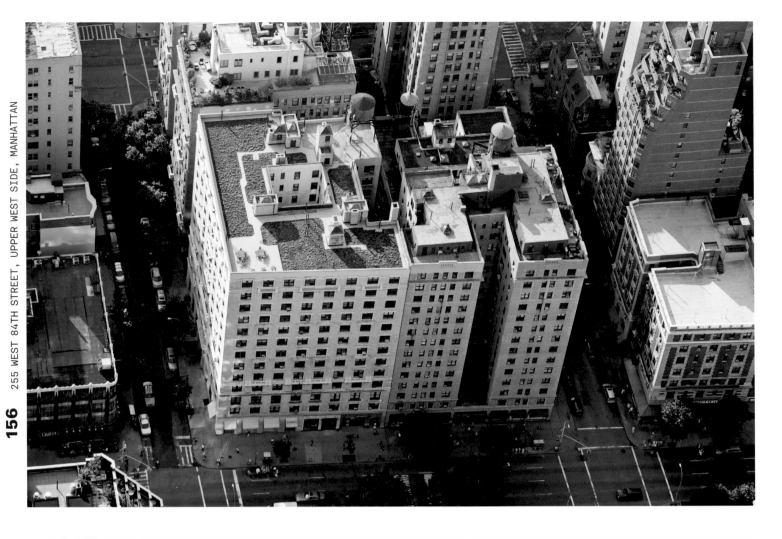

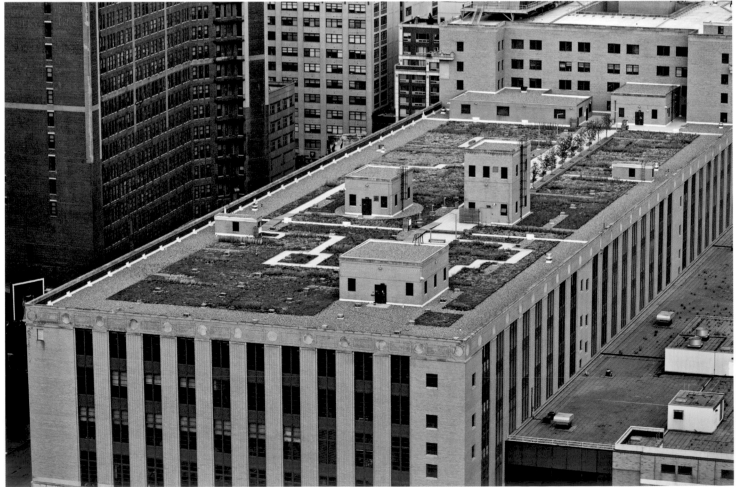

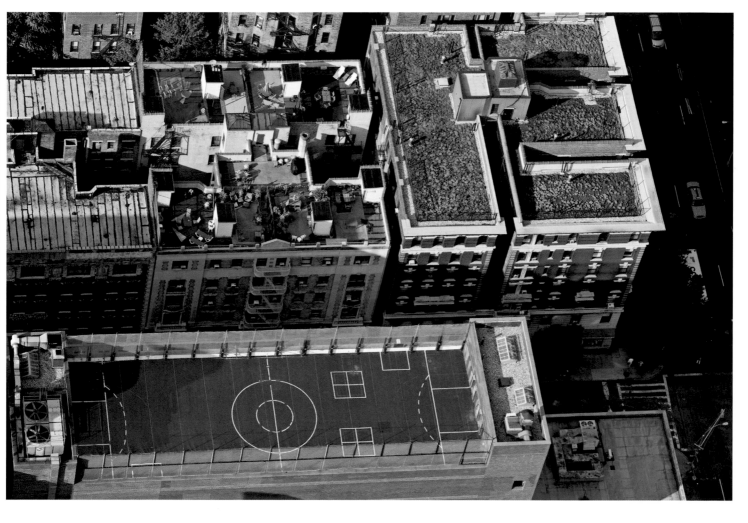

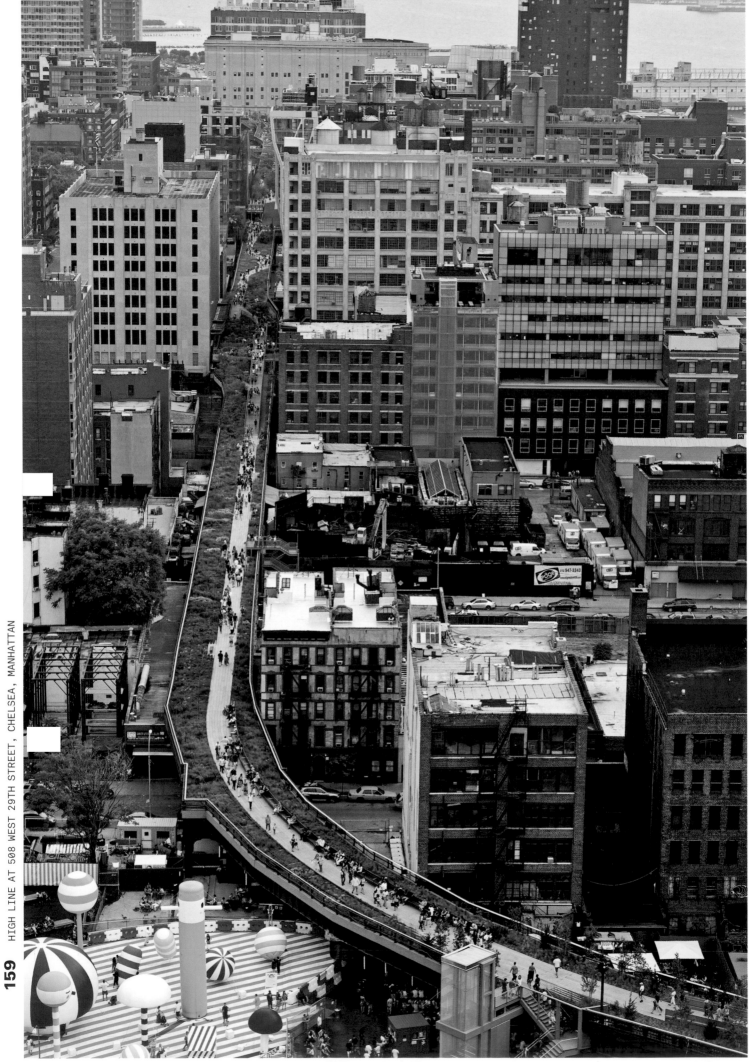

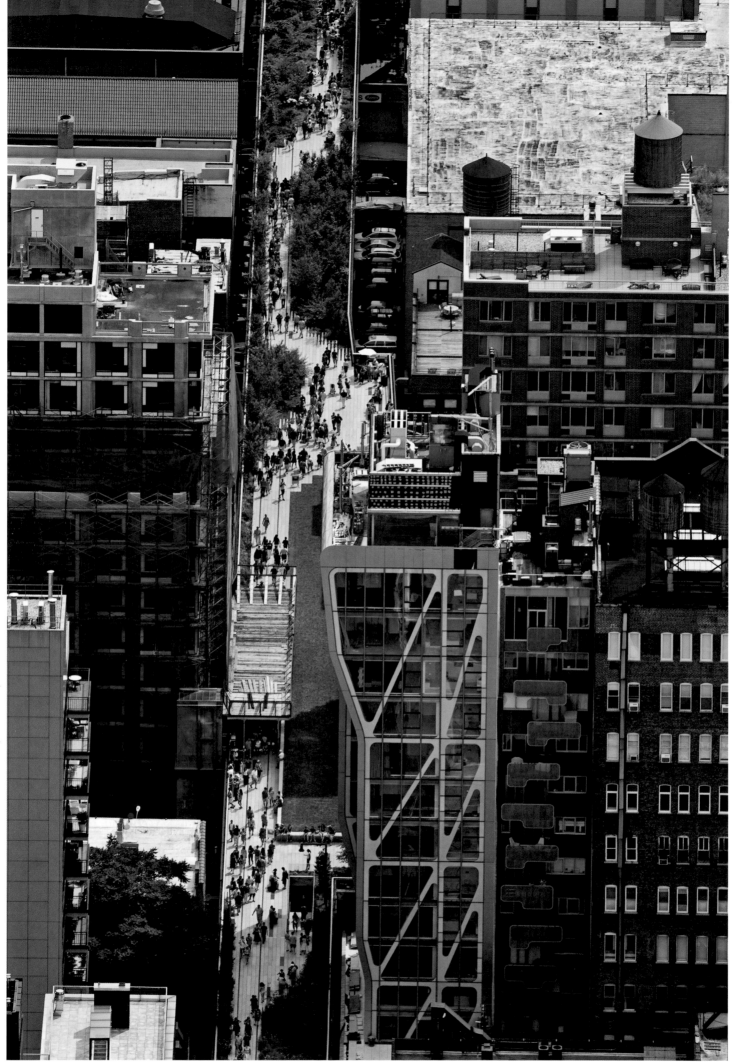

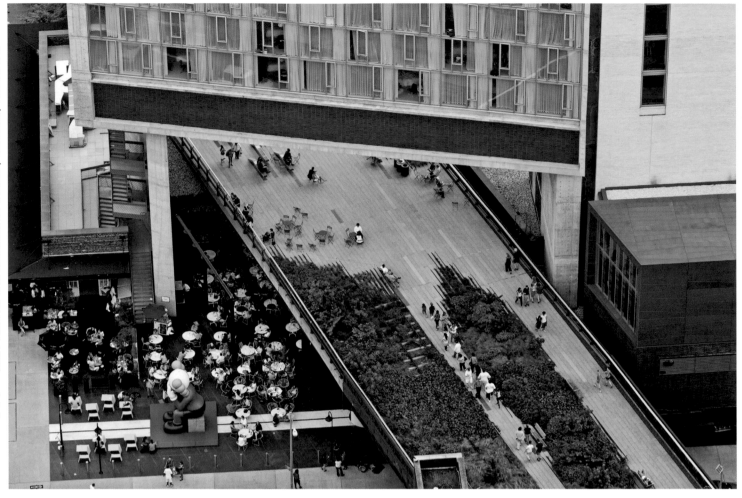

161 HIGH LINE AT 848 WASHINGTON STREET, CHELSEA, MANHATTAN

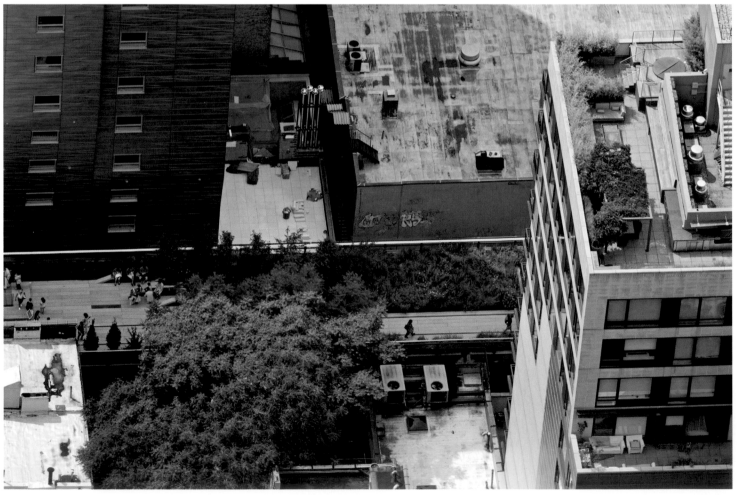

162 HIGH LINE AT 229 10TH AVENUE, CHELSEA, MANHATTAN

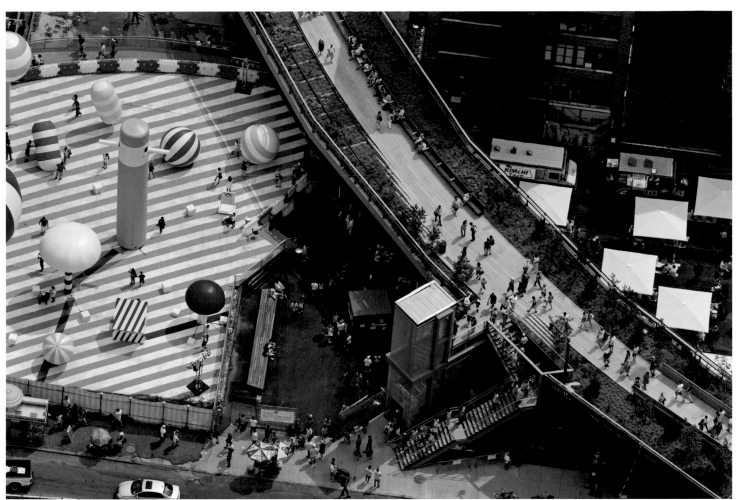

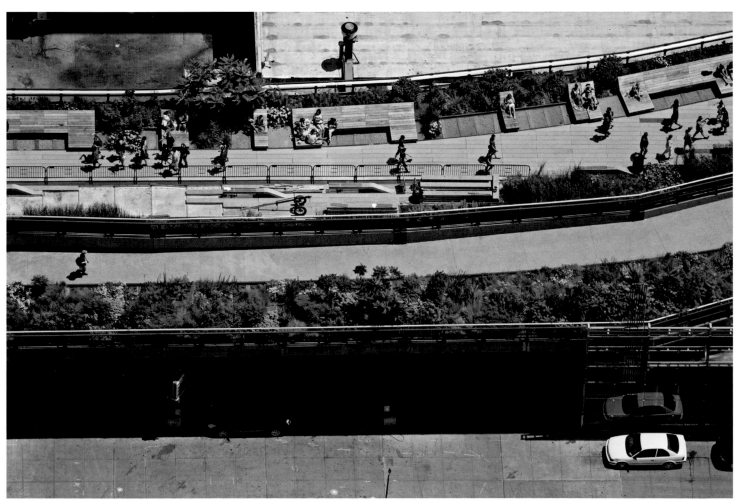

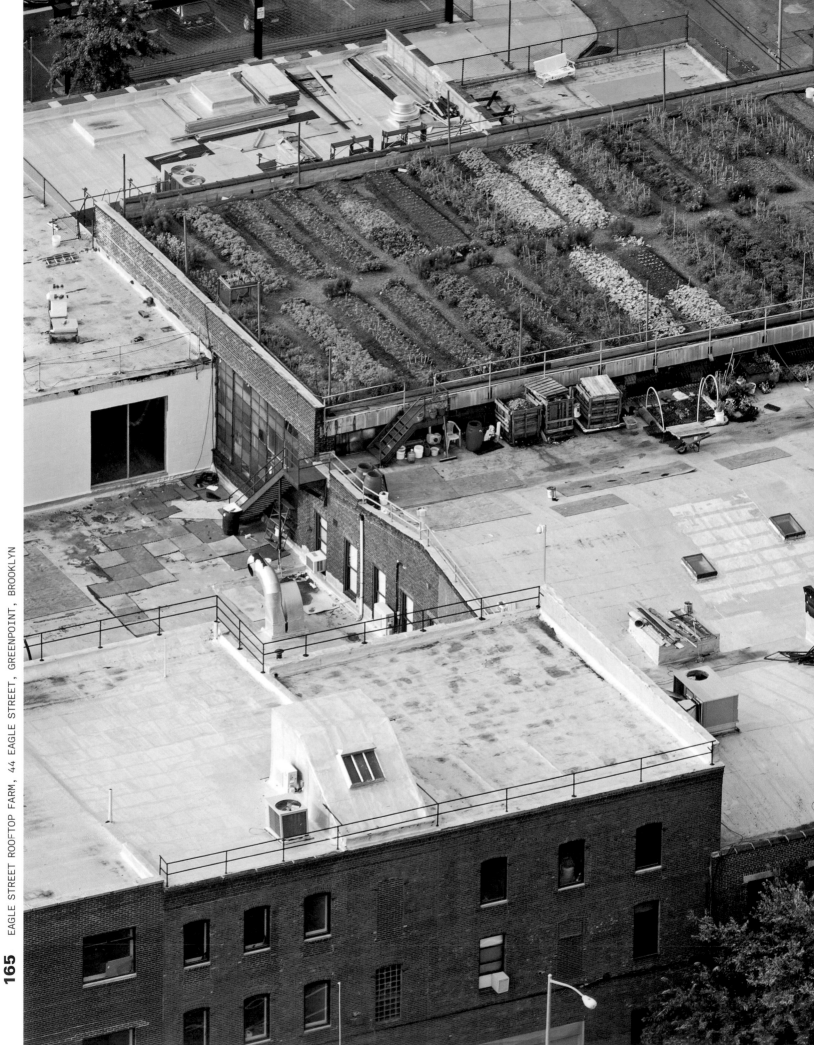

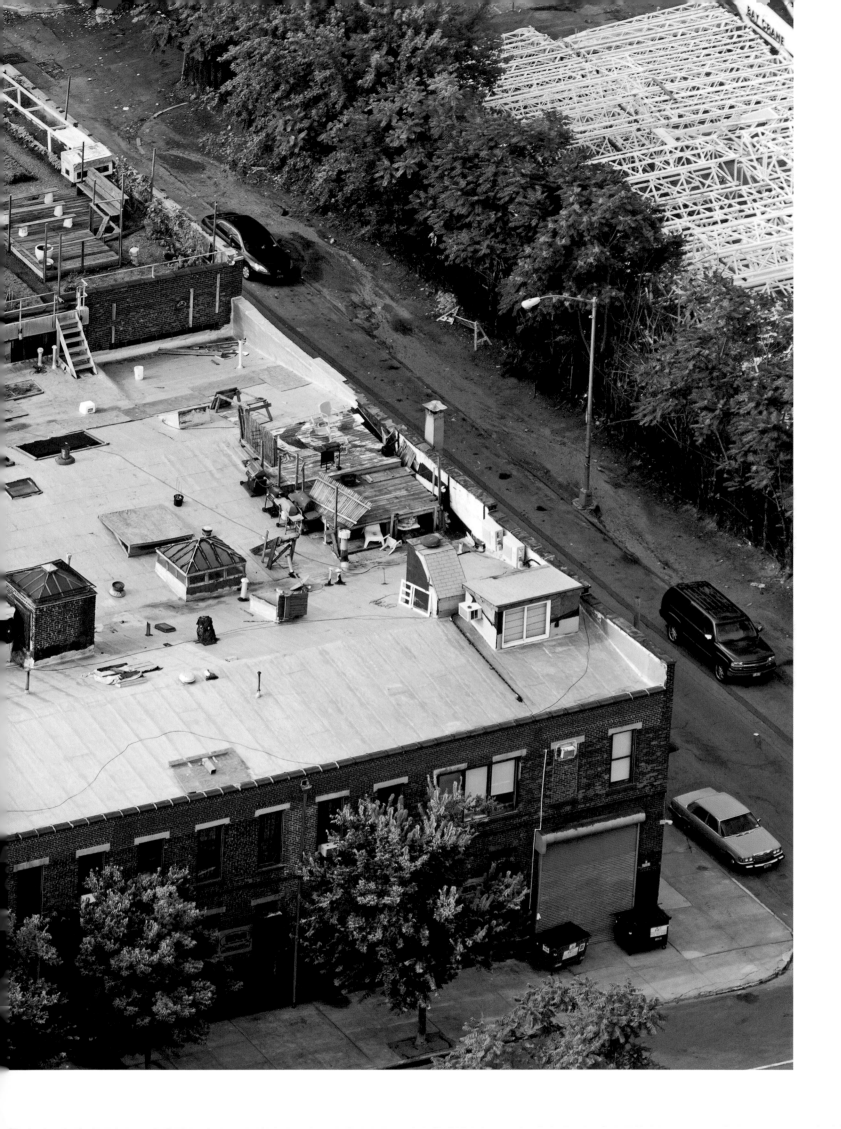

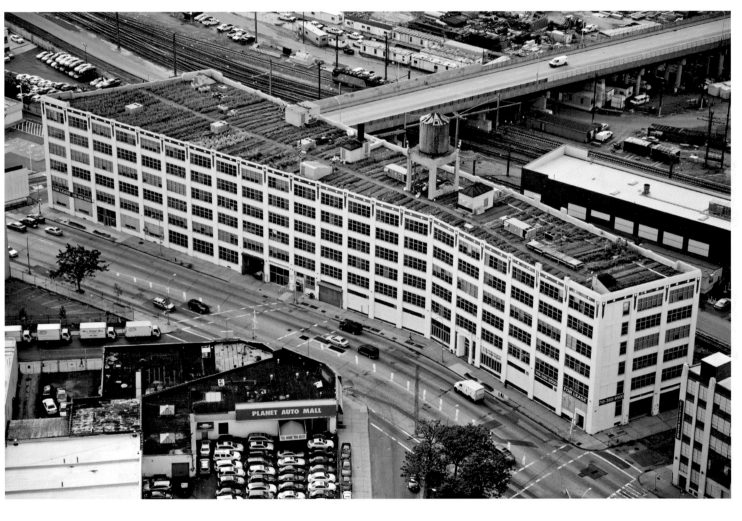

167 BROOKLYN GRANGE, 37-18 NORTHERN BOULEVARD,
LONG ISLAND CITY, QUEENS

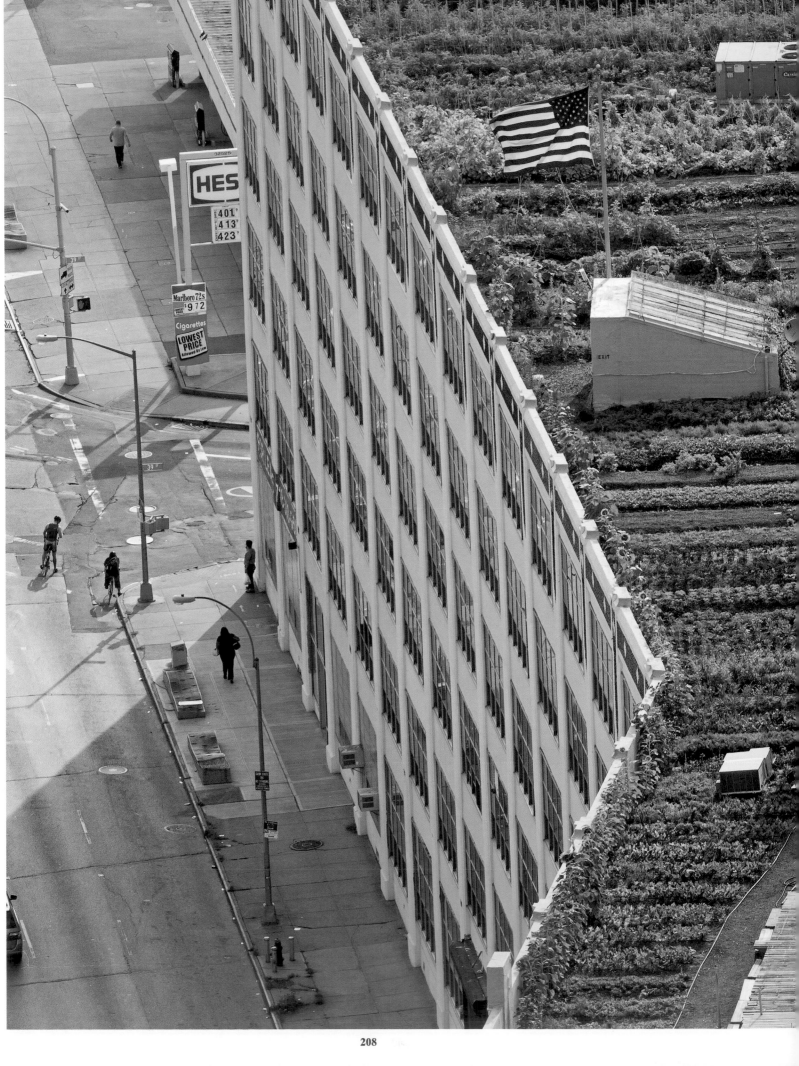

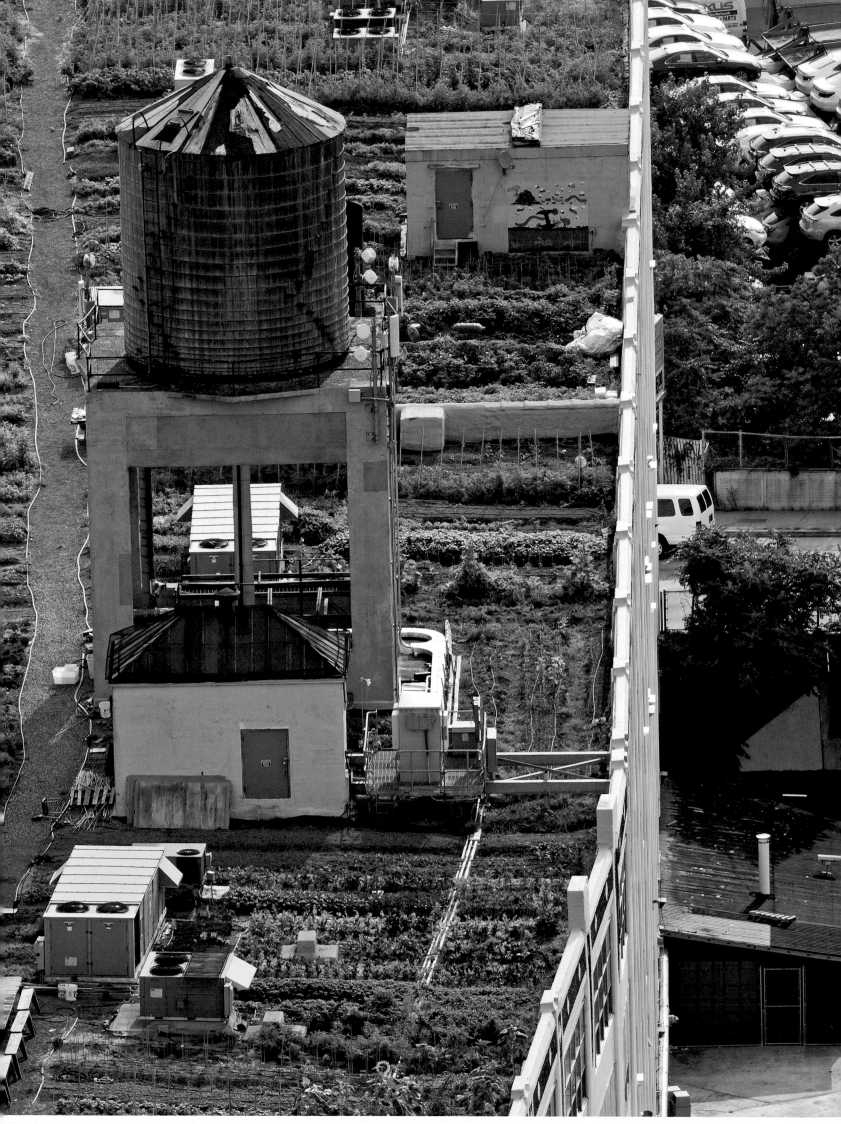

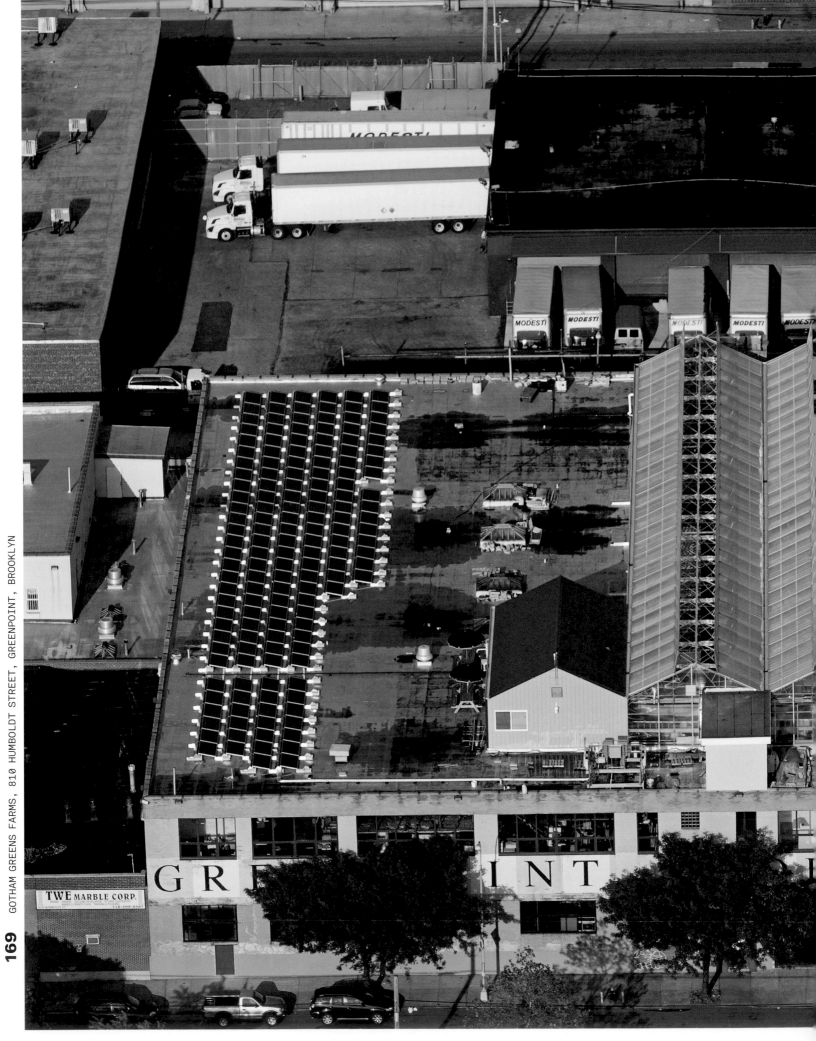

169 GOTHAM GREENS FARMS, 810 HUMBOLDT STREET, GREENPOINT, BROOKLYN

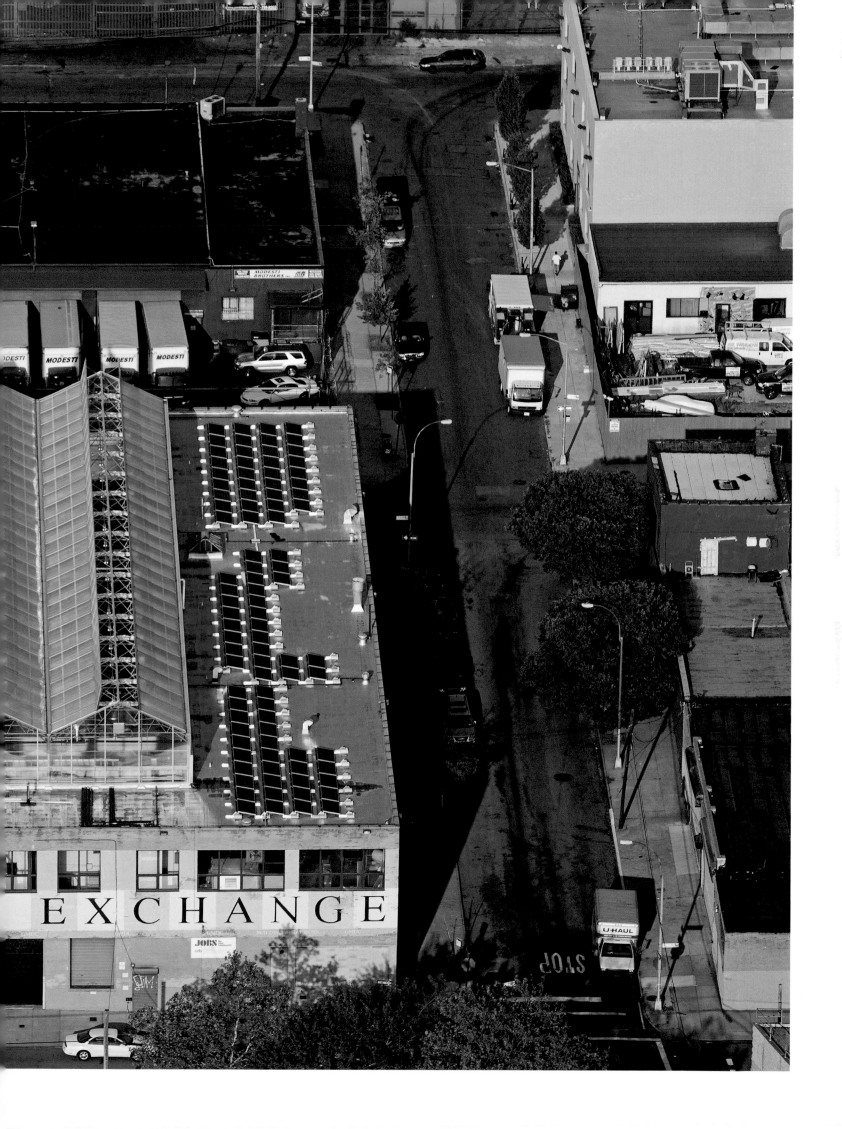

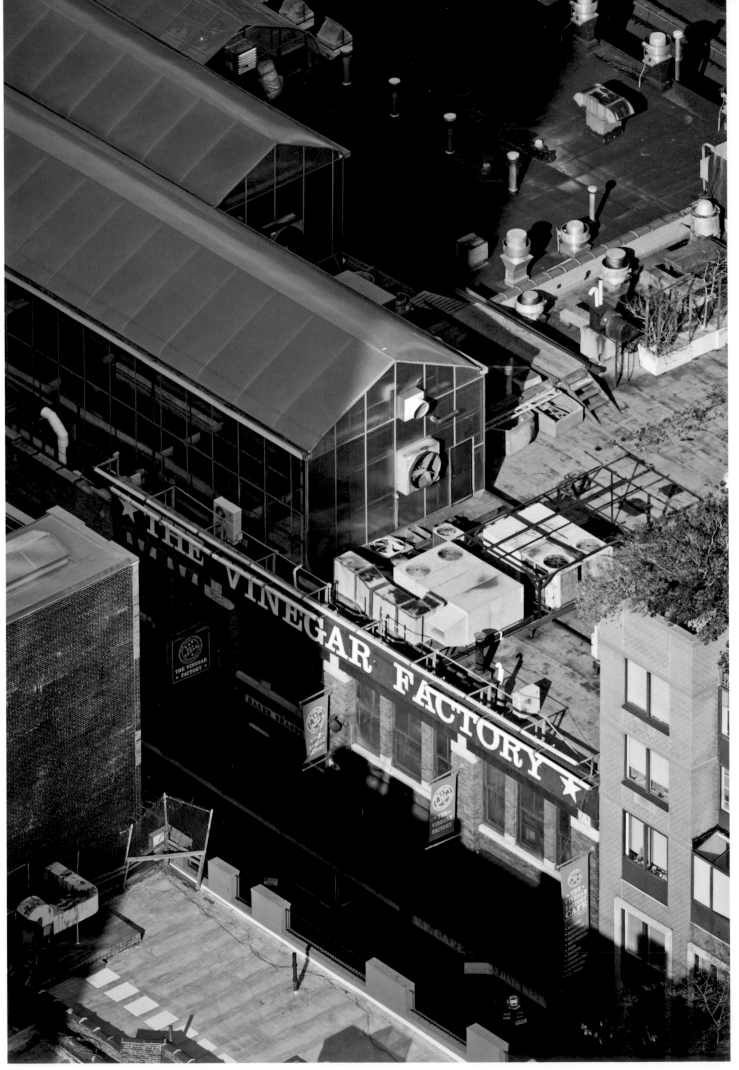

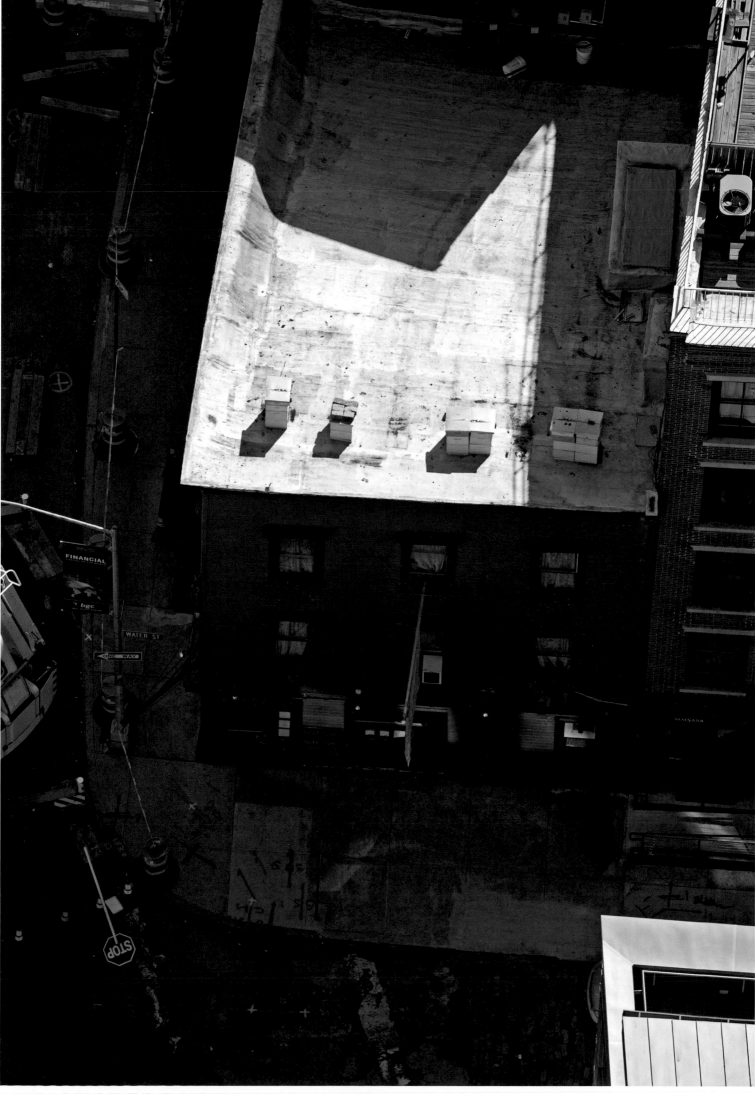

Oddities

Urban rooftops, with their noisy mechanical systems, extreme temperatures, fragile surfaces, and vertiginous heights, might not appear to be the most hospitable spaces. While exploring New York City by helicopter, I was initially surprised by the profusion of rooftop playgrounds, swimming pools, and open-deck restaurants. Yet given the cost of real estate and lack of open space in the city, it now seems natural that its rooftops would support a wide variety of uses.

However, I would occasionally come across a rooftop that defied explanation. One of the most unusual was atop 77 Water Street in the financial district. The building is topped with a biplane resting on the end of an Astroturf landing strip, which can be seen only from the air and from the higher floors of neighboring buildings. I later learned that it is a model of a Sopwith Camel, a British fighter plane from the First World War. Designed by Rudolph de Harak and built by sculptor William Tarr in 1969, the plane and airstrip were commissioned by the building's developer for the sheer amusement they would provide to viewers in the neighboring skyscrapers.

Sometimes I viewed evidence of mysterious activities in progress, such as a stage company setting up props for a rooftop fashion shoot. Sandbags holding down construction materials or overlapping painted circles might indicate some future rooftop amenity waiting to be built.

I often wondered about the intended audience for graffiti art and written messages. Whose alien eyes were these meant for? Did their authors seek affirmation from some spirit looking down from above? I have since learned of a more prosaic motivation: the big characters drawn on rooftops with fire extinguishers are meant be seen on Google Earth. (Incidentally, rooftop graffiti brings to mind one serious obstacle to rooftop conversions: its presence on supposedly secure roof spaces demonstrates a vulnerability in security and raises fears that unguarded rooftops will provide access to living spaces below.)

The oddities in this chapter show a spirit of fun and illustrate diverse possibilities for the creative use of rooftop spaces. A roof is a fifth facade that can be walked on; what now seems odd to me is that so many of the city's rooftops are so underutilized.

As urban populations continue to grow, it is increasingly important to keep our connections to open space and the natural world. Making our cities even more green and livable in the future will depend on a concerted effort to develop rooftop spaces. The fact that playgrounds, pools, and even a replica of a vintage aircraft can make their homes on the roofs of New York City should serve as an example for the myriad possibilities of rooftops everywhere.

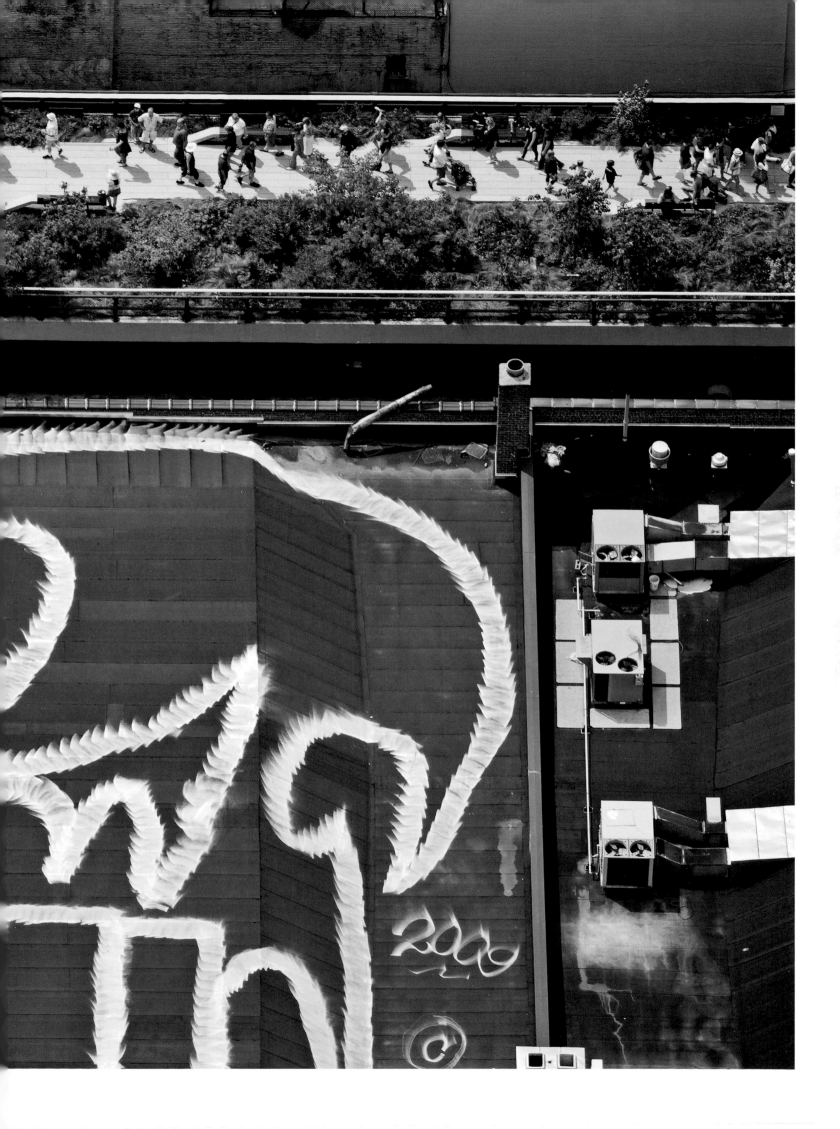

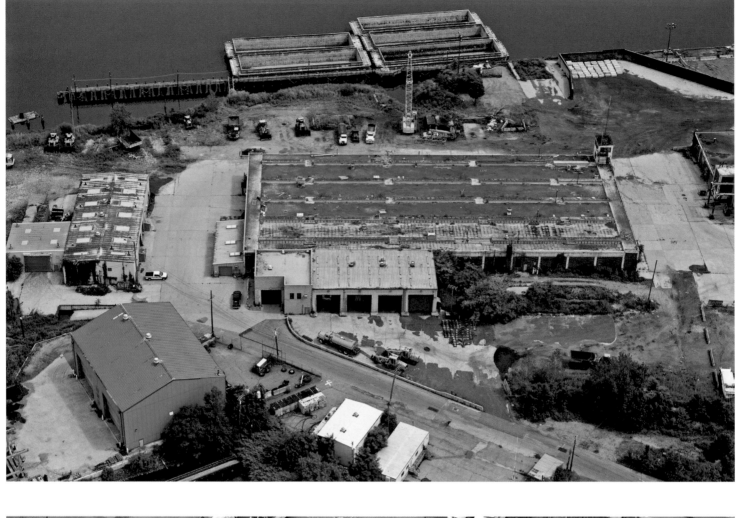

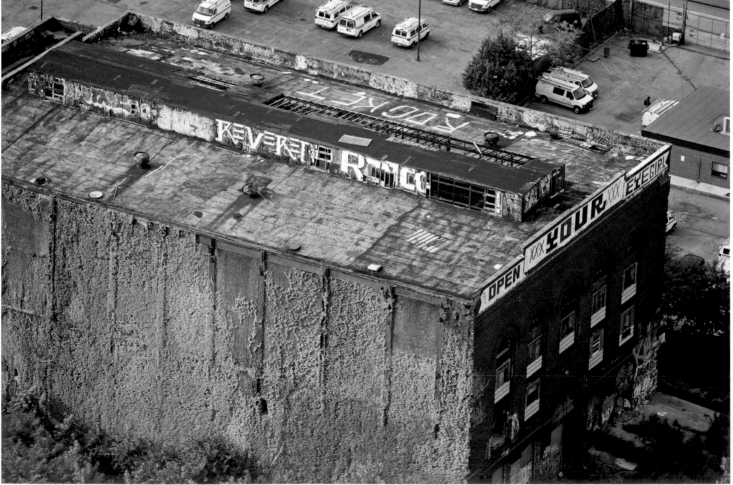

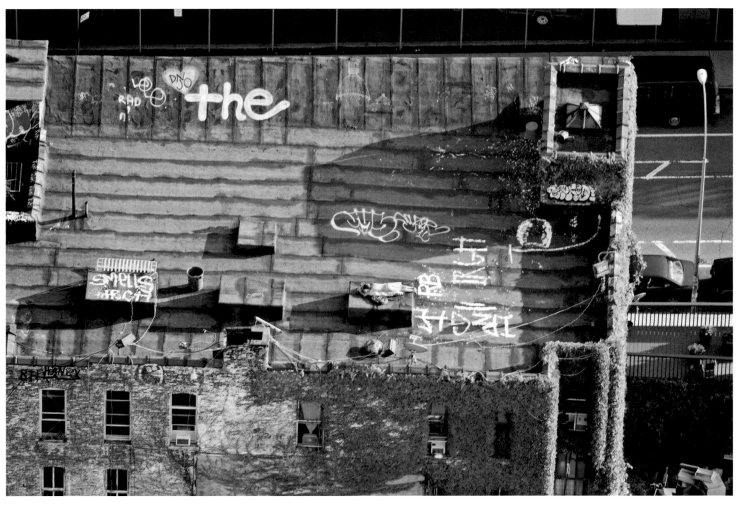

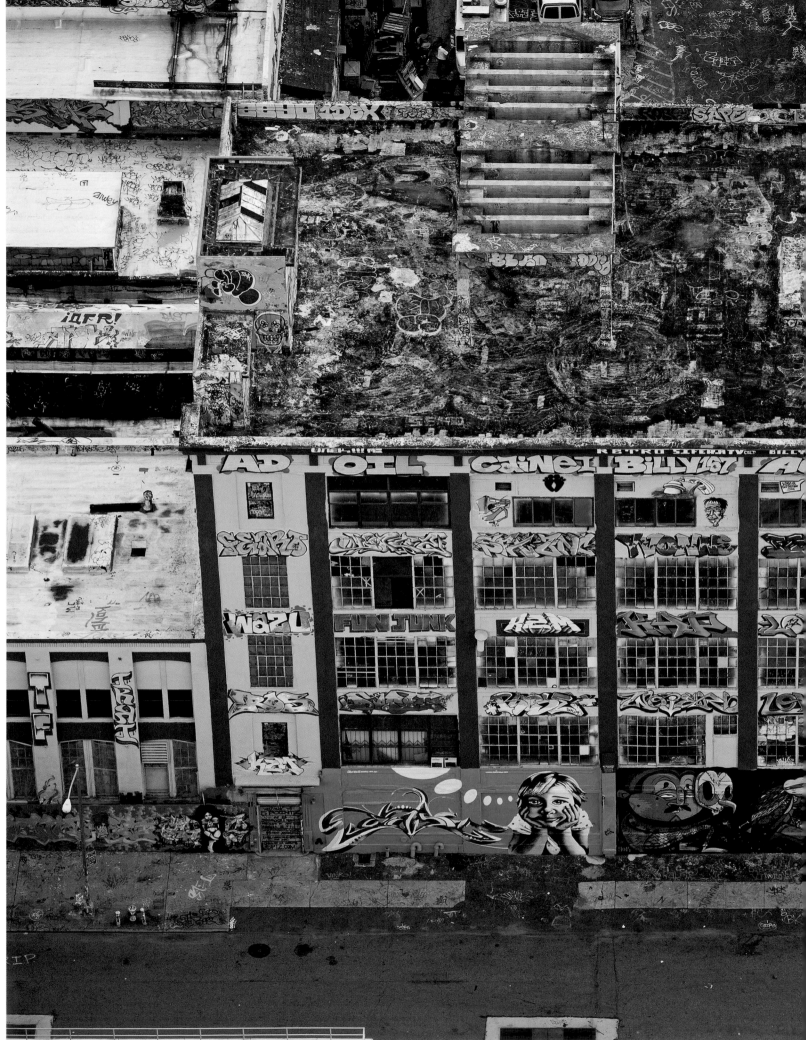

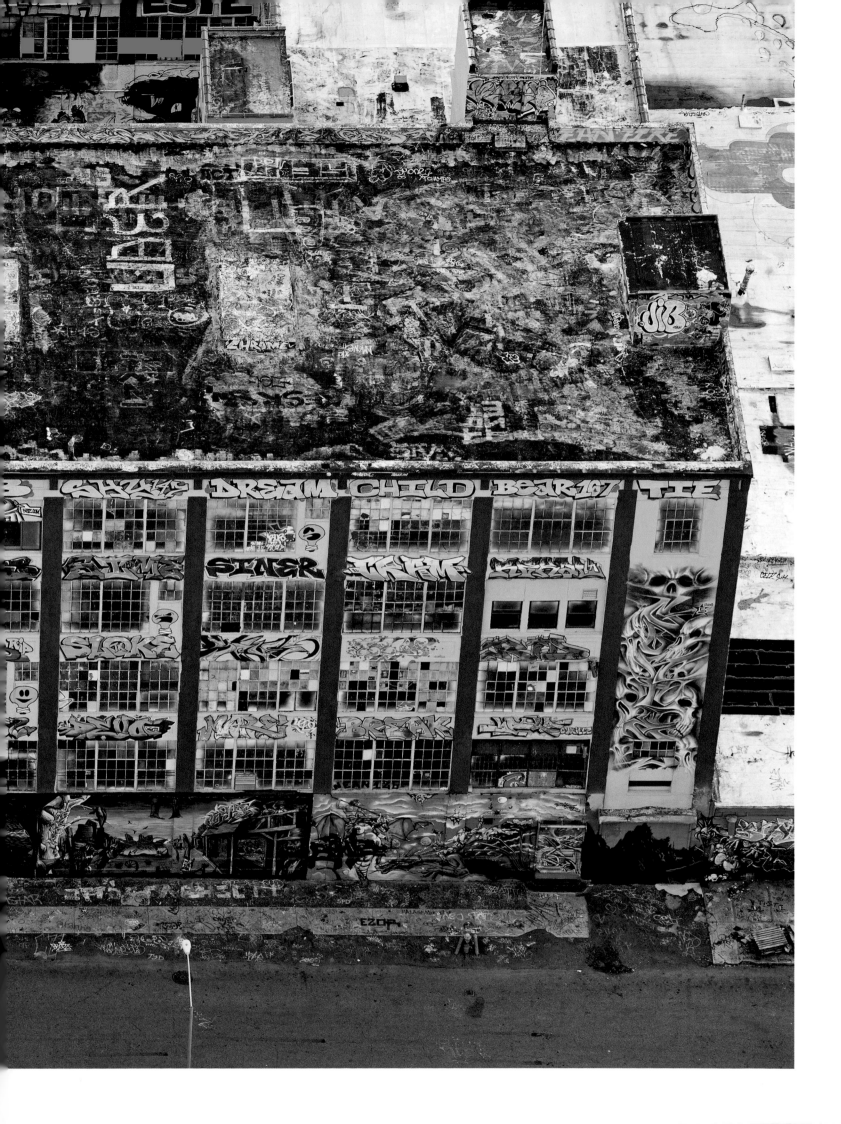

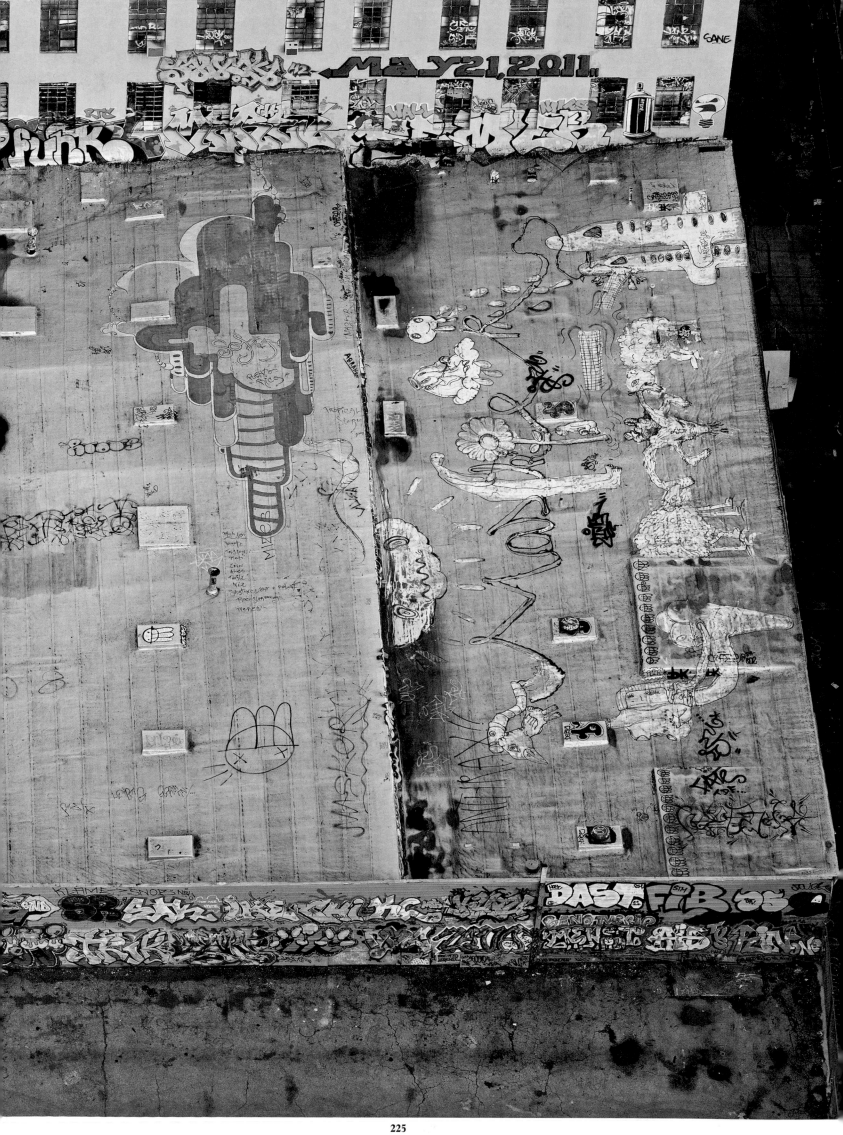

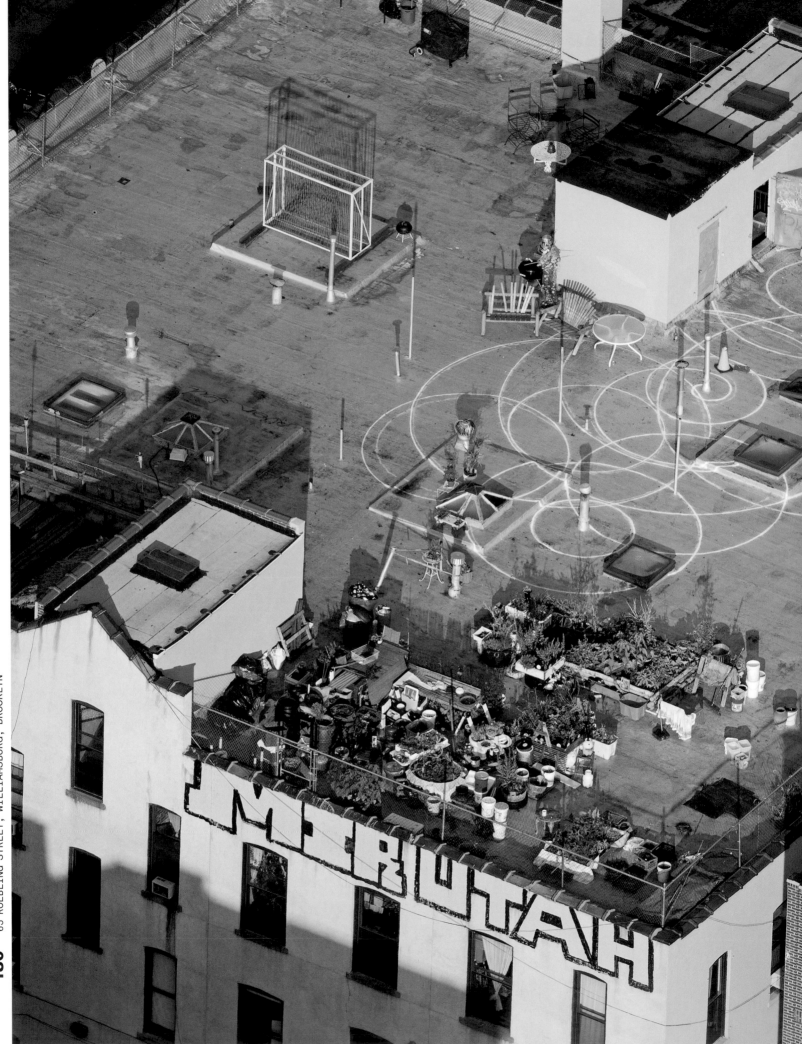

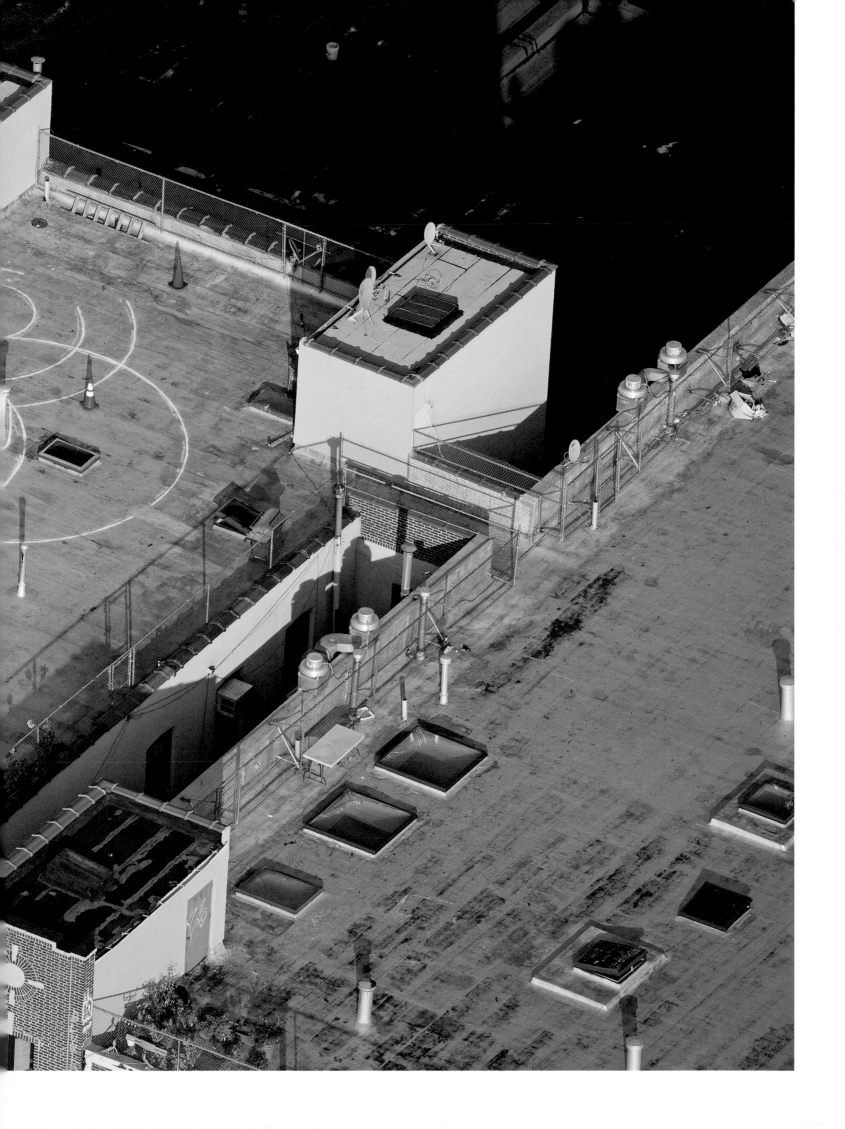

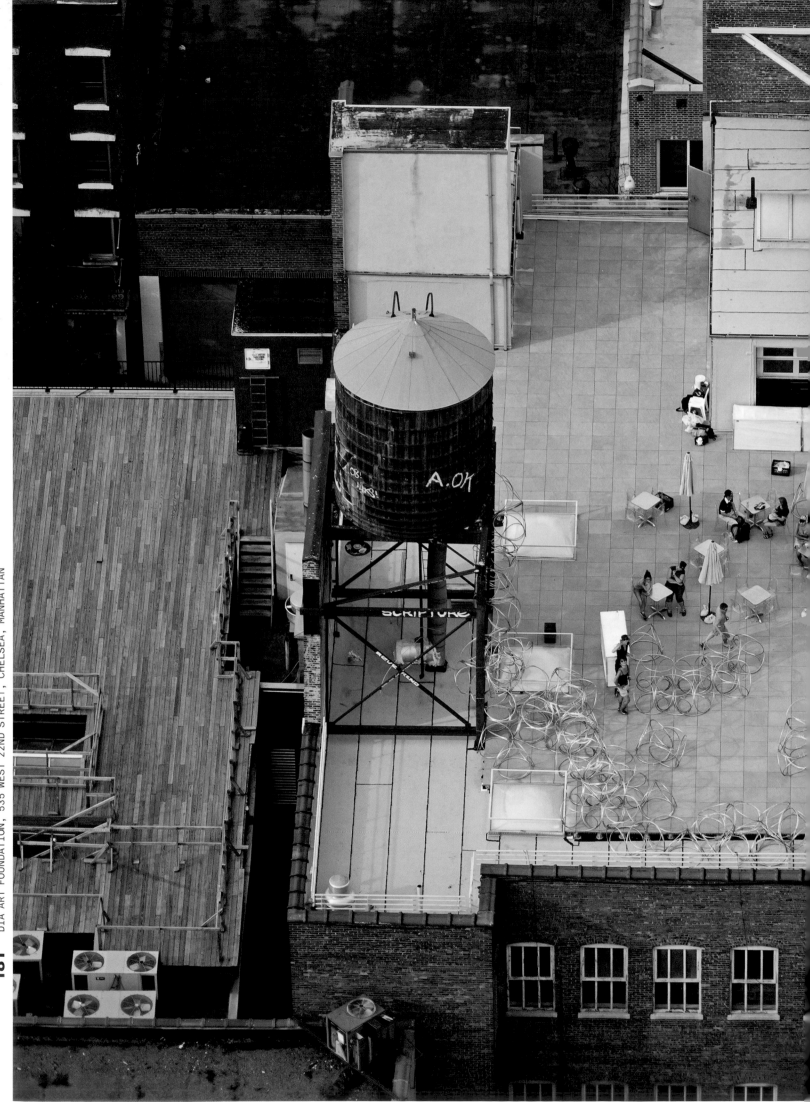

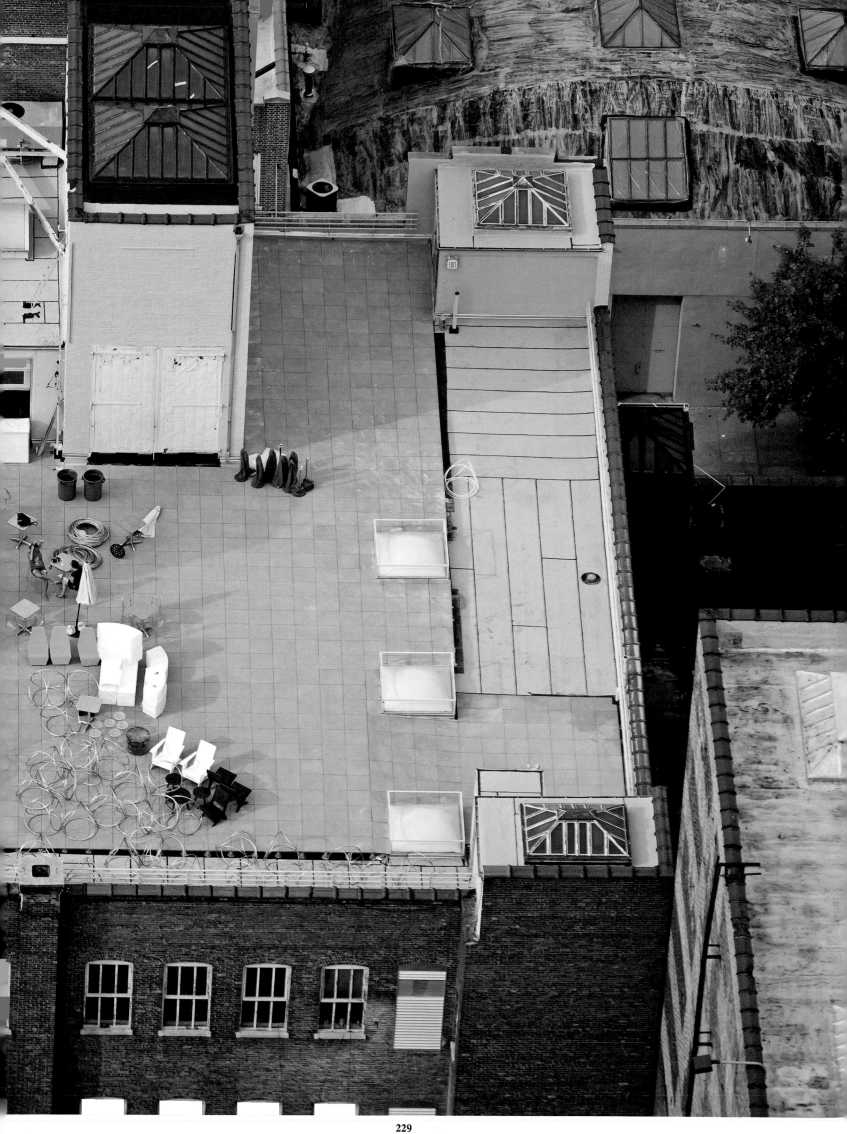

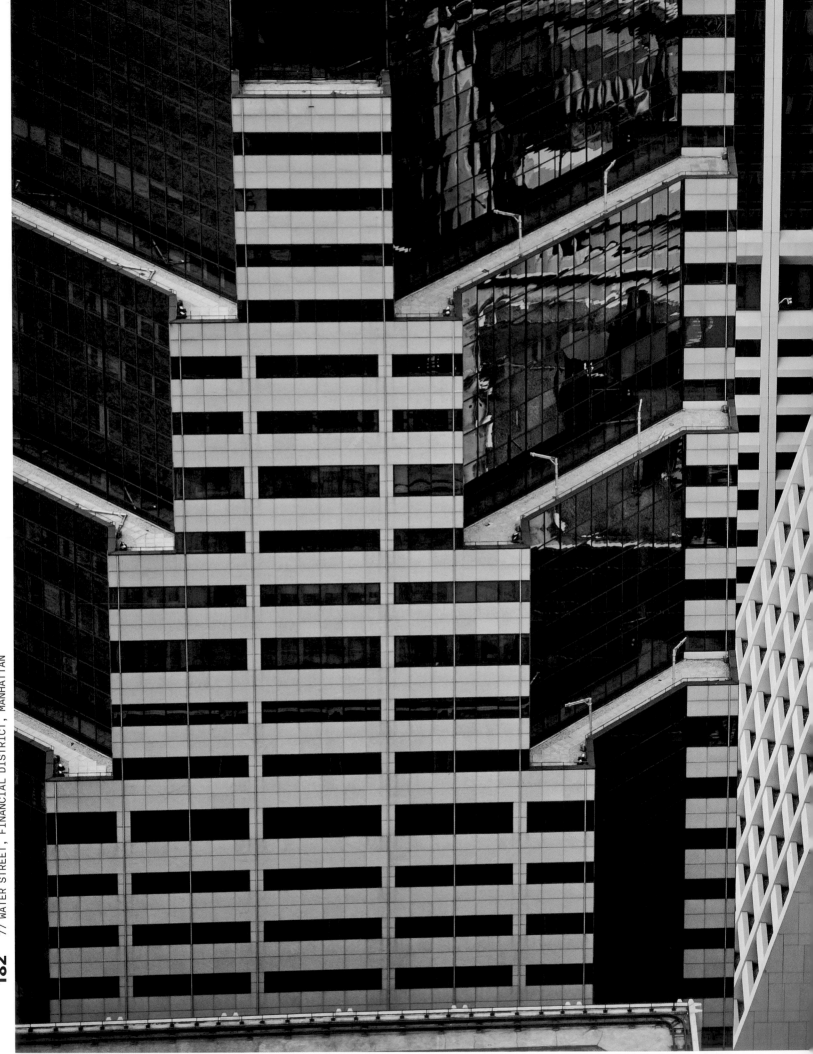

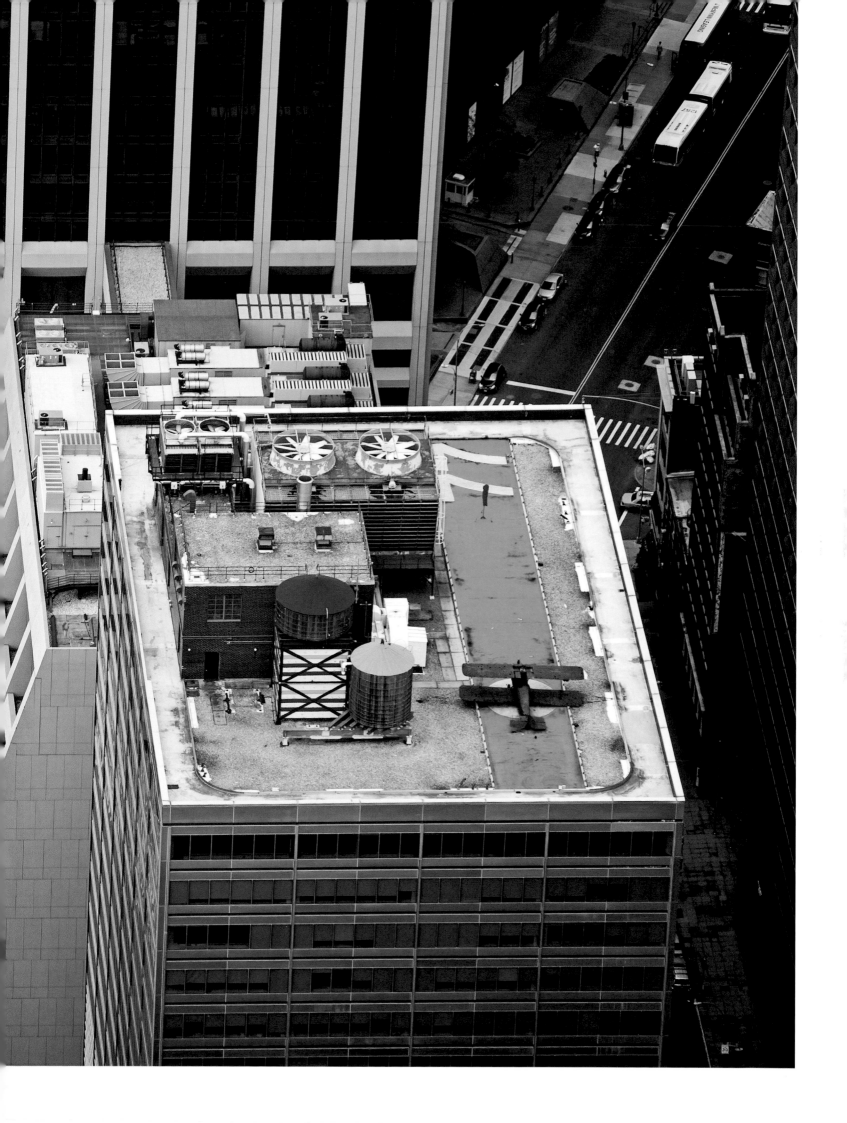

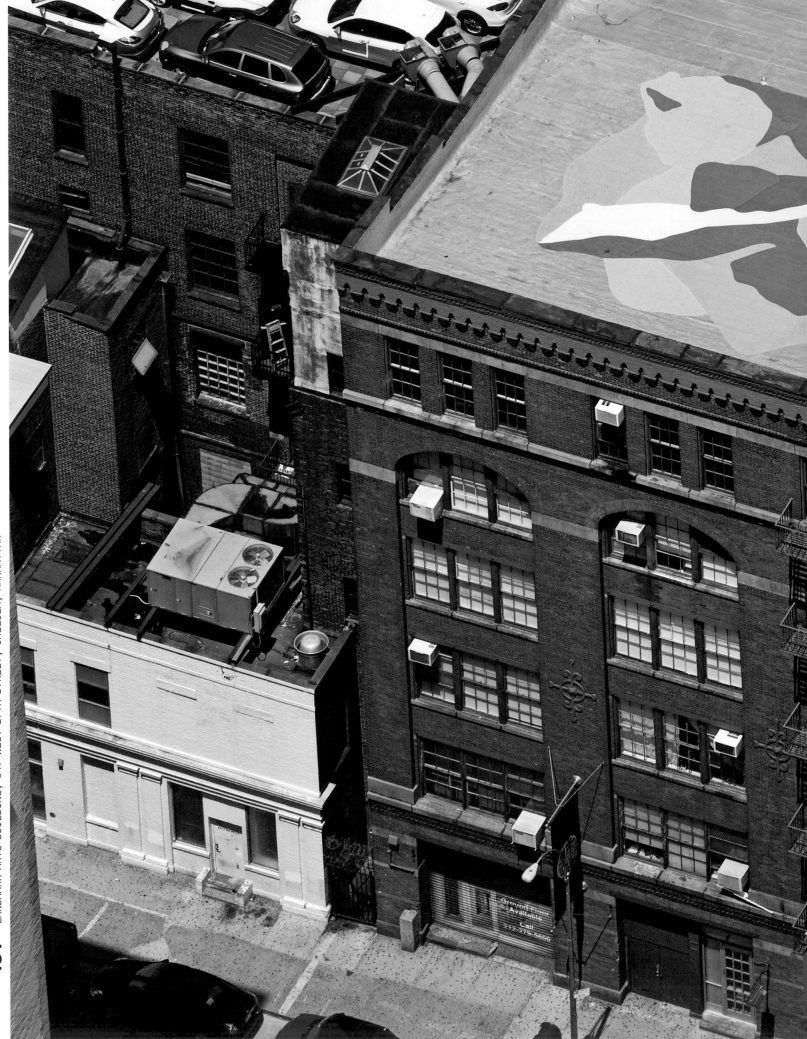

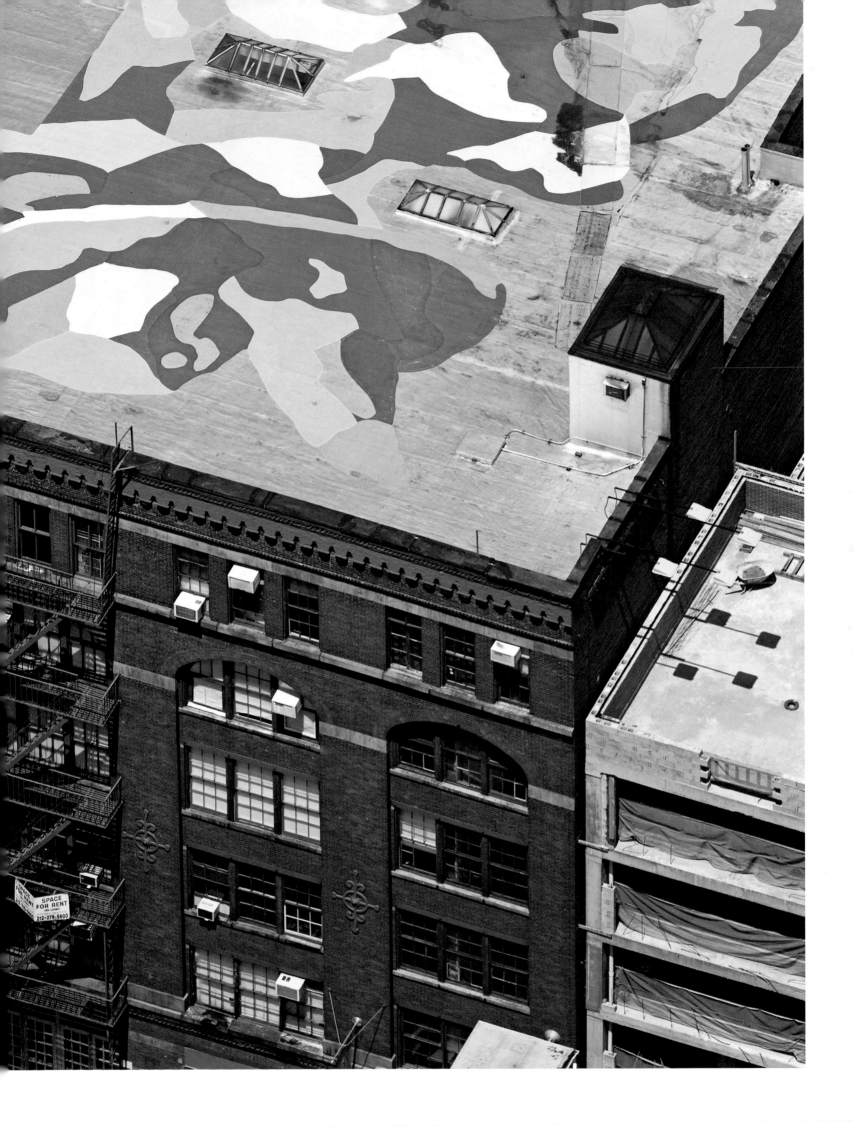

Published by
Princeton Architectural Press
37 East Seventh Street
New York, New York 10003

For a free catalog of books, call 1-800-722-6657.
Visit our website at www.papress.com.

First published in French in 2012 by Dominique Carré Éditeur
© Dominique Carré Éditeur, 2012
www.editionscarre.com

For Dominique Carré éditeur
Designers: Pierre Bernard and Sacha Léopold

For Princeton Architectural Press
Project Editor: Linda Lee

Special thanks to: Bree Anne Apperley, Sara Bader, Nick Beatty,
Nicola Bednarek Brower, Janet Behning, Fannie Bushin, Megan Carey,
Carina Cha, Russell Fernandez, Jan Haux, Diane Levinson, Jennifer Lippert,
Jacob Moore, Gina Morrow, John Myers, Katharine Myers, Margaret Rogalski,
Elana Schlenker, Dan Simon, Andrew Stepanian, Paul Wagner, and
Joseph Weston of Princeton Architectural Press
—Kevin C. Lippert, publisher

Library of Congress Cataloging-in-Publication Data available
from the Publisher upon request.